NETWORKED BODIES

THE CULTURE AND ECOSYSTEM OF CONTEMPORARY PERFORMANCE

Asia Discovers Asia Meeting for Contemporary Performance
2017-2021

Edited by River Lin

TAIPEI
PERFORMING ARTS CENTER

CHAPTER 1
THE ARTIST'S BODIES AND RESEARCH

CHAPTER 2
WORKING COLLABORATIVELY
IN TRANSCULTURAL PRACTICES

CHAPTER 3
MAPPING THE ART ECOSYSTEM

Preface
The Future and the World We Have Made

Ruo-Yu LIU
Chairwoman of Taipei Performing Arts Center

Translated by **Johnny KO**

The journey of reading this book has led my body and mind to another universe, a 'world' we have been waiting for, and one shaped by artists through encounters with each piece of writing and each writer. This is a time for celebrating and unveiling the 'world'!

The 21st century is an age of spiritual awakening. With the continuous development of digitality, the Web and technology, the new humans have emerged and transformed past ways of living.

One-third of the DNA coding and codons of millennials has been unlocked by the universe. The new humans have left the normative behind to inspire new-generation creativity with the awakened spirit. So-called social etiquette, national and ethnic identities, cultural forces and traditions no longer seem to rule the new generation. Meanwhile, artists, in a larger database uncovered by the awakened spirit, are actively making work.

This reminds us that, on earth, we are simply small beings. Sometimes, unexpected encounters bring you and me together as if we have long been acquainted with one another. In Buddhism, the fundamental 8th consciousness *ālāyavijñāna* (storehouse consciousness) steers one's multiple lifetimes. Physical appearances, such as that of a man or woman, are ephemeral in one's current existence as lifetimes circulate through *pratītyasamutpāda* (dependent origination). Ultimately, we trivial beings follow the flows.

In this new generation, the power structure formed by all types of social etiquette and canons have been dismantled through the drive of immense spirituality, with networks, technology, borderlessness, rulelessness, genderlessness, and racelessness, among others, taking its place. The new humans are born with fearless freedom in their genes.

The disciplines and customs of the past century have been torn down by artists living in a time of embracing their ubiquitous creativity.

Therefore, what kind of 'world' exactly would it be?

It is a world of spiritual-awakening, freedom, openness, friendliness, hybridity, borderlessness, and of course, one with more parted, solitary, and precarious states.

It is clear that sustaining 'traditional art' will be more challenging than ever. However, incredible creations that require more demanding techniques have been managed and enacted by the new humans, as evidenced by their practices in the metaverse. The 'etheric body' has merged the laws between human physicality and gravity. The relationship between human beings and nature has also become more harmonized and closer to the earth, as tranquil as the fish in the water, the birds in the sky, the animals living in the mountains, and how the wind blows and the rain pours.

Over the past centuries, Asian civilizations have been constituted by their respective orientations. This 'world', referencing what the Chinese philosopher Laozi suggests, might have existed in an empty and formless state during the creation of the world.

Taking this perspective, ADAM's facilitation of encounters with younger generations at Taipei Performing Arts Center (TPAC) has enabled this visionary performing arts institution to proclaim that 'the future is now.'

The framing of the three-dimensional world, by new-generation artists in Asia, has been emancipated through dealing with notions of decentralization, anti-Eurocentrism, colonial memories, authoritarian economy, and the legacy of slavery among others. In the coding of the new human DNA, four- and five-dimensional universes are seen through the work of artists.

Seeking a return to the existing and invisible elements of his body, Kazuo Ohno resisted the canon of Western modern dance to embrace alternative and prenatal images of dancing bodies. Takao Kawaguchi thus stages the hosting of Ohno's spirit, for the presently living, to perform the entire post-war universe. Watan Tusi's choreographic

process stems from the collection of tribal songs and dances, oral histories, and myths, which results in the development of an open-source 'step notation.' The steps of Indigenous peoples, in a relaxed, natural and slightly bent posture, enact a 'down to earth' approach to propel the body upwards with the support of the dynamics of the earth. This notion embodies the Indigenous peoples' cosmic perspective while also echoing contemporary corporeality and mythology.

While Su Wen-Chi looks at microphysical reality through the perspective of the macrocosm in her work, the artist reveals a unique avenue for contemporary digital performance in responding to the interrelationships between everything in the cosmos. Melati Suryodarmo's performance art transforms rituals into enactments of living in a collective society. Choy Ka Fai works in the context of globalized post-Internet or post-human arts to initiate dialogues with the metaverse through the supernatural. The long-term project of Su Yu Hsin and Angela Goh, with the support of ADAM, has further revealed the intersection of digital culture and colonial histories. Eisa Jocson depicts a tableau of desire that weaves colonial structures and affective labor together from her practice and exploration of pole dancing to her incarnation as a macho dancer in gay bars.

In terms of cross-cultural collaborations and practices, Xiao Ke and Zi Han's journey in exploring 'what is chinese?' profoundly reflects the activist cultural process from the notion of post-colonialism to decolonization. Chen Wu-Kang and Pichet Klunchun, too, have proposed their transcultural performance through a non-Western-centric approach, transcending Eurocentrism and opening dialogic spaces in Asia. Daniel Kok and Luke George's questionings of identity and queer actions reflexively criticize the cross-cultural context in Singapore and Australia. FOCA and Leeroy New, on the other hand, openly and honestly deal with the ineradicable cultural or individual differences that exist in international collaborations, moving towards locality and community engagement. When we further query 'What is "Asia"?' and 'What is "Asian contemporary performance"?', *IsLand Bar*, born in ADAM, stimulates and provokes our thoughts on hybrid and non-binary identities. Meanwhile, through the collaboration of Michikazu Matsune and Jun Yang, we learn how to think oceanically and transform collective knowledge beyond aspects of economy, country and geography into communal, regional, global and planetary practices and identities.

We also learn about the word 'world,' mentioned by Chiaki Soma in her interview. The term 'shi jie' (in Mandarin) was introduced into the Chinese language through the translation of Buddhist scriptures: 'shi' refers to a constant flow, while 'jie' signifies direction or position. Perhaps the so-called 'world' was born from the interweaving of time and space; it is plural and always in transition, and through artistic work, we see the 'world.'

This publication assembling the practices and discourses of 'Asian contemporary performance' is assuredly a statement of 'the world we have made' for the now and the future, as well as a means of connecting TPAC and other 'worlds.'

Foreword
What's in a Name

John Tain

John Tain is Head of Research at Asia Art Archive. Previously, he was a curator of modern and contemporary collections at the Getty Research Institute, Los Angeles. His recent curatorial projects include *Translations, Expansions* in *documenta fifteen* (2022), *Art Schools of Asia* (2021-22), *Crafting Communities* (2020), *Modern Art Histories in and across Africa, South and Southeast Asia* (MAHASSA, 2019-20).

Unlike the visual arts, the performing arts has always enjoyed a much more ephemeral existence. While a painting or a sculpture generally enjoys a stable existence once completed, a piece of theater, dance, or music occupies space only during the course of a certain duration of time. Once over, it continues to exist, but only in the mind of its viewers and participants.

And yet, somewhat improbably, something lasting seems to have taken hold with the founding of Asia Discovers Asia Meeting for Contemporary Performance at the Taipei Performing Arts Center (TPAC) by artist and curator River Lin. ADAM – as the annual event is popularly and affectionately known among the larger community – has managed to foster a wide-ranging network of artists and programmers from across the Asia Pacific region, and beyond, over its five annual iterations despite its being dedicated to the ephemeral arts. This is no mean feat, as by the time of its founding in 2017, the field was already thick with festivals, professional meetings, culture industry markets, and other forms of gatherings that, since the 1990s, have encouraged the growth of performing arts networks across Asia and fostered a more tightly interconnected performing arts scene around the world.

If ADAM has proven to have staying power, and to be more than just a face in the crowd, it is partly because it has distinguished itself as an opportunity, not just for networking among industry professionals, but also for artists to meet one another and to spend sustained time together in the workshopping of ideas and in-progress pieces. Thus, as it took place in August 2018 (which was when I experienced it in person), the formal meetings were preceded by Artist Lab, in which a number of creators got to know one another, partly by making, thinking, and just living together for the couple of weeks of the residence. The meetings were also bookended by several presentations by the participating artists, in which they could showcase collaboratively developed pieces, often of startling freshness and inventiveness, especially considering that they were produced in a short amount of time. This emphasis on artist development is also what has sustained ADAM and allowed it to persevere in the face of the immobility imposed by the pandemic. Shedding the more meeting-related functions of its first iterations, the event honed in on serving as a platform for artistic fertilization, with the 2021 'meeting' re-imagined as three separate in-person and on-line modules spread throughout the year.

This emphasis on process and ideas underscores one of ADAM's unique strengths, alluded to by its reference to 'contemporary performance.' That is, aside from its geographical ambitions to bring together Asia, the event spans disciplinary ones as well, moving between the performing arts and the visual arts through the shared but unlike vocabulary of performance. A format that came into its own in the 2000s, performance differs from its predecessor, performance art. Whereas the latter emerged out of the visual arts starting in the late 1960s partly as an outgrowth of happenings and other similar actions, and frequently featured the artist's own body in a non-art setting, the former takes as its starting point the live experience as a shared commonality between theater, dance, music, and other performing arts. However, while it is now hardly unusual to find choreographers working in an exhibition setting, or visual artists performing on a stage, it is still rare to see practitioners from the different fields working together, as can be found at ADAM. It reflects the increasing convergence between these different genres by adding visual artists to the mix of choreographers, actors, directors, and musicians that it hosts – hardly surprising given Lin himself started in theater before turning to formats more adapted to art spaces. In doing so, it has allowed for the production of new kinds of exchange and discursive shift, one that has been exciting to witness.

Now, on the occasion of the opening of the Rem Koolhaas-designed new home of TPAC, ADAM celebrates its fifth anniversary. One can certainly hope that it will enjoy many more anniversaries to come. And, just as Adam was the first of his kind, let's hope that ADAM presages the coming of a whole new generation of programs like it.

Calling for (the Absent) Asia

Chun-Yen WANG

Chun-Yen WANG received his Ph.D. in Theater Arts from Cornell University. An Assistant Professor of Cultural and Performance Studies at National Taiwan University, he is the recipient of multiple accolades such as the S-AN Aesthetics Award, Taiwan Merits Scholarship and Fulbright Scholarship. Wang's research interest lies in contemporary Taiwanese theater, cultural translation, as well as the relationship between epistemology and aesthetics. In recent years, he has been concentrating on the interdisciplinary performance of global Chinese. Wang is a regular contributor to the Performing Arts Reviews website sponsored by the National Culture and Arts Foundation, Taiwan.

Translated by Johnny KO, Wah Guan LIM

"Asia," as a registered signifier, emerged arguably after the 19th century. When Karl Marx defined a mode of production as a combination of productive forces and relations of production, he singled out the "Asiatic mode of production" to differentiate it from "the West." Yukichi Fukuzawa's *Datsu-A Ron*, a theory proposed in 1885 arguing that Japan should "leave" Asia and "enter" Europe, does not in any sense mean geographically moving the country from the eastern hemisphere to the European continent; this notion also initiated the so-called "understanding of Asia," which, strictly speaking, does not draw semantic equivalence with the territorial. Here, the concept refers more specifically to a knowledge paradigm shift from Confucianism to science; arguably, it also delineates a shift in intellectual consciousness. Since then, for more than a century, the likes of Tetsuro Kazuji, Sun Yat-Sen, Yoshimi Takeuchi, Takeshi Hamashita, Yuzo Mizoguchi, Sun Ge, Wang Hui and Chen Kuan-Hsing, have dedicated themselves to providing reflexive readings of "Asia," while at the same time also responding

to the problematics of "Asia", such as questionings of 'the Greater East Asia Co-Prosperity Sphere', 'Bandung Conference/Afro-Asian Conference' and even the 'Pivot to Asia' strategy, which still continues to this day and age.

Theoretically and critically speaking, "Asia" is actually a derivative of "Europe," and exists as its antithesis. Likewise, "Europe" here is not termed geographically, culturally or civilizationally, but rather discursively, self-fashioning as the only value of modernity and thus further distinguishing Asia as its other. In other words, the terms Europe, Asia, or any other continent, are all part of the formation of world history. This particular classification of world history is the embodiment of what Stuart Hall terms "the West and the Rest." As long as Asia continues to be considered in this framing, it can only emerge in stereotypical imageries and postures, for instance, the vocabularies of specific body movements, traditional rituals, and identities and language systems formed by lands or skin colors. Henceforth, so long as a materialistic and historical understanding of the "complexity of (de-)Asia" continues to remain absent, any attempts to decouple the uncritical binary of pro- or anti-Europe, or pro- or anti-Asia, will ultimately be in vain.

Why a book on Asia and performance still matters

Let's consider what exactly is the "Asia" we are addressing here. First, the terms "Near East," "Middle East" and "Far East" were coined as the opposite of Western modernity. Next, in the configuration of the Cold War, the imagination of regionalization emerged and, through development theory, Asia was divided into East Asia, Southeast Asia, South Asia, West Asia, Central Asia and "Asia-Pacific" (Despite how ill-fitting it seemed, the United States quietly emerged in this allocation of "Asia"). Then came the ASEAN+3 (China, Japan and South Korea), which was established with neoliberalism and business cooperation as its framework. Ultimately, has the increasing growth of forces of production strengthened the boundaries among nation-states in contemporary Asia? Or have their frontiers been weakened by the transaction between capital and labor that has proven to be unstoppable? Concurrently, has contemporary Asia become more closely connected to world history/the West/ Europe through the means and approach of globalization, supranationalism, international cooperation, ecology, working together, or even the pandemic? Or instead, can we expect to unfold new discourses of identity-performance through artistic interrogation and exploration, and simultaneously question the authenticity and identity politics represented by "performance" and "performer"? Specifically, we should understand that we cannot accept, and must refuse, a return to categorized differences complicit with the modernity of classification, such as race, nation, complexion, culture or language which are disguised as neutral and equivalent to one another, while such visible or invisible, processed or resolved historical legacy has been continuously erased by the regime of translation.

What the body and performance can(not) do

This book encompasses a variety of issues in multi-disciplines including cross-cultural studies, field research, curating, network, aesthetics, documentary, critique, historical investigation, as well as notes, autobiographies, interviews and conversations, through which we might want to carefully and critically rethink contemporary Asia. In my opinion, with various understandings from multiple disciplines, life journeys and international practices, this publication is neither a collected manifesto, nor an imprint of harmony and integration. On the contrary, it is the very embodiment of incarnations and trajectories the world history and the network of contemporary corporeality. This book itself, as what ADAM (Asia Discovers Asia Meeting for Contemporary Performance) by Taipei Performing Arts Center represents, is a platform and signifier for dialogue, rather than a solution or staged performance. We would be doomed to fail to seek or locate the signified contemporary Asia in any gatherings and this book's articles through labels. Through the notion of cultural materialism, we must see every gathering, performance and article as the performative rather than a performance, as demonstrated by the limitations and pitfalls of the "contemporary" and "Asia." And only upon doing so can our imagination begin to unfold.

River Gatherings

Madeleine Planeix-Crocker

Madeleine Planeix-Crocker is a French-American research-practitioner, curator, and educator. Born and raised in Los Angeles, Madeleine grew up in a dancing household and continues to develop her movement-based practices in the studio. She is Associate Curator at Lafayette Anticipations, a contemporary art center located in Paris. Madeleine also co-directs the "Troubles, Dissidences et Esthétiques" Chair at the Beaux-Arts de Paris. A graduate of Princeton University, she is pursuing a Ph.D. in performance and gender studies at the École des Hautes Etudes en Sciences Sociales (EHESS); her current research focuses on tools for commoning in contemporary performance. Madeleine facilitates a theatre and creative writing workshop at Women Safe, a brave space for womxn-identified survivors of violence situated in the Yvelines (France).

I must admit I was surprised when artist and curator River Lin extended me the invitation to pen the foreword of this book. The opportunity arose during his performance *My Body is a Queer History Museum* which I curated last spring at Lafayette Anticipations. [1]

Working with River, I realized that our embodied commitments to our respective practices provided rich, dialogical foundations from which collaboration could be born. Indeed, my curatorial approach is nourished by my lifelong training as a dancer and my current doctoral pursuits in performance and gender studies. I acknowledge that though in active deconstruction, my locatedness remains marked by European and North American histories/ scholarship of damagingly biased and violent relationships with specific bodies in being, thought, and affect.

As such, I questioned my position in writing the foreword to a book celebrating ADAM's five-year existence and efforts in support of situated exchanges across the Asian continent. River remained committed to the invitation, allowing me to understand this opportunity as an extension of our ongoing dialogue which I will attempt to honor in the words below. It

is therefore through the lens of our previous collaboration that I can best conceive of this foreword.

Upon reading the accounts assembled in *Networked Bodies*, I believe that with and through ADAM, River has generated (in other words curated, beyond) a vibrant intersection of cultural, artistic, and political communities – a genuine reflection of his methods, manner, and imagination, or what philosopher Sara Ahmed might recognize as a "queer commitment." [2] Through these essays, I was also delighted to reconnect with performers, curators, and critics with whom I have had the joy of crossing paths in my current home-base of Paris. My gratitude in full extends to River and his fellow authors, both known and new to me, whose contributions painted a landscape of "networked bodies."

During a podcast interview in which we were guests, hosts Clara Schulmann and Thomas Boutoux prompted us to introduce River's upcoming performance at Lafayette Anticipations through chosen sources. [3] River proposed the song *Thank You* by ABAO, "an Indigenous/ First-Nation singer from Taiwan who has in recent years created musical works combining linguistic performances of her mother-tribal language, English, and Chinese-Mandarin in order to manifest her/their hybrid and queer identities." [4] In resonance, I intuitively shared a passage from cultural theorist Gloria Anzaldúa's seminal *Borderlands/La Frontera: The New Mestiza*. Later, upon articulating the invitation to write this foreword, River mentioned this reference as pivotal in our discussion. I will thus cite a more extensive passage here:

Cradled in one culture, sandwiched between two cultures, straddling all three

cultures and their value systems, la mestiza undergoes a struggle of flesh,
a *struggle of borders, an inner war [...] The coming together of two*
self-consistent *but habitually incompatible frames of reference*
causes un choque, a cultural *collision [...] But it is not enough to*
stand on the opposite river bank, shouting *questions, challenging*
patriarchal, white conventions. A counterstance locks one *into a duel of*
oppressor and oppressed [...] it is not a way of life. At some point, *on our*
way to a new consciousness, we will have to leave the opposite bank [...]
Or perhaps we will decide to disengage from the dominant culture, write it off
altogether as a lost cause, and cross the border into a wholly new and
separate *territory. Or we might go another route. The possibilities are*
numerous once we *decide to act and not react.* [5]

In Anzaldúa's account of her Chicana upbringing, caught between the hybridization (*mestiza*) of Mexican-Indigenous heritage and white culture, we can hear the complexity of living through border-existences. *My Body is a Queer History Museum* presents the experience of such inter- and intra-cultural tensions, shared by performers who recount personal stories of displacement, migration, and arrival into France. They evoke queer movements, too, in their non-linearity, desires, and strange orientations, claiming space and legitimacy within institutional confines. I do not believe the piece to be a promise of reconciliation. Rather, it is a journey into the possibilities of entering the river and deciding which acts of bridging one wishes to support. [6]

River's approach self-identifies with the concept of "expanded choreography," [7] suggesting ways of understanding movement in dialogue with the visual arts in order to question the normative production of artwork. However, I believe that his practice also engages with the criticality of André Lepecki's call for "exhausting dance" of its implication in "the political ontology of modernity," [8] an implication deeply ensconced in colonialism. Indeed, into *My Body is a Queer History Museum* are woven significant moments of stillness or slowing down, which could be read as kinetic acts of re-filling dance with micro-frequencies and fascial tensions in opposition to the incessant, virtuosic movement. These deliberate choices of rest allowed the viewer to feel time through the performers' embodied and life-affirming presence – disguised, vocalized, and exercised.

Upon reading *Networked Bodies: The Culture and Ecosystem of Contemporary Performance*, I witness how such an endeavor of undoing carries over from River's performance practice to his curatorial commitments, particularly with regard to ADAM. Indeed, the anthology sheds light on contemporary, situated approaches to "the notion of composition," [9] breaking with linear processes of gathering through decolonial and collective movement-based practices.

The astute ternary rhythm allotted to *Networked Bodies: The Culture and Ecosystem of Contemporary Performance* announces ADAM's mission, namely to support experimental research, "transcultural practices," and the elaboration of a meaningful "ecosystem" of the arts throughout Asia, at times reaching out to Oceanic neighbors. The first chapter features portraits of historical figures (cf. Nanako Nakajima on Takao Kawaguchi & Kazuo Ohno) as well as driving forces (cf. Cristina Sanchez-Kozyreva on Melati Suryodarmo, and Betty Yi-Chun Chen on Eisa Jocson) in contemporary scenes of performance across the continent. Artists engage in the rehabilitation of forgotten and/or neglected practices while revisiting their contributions in light of more recent concerns pertaining to technology, climate change, gender/race relations and inclusivity (cf. Chih-Yung Aaron Chiu on Su Wen-Chi, Tsung-Hsin Lee on Su PinWen, and Jessica Olivieri on Latai Taumoepeau). Situated knowledges offered by renewed connections to ancestral and Indigenous traditions, such as Shamanism's

"compossession" [10] (cf. Nicole Haitzinger on Choy Ka Fai), are also set in contrast with burgeoning cityscapes bearing universes within universes, as shared through Xin Cheng's Situationist wanderings. [11]

The second chapter raises a series of pressing questions with regard to curatorial and performative practices that engage participants of different backgrounds (cf. Tsung-Hsin Lee on FOCA & Leeroy New, I-Wen Chang on Chen Wu-Kang & Pichet Klunchun, and Freda Fiala on Michikazu Matsune & Jun Yang), as well as audience members with whom the projects are shared (cf. Anador Walsh on Angela Goh & Su Yu Hsin). As a scholar focusing on the commons in contemporary performance, I was particularly taken by the instances of mutualizing illustrated in this chapter. Indeed, be it the "camaraderie and friendship" [12] built into the foundational fabric of ADAM (cf. Ding-Yun Huang) or the attention granted to strategic tools (rope, plants, play) mobilized by Daniel Kok and Luke George (cf. Betty Yi-Chun Chen), the intentions of commoning inevitably lead to forms of "communality" [13] in which differences are not only celebrated but worked upon. The active processes of disidentification from the "pantheons" of Western canons (cf. Betty Yi-Chun Chen) point to instances of re-appearing together within histories of dispossession (cf. Tsung-Hsin Lee).

Performance researcher Freda Fiala's insight serves as a transition into the third and final section of the book: "While, certainly, the intention in this case, is not to impose a fictive sense of togetherness, as 'kinship,' the content they decide to share rather turns to an understanding of and, perhaps, even commitment to 'Asianness' as a geopolitical responsibility." [14] The connections formed across bodies of land and water are beneficial to the projects at hand. Significantly, too, the said "responsibility" embedded within these connections holds the promise of a sustainable "ecosystem" irrigated by the arts. As such, this chapter carries overarching questions pertaining to the structural organization of initiatives such as ADAM, in favor of their durability and in light of systemic forms of oppression, namely neo-colonialism and ecocidal patriarchy, as well as immediate crises such as the COVID-19 pandemic (cf. Ding-Yun Huang on "lab-ing," and Rosemary Hinde on "networking"). Indeed, Enoch Cheng unpacks the polysemic meanings of "discovering" built into ADAM's make, insisting on the importance of continual gatherings within Asian contexts: "Perhaps it is a perpetual task for Asia-s to discover, to 'get to know' each other." [15] The importance granted to those included in these renewed discoveries inevitably impacts the inner workings of such encounters – their utilized resources, contractual agreements, and potential risks. For instance, while Helly Minarti signals the ahistorical application of choreographic methods onto Indonesian dance, Cheng maintains his big-picture perspective with regard to the role performance plays in "actualizing a reality" [16] as well as the performativity of the roles we adopt in such a forward-looking process. Here, we understand movement, dance, and performance as worlding languages, activators of histories past and new.

This overview, which undoubtedly will be unpacked in the ensuing introduction by River himself, provides insight into the scope and depth of ADAM's actions, and bears witness to my admiration for the supported projects bridging spatio-temporal contexts vast in expanse, histories, and productions. As proposed by art critic Alvin Li in his reading of Xinyi Cheng's exhibit – host to *My Body is a Queer History Museum* in Paris – acts of worlding are enchanting. [17] I became spell-bound myself by River's activation of the commons through performance, treading new paths for collective encounters. Surprised, therefore, I am not that he is able to facilitate such meetings through ADAM, as my co-contributors will expressively testify to hereafter. To read *Networked Bodies* is to dive into the river and embrace its flow, generous in gatherings and learnings.

Works cited

· Ahmed, S. *Queer Phenomenology: Orientations, Objects, Others.* Duke University Press, 2006.

· Anzaldúa, G. *Borderlands/La Frontera: The New Mestiza.* Aunt Lute Books, 1987.

· Lepecki, A. *Exhausting Dance: Performance and the Politics of Movement.* Routledge, 2006.

· Li, A. "Waiting with Xinyi: On Idleness and Utopia." *Seen Through Others* catalogue, Lafayette Anticipations éditions, 2022, pp.131-135.

1. Lafayette Anticipations is a contemporary art center situated in the Marais district of Paris. This durational piece, composed with five Paris-based dancers, was set within the framework of painter Xinyi Cheng's first major solo show in France curated, in turn, by Christina Li.

2. In truth, this is the second writing invitation River has extended in my direction. The first arrived with the joyful news of his nomination for the Anti-Festival LIVE Art Prize (2022) and allowed me to return to our specific collaboration around *My Body is a Queer History Museum*. It can be read upon publication in the fall of 2022.

3. The entirety of which can be listened here (in French), *En déplacement*: https://soundcloud.com/galerie-jocelyn-wolff/en-deplacement-4. Thanks again to Clara Schulmann and Thomas Boutoux for opening this platform to us.

4. River Lin, presenting his selected reference for the *En déplacement* podcast (Email, 22 April 2022). *Thank You* by ABAO can be listened to here: https://youtu.be/4cAp_ldqOuM.

5. Anzaldúa, G. *Borderlands/La Frontera: The New Mestiza*. San Francisco: Aunt Lute Books, 1987, pp. 100-101.

6. I keenly recall River holding 'Tea Ceremonies' on one of Lafayette Anticipations' suspended platforms which serves as a bridge between two fixed museum wings. Here, the artists welcomed guests in 1:1 or small group formats to re-consider traditions of intimate gathering and sharing.

7. This concept, emerging in the early 2010s namely in the context of European-American art and performance history, is placed in conversation with pieces such as Trisha Brown's *Man Walking Down the Side of a Building*, 1970, or, more recently, Xavier Le Roy's exhibition *Retrospective* held in 2012 at the Fundació Tàpies, Barcelona.

8. Lepecki, A. *Exhausting Dance: Performance and the Politics of Movement*. New York: Routledge, 2006), p. 16.

9. Haitzinger, N. "Digital Shamanism: On the Curation of Existences in Choy Ka Fai's Oeuvre," in *Networked Bodies: The Culture and Ecosystem of Contemporary Performance*.

10. Ibid.

11. I would like to note here that this forward was written prior to an integral translation into English of all articles. My incomplete citation of essays in this overview bears witness to this editorial timeline and not to willful exclusion. I regret my linguistic limitations that deny me access to the articles in their language of origin.

12. Huang, D. "Collective and Collaborative Work and Its Pre- and Post-Performance: IsLand Bar (2017-2021)," in *Networked Bodies: The Culture and Ecosystem of Contemporary Performance*.

13. Chen, B. "Bound Together: Luke George and Daniel Kok's Collaborative Artistic Practice," in *Networked Bodies: The Culture and Ecosystem of Contemporary Performance*.

14. Fiala, F. "Thinking Borders, Oceanically: On *The Past is a Foreign Country* by Michikazu Matsune and Jun Yang," in *Networked Bodies: The Culture and Ecosystem of Contemporary Performance*.

15. Cheng, E. "Notes on Enquiries into Asia(s)," in *Networked Bodies: The Culture and Ecosystem of Contemporary Performance*.

16. Ibid.

17. Li, A. "Waiting with Xinyi: On Idleness and Utopia," in *Seen Through Others* catalogue. Paris: Lafayette Anticipations éditions, 2022, p. 133.

Introduction

River LIN
Curator of ADAM

River Lin is a Paris-based Taiwanese performance artist working across dance, visual art and queer culture contexts through making, researching and curating. His work has been presented by international institutions including Centre Pompidou, Palais de Tokyo, Lafayette Anticipations, Centre National de la Danse (Paris), M+ (Hong Kong), Rockbund Art Museum (Shanghai) and Taipei Fine Arts Museum among others. Since 2017 , he has directed ADAM with and by Taipei Performing Arts Center. He has also recently co-curated festivals in Austria, Indonesia and Australia. Lin is a Shortlisted Artist for the 2022 Live Art Prize in Europe.

This book is based on the exchanges, research and practices undertaken by artists from across the Asia-Pacific region and beyond who have worked with performance as a medium, form and method during the 2017-2021 editions of ADAM (Asia Discovers Asia Meeting for Contemporary Performance). It proposes or questions work-in-progress modes of knowledge production in the glocal context of contemporary performance. This publication documents the trajectory of ADAM, and further expands the discursive process for the problematique related to issues such as geopolitics, community and social engagement, cross-cultural studies, and interdisciplinary art. As the curator of ADAM, my work is to continuously explore and stir these speculations with artists, and stage how they choreograph, sculpt, concoct and circulate their thoughts and findings performatively.

Through a point-line-plane approach, *Networked Bodies: The Culture and Ecosystem of Contemporary Performance* looks at the performance process in three aspects: the individual practices of artists, collaborations between artists, and the art ecosystem. This composition presents how contemporary art, society and culture have intertwined into an intricate network (alas, this publication explores only a part of it).

The first chapter, "The Artist's Bodies and Research," examines the creative research and development behind live works and actions of performance, dance, theatre, new media and visual artists. The specific histories, social progresses and contemporary cosmoses connected to the inner recesses of their bodies enlighten us on how the body can be used as a language and instrument of fieldwork, as well as how artistic research is replete with process-oriented performativity. "Working Collaboratively in Transcultural Practices," meanwhile, is a collection of artists' firsthand experiences of collaborations and back-and-forth dialogues. The various exchanges and reflections between them catalyze experimental discourses of cross-cultural practices beyond theoretical frameworks. The third chapter, "Mapping the Art Ecosystem," depicts the intersections of the artist community, contemporary society and the institutional realm in the 21st century context. It charts where we are presently and stimulates our understanding of how different hues of cultural and art practitioners have together colored the ecosystem, including all the contributors to this book: artists, curators, academics, art critics, producers, members of cultural institutions and the like.

There is, however, no single understanding or consensus of 'Asia as method' in these networked bodies. The way a piece is situated and associated with other pieces in the same or another chapter of this publication suggests how discourses could be questioned, rather than being installed. It invites readers and arts practitioners to reflexively rethink about 'who' is perceiving and rehearsing the notions of 'Asia,' 'inter-Asianness' and 'contemporaneity' – for 'what,' from 'where' and 'how' – as well as what cultural imaginations have arguably been articulated or withdrawn amidst it all.

ADAM was initiated in a bid to build a cultural infrastructure that is open-minded and heterogeneous, as well as to seek a decentralized and non-binary discourse on contemporary performance culture through the research and practices of artists. As a publication that transforms on-site happenings, making-of processes and echoes into knowledge production, this book also responds to the social and arts ecosystem impacted by COVID-19. With the opening of Taipei Performing Arts Center in 2022, ADAM continues to investigate the networks and bodies of Asian and global contemporary art and performance through this book.

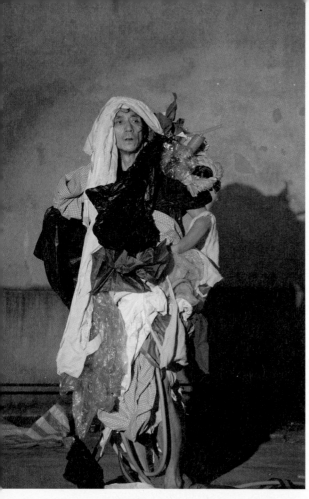

About Kazuo Ohno, Takao Kawaguchi,
2019 camping asia.
Image courtesy of Taipei Performing
Arts Center.

Weaving on the Moon,
TAI Body Theatre, 2020.
Image courtesy of TAI Body
Theatre. Photo by Ken Wang.

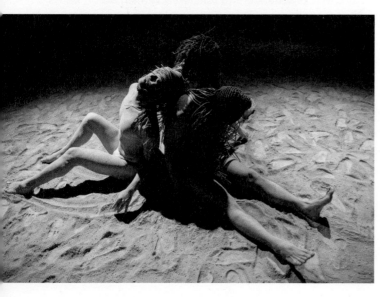

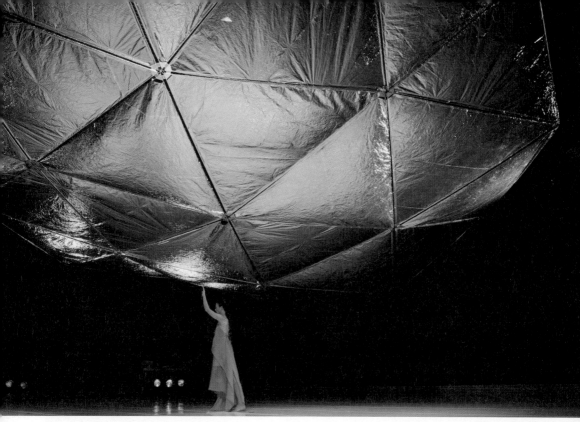

Unconditional Fact and Love, Su Wen-Chi, 2017.
Image courtesy of YiLab. Photo by LEE Sin-Je

CosmicWander: Expedition, Choy Ka Fai, video still, 2021.
Image courtesy of the artist.

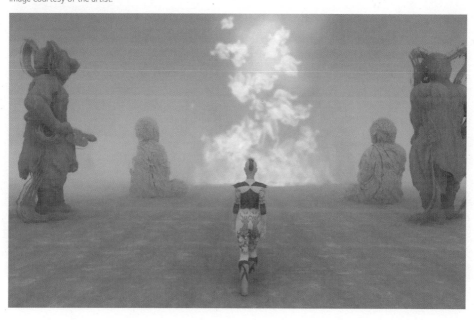

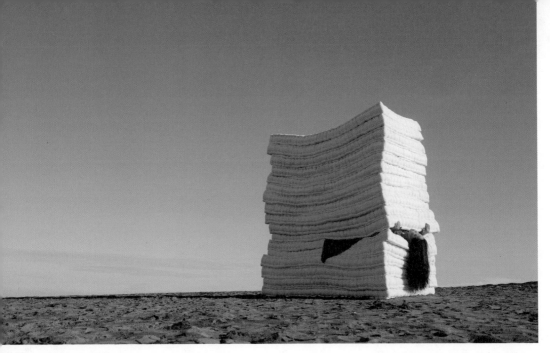

Dialogue With My Sleepless Tyrant, Melati Suryodarmo, 2012.
Image courtesy of the artist.

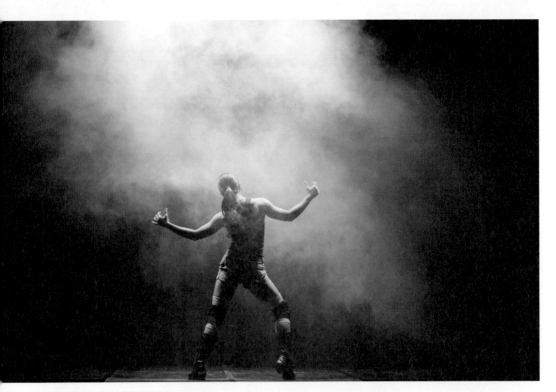

Macho Dancer, Eisa Jocson, 2018 Taipei Arts Festival.
Image courtesy of Taipei Performing Arts Center. Photo by Gelee Lai.

Girl's Notes, Su PinWen, 2018 Taipei Fringe Festival.
Image courtesy of Taipei Performing Arts Center. Photo by Lô Bōo-Him.

Convivial awning in Phnom Penh.
Image courtesy of Xin Cheng.

The Last Resort, Latai Taumoepeau, 2020.
Image courtesy of the artist. Photo by Zan Wimberley.

Behalf, Chen Wu-Kang x Pichet Klunchun, 2018.
Image courtesy of Chen Wu-Kang. Photo by Etang Chen.

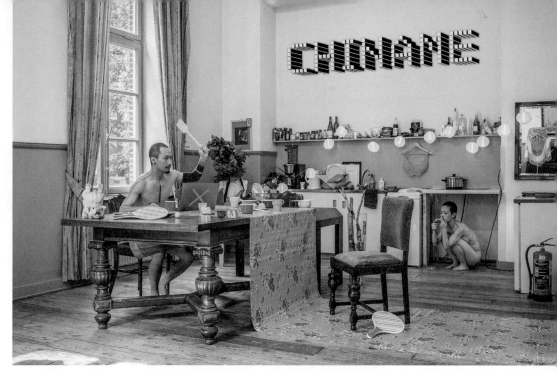

CHINAME, Xiao Ke x Zi Han.
Image courtesy of the artist.

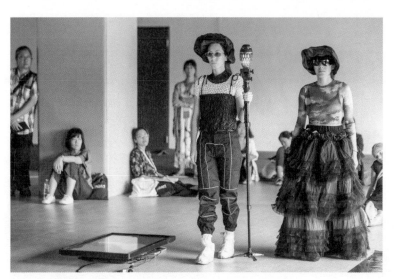

Paeonia Drive (work-in-progress presentation), Su Yu Hsin x Angela Goh, 2019 ADAM.
Image courtesy of Taipei Performing Arts Center. Photo by Pi-Cheng Wang.

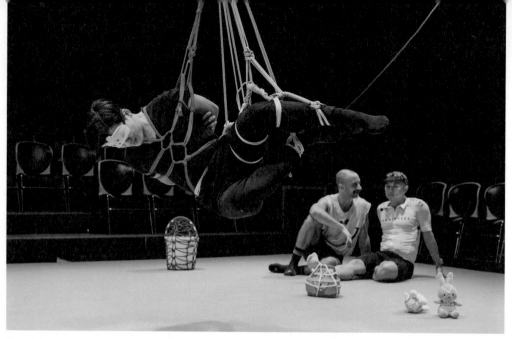

Bunny, Luke George x Daniel Kok, 2019 Taipei Arts Festival.
Image courtesy of Taipei Performing Arts Center. Photo by Hsuan-Lang Lin.

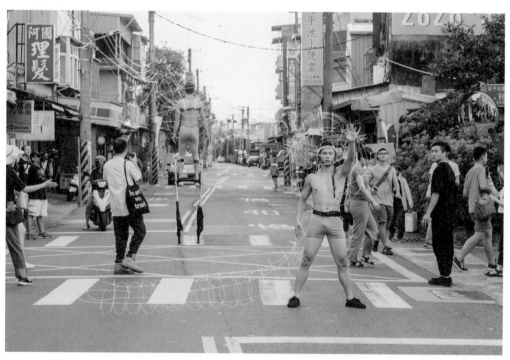

Disappearing Island, Formosa Circus Art x Leeroy New, 2019 Taipei Arts Festival.
Image courtesy of Taipei Performing Arts Center. Photo by Hsuan-Lang Lin.

IsLand Bar (Taipei): Sweet Potato Affair,
2019 Taipei Arts Festival.
Image courtesy of Taipei Performing Arts Center.
Photo by Hsuan-Lang Lin.

The Past is a Foreign Country,
Michikazu Matsune x Jun Yang, 2018.
©Michikazu Matsune Jun Yang.
Photo by Elsa Okazaki.

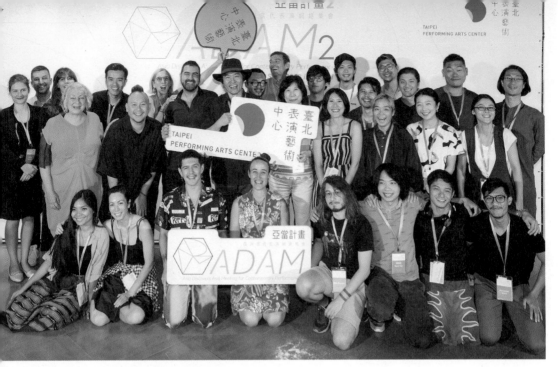

The press conference of ADAM, 2018.
Image courtesy of Taipei Performing Arts Center. Photo by Pi-Cheng Wang.

ADAM Artist Lab, Justin Shoulder leading a workshop, 2018.
Image courtesy of Taipei Performing Arts Center. Photo by Pi-Cheng Wang.

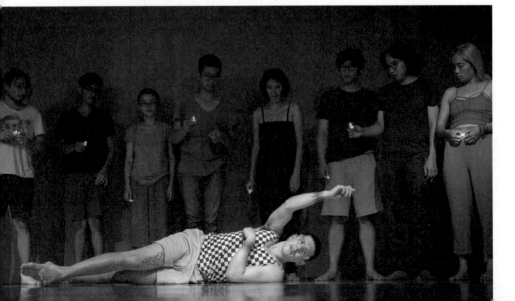

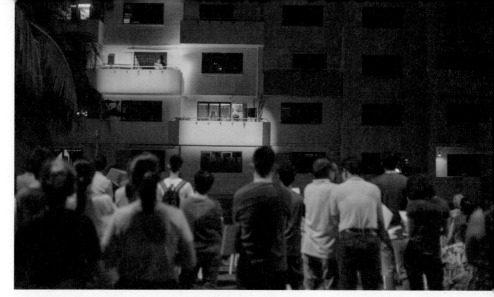

Community performer/architect sharing about the architectural history of the estate.
©The Pond Photography/Drama Box

Choreo-Lab: Process in Progress #2, 2015 incarnation of the previous
1970s-1980s platforms organised by JAC. Image courtesy of Helly Minarti.

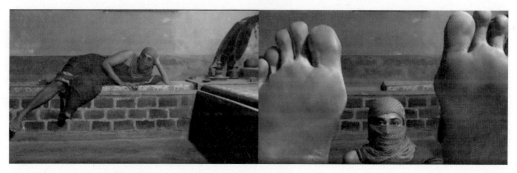

FW: Wall-Floor-Window Positions (screenshots), 2020 ADAM. Image courtesy of Taipei Performing Arts Center.

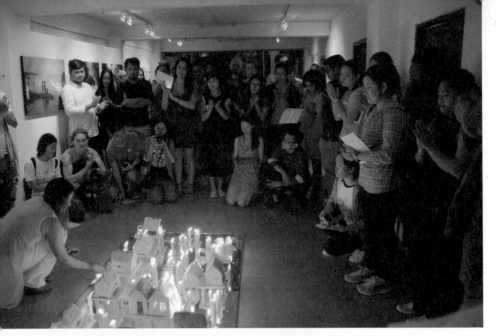

Artist Sao Sreymao doing a
performance during her solo
exhibition at Sa Sa Art Projects, 2018.
©Sa Sa Art Projects

Oral Movement: Musée de la Danse in Taipei, 2016.
Image courtesy of Taipei Performing Arts Center.
Photo by Pi-Cheng Wang.

2018 Pulima Art Festival.
Image courtesy of Indigenous Peoples Cultural Foundation.

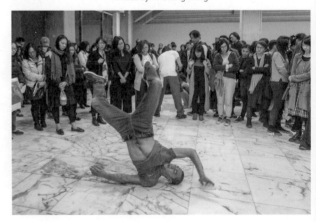

About ADAM

Asia Discovers Asia Meeting for Contemporary Performance (ADAM)
was founded by Taipei Performing Arts Center in 2017. Jointly conceived
with River Lin, a Taiwanese artist and curator currently living and working
between France and Taiwan, the project aims to build a research and
exchange platform for cross-cultural and interdisciplinary performance
art in the Asia-Pacific region. Different from other similar networks and art
markets that focus on transactions, ADAM emphasizes an 'artist-led' concept
and practice. It invites artists to disrupt the relationships and dialogues
between institutions and artist communities through the ecological
processes of conception, research and development, as well as production,
and also provides sustenance and companionship to artists while they
embark on their journeys in creative research and co-creation.

ADAM mainly consists of two phases: Artist Lab and annual Public Meeting.
Every year, Artist Lab invites artists to convene in Taiwan and take part in
a collective research residency targeting different themes. Their interim
findings are shared through presentations in the Public Meeting which is
also attended by professionals the likes of representatives of international
institutions, curators, and artists, as well as local audiences. Through
activities held by ADAM and invited artists, such as work-in-progress
presentations, forums, and workshops, networks and dialogues are forged.

The project has received generous support from various partners, including
Hong Kong's West Kowloon Cultural District, Singapore's Esplanade - Theatres
on the Bay, Sydney's Performance Space, Singapore's National Arts Council,
Australia Council for the Arts, Creative New Zealand, and Kyoto Art Center,
facilitating the realization of a network for contemporary performance in
Asia and enabling artists to continually broaden our perspectives.

* Please refer to the website and appendix for more details of ADAM.
 https://www.tpac-taipei.org/en/projects/adam-project

CHAPTER 1
THE ARTIST'S BODIES AND RESEARCH

The Archive and Repertoire of Butoh: Takao Kawaguchi's *About Kazuo Ohno*

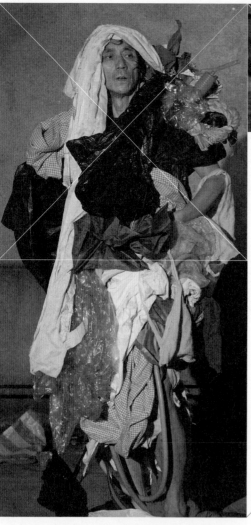

Nanako NAKAJIMA

About Kazuo Ohno, Takao Kawaguchi, 2019 camping asia.
Image courtesy of Taipei Performing Arts Center.

Archive fever

Known for its shocking, contorted body gestures and dedication to breaking taboos, Butoh is a contemporary art form that draws on both Euro-American and native Japanese sources. Butoh originated from new dance movements presented in the late 1950s, in the works of two founders, Tatsumi Hijikata and Kazuo Ohno, both of whom rejected contemporary Japanese modern dance's strict adherence to Western styles. Hijikata called this movement *Ankoku Butoh*, meaning dance of darkness or blackness, until he passed away in 1986.

Butoh is difficult to define, and its definition is highly controversial. In terms of its theory and practice, Hijikata's ideas were so influential that they are regarded as the source of all Butoh practice. One critic has explained that nudity, shaved heads, white-plaster makeup, and transvestism are considered essential elements of Butoh; however, Hijikata believed that Butoh consisted of a peculiarly Japanese quality of physical action and that it emphasized the spiritual climate of Asia, especially that of Japan. Whether one accepts his essentialism or not, a tentative understanding of Butoh is that it is an innovative attitude toward the body in dance that does not produce the shaped body.

After the Butoh legend Kazuo Ohno passed away in 2010, we then heard about the sudden death of his son Yoshito Ohno, in 2020. The legacy of Butoh has now been transformed into a kind of archival knowledge available to the public. Along with the Hijikata Tatsumi archive, the archives of the Ohnos have been published online for free use. The various approaches to Butoh are made possible through this recent effort at sharing materials.

Dancers outside of the Butoh community started experiencing this artform which produced no visibly shaped movement but legitimated the spiritual discipline, and the genre of Butoh embraced the notion of archiving. For a long time, nobody knew what Butoh was. Now everyone inductively knows Butoh from the archival legacy.

The discipline of Butoh is, however, strict. It could become so intense to the limit of physical torture and continuous verbal assaults by masters. This tradition is the rite of passage to becoming a member of the Butoh community. Some still subject newcomers to these rituals. Archiving Butoh,

therefore, does not only democratize Butoh for outsiders, it also emancipates insiders from restrictions, freeing them from an age-old curse.

About Kazuo Ohno by Takao Kawaguchi

Takao Kawaguchi clearly states that he has neither learned Butoh nor had a chance to watch Kazuo Ohno on stage. Rather, Kawaguchi established his career in the field of media art performance as a member of the well-known artist collective, Dumb Type, from 1996 to 2008. In his performance titled *About Kazuo Ohno – Reliving the Butoh Diva's Masterpieces*, which is a re-enactment of selected works by Butoh legend Kazuo Ohno, Kawaguchi, in collaboration with his dramaturg Naoto Iina and supported by the Kazuo Ohno Dance Studio, has literally copied the dances from video recordings of Ohno's masterpieces, including the film *The Portrait of Mr. O* (1969, dir. Chiaki Nagano), as well as the performances *Admiring La Argentina* (1977), *My Mother* (1981) and *The Dead Sea* (1985). While Ohno had practiced dance almost his entire life, he only established his own improvisatory style later in his career and became known internationally after his retirement from his day-job. The last three of these works are characteristic of Ohno's eclectic and willowy Butoh style after he experienced the training backgrounds of modern dance and gymnastics.

Since its premiere in 2013 at Tokyo's d-Soko Theater, this piece has continuously evolved. I first saw it at the Yokohama BankART Studio NYK, in the program of Kazuo Ohno Festival 2013. Together with the familiar members of the Tokyo experimental dance community, I had the chance to see the original version. At the beginning of the piece, Kawaguchi strangled himself with litter and played with a fan and a mop. The audience were left standing to watch him in the entrance space which was next to the photo exhibition of Ohno. The performance area was not fixed, so Kawaguchi often crossed into the space where we were standing or sitting. What he was doing was not at all a dance to the music, but a series of spontaneous actions: throwing blue sheets at a fan, hanging up banners in the venue, and changing out of his clothes into shreds of blue tarp... This part was a homage to *The Portrait of Mr. O*, in which Ohno attempted to explore potentials of his performance by carrying out absurd actions.

When Kawaguchi wrapped his body in the pile of litter, Bach's *Toccata and Fugue in D Minor* was heard. That was the cue for Divine – the aging male

prostitute created by Jean Genet, presented in Ohno's *Admiring La Argentina* – to appear. In Genet's novel *Our Lady of the Flowers*, Divine contracts pulmonary tuberculosis and eventually meets his end vomiting blood. With this music, Ohno, in dress as Divine, first appeared from the auditorium in the crowd and walked up to the stage as if embarking on a death journey. In similar fashion, the debris-clad Kawaguchi stood up and invited the audience to the space behind to take their assigned seats in the black box theater.

After this opening sequence, Kawaguchi presented various scenes from three works in Ohno's repertoire. Most of the time, the titles of the pieces and scenes were projected on the wall next to him. All the costumes were hung and exhibited on stage, and Kawaguchi showed us the process of changing into and out of them in a Brechtian way. While preparing for the next piece, Kawaguchi's own physicality was inserted, which constantly changed my perception. Because storytelling was often done in dance, role-play is a part of dance in Japan. As Ohno played Divine, Kawaguchi played Ohno: this line is our cultural tradition.

This performance was, from the way it was presented, a study of Ohno: the scenes are carefully chosen and performed by Kawaguchi, while his movement quality was far harder and sharper than Ohno's. He was carefully following the outline of Ohno's movement. I recognized some of Ohno's signature movements such as the opening up of the arms toward the sky with open hands while taking one step toward the front stage. This was an amazing project, which was never possible in the Butoh community. Because this idea of copying Ohno was too foreign a concept within the discipline, it would never be conceivable to Butoh performers. Kawaguchi was able to do this because he was outside of the Butoh community.

Kawaguchi's controversial approach of copying Ohno's dances from archival materials actually follows in the very footsteps of Ohno's soul searching, artistic trajectory. *The Portrait of Mr. O* was created during Ohno's slump. Ohno and Hijikata had been presenting their works continuously until 1967, by which time Ohno felt he could no longer perform in front of an audience – a sentiment that would linger for 10 whole years. Away from the public eye, Ohno began working with experimental filmmaker Chiaki Nagano, making the *Trilogy of Mr. O*. Without this inner voyage, Ohno would never have danced in public again, and so this work prepared him to take his next big artistic step toward his masterpiece, *Admiring La Argentina*, in 1977.

The medium of film was able to supply a mirror image not only for Kawaguchi, but also for Ohno in his soul-searching phase. Ohno continuously watched these films by himself to look for an alternative way of creating his own style of dance. For Ohno, the process of negating his body, which had been trained in modern dance techniques, and seeking an alternative, prenatal image of the dancing body was a way of returning to what was inherent in his body. Because Kawaguchi followed the same observational process that Ohno did with film and copied the external form of his body, he reversed the order to re-experience Ohno's artistic quest within his (Kawaguchi's) own body. Ohno's dance was often improvisational, made up of movement drawn from the interior, so this reversal from exterior to interior, from the present to the past, is an effective, filmic approach for Kawaguchi in studying Ohno's 'dance of the soul.'

When the performance in Yokohama in 2013 finished, I saw Yoshito Ohno, Kazuo's son, entering the stage with a bouquet for Kawaguchi. Yoshito was one of the organizers assigned to congratulate Kawaguchi on his performance. Offering a flower to Kawaguchi, Yoshito started dancing with his finger puppet made in the image of his father. Later, I heard from Yoshito that he received a gift box from his student in Mexico after Kazuo Ohno's death. In this box, he found this finger puppet which was made from the stage figure of Kazuo Ohno in a black dress. I was somehow struck by this moment because the encounter was so dramatic as well as complicated. Yoshito Ohno had long lived with, supported, and contributed to the success of his legendary father. However, as a dancer, he was always in his father's shadow. His performances were often criticized and compared to those of his genius father. How did Yoshito feel about Kawaguchi's performance which imitated Kazuo Ohno far quicker than his own? While I applauded Kawaguchi's project, I also cared about Yoshito.

Beyond the copy and the original

After seeing this show by Kawaguchi, I have met people who reacted differently to his approach. Some admire Kawaguchi for his innovation, while others in the Butoh community declined to see his show. Kawaguchi embarked on an international tour before returning to Japan for his national tour. Throughout the process, the content of this piece continuously evolved, gaining more recognition from the audience with the passage of time. Kawaguchi used to run the Tokyo International Lesbian and Gay Film Festival.

Along with his work as part of Dumb Type, which has dealt with various identity politics, he is familiar with the rhetoric and approaches in queer culture that involve different bodies.

Filmmaker Chikako Yamashiro has documented the process of Kawaguchi emulating Kazuo Ohno. In *The Beginning of Creation: Abduction/A Child* (2015, 18 minutes), she presents the creative process behind *About Kazuo Ohno*. Kawaguchi captures Ohno's movements and choreography from video documentations of his legendary performances, replicating the actions with his own body. The filmmaker's gaze clings to the enigmatic exposed figure that emerges as she chronicles how the artist inherits the experience of others with his own body.

In this film, Kawaguchi's solitary and sincere dialogue with the absent Ohno is portrayed. Kawaguchi drew thousands of sketches of Ohno's gestures and movements before he even started dancing. Pausing each shot of the archival footage of Ohno, he traced the legend's poses and adjusted his own to match. Through this process, Kawaguchi came to realize how complex his choreographic sequences were. The more he tried to imitate Ohno's actions, the more he ended up erasing his own identity, according to Kawaguchi. What has become apparent is the difference between Ohno and himself.

In 2017, Kawaguchi organized a 'body sculpture workshop' at Saitama Arts Theater together with his performance of *About Kazuo Ohno*. In this workshop, he revealed and transmitted his creative process to the participants. Also, since 2017, Kawaguchi has begun working with a modern ballet coach to correct his imitated movements during rehearsals. In the words of Keiko Okamura, the ex-curator of Tokyo Photographic Museum who observed this process, *About Kazuo Ohno* was not about the entanglement between the copy and the original anymore. Kawaguchi's project is more detailed and careful: rather, this is a continuous project to inherit the experience of others.

The legacy of Butoh is, however, homosocial. Katherine Mezur criticizes this closed lineage: Butoh scholars and critics left the female performers unnamed, obscuring their distinctive contributions and labor by not considering the collective characters as central to Butoh's corporeal politics and radicalism, while they celebrate the legacy of Butoh founders Tatsumi Hijikata and Kazuo Ohno. If the choreography of female performers like Yoko

Ashikawa and Anzu Furukawa are integrated into the legacy of Butoh, one recognizes the process of transfer to other bodies while still maintaining differences. While Butoh's lineage is free from the myth of the original, Takao Kawaguchi is also free from 'copying' the 'original' Kazuo Ohno.

For the sake of others

In 2017, I had a chance to see *About Kazuo Ohno* again in Berlin. It was presented by the Tanz im August festival with a focus on Butoh reconstructions juxtaposed with works by American and Brazilian choreographers. *About Kazuo Ohno* was performed at the black box theatre of HAU 3. Kawaguchi unveiled the performance outside of this redbrick building. I carefully watched the performance and acknowledged various alterations.

After resetting his costume and props, Kawaguchi began putting on white make-up, iconic of Ohno's Butoh, on stage – this was new. During the scene "Dream of Love" from *My Mother*, I was surprised that his dance flowed smoother than the first time I saw it. From time to time, his postures even reminded me of certain documentary photos of Ohno performing this piece. The ultimate revision I noticed was the new scene featuring Yoshito Ohno embedded in the intermission of the work. In this scene, the face of Yoshito Ohno in close-up was projected against the back wall, and he danced with a finger puppet of Kazuo Ohno to Elvis Presley's *Can't Help Falling in Love* at the Kazuo Ohno Dance Studio in Kamihoshikawa. Yoshito's eyes were so fixated on the puppet that I felt an intense emotional attachment between the two, even though they were two different entities.

Presley's *Can't Help Falling in Love* was Kazuo Ohno's favorite song. Yoshito was looking for someone who was inhabiting within him. I was unexpectedly moved to tears by this touching scene. Yoshito inherited his father's legacy. He was another mimesis of Kazuo Ohno within Kawaguchi's context. This emotional scene transformed the whole perception of this performance thereafter. Kawaguchi emptied the theater space, inviting those who were not present physically – in other words, moving images, spirits, ghosts, ancestors, or the departed – to enter. This offered another dimension to Kawaguchi's attempt, which made the rest of the piece considerably moving and re-spirited.

According to a dance critic, the power of narrative distinguishes Kazuo Ohno from Kawaguchi. The Ohnos lived side by side with spirits and stories. They had a close affinity with the spirits of other people such as La Argentina and Tatsumi Hijikata, as well as other forms of life. Kazuo Ohno consistently stressed the importance of expanding one's physical awareness beyond the limits of one's deeply ingrained human sensibility. When Yoshito had technical problems during his class, he told his students that Hijikata might have visited his studio. This brings the Ohnos the power of creation, whereas their spectators, the purpose of salvation. Their audiences were often emotional and started crying even before Kazuo Ohno performed. On the other hand, Kawaguchi's project astonished us with his critical approach, albeit without the emotional drive. Nonetheless, Yoshito's daughter once told me that Kawaguchi had become her grandfather's doppelganger when he came out of his rehearsal at the Kazuo Ohno Dance Studio.

The lines between process and presentation are extremely blurred for Kazuo Ohno. As Kawaguchi states, Ohno is so charismatic that the boundary between choreography, his physicality and personal habits is not binary (interview from *dancedition* 2017). In the Japanese context, dancers' daily lives and the stage are inextricable. The work just transmits the product of their daily circumstances. Also, dancers keep dancing until a mature age, changing the choreography to suit their conditions. Consequently, there is no proper archive of 'original' dance but repertoires, which themselves are continuously evolving.

Ohno used his dance as a bridge between himself and nature and spirituality. He felt he was surrounded and inhabited by the dead who took the form of ghosts. We cherish both our own lives and those of others around us with painstaking care. Others have sacrificed their lives so that we could enter this world, and Ohno explains this idea as a mother's pain or suffering. If a child becomes ill, their mother would do anything, even going so far as to surrender her own life for that of her offspring. Ohno needed to feel such heartache emanating from dance. He said that the suffering of others has, without our ever fully realizing it, been engraved in us. We have survived only because others died in our place. We owe our experiences to the sacrifices made on our behalf.

Kawaguchi has carefully simulated these visible movements of Ohno based on the legend's archival materials, thereby embodying the invisible pain or

suffering of others. In the very meaning of suffering, Kawaguchi offers his body for that of Ohno, entering the world to become Kazuo Ohno for us. After Kawaguchi's performance in Berlin, a German friend of mine wrote to me emotionally that she would never have known how beautifully Kazuo Ohno performed without Kawaguchi's work. The story goes on. Just as Ohno used to merge with the spirits of the departed, Kawaguchi tries to reach out to those with whom he shares his body. He is touching the whole universe of the past for the sake of us in the present.

A great many people are constantly coming to life in me. Aren't they reaching out to me in my day-to-day life as their souls permeate my body? That's not inconceivable. Since each and every one of us is born in and of this universe, we're linked to every single thing in it. There's nothing to stop us from reaching out and touching the entire universe.

———————————————————————————————— *Kazuo Ohno*

Takao Kawaguchi

Takao Kawaguchi (b. 1962) is a
choreographer, performer and artist.
After working for the dance company
ATA DANCE, he became a member
of the collective Dumb Type between
1996 and 2008 while collaborating
with visual artists, working with light,
sound and video. Since 2008, he has
developed his solo series of site-specific
performances under the general title *A
perfect life* until today, which includes
from Okinawa to Tokyo, presented at
the 2013 Yebisu International Festival for
Art and Alternative Visions held at Tokyo
Photographic Art Museum. Most recently,
he has created Butoh dance pieces like
The Ailing Dance Mistress (2012), based
on the writings of Tatsumi Hijikata, and
*About Kazuo Ohno – Reliving the Butoh
Diva's Masterpieces* (2013). In 2021,
Kawaguchi was the artistic director of
TOKYO REAL UNDERGROUND, and also
co-organized INOUTSIDE, a two-day art
and performance event in Tokyo.

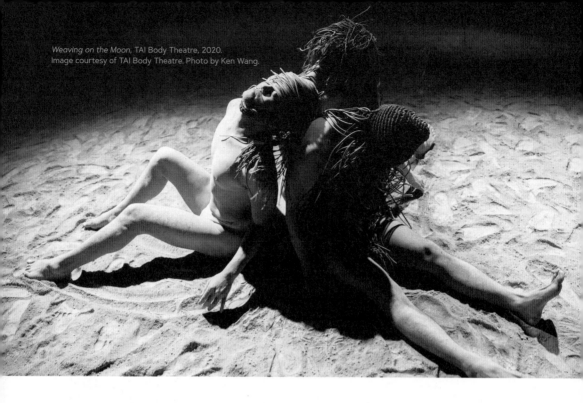

Weaving on the Moon, TAI Body Theatre, 2020.
Image courtesy of TAI Body Theatre. Photo by Ken Wang.

The Discursive Body in Fluid Performance Processes: Watan Tusi's TAI Body Theatre

Ling-Chih Chow

Translated by **Elizabeth LEE, Johnny KO, River LIN**

On the day I visited the *gongliao* [1] studio of my friend Watan Tusi's TAI Body Theatre, he was weaving. I squatted next to him and quietly observed dozens of wefts shuffling back and forth. The *Ubung* loom upheld a webbed space that was taking shape, seemingly inviting dreams to slip through the chinks between the threads. As light and shadow underwent multitudinous geometric transformations, the lines seemed to constantly bifurcate to create spaces of their own, forming multiple paths that crisscrossed and extended endlessly. The colours and the woven patterns of the fabric transmuted, resembling the rocks and vegetation in the mountains, echoing the sacred memories of myths and home, while also being reminiscent of the imprint of the blood, sweat, and tears left behind by farmers, migrants, and labourers.

Dancers were rehearsing in the studio at the same time. 'Pung, pung, pung...' the sound of their steps and the loom formed a dialogue. Despite being out of sync, their respective rhythms resonated in the shared space by repeatedly approaching toward and parting from one another. Watan often choreographs such bodily rhythms into his work. In their dance, the performers enact a common scope while each follows an individual rhythm responding to the collective body. As the dancers align their breath and energy, the formation of the dancing body allows them to integrate and become one through their heterogeneous existence while working together. As Watan says, because "individuals exist within the collective, and vice versa", differences co-exist.

Watan's notion of 'togetherness' connects to weaving. His weaving of traditional tribal patterns, such as the rhombus image representing the eyes of ancestors, as well as the use of threads made of heterogeneous materials in a piece of fabric, is at the same time weaving emotional and creative narratives of one's history and memory. As the fabric is handwoven, it does not bear the monotonous uniformity of a machine-made textile; instead, it invariably has an organic touch due to the application of varying forces. It sees dynamic trajectories threaded by circumstances and times that are in flux.

Poetic choreography of dreams and viewing

"Until today, I've been too busy to weave for a long while. However, I had a dream last night. I dreamt of a spider," Watan told me while weaving. He thought that the dream was a reminder prompting him to resume weaving. Dream omens have always been a spiritual dimension that is crucial to Watan. Dreams, like myths, are more than a connection between the Indigenous

peoples and spirits. In the context of artistic practice, they serve as the key to unlocking poetic languages and spirituality. Dreams represent a form of resistance to modern society, as well as a way of opening the mind to read and listen to the world. While weaving, one must keep count attentively, arranging yarns and creating patterns with a sober mind. In doing so, intensively composed movements, vibrations, sounds, and the rhythm of 'the weaving body' create a space that houses an entrance to a dreamscape where one can temporarily escape reality and enter another parallel dream. In that space, everything can be found and choreographed in the vein of woven threads, expanding one's mind called by the ancestor to the unknown.

One night in 2021, in a green paddy field, dancers in red tassel costumes woven and designed by Watan sang and moved, simulating a duet between human flesh and myths, their shadows overlapping. This piece, *Sneak into Dreams*, choreographed for the Ceros tribe (in Hualien), enables the audience to experience the underlying dreams of the landscape and the power of myths. It invites us to access the landscape and mythology through an alternative understanding and imagining of the relations between humans and the ecology. Each step, spin, and spiral reveal heterogeneous connections and in-betweenness with the transformation and translation of all things on earth beyond human existences.

Then there is the piece *The Veiled Way* (2019), which was performed in the watercourse of a historical landmark in Tainan. On a long staircase built upon the hill, dancers perform/simulate the sounds of birds, swaying bamboo, and the wind, questioning what is in a name and speaking in Indigenous tongues. This work investigates the origins of ethnicities and how rivers could return to the rhythm of the watercourse after having been displaced. Moreover, it reflects on how, in between memories and the forgotten, humans would co-exist with the ecology after experiencing diaspora and ecological catastrophes (such as the compound disaster event caused by Typhoon Morakot in 2009 in Taiwan).

Investigating what history one has inherited, as well as what has shaped one's surroundings and specific biopolitics, is a central concern in the work of Watan and his partner Ising Suaiyung.

Because of events in Taiwan's colonial history, such as the Resettlement Policy imposed during the Japanese Colonial Period, its Indigenous peoples

have experienced war, migration, political persecution, and conflict with colonisers. To some degree, their original 'tribes' no longer existed. When tribes are lost, their traditions too are fragmental and ruptured. Thus, dealing with and interpreting history matters enormously. TAI Body Theatre refuses the notion of the representation of heritage, including the visual codes of Indigenous costumes and patterns. Ways of rebuilding their understanding do not merely rely on learning traditional dances and songs, but also through performing the entire entity of the body, during which they respond to and articulate what has been embedded in the Indigenous people's contemporary situations and histories. 'TAI', meaning 'to look' in the Truku language, [2] suggests that they must look and feel (even into the dark) before doing work.

Unsettled thoughts and the realm of mythology

Watan's artistic approach stems from collecting various tribal songs, dances, oral histories, and myths. With his dancers, he has developed an open-source 'step notation', inspired by human movements and rhythms in various spatial conditions, such as a person on a slope or the actions of a hunter in a forest. The dance steps are thus all about the body in motion and manual labour. For instance, one of his earlier works, *Tjakudayi, How to say I Love You* (2014, 2018), deploys the subtle metaphors in Paiwanese love songs to ponder the problematics of tribal resettlement in relation to the notions of inclusion and openness with the ecology. Meanwhile, *Dancing under the Bridge* (2015) deals with the life experiences of the urban Indigenous peoples. On the other hand, *The Path of Water* (2015) and *Tminun* (2016) culturally unearth memories of the Truku people's labour.

In recent years, Watan has further worked with the Truku language, placing it into his choreographic methods. He sees translation as cultural interpretation and artistic practice, and has integrated the rhythms of Truku words into composing sonics and the body's breath. In Truku, the naming of a place is driven by observing and accessing nature, depicting imaginings of its corporeality and myths. Similarly, the name of a dance opens up the realm for translating and interpreting myths.

The Truku language is polysemic and elicits cultural connections and thoughtful dialogues when translated into Mandarin. Such translation too nourishes corporeal perspectives different from the modernised body. The term *'lmlug'* (rhythm) that the Truku elders often speak of also means

'vibration', 'frequency', 'unsettled', 'thought', and 'living'. Ultimately, "humans can only generate thoughts amid unsettledness". Watan's 'step notation' explores relations between the body and the earth, as well as the depths of inner spirituality. The experiences of the mobile body, informed by Indigenous tribes located in various geographical conditions and cultures, have undergone historical shifts and transitions, resulting in accumulated gestures, movements, rhythms, and postures. They have returned to stimulate thought on how the body could essentially respond to its surroundings to form the contemporary discursive process, while also relocating the body to navigate and create new paths.

In contrast to the upward jumps mostly driven by bottom-up steps in Western dance, Indigenous dance embeds the feet into the ground and relaxes the lower body to generate action, and the jump is a rebound from downward dynamics. This 'down to earth' approach brings the support and energy of roots back to the body, becoming an expanded and circulating inner power. It connects the body and earth to resonate with each other, vividly manifesting the Indigenous peoples' cosmic perspective through the cycle of steps and jumps. It is the embodiment of contemporary existence as well as the echoes of myths.

Memories of blood and the time of the wounded body

Besides the 'step notation', Watan's choreographic language of the upper body is mainly composed of weaving gestures which display the tension of seeking balance in an unsettled situation. Gestures such as *qmnuqih* (twisting threads), *dmsay* (merging horizons), and *lmuun* (creating patterns) resemble a ritualistic dance as well as mythical creatures in the sky and on the land. Watan's gestural choreography is further combined with the 'down-to-earth' labour created by Ising, such as the movements of embroiderers, winemakers, chefs, construction workers and so on. Through these gestures, complex procedures and manual labour have been transformed into poetic body language. Through various practices of rituals, song and dance, as well as life, language and the body become a vessel for cultural memories and a medium that carries the weight of history. The awareness of such practices, together with actual labour, transfigures the body into an artistic creation. It dives into the complex flux of cultural and historical entanglement, different from approaches to a singular identity defined by ethnicity or territory, enabling the exploration of the historical perspective of the unsettled body. Watan's

method draws on his cultural genealogy, reflexively investigating traditions while being aware of the symbol-based problematics of representation and exhibition. In doing so, Watan has generated connections and dialectics between multiple dimensions in context.

In *Terrace on the Hill* (2017) and *The Fragrance of Aged Wine* (2017, 2021), we can see how the artist transforms the fragmented bodies (of humans and mountains and woods) in the diaspora with a trajectory of labour and affliction into a spectral chorus of phantoms and a revel of wounded bodies. In *Weaving on the Moon* (2020), an ethereal figure that transcends gender and boundaries is seen in a concealed space. It discovers the body's ability to weave flowing between its fingers and proceeds to thread a link to the spiritual world and manifest synchronised chaos.

Echoing the Truku saying that "the Weaver God weaves one's life", TAI Body Theatre's 'step notation' and gestural repertoire weave the red eyes of ancestors and the memories of bygone bloodshed. The unsettled vibration moves us to a place where ongoing dreams and ambiguity intersects, a formless territory that allows the power of myths to reside within the Indigenous body with explicit awareness. In the mountains at night, one embraces fear and confronts the darkness; every sound, smell and movement becomes a living and nocturnal dreamscape.

1. *Gongliao* refers to a temporary structure which serves as a resting place for labourers. This term is used to describe the rehearsal space built by Watan and his team.

2. Currently, there are 16 officially recognised Indigenous Nations in Taiwan. The Truku people was officially recognised in 2004. Its population stands at about 32,333 (as of January 2020).

Watan Tusi

Born in Swasal village, Watan Tusi is of Truku descent. The word *'tai'*, in the Truku language, means 'to see' or 'to observe', suggesting the artist's gaze and speculation about traditional Indigenous culture. Tusi investigates ways for Indigenous music and dance to transcend beyond traditional ceremonies and touristic performances.

After conducting two years of field research on various tribes' step movements on the land in daily life, Tusi documented over 60 'step notation' scores. New physical and dance forms are evolved from the deconstruction and reconstruction process. TAI Body Theatre's work concerns Indigenous literature, body and music, as well as the status of Indigenous peoples, environmental conflicts and related issues.

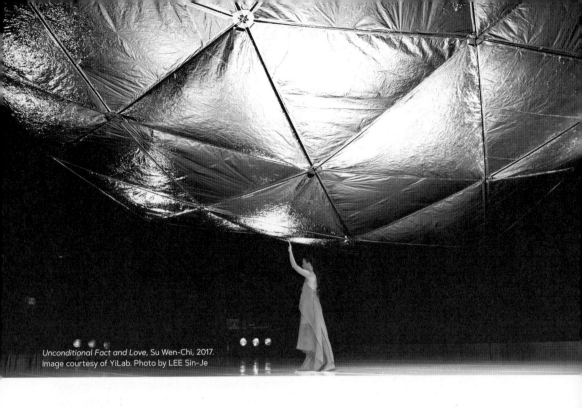

Unconditional Fact and Love, Su Wen-Chi, 2017.
Image courtesy of YiLab. Photo by LEE Sin-Je

The Intersection of the Body, Technology, and Science: Su Wen-Chi's Interdisciplinary Practice

Chih-Yung Aaron CHIU

Translated by
Elizabeth LEE, Johnny KO, River LIN

In recent years, the interdisciplinary embodiment of technology has been increasingly integrated into forms of theater and dance as practices of 'interdisciplinary art' or 'transmedia,' spotlighting how various bodies of the arts embrace one another. As opposed to performing arts, making digital performance art enriches the capacities of tech-coordination, interactivity and techno-spectacles, and requires interdisciplinary collaborations between the parties involved.

Choreographer and new-media performance artist Su Wen-Chi investigates the possibilities of performance anew through the innovative application of new-media technology, expanding on the speculations about how digital technology has impacted the field of contemporary art. Throughout her oeuvre – from *Heroïne* (2007), *Loop Me* (2009) and *ReMove Me* (2010) to *W.A.V.E.* (2011) and *Off the Map* (2012) – technology, as both a notion and entity, has formed the body of Su's work. More recently, after her artist-in-residence program at CERN (Conseil Européen pour la Recherche Nucléaire), [1] Su created *Unconditional Fact and Love* (2017), *Infinity Minus One* (2018) and *Anthropic Shadow* (2019). This article examines the trajectory of Su Wen-Chi's artistic contexts, the shifts therein, and her interdisciplinary vision for performance, technology and science, with her residency at CERN as the turning point.

From the micro perspective on technology to the macro view of the cosmos

In *Loop Me*, Su Wen-Chi looks at the ebb and flow of the interactions between the body and technology. She instils significant technological and new media components into her series of works, gradually elevating the status of technology to that of dancers. The piece *ReMove Me*, on the other hand, questions whether the body can return to its most primitive state. It imagines how the body can be rid of new media to perceive in the most direct and primal manner. Meanwhile, *W.A.V.E.* integrates concepts such as urban space and architecture into the stage design as well as the entity of the artist's body.

Su's research residency at CERN in 2016 stimulated her to view and approach new media art and technology with a new scientific perspective. Through the appointment as Artist-in-Residence at NTCH (National Theater and Concert Hall, Taiwan) in 2017, she continued to investigate the intersectional

possibilities of the arts and science. Science has broadened Su's horizons in the philosophy of technology, shifting her micro perspective on technology in the contexts of performing arts and new media art. CERN, therefore, served as a turning point in the artist's creative trajectory. In Su's pre-2016 works, the artistic concern falls on exploring the social aspects and communication between humans and technology, as well as revealing the problematics of interpersonal communication and human cognition through technology. Afterwards, her work corresponds to the imagination of the laws of nature, adopting approaches that scientists and artists use when working on a method, formula or language, to redefine a new conception. In quantum physics, for instance, Su sees new philosophical thinking with a wider temporal dimension in the philosophy of science. While dealing with terms such as 'science,' 'universe', and 'quantum' as microscopic or macroscopic units, she has also repositioned her ways of questioning the notion of performance. Therefore, in *Unconditional Fact and Love* and *Infinity Minus One*, the artistic concern takes the physics concept of 'materiality' as a point of departure. At the same time, scientific perspectives have become fundamental to the conception of her works.

Su states that the evolving context of her works sees a shift in perspective. *Loop Me, ReMove* Me and *W.A.V.E.* deal with specific short-to-mid-term issues in art history that reflect how sociologists observe and question contemporary society. Comparatively speaking, they are societal and cultural concerns. Post-CERN residency, such sociological interrogation has been replaced by a methodology dealing with a broader temporal perspective. The questioning of *Unconditional Fact and Love* and *Infinity Minus One* with broader scientific approaches anchors herself in a macro-proposition to understand imaginings of such magnitude, as well as how artists would translate methods offered by scientists through interpretative methods.

Unconditional Fact and Love, for instance, questions how scientists and artists view the similarities and distinctions between aspects of facts and beliefs, and also observes microscopic physical phenomena from a macroscopic perspective of the universe. It utilizes embodied scientific symbols: the image of the dome of the universe as the set design, as well as narrative performance, to re-accommodate the notion of science on a human and objective scale, making it more cognizable. In addition, *Infinity Minus One* channels imaginings of advanced science, embodying the existence of the universe, theology and human beings through performing the body and

technology. In this work, with its sophisticated yet minimal lighting design; simple, monotonic yet layered sound design; polyphonic and explosive singing; and subtly choreographed and compelling movements and actions, the artist questions, "What makes life? What makes the universe? And what is Homo sapiens?" Later, in *Anthropic Shadow*, Su draws on her experience of working with climatologists and subtly integrates the scientific perspective into social concerns on a broader temporal scale.

The relationship between the body and the field

In *Loop Me*, *ReMove Me* and *W.A.V.E.*, Su Wen-Chi mediates how 'media' informs the entity and image of the human body while digital technology has visualized the configurated ways of living. Digital technology has also deployed the sensibility in digital aestheticism with technological interfaces and the subjective body.

Loop Me and *ReMove Me* are interrelated, concerning the relationship between the imagery body and corporeality. *W.A.V.E.*, meanwhile, moves forward to look at the power struggle between 'technology' and 'corporeality' by staging a dancer resisting against and negotiating with a gargantuan and living technological installation. However, the ensuing *Off the Map* addresses this techno-physical relationship by minimizing the capacity of staged technology and holding the space using the artist's body.

In Su's early trilogy, the notion of arithmetic logic in computing divides one's body and consciousness, transforming the self into multiple digital agents or digital selves foregrounded in the corporealization of new-media technology. It signifies how inseparable the body and digital agents have become. The digital agents are another present subject embodied by the porous and fluid intersection of the body and its digital representations. Be it the digital agent in *Loop Me*, the ambiguous figure of the artist in *ReMove Me*, or the choreographed transformation between the body and (the matrix suspension lighting) installation in *W.A.V.E*, they are all manifestations of a 'hybrid entity.'

In her recent works *Unconditional Fact and Love, Infinity Minus One* and *Anthropic Shadow*, when accommodating the dancer's body on stage, it is still the field, setting and environment that negotiate with and ultimately define what the dancer represents. In this series of works, Su has more specifically illustrated the intersection of the body and the field, thus creating dialogic

space. She juxtaposes the dancer's body and digital media with scenographic settings to create the dialectical theatricality.

Now and again, Su's work also examines the role of dancers from a macroscopic perspective, and such scrutiny sometimes leads to their absence on stage. Throughout the process, Su constantly questions herself: Do dancers disappear when constructing a more objective cosmic view or imagining of science, or do they become a distinctly material/physical phenomenon instead of being human, as characterized by sociality and culture? In *Unconditional Fact and Love* and *Infinity Minus One*, the dancers' bodies are disassociated from the signifiers and identity of a human being; instead, they become the material that attempts to open up a dimension and unfold time. Thus, through Su's 'scientific lens' that provides microscopic and macroscopic perspectives, the dancers' bodies in *Anthropic Shadow* are situated in a rapidly metamorphosing state as a non-human existence.

Su employs contemporary technology and media to depict a new condition of human existence and perception, whether it is the microscopic view of science and technology in her early works or her later pieces concerning science's panoramic perspective on the cosmos. Her early works take multiple screens on stage as the matrix through which the dancers' bodies and digital agents weave. Through interactions between the dancers and computing-arithmetic symbols, the multi-layered virtual space presents a living world in which human beings and technology embody one another. Su's more recent works, however, feature the essence and dancing presence of the body. Interlinking, interlocking, and intertwining choreographic movements, for instance, metaphorize the birth of life; while dancers move like dividing cells, resulting in choreography that represents a composition of existence.

Dialogue and translation: another horizon of performativity

The 'presence' of the artist's body shapes performance and liberates the body from its constraints by exploring various performative possibilities. The body communicates through 'language,' while 'performative discourse' can be deployed to enhance our perception of facts and our body-mind-spirit relationship with reality. While referencing bodily codes and symbols, Su Wen-Chi's body of work is a substantially technology-orientated practice. The subjectivity of media and technology has been continuously formed

by the avant-garde experimentations, and these tools have become indispensable mediums in the context of her work of live performance.

Artistic research matters to Su and sits in the early phase of her creative process. Thanks to the academic training she previously received in the UK, her practice of performance making has shifted. Academic research is often conducted through reading while artmaking corroborates specific research which, in turn, supports the artwork. This learning process has influenced Su. The artist believes that she failed to find vocabulary that resonated with audiences when *Unconditional Fact and Love* was made. It was minimal regarding the experiential and performative conditions on stage, and perhaps less engaging with the audience's sensibility. It was not until *Infinity Minus One* that she struck the balance while simultaneously collaborating with scientists to coordinate performative components for the theater setting and proposing micro-cosmos perspectives that would be accessible to viewers.

When choreographers attempt to articulate materials and notions of dance with scientific knowledge, what scientists offer are resources and knowledge about facts. Having worked with scientists, Su has learned that artists too can work in scientific ways. Although scientific facts sometimes seem to conflict with the imagination of artists, the two parties would somehow come to a consensus at certain points. During the collaboration with Spanish astrophysicist Diego Blas, Su realized that a choreographer usually employs lighting colors in their theater work according to emotional or artistic expressions. Scientists, on the other hand, recognize colors through the electromagnetic radiation of a specific range of wavelengths visible to the human eye. When the two parties work together to eventually translate scientific knowledge into a body of staged work, what defines 'aesthetics' is something that relies on ongoing and conditioned negotiation.

Su has presented another horizon of performativity in her recent works which encompass scientific factors, embodied by the use of technology such as lighting and sound installations. Arguably, what performance could do is translate scientific phenomena that are often imperceptible into accessible experiences. Consequently, exploring and translating the performativity of scientific discourse into performance making, as well as working with scientists, have become the crux of the artist's ongoing inquiry.

Conclusion

"Dance making is rather revolving around questioning, beyond choreographing movements," Su Wen-Chi states. From her early microscopic focus on socio-cultural concerns to the shift towards a macroscopic perspective in the context of the history of science, a transformative trajectory and aesthetic shifts – triggered by the scientific nourishment from CERN – are imprinted in Su's artistic philosophy and creative strategy, as observed in her oeuvre.

The source and medium of science and digital technology have embodied Su's work. Its aesthetic experience also concerns how technology applies to the artist's body. In her latest VR work, *Black Hole Museum + Body Browser* (2021), Su further explores corporeal sensations and images mediated by technology through scientific approaches to once again look at the existence of humanity in the cosmos. Undoubtedly, Su Wen-Chi has opened up a new avenue for contemporary digital performance situated with everything in the context of cosmology.

1. Su Wen-Chi and Pei-Ying Lin's collaborative proposal, *Slices of Interconnectivity*, won the Accelerate@CERN Taiwan award, funded by Taiwan's Ministry of Culture and jointly organized with CERN. The pair took up their residency in 2016.

Su Wen-Chi

Conflating the notions and forms of
new media and performing arts, Su
Wen-Chi rethinks the possibilities of live
performance in new media contexts. She
has been appointed Artist-in-Residence
at the National Theater and Concert Hall
in Taiwan (2017), CERN (2016), and Artist-
in-Research at EMPAC (Experimental
Media and Performing Arts Center),
Rensselaer Polytechnic Institute, Troy,
NY (2020). Su was the recipient of the
Jury's Special Award at the 9th Taishin
Arts Award in 2009 and the Alternative
Design Gold Award at World Stage
Design 2017. In 2021, her collaboration
with Swiss skincare house LA PRAIRIE
was exclusively presented at Art Basel
Miami.

Digital Shamanism: On Half-Spiritual Eyes and the Curation of Existences in Choy Ka Fai's Oeuvre

CosmicWander: Expedition, Choy Ka Fai, video still, 2021.
Image courtesy of the artist.

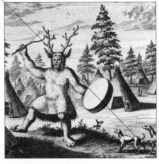

Tungus Shaman; or, Priest of the Devil,
Nicolaes Witsen, *Nord en Oost Tartarye,*
1692.

Nicole HAITZINGER

In a certain, albeit simplistic way, it would be possible to assign Choy Ka Fai's oeuvre – here, especially *SoftMachine*, *Unbearable Darkness* and *CosmicWander* – to an aesthetic of a globally circulating (post-)internet or posthuman art. The Berlin-based artist from Singapore studied Media Art there, and afterwards Design Interaction at the Royal College of Art in London: this is evident in the virtuoso use of video and digital technology in his works, which are presented in art institutions and festivals worldwide. Similarities to transmedia video works by US artist Ryan Trecartin, European theatre director Susanne Kennedy or artist Hito Steyerl are obvious: brightly coloured backdrops, hyper-realisation of figures, exhibition of the performativity of the digital, interfaces of real and digital bodies, voices alienated by synthesizers or playback as one signal among many, an ambiguous relationship between 'reality' and fiction. More precisely, it is an artistically motivated emergence of post-utopian scenes [1] in which traditional cultural practices, pop culture, science fiction, everyday stories and questions about the ethics of the political are interwoven. In post-internet art, interfaces are constantly created through complex resonances between hardware, software and the physical body that are designed to overwhelm the senses. In contrast to the current media-critical, philosophical and cultural studies discourse led by Byung-Chul Han, post-internet art is characterised by a performative understanding of media and relational configurations of online and offline formats. In his writings, Han emphasises the negative effects of digital technology on civil societies and interprets the apocalyptic threats of the homo digitalis "as an anonymous human being" (without a 'soul') and the "digital swarm" (without collective consciousness). [2] Digital culture is already integrated into numerous cultural expressions and forms the life horizon of many 21st century existences. In this sense, digital media are to be understood as wayward and sometimes arbitrary messengers: in their acts of transmission, they have culture-creating, reality-constituting and event-generating functions, since they are structure- and form-giving, or as Ana Vujanović pointedly summarises it for the context of the performative arts: "From a materialistic-poststructuralist critical perspective it would mean that the medium materially intervenes in (a non-material, notional) content, however, the medium should be understood in Deleuzian or Massumian terms, as a field of sensation, affects, and events, and not only as a field of social concepts and the practices of its material signifiers." [3]

"There is a point at which technology becomes magic." (Choy Ka Fai)

(Post-)internet or posthuman art are certainly two facets that characterise Choy Ka Fai's artistic work. However, I would like to shed light here on another facet of his oeuvre that I believe is profound and particular, namely his 'curation of existences' against the horizon of the digital; I will return to the implications of an expanded notion of curating later. For Choy, the concept of existence by no means only encompasses human existence, but also numerous 'paranormal' phenomena, 'other than human in this spiritual realm' – for example, genderless spirit beings. In this sense, Choy queers 'centristically' circulating art discourses with a wink and humour. In doing so, he exposes their historical situatedness in a 'western' or colonial matrix. [4] Against any authenticity effect, his artistic work is characterised by diverse interweavings of globally circulating and canonised, as well as very particular, references. For instance, he formats *SoftMachine* (2012–2015), a search for an inherently "spiritual" Asian body provoked by a statement by British choreographer Akram Khan, [5] according to the compositional principles of William Burroughs' novel of the same name: "*SoftMachine* is the title of a novel by William Burroughs. He made a novel by cutting and pasting different novels. I see the body also as a Soft Machine that cuts and pastes and becomes a new machine by itself. The body is full of all kinds of technology that humans still have to explore fully." [6] Through a series of 80 interviews and in the gesture of documentarism [7] of various performative dance practices, he deconstructs the phantasm and stereotype of Asian dance in the singular. At the same time, the fascination for the metaphysics of the (human) body in general becomes evident.

In his next artistic work entitled *Unbearable Darkness* (2019–2021), he explores, documents and stages a hosting of the re-appearance of the late Butoh dancer Tatsumi Hijikata. He appears as a metaphysical entity in the body of a shaman, and finally, made possible by the technical apparatus of Choy Ka Fai, emerges in the form of various avatars. The Chilenean-Mexican choreographer Amanda Piña pointedly defines this practice of hosting the re-appearance of ghosts in contemporary performative and transmedial art with decolonial implications as compossession: "Compossession combines composition and possession, referring to different forms of knowing and knowledge, beyond a 'western' conception. As an alternative to the notion of composition, compossession operates in decolonial terms beyond the notions of time, space, subject, object proposed by 'the contemporary' as a

continuation of modernity/coloniality." [8] An essential difference to the New Age shaman phantasm is that the hostings of re-appearances are by no means particularly theatrical or emotionally overwhelming; on the contrary, performative contemporary art accentuates the functional motor processes and vocal articulations of a compossession.

In *Unbearable Darkness*, Choy Ka Fai re-engineers Hijikata's presence with motion capture and uses all available technological possibilities to enable the appearance of the ghost in the theatre space in the form of a performance or a 3D video game: "We had five different avatars for Hijikata that represented his ages from 20 to 50. Because we didn't reset the system, it felt like every 20 or 30 minutes the avatar would deform on its own and go into a ghostly state. We were inspired by Francis Bacon's paintings, so it was fitting that the avatar would go in this half-human, half-ghost state." [9] Like most of his artistic works, *Unbearable Darkness* is conceived as genre-reflexive and durational. It is shown in different (and sometimes overlapping) formats (such as live performance, documentary film, website, performative installation, video game) and adapted and varied depending on the context and situation.

In the format of the performance, the appearance of the Hijikata avatars is interwoven with a contextualising strategy of documentality in the sense of Hito Steyerl's conceptual profiling [10] that characterises Choy Ka Fai's work in general. More specifically, this means that he documents, for example, the research trip to the summoning and appearance site of the spirits of the dead, Mount Osorezan, a Japanese gate to the underworld, or the interview with the ghost Hijikata – embodied by the blind shaman Hiroko Matsuda – on film and incorporates these videos into the live performance as a commentary.

As with *SoftMachine*, *Unbearable Darkness* embeds particles of a *shamanistic practice* in the context of contemporary art.

But what are we talking about when we speak of shamanism?

Perspective 1: History with a capital H

If we look at the Eurocentric History of shamanism with a capital H, two aspects become clear: on the one hand, the contouring and demonisation

of the shaman in monotheistic discourse, on the other hand, the equation of artist and shaman. The first picture of a native Siberian shaman was made by the Dutch scholar Nicolaes Witsen on one of his cartographic expeditions in 1669: it shows a figure wearing reindeer antlers, a drum and clawed feet, a human-animal hybrid par excellence, described in the caption as 'the devil's servant' (see p.62).

The image spread throughout Europe and established the prototype of the shaman as a collective phantasm. Secondly, and not coincidentally, a parallel phenomenon to the discursively accomplished separation of ritual and theatre, the Enlightenment discourse of the 18th century leads to an entanglement of the categories 'artist' and 'shaman': the individualised 'genius' artist of modernity, lifted out of diverse cultural networks, is endowed with a shamanistic energy whose origin is now 'found' (i.e. rather than invented or constructed) in the Stone Age and cave art in the first place. [11] The (male) artist is equated with the shaman in a formulaic and complexity-reducing function and later even in his manifestation in European knowledge culture, or makes this equation himself: "Despite a disconnect of several millennia, modern artists too, from Wassily Kandinsky and Vincent van Gogh, to Joseph Beuys and Marcus Coates, have been labelled as inspired visionaries who access the trance-like states of shamans, and these artists of the 'white cube' or gallery setting are cited as the inheritors of an enduring tradition of shamanic art." [12] 'Romanticising' and universalising resonances of a shaman phantasm determined by European patterns of reception can be observed right up to the cultural discourses of the present day: "Who are our shamans? Campbell: It is the function of the artist to do this. The artist is the one who communicates myth for today." [13]

The shamanistic paradigm in Choy Ka Fai's work, his slightly ironic search for the metaphysical 'Asian' body, his hosting of re-appearances of ghosts or his transfer of trance into the virtual realm, is completely different from the Eurocentric stagings of the artist as shaman. Perhaps the most fundamental difference is that the European artist shamans of the 20th century, like Joseph Beuys, still embody the topos of the singular artistic genius. Choy's stage of the many, his ensemble of 'real' (living or dead) and virtual figures, counters this grand narrative with something different. In a way, one can say that these are queer performances if one introduces an expanded understanding of queer here, which is not primarily based on sexual identity constructions, but understands queer in the sense of "the pleasures and

difficulties of moving between multiple and layered identities". [14]

Perspective 2: The shaman as 'curador' of existences in decolonial thought

For several years I have been researching decolonial art and writing practices in *The School of the Jaguar* [15] with Mara'kame Juan José Katira Ramirez, a 'shaman' of the Wixárika comunidad in northern Mexico. He interprets the term 'curator', abstracted in the global art discourse, as 'curador' in its potentially healing function of caring for a particular community. At the same time, he identifies with this kind of profession. Among the Mara'kame, 'curador' and 'shaman' are almost congruent. Both are 'cosmic diplomats' and particularly capable of changing perspectives. They mediate between completely different yet interconnected worlds and work to ward off attempts at manipulation by protagonists of the metaphysical world and to maintain the precarious status quo of the (relational) existence of human life. This life is constantly exposed to many threats in the indigenous contemporary world.

"So the relationship between human beings and gods is anything but harmonious – it oscillates between kinship and enmity, identification and antagonism. [...] Therefore, visiting gods at their cult places often also means travelling to dangerous, alien worlds. [...] The beings of the other world live in skyscrapers or family homes whose furniture resembles the film sets of pre-prime time series or television. Many underworld gods [...] use modern electronic devices, and survey world affairs from offices equipped with flat screens. [...] But one's world and that of the 'others' often are engaged in permanent conflict." [16]

Shamanistic practices are determined by different cultural, social and ecological conditions. Structures and manifestations differ from region to region and from continent to continent. Nevertheless, two principles can be named that appear in the most diverse shamanistic and cosmotheistic contexts: *Identity proliferation*, which is in contrast to the 'western' model of the modern individual (in the sense of autonomy and indivisibility) and the *immediate appropriation of alterities*, be they unknown gods, beings or new technologies.

Referring to these two principles, one could say that Choy Ka Fai's artistic oeuvre is profoundly based on digitized shamanistic practices in the sense of

a constant shift of identities and appropriation of alterities. He provides in his work the structural and metaphysical connections between shamanism, art, pop culture and virtual realities.

Perspective 3: The half-spiritual eyes of 'the extreme self' [17]

"In the metaverse of today and tomorrow, I propose that contemporary dance itself can no longer stay within a physical house or stage, it is necessary to create dance that transcends across various media. Maybe dance has already become a trans-media practice, where the commune is the virtual, where dancing bodies are mere points of presence on social media, where the digital self becomes the extreme self that disintegrates into a crescendo of emojis." (Choy Ka Fai)

CosmicWander (2019-ongoing) represents a culmination of digital shamanism in Choy Ka Fai's oeuvre in which he uses different techniques of the aforementioned cultural phenomena to reveal 'paranormal dance experiences', the 'supernatural' and the excavation of transcendence. On his journey through Asia, Choy documented a variety of spiritual practices and shamanistic dances from different communities and assembled them into immersive installations: "My proposition […] is to create a parallel spiritual universe in virtual reality – to collapse the spiritual and the technological worlds." [18] In Taiwan, the most liberal of the Asian democracies, Choy discovered a special form of shamanism, namely the phenomenon of the Third Prince, which he translates artistically in *CosmicWander*. Third Princes are contemporary shamans of each gender, into whom the patron god Nezha enters and who ultimately serve the community by advising them on day-to-day issues and concerns. Basically, anyone can become a shaman once they have received the call from Nezha and have learned and followed the rules of the respective temple, regardless of gender, age or social status. Choy asked, as part of his project *CosmicWander*, what rules should be followed in shamanistic practice, and the answer from the beta-alpha character with the lollipop in his laughing mouth is: "No cigarettes, no alcohol, no sex, no sex, no sex." [19]

Two aspects are particularly fascinating: (1) the multiplicity of the Shaman; i.e. a female shaman is an online live streamer during the day, for example, while in the afternoon and night she serves in the temple and lets the god enter her body in order to provide help, and at around midnight, she poses as a bikini model; Third Princes sometimes have hundreds of thousands

of followers on Instagram, their own YouTube channels, fandom and their digital devices and social media platforms are tools to switch between reality and the supernatural world. (2) Taiwanese shamanism is to be understood here as a gesture of resistance against repressive (political) regimes and restrictive normative worldviews. One playfully resists 'moral policing'. Cultural and religious appropriation becomes a catalyst for new visualisations and embodiments of deities at the interface between the human body and the digital world. Following the Taiwanese phenomenon of the Third Prince, Choy Ka Fai is currently working on the realisation of an android shaman in various formats, such as a video game:

"In the wake of an entire generation having forgotten to communicate with their Gods, an Android Shaman was created. Her mission was to collect and decode information, to reclaim that lost ability. Seeking a time capsule containing ancient mantra, so she may use it to contact the Third Prince. The Android Shaman yearns for reconnection with the supranatural realm." (Choy Kai Fai)

Established formulas of rituals combined with the codes of VR in the format of scrollytelling evoke a trance-like and potentially reality-altering experience in the dispositif of contemporary art. The 'half-spiritual eyes' of the (extreme) self and the 'Curation of Existences' in Choy Ka Fai's oeuvre evokes an appearance of the many on different stages simultaneously, in the black box, in (post-)virtual space, in spiritual places of invocation and manifestation. His artistic work shows in many ways that our divided world stands in much larger transhuman constellations.

1. Nicole Haitzinger, "Europa. Post-Utopian Stagings in the Present and in Modernity", in *Dancing Europe: Identities, Languages, Institutions*, eds. Nicole Haitzinger and Alexandra Kolb (Munich: epodium, 2022), pp. 27–36.

2. Byung-Chul Han, *Im Schwarm: Ansichten des Digitalen* (Berlin: Matthes & Seitz 2013), p. 19.

3. Ana Vujanović, "The Choreography of Singularity and Difference *And Then* by Eszter Salamon", in *Performance Research*, 13:1, 2018, pp. 123–130, DOI: 10.1080/13528160802465672.

4. See Choy Ka Fai's interest in the "...metaphysics of the human body. Through research expeditions, pseudo-scientific experiments and documentary performances, Ka Fai appropriates technologies and narratives to imagine new futures of the human body." https://www.ka5.info/about/biography.html.

5. "The Western perception of what is Asian, does not interest me so much. I remember Akram Khan saying the Asian body is inherently spiritual. So immediately I asked myself *what do you mean by the 'Asian body'*? There are more than 48 countries in Asia! This also triggered my expedition throughout Asia." Choy Ka Fai in conversation with Karlien Meganck from deSingel, Antwerp at Tanz im August, Berlin, 2014, https://www.goethe.de/ins/id/lp/prj/tco/por/Choy/enindex.htm.

6. Choy Ka Fai in conversation with Karlien Meganck from deSingel, Antwerp at Tanz im August, Berlin, 2014, https://www.goethe.de/ins/id/lp/prj/tco/por/Choy/enindex.htm.

7. Hito Steyerl, *Die Farbe der Wahrheit. Dokumentarismen im Kunstfeld.* (Wien/Berlin: Turia + Kant, 2018).

8. Amanda Piña, "Ideas for a practice of 'Compossession'", in *Endangered Human Movements Vol. 3 – The School of the Jaguar*, eds. Amanda Piña, Angela Vadori and Christina Gillinger-Correa Vivar (Wien: BMfB / nadaproductions, 2019), pp. 283–295.

9. Mi You, "Trance in the Virtual Realm: A Conversation with Choy Ka Fai", *in so-far*, Issue 2, Artificial Intelligence, August 2019, https://so-far.xyz/issue/trance-in-the-virtual-realm-a-conversation-with-choy-ka-fai.

10. "Documentality describes the permeation of a specific documentary politics of truth with superordinate political, social and epistemological formations. Documentality is the pivotal point, where forms of documentary truth production turn into government – or vice versa. It describes the complicity with dominant forms of a politics of truth, just as it can describe a critical stance with regard to these forms. Here scientific, journalistic, juridical or authentic power/knowledge formations conjoin with documentary articulations [...]." Hito Steyerl, "Documentarism as Politics of Truth", in *Jenseits der Repräsentation/ Beyond Representation: Essays 1999–2009*, ed. Marius Babius (Köln: Walther König 2016), pp. 181–187

11. On the discursive interweaving of Art and Cave in the beginning of 20th century, see: Robert Wallis, "Art and Shamanism: From Cave Painting to the White Cube", in Religions 10, 54, 2019, pp. 11–12, https://doi.org/10.3390/rel10010054. "The authentication of cave art at the turn of the twentieth century, then, provided archaeological evidence which lent empirical, chronological weight to the idea that shamanism and art have ancient, universal origins. The presumed affinity between shamanism and art was applied to Upper Palaeolithic cave art during the first half of this century, reifying the metanarrative of spirituality as the domain of human creativity and imagination, with shamanism as its origin, and cave art as the earliest form of its visual expression." (p. 12)

12. Robert Wallis, "Art and Shamanism: From Cave Painting to the White Cube", in *Religions* 10, 54, 2019, pp. 1–21, https://doi.org/10.3390/rel10010054. Or more specifically on shamanism in 18th century: Gloria Flaherty, *Shamanism and the Eighteenth Century* (Princeton: Princeton University Press, 2016).

13. Joseph Campbell, *The Power of Myth* (New York: Anchor, 1991), p. 91.

14. Clare Croft, "Introduction", in *Queer dance. Meanings and Makings*, ed. Clare Croft (Oxford: Oxford University Press, 2017), p. 2.

15. See the description and documentation of *The School of the Jaguar*: https://nadaproductions.at/projects/endangered-human-movements/school-of-the-jaguar.

16. Johannes Neurath, "Being more than one. Complex identities in indigenous modernity", in *Endangered Human Movements Vol. 3 – The School of the Jaguar*, eds. Amanda Piña, Angela Vadori and Christina Gillinger-Correa Vivar (Wien: BMfB / nadaproductions, 2019), pp. 108–109.

17. This is a landmark reference for Choy Ka Fai's current artistic work: Shumon Basar, Douglas Coupland, Hans Ulrich Obrist (eds.): *The Extreme Self: Age of You* (Köln: Verlag der Buchhandlung Walther und Franz König, 2021). This small, curated art book is a brilliant visualisation of current trends in art and society at the intersection of analogue and digital.

18. Mi You, "Trance in the Virtual Realm: A Conversation with Choy Ka Fai", in *so-far*, Issue 2, Artificial Intelligence, August 2019, https://so-far.xyz/issue/trance-in-the-virtual-realm-a-conversation-with-choy-ka-fai.

19. See: https://youtu.be/tArqeJvxJPw.

Choy Ka Fai

Choy Ka Fai is a Berlin-based Singaporean artist. His multidisciplinary art practice situates itself at the intersection of dance, media art and performance. At the heart of his research is a continuous exploration of the metaphysics of the human body. Through research expeditions, pseudo-scientific experiments and documentary performances, Ka Fai appropriates technologies and narratives to imagine new futures of the human body. Ka Fai's projects have been presented in major institutions and festivals worldwide, including Sadler's Wells (London, UK), ImPulsTanz Festival (Vienna, Austria) and Tanz Im August (Berlin, Germany). He was the resident artist at tanzhaus nrw in Düsseldorf (2017–2019) and Künstlerhaus Bethanien in Berlin (2014-15). Ka Fai graduated with a M.A. in Design Interaction of the Royal College of Art, London, United Kingdom.

Performance Art:
Melati Suryodarmo's Walk of Life

Dialogue With My Sleepless Tyrant, Melati Suryodarmo, 2012.
Image courtesy of the artist.

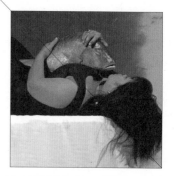

Ugo, Melati Suryodarmo, 2008.
Image courtesy of the artist.

Cristina SANCHEZ-KOZYREVA

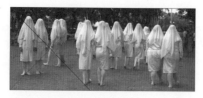

SWEET DREAMS SWEET, Melati Suryodarmo, 2013.
Image courtesy of the artist.

Being present with one of Melati Suryodarmo's performances is at once an aesthetic and stunning experience. Her movement is often rhythmic and tuned to some kind of cycling pace that accelerates or decelerates akin to the act of breathing. She composes extreme visual images drawn from a minimalist taste for monochromatic clothing and similarly distilled backgrounds. Suryodarmo has been powerfully using her body for more than 25 years, elaborating endurance art that connects her visual settings with her inner self, drawing from her training in body movement and Butoh, stage theatre, choreography, and dance to deliver powerful visual and sensorial messages. But her work is also uncomfortable, especially in performance art because of the excruciating exertion she seems to force upon herself in her durational performances, some with more violence than others, sometimes for up to 12 hours. This in turn highlights a wider understanding of physical and emotional strains which, depending on the context, mirror tensions at the societal level. This inner world/outer world relation is part of what connects her to the audience and conduits original messages about self, cultural and displacement history, and feelings of cracking and/or mending in our collective or personal condition. The result leaves you with an aftertaste where the absurd, the extraordinary, and the intimate are all surprising co-ingredients.

Born in Surakarta (Solo), Indonesia, in 1969, Suryodarmo comes from a large country with multiple and complex sets of identities. It was colonised by the West and traversed an arduous political history, the consequences of which partly shaped the artist's upbringing. She is also a woman who has experienced cultural exile and alienation. Suryodarmo initially studied international politics in Bandung. Anecdotally, she met some artists there and was introduced to a documentary film about the work of Joseph Beuys in 1988, in which non-conventional ways sparked something in her in terms of new possibilities. She then moved to Germany, where she studied at the Braunschweig University of Art (HBK) between 1994 and 2001. It was also at this institution that she learned Butoh, of which she had some knowledge from working with her father, as well as collaborating on choreography with Butoh dancer and performance artist Anzu Furukawa. The encounter with Furukawa was a teaching influence that remains very present in Suryodarmo's practice today as she integrates the post-war Japanese philosophy and movement work of Butoh, as taught by Furukawa, with her own composite dance and body philosophy and practice. At HBK, she studied time-based media with Austrian avant-garde filmmaker Mara Mattuschka, which gave her foundations for work involving camera, video, and direction. She also

trained in performance art under the tutelage of Marina Abramović, with whom she participated in the 50th Venice Biennale in 2003 and in many other collaborations beyond Suryodarmo's student years. Abramović, who is known to be a radical tutor – both physically and mentally – to her students, was a very good teacher to Suryodarmo. She introduced her to performance art, as much as she taught her about living with such peculiar artistic practice and how to manage herself as an artist, and encouraged her to overcome insecurities, to come closer to her own individuality, and connect to it. These particular considerations are noteworthy in understanding the journey of the artist, and how by honing a better understanding of herself and learning to take care of her practice materially, it gave way to the development of a unique artistic language that stands on its own.

Suryodarmo stayed for more than 20 years in Germany, which was not always easy on a personal level, but it furthered some of her formal knowledge, especially in subjects such as the relationship between performance and feminism, and the names associated with performers who made a mark in the field. In performance art, in particular, Suryodarmo grew to see the potential for freedom behind the essence of the discipline. In this sense, performance offers larger horizons than objects do, since they are limited by their aesthetics and are fixed in time. Performance cannot be anchored the way an object can, and so it ends up being a practice interwoven with the practice of life itself.

And Suryodarmo's research unearths movement that relate one's interior world and the world at large through the body. Compared to other forms of performance, Suryodarmo often says that performance art's absence of script or defined choreography allows it to open its narrative to a new interpretation at every performance. The framework – a setting or stage, a dramatic dress, a specific action repeated for hours – supports the work, but the narrative only happens in real time. We change, the artist changes, the surroundings change, and all of this influences the unfolding of a piece. In an interview with STPI on the occasion of her 2018 residency at the Singaporean institution, as she experimented with pulp and paper, she mentioned retaining the original spirit of performance art, which she described as the spirit of radicalism against the conventional. For Suryodarmo, performance art does not have to have an audience, it is the art of doing, and it can be done in a natural landscape without people; it is not a show for a stage and does not necessarily need institutional frameworks. Additionally, to practice

performance art means that you always have with you your primary material – your body.

Suryodarmo has been relentless in her path, in spite of the challenges of her practice and the lack of commercial revenue the artform is known for. Nearly 10 years ago, she moved back to Indonesia, and opened Studio Plesungan in 2012 in her native Solo, turning her home into a place of community and exchange for the arts. She has consistently pursued an authentic work, whose richness draws from long-standing philosophical and intellectual research, meditation, release technique, tai chi, and other mixed methods of body movement, as well as a penchant for sharing – including by blending disciplines – with a community of performers and dancers. Studio Plesungan consists of a living space, alongside with an indoor hall, an outdoor stage, and various pockets of spaces on the grounds to run workshops and train. Set as an interdisciplinary platform, Studio Plesungan is where Suryodarmo invites established and less established, local and international performers to share their ideas and experiences with each other, teach, perform, and present their works to a large audience of locals and visitors. In 2007, Suryodarmo created "Undisclosed Territory", an annual international performance art festival that facilitates the exchange between performers. The studio has been hosting the event since its opening. Lasting several days, during which participants take part in classes, formal and informal exchanges, including shared mealtimes, sleeping on-site or nearby, the festival concludes with a series of performances contributed by the partakers. The studio also lets other groups use its stages as a venue for various dance projects and festivals, and a collaboration with the Cultural Centre of Central Java. So it showcases a mix of practices that not only include performance art but also Javanese dance, contemporary choreography, theatre, and visual arts – Suryodarmo is a firm believer in the potential of merging influences when it comes to appreciating and creating authentic and original works.

Conceived with community at its core, people from different cultural and economic backgrounds come through all the time. And it is also where Suryodarmo teaches students dance and choreography, with influences from Butoh and other body work, essentially passing her knowledge and experience of movement work, so students can learn to be aware of their energy, to release and deliver it, and to find their own flow. Butoh is part of Suryodarmo's training and the most influential element. It is an artform that Suryodarmo sees as closer to performance art than dance because of

its conceptual and imaginative dimensions, as well as how it approaches the body in a form of becoming. Suryodarmo says that Furukawa tried to teach them how to bring Butoh to the realities of life with the understanding of the inner body. From her, she also learned how to research social realities, histories, and memories, how they interact with our bodies, and how, through imagination, it can create powerful stage pieces. Another strong thought influence in Suryodarmo's journey was the encounter with scholar and performance artist Boris Nieslony. Shaping a network of connection and support with other artists as part of one's performance art ethos is a direct impact of his thinking. Even before the inception of Studio Plesungan, he helped her create the Performance Art Laboratory Project in Bali which, from 2007 to 2010, offered a space for artists to exchange practices and experiences in order to develop an ecosystem of arts in Indonesia. All these initiatives are the translation of the idea that co-existing within a supportive community, sustaining each other materially and spiritually, forms another integral part of the practice of a performance artist.

Suryodarmo was born into a family of dancers and performers, tuning in since a very young age into the truths of the body as a performative filter for life experiences. She practised Amerta, a form of exploratory body movement and meditation, with her father and watched her mother dance, while training herself in dance and Javanese meditation. Suryodarmo practises sumarah meditation every morning. Sumarah is a philosophy of life and a form of meditation that originally comes from Java, Indonesia. It involves the deep relaxation of the body, emotional state, and the mind as a way to develop sensitivity and acceptance, and to connect with one's inner self. It is a practice of conscious surrender. It emphasises a deep relationship with nature and the acceptance of the natural order of things, and for performance, it means that it helps to sense one's own being and the beings of others present during a performance.

The body and mind are an essential part of that presence. Not only are her durational performances demanding in terms of physical endurance – which means she learned to read her body in aspects such as what and when to eat beforehand or how to control her breathing – but they are also about how to keep one's mental state focused on a single intention. It involves knowing how to receive energy and how to use it, how to maintain one's inner presence and honesty towards the work. To do so, the performer pays attention over the years on the changes undergone by their body and states of mind. It is

an ongoing process. In making art, Suryodarmo also asks questions that are useful for her own philosophy of life. Since performance is related to the walk of life itself, creating an artwork comes from the inner self and is a practice that reinforces and is interconnected with the path of uncovering one's knowledge and truth.

The past several years have brought a succession of major international accolades for Suryodarmo, making her innovative artistic path more available. She presented her work in several institutions, with the inclusion of her first museum solo at home, *Why Let the Chicken Run?*, at Museum MACAN in Jakarta, Indonesia (2020). On the occasion of her retrospective, Suryodarmo presented a talk (2021) with the museum director Aaron Seeto, where she defined performance art as something that creates a new reality during the time of the performance. "It is a work that is considering the experience of change, of a process… For me, being in the process of life is performance art." And in fact, Suryodarmo often questions what constitutes the value of contemporary artwork, and the answer is neither in the Western canon nor in the objectification of Indonesian culture. "I feel like we are comparing and competing aesthetically with the West," she said, adding that the comparison can be fruitful in terms of techniques, but it should not compete in philosophical, conceptual, and aesthetic terms. "We should begin to look into our own history and aesthetics. International recognition is secondary." Traditional Javanese culture is something Suryodarmo researches expansively even if ultimately she integrates it in the context of her own contemporary cultural environment.

In addition to drawing from her surroundings and daily life, she researches traditional knowledge, rituals, ceremonies, and dances, including those nearly forgotten. In particular, how Javanese often sense their environment first and adjust the rhythm of their lives to their sensory faculties. In Solo, people live differently from those in Jakarta, closer to their Javanese cultural roots. She follows symbols and their meanings from her own environment and follows their memories, traces, and influences within the cultural environment of today. She says, "For me, rituals are a means to connect collectively or individually to a situation, common or particular. Meaning rituals are needed to shape our focus on purposes such as spirituality, religion, etc." So, rituals are a framework and a vehicle. In her performance art, Suryodarmo brings rituals as a way to transform her ideas into meaningful actions: "the meaning of an action is set in a certain space and with a relationship with all the

supporting materials used for the performance." From what she says, it seems that we can find in rituals the focus needed to walk the pathway between our way of experiencing the present, the expression of our bodies, and the cosmos. It is confirmed by another thought she shared with me where "looking at traditional rituals is mostly to focus on the relationship between humans, humans and nature, and god or higher spirit… but whatever the reason for the ritual, it needs the construction of symbolic actions to reach their goal."

Suryodarmo is interested in observing different cultural viewpoints, considering and questioning her own relationship with her community in order to understand it better.

On this question of traditional rituals and the use of symbols, she says, "If traditional rituals were transposed to contemporary times, they would be a resource for conceptual art, because all the actions and all the objects that you see in rituals represent a certain meaning symbolically." One should consider cultural symbols, shaped as objects or actions, as part of a performer's language. But in doing so, her attention goes towards the essence and philosophy of things rather than towards their formal embodiment and nostalgia. In other words, she may use the symbols but will remain open to the undercurrents, to the deep meaning of people's actions and flow. Traditions are meant to be updated, so we can connect with them better and also evolve. Additionally, on the physical level, when it comes to making durational performances, traditional rituals represent support that taught Suryodarmo to go beyond the limits of time and body, as the latter is given the opportunity to "overcome physicality itself".

Artistic research could take years, and many of Suryodarmo's works build upon each other step by step following one concept or another. It may be that the artist takes an experience as a point of departure and learns more about it, which will inspire her to go somewhere or follow particular ideas that will in turn inspire her to create something… But by building on her own experiences and bringing her rich voice into her work of, say, being a woman, a Javanese woman who lived abroad and who is now back, of traumatic memories and losses, it does not make her art practice biographical. Many of her performances seem personal and many are very intense. Shooting arrows, spitting out ink, grinding charcoal, dancing on butter and so on, are actions that, especially in a durational setting, are quite unsettling. In her performances, there are references to uncontrollable physical, spiritual, and

mental-emotional turmoils, tensions, and even eruptions, which can relate to various states of the human condition: being oppressed, lost, invisibilised, or in grief. Suryodarmo makes a clear difference though between acting a feeling and becoming it. The movements she makes are purposeful, as they are aligned with the emotion or symbol or historical vibration she is speaking about, but they are not choreographed, thus unfolding in new patterns and sequences each time.

She does not use performance art to overcome, exorcise, come to terms with, or resolve a personal matter. It is rather that you can only depart from your own experience in the making of contemporary artwork, and that comes from your connection with your inner being. In a way, life is colourful and if, through body and mind-work, you can harness its colours in your toolbox, as a performance artist, you can access them later when you are off painting live, so to say – with your body and soul. Or perhaps it is as if the performer tunes its presence into a particular radio-wave-like frequency and starts summoning the emotions related to that wavelength – for instance, sorrow and loss, identity struggles, surrendering and letting go, or the fear that arises when we have to face various life challenges. It does not mean that the artist wants to control a narrative or force an interpretation on the viewer, however. In performance art, the freedom inherent to the practitioner is also extended to the onlooker, in how they perceive the piece, how they want to interact with it, according to their own context, time, and energy. Suryodarmo once told me that we carry with us our views of the world, both from the vantage points of our smaller inner world and our larger outside world, and that they are related to each other naturally; that although everyone has their own stories and backgrounds, since we live in a collective society, we are all undeniably connected.

Melati Suryodarmo

Melati Suryodarmo's performances have been dealing with the relationship between a human body, a culture to which it belongs, and a constellation where it lives.

Suryodarmo has presented her works in various international festivals and exhibitions since 1996, including *Wind from the East*, KIASMA Helsinki (2007), Manifesta7, Bolzano (2008), Luminato Festival Toronto (2012), and Asia Pacific Triennial, Brisbane (2015). She is the 2021 recipient of the Bonnnefanten Award for Contemporary Arts.

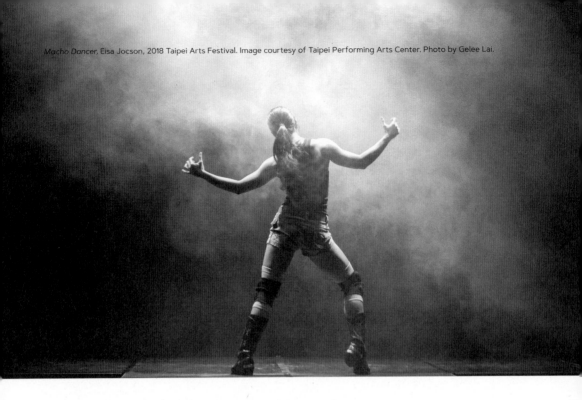

Macho Dancer, Eisa Jocson, 2018 Taipei Arts Festival. Image courtesy of Taipei Performing Arts Center. Photo by Gelee Lai.

How the Body Moves: Eisa Jocson's Work and Research

Betty Yi-Chun CHEN

Translated by **Elizabeth LEE**

For a decade, Eisa Jocson has created a recognizable stage presence in major international arts festivals. Not only because of her capacity to switch from extremely masculine body movements to extremely feminine ones, but also because her creations unpack the body politics in the Filipino context, exposing a tableau of desire that weaves colonial structure and affective labor together: from her exploration of pole dancing in *Death of the Pole Dancer* (2011) to incarnating a macho dancer, a unique phenomenon in Filipino gay bars, in *Macho Dancer* (2012). In *Host* (2015), she then took up the challenge of embodying a hostess whose job requires constant switching between various body cultures to entertain her customers. This performative 'triptych' seems so structurally composed, both in practice and discourse, as if she had been following a master plan.

And yet, the reality of the process is different: "Like all my works, it's an aggregate of conditions," Eisa told me in our interview. The idea of 'affective labor' did not emerge until *Macho Dancer* and *Host*. Although her early pole dancing works were already critical of spectatorship, they ultimately focused on the exploration of visual composition like a formal study. A master plan was not there. In this interview, I would like to look at the interactive development between her works and research throughout the years. The ways in which her body practice and discourse gradually gave rise to the interconnection we perceive now are perhaps a lot more organic than the conceptual presentations which seem to be taken for granted in later reviews.

Unpacking physicality

Eisa was trained as a classical ballet dancer from a young age and majored in sculpture at arts college. She transferred to visual communication because her family wanted her to "be more practical" (nursing was the other option). During that period, she missed physical practice very much and tried out cheerleading, street dance, and jazz dance. But it was not until she stepped into a pole dance studio in 2008 that something started to grow. She told me that she chanced upon a transitional phase of pole dancing in the Philippines as it just entered fitness studios. Pole dancing assumed a different socio-economic status in this context, unlike that in the red-light district: strippers became instructors, and the participants were women who paid out of their own pockets to explore and learn. It was no longer a transaction offered up for the male gaze. Devoted to teaching while also taking her students to competitions, Eisa felt the power of this female dance community.

83

This experience of pole dancing shaped Eisa's practice fundamentally: dance concerns not only techniques, but the relationships it generates; the implications of the dancer's body and its function in a given social context are inseparable. Hence in *Stainless Border* (2010), Eisa brought pole dancing from its usual private spaces to the public. She took flagpoles and gateposts, which symbolized governance and discipline, as her dance poles. Her guerrilla-like intervention of vertical movements disrupted the horizontal lines in the urban space. Intervening in the ways of seeing is also the departure point in *Death of the Pole Dancer*, in which the process of installing the pole and testing its stability defined the framework of the piece. The pole dancers' physical flexibility no longer functioned solely to seduce spectators. She began to probe into the gap between pole dancing techniques and the image evoked by them.

After these initial steps, Eisa went further beyond pole dancing and trained herself to become a macho dancer, which requires a body and gender language on the opposite spectrum. She spent a year training under an instructor and building up muscles, all the while breaking down the vocabulary of a macho dance in great detail and learning how to conjure the illusion of weight and masculinity as a dancer, including exploring the effects created by costumes and the use of music. "I think that's where my fascination exploded," Eisa spoke intently as though she wished her expression could be more precise. "The viscosity in which they move in, to the point you feel the space thickening. Their embodiment is so thorough." The process of training and research was also presented in formats such as exhibitions and lecture performances (for example, in *Corponomy* in 2017).

Looking back, the illusion called forth by physical skills, and the relationship thus formed, is the running theme in Eisa's body practice and research. The actual physique of a macho dancer might not be 'macho' at all. The appearance of masculinity is created through techniques, just as the appearance of lightness, elegance and gravity defiance exhibited in ballet and pole dancing – with which Eisa's body is familiar – is achieved through practice. "I want to challenge the feminine training inscribed on my body and what my body knows, and what my middle-class upbringing has informed me," Eisa explained. This was another intervention in spectatorship. When a female body picks up the techniques of a macho dancer, the seemingly natural projections of gender and desire are affected too, stimulating the audience to

think about their preconceived ideas. Off stage, the impact of macho dancing on her body continues its sway. For example, her body became "out of place" when she returned to pole dancing with such a masculine body. Or, when going home alone late at night, she could avoid potential harassment through enacting some of the masculine body languages. "When your body changes, your relationship with other people also changes," Eisa remarked. Such awareness became her approach to identifying the meanings of the body.

Crystallization of concept

Macho Dancer became a watershed in Jocson's works. This is not only because of the above-mentioned challenge of physical transformation, but also because of macho dance's specific connection to the Filipino context. Macho dance became her focus thanks to both Eisa's own development and a serendipitous encounter with the Singaporean artist Daniel Kok, who also practices pole dancing. The two had an exchange on seduction tactics employed in different parts of the world, and macho dancing was one of the practices Eisa shared with Daniel. The fact that macho dancing is a unique Filipino phenomenon only became clear to Eisa in this exchange. She then began to dig into the causes and conditions which contributed to the existence of such a type of dance: for example, the male images people desire in macho dancing, its link to colonial history, the influence of American pop culture, as well as the Philippines' economic dependence on providing services to the global entertainment and care industry (through tourism in the Philippines or labor services in other countries by overseas Filipino workers). "This whole universe came with macho dancing," Eisa commented.

In other words, macho dancing as a body practice is both cultural and political: it reflects not only a superficial sense of cultural belonging, but refers to a specific local condition and a survival strategy used by people. For Eisa, these macho dancing bars are the authentic melting pots of Filipino pop culture. "It's more constant than our actual cultural center of the Filipinos. Much more radical. A more reliable space than our cultural centers that are dogmatic and colonial. Much more bastardization. People are quite genius in the way they come up with the shows," she shared in the interview. Through physical practice, formal study and the Filipino context, a concept was crystalized in her practice: she is concerned with both how the body moves and what conditions make it move.

85

Key notions in sociology and migrant studies obviously help her articulate her research on the interconnection between desire, intimacy and labor. These notions, such as affective labor, or the idea of 'indentured mobility' proposed by the Filipino scholar Rhacel Parreñas, later appear in her discourses and are used for structuring the contexts of her works. Parreñas proposed to replace the concept of 'human trafficking' with that of 'indentured mobility' when she researched on the case of Filipino hostesses working in Japan. Such replacement foregrounds the fact that when governments introduced related policies, they still view migrant workers as commodities while ignoring the hostesses' agency and pursuit of freedom regardless of the restraints and confinement imposed by their unequal contracts. One can imagine that Parreñas's works must be an important reference to Eisa's *Host* (2015). In this piece, Eisa again approached the issue through dance techniques and transforming her own body, focusing on the production of and switching between several female images. *Host* deploys traditional Japanese dance and Korean pop songs. And such a trans-border context stresses the Filipino hostesses' ability to incarnate various cultural gendered images and their creativity to satisfy the clientele's/audience's requirements. This is how Eisa responded to the tension between coercion and choice within the concept of 'indentured mobility.'

Yet ultimately, her works concern more than a collection of discursive keywords. Given she has learnt so many different techniques, I asked Eisa whether finding her own style of macho dancing (or other kinds of dance) is a concern for her when she choreographs? She told me that dance vocabulary and choreography are two different matters. Just as classical ballet employs an existing vocabulary to create choreography, the composition of her works stems from herself. That said, she has to maintain the integrity of the dance's vocabulary, as "the vocabulary brings with it a certain worldview, state of relations. That's the point of discourse. If you mess with them already, then you lose the original context of the piece," Eisa pointed out.

As for choreography, she would look at it holistically in terms of spatial dynamics, light, sound, and certain dramaturgy of how the piece would unravel, thereby 'composing [the] body on stage.' For example, Eisa simulates the setting of a macho dancing bar through lighting and movements, with the audience situated lower than the stage so that they have to look up. This is one of the ways in which she constructs masculine power on stage. In *Host*, however, the relationship between the performer and the audience was much

more equal. There were even some floor movements where the performer had to raise her head in order to see the audience. Such postures evoke submission within a power relationship. In these works, the actual methods of choreography are largely decided by the materials, and the ways in which they are received are also determined by the audience. Sometimes, it is the gender aspect that is highlighted, other times, it is the colonial context or something else. Eisa told me that some people criticized her for studying these communities and their dances without offering them actual assistance. She does not agree with such attitudes, though. She believes that imagining others needing salvation is an act of superiority. "I'm first a fan, completely fascinated [by their practice]." That is her point of departure when entering a field of research, and what drives her to go on.

In her latter *Happyland* series – including *Princess* (2017), *Your Highness* (2017), and *Manila Zoo* (2020) – the critical perspective on migrant workers, colonial structure and affective labor focuses on the communities much closer to the artist herself: the performing artists who also provide entertainment overseas. This series began with the mass exodus of performers from the Philippines to Hong Kong Disneyland, among whom were former dancers from Ballet Philippines (this wave of the exodus of Filipino dancers was also the subject of Eisa's 2008 BA thesis). These Filipino dancers exert their bodies to entertain the visitors, yet, because of their skin color, they could never land the princess roles. More often than not, they play the animals in *The Lion King*.

Finding agency through hijacking and mimicry

In the *Happyland* series, Eisa and her collaborators demonstrate strategies of mimicry, from the happy Snow White to desperate caged beasts inside the screen (as the pandemic struck, *Manila Zoo* had to switch format, with the cast performing online for the audience at a distant theatre). Yet these disguises can mutate during the process of overwriting: animals go wild, and the princess loses her grace. The switch between faithful copy and mimicry is often ambivalent. One's own identity may come under threat if the imitation gets too close to the original. This is exactly what Eisa wants to address: owing to the historical and socio-economic conditions, Filipinos are such experts at altering oneself in order to accommodate others, as it is the only way to survive. For her, mutation is a form of hijacking, which opens up an opportunity to take away what was forced upon them. Eisa mentioned,

several times in the interview, that fierce resistance and struggle, for her, do not fit in the Filipino context.

Another instance is *Manila Zoo*. At its premiere in Frankfurt, the cast decided to perform certain sections naked. This sparked debates among the team at the venue. Seeing the Filipino performers naked and moving like animals on the screen was too much of a reminder of the human zoos at the expos of the last century. Concerning such unease, Eisa responded that if no discomfort would be triggered, there would be no point in making this decision. For her, difference is a given. She would always want to explore that discomfort, tension, or ambivalence, and question the process through which such cultural difference is homogenized into the norm.

"There is more to unpack and question. This is how I imagine my general audience to be, even if that's not the case. But I want them to always reflect on how they're looking at what they're looking at and why," Eisa described the intention behind her creations.

A few days before our interview, she had just completed a series of works in the form of karaoke videos, a form she has been exploring since *The Filipino Superwoman Band* (2019). In her latest project, *Bidyoke* (2021), she invites overseas Filipino workers – including migrant workers in the United Arab Emirates, or the Filipino singers who still have to work on cruise ships during the Christmas holidays – to create music videos to tell their own stories. This is a strategy responding to the pandemic measures; at the same time, it is also a form of resistance to the online formats which highly depend on technological infrastructure. Eisa is pleased to find a way to share resources during the pandemic, allowing the participants to get paid for their work. This reminds me of how she was inspired by the power of the pole dancing community in her early days. This is, again, a response out of "an aggregate of conditions." How the body moves can never be separated from the conditions in which the body finds itself, whether it is about moving in society or on stage. As the pandemic continues, the future of live performance remains uncertain. But the body practice outside the cultural centers persists, just as the artist's endeavor continues to shed light on the communities and relationships formed through these practices.

Eisa Jocson

Eisa Jocson is a contemporary choreographer and dancer from the Philippines, originally trained as a visual artist with a background in ballet. From pole to macho dancing to hostess work, Eisa investigates the labor and representations of the dancing body in the service industry. She is also concerned with identity and gender formation, as well as Filipino social mobility. Her work has toured extensively in major performing arts festivals and biennials worldwide, including Tanz im August, Berlin (2013 & 2015), Zurich Theater Spektakel (2012, 2013, 2015, 2017), Theatre der Welt, Germany (2014), Asia Triennial of Performing Arts, Melbourne (2017), and Sharjah Biennial (2019).

The Manner and Mind of an Anti-Establishment Girl: Su PinWen and the Trajectory of the *Girl's Notes* Trilogy

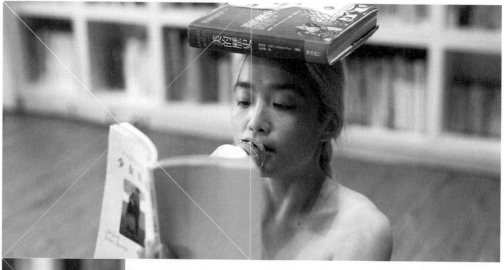

Tsung-Hsin LEE

Translated by **Stephen MA**

Girl's Notes, Su PinWen, 2018 Taipei
Fringe Festival. Image courtesy of
Taipei Performing Arts Center.
Photo by Lô Bōo-Him.

"Feminism is definitely anti-establishment," said Su PinWen resolutely. Their radiant eyes looked at me with the "power of feminism" they state. [1]

The notion of anti-establishment has shaped Su PinWen's body of work throughout their creative journey of *Girl's Notes*. It is indeed a 'journey' because not only has the 'work' challenged the systematic, but the artist's speculation of the creative process has also challenged heteronormative patriarchy and further explored the possibilities of action taking. In this article, I will be presenting the research and development of the *Girl's Notes* trilogy based on my observation, as well as the artist's trajectory of thought regarding the notion of (anti-)establishment. [2]

"What I merely need is for you to look at my naked body."

In the performance of *Girl's Note*, with the voluminous *History of Beauty* on top of 'her' head, Su PinWen donned a nude strap dress and stood in front of 'her' audience. 'She' slowly, lightly, elegantly, and also carefully looked around, giving each member of the audience a tender and warm glance, as well as a reserved smile like that of a young girl — not too much, not too little, just enough to show 'her' canine teeth; combined with two braids, 'her' innocence seemed like a hard slap in my face. This slap had nothing to do with shattering the peep of heteronormative patriarchy, nor did it have anything to do with the re-criticism of the critique on sexual desire. It was a slap that rendered me dizzy and off balance. Without my noticing, Su PinWen was already slowly taking off 'her' dress, and I seemed to have no choice but to force myself to continually gaze at the singular performer — Su PinWen, or perhaps 'her' naked body. Of course, I could have chosen to turn my eyes away and look at the audience members around me and my surroundings, or the coffee machine and extension cord on the floor; but I could not avert my gaze, for 'she' was looking at me so tenderly, inviting me to continue staring at 'her,' in a way that was neither right nor wrong, a way that I had yet to know.

"What I merely need is for you to look at my naked body" — 'her' resolute eyes seemed to deliver this message, just as Su PinWen later told me in our interview. Su PinWen had a book on 'her' head as if performing an exercise in an etiquette class from the middle of last century, where women had to stand straight and stabilize the upper body in order to achieve the perfect posture. Maintaining such a posture, 'she' quietly performed many seemingly everyday actions, like brewing coffee, and bending over to pick up or put

91

down something; every action created various degrees of wrinkles on 'her' skin. The layered wrinkles raised possibilities of diverse and discontinuous connections to access 'her' actions. Later in the performance, Su PinWen, or perhaps 'her' naked body, suddenly started to repeatedly contract 'her' muscles, creating more obvious lines and wrinkles on the naked neck, arms, and face. Between the recurrent spasms, it was as if the young girl suddenly got frightened, and then quickly suppressed her fear. I was not sure what happened to her, as there are too many things that could scare a young girl in this heteronormative patriarchal society. Therefore, the reason for her fear was no longer important, or perhaps, it was not important to begin with. What was more significant was the wrinkled surface of the naked body caused by the fright, an instant in which good posture and etiquette were shattered and restored. Would 'ugliness' be inevitable once 'beauty' was destroyed? No, at least this idea never for a moment crossed my mind.

"Go beyond two, start from three."

In the second year of the project (2019), the title *Girl's Notes II* not only resembled a sequel of a publication, but also denoted an 'ongoing' concept. [3] Although the introduction of the work stated that it was a solo series, [4] to Su PinWen, it was a duet.

Carrying the concept of 'blind dates' and through the format of true and false questions, this work stimulates the audience to imagine the possibilities of "going beyond two." "Go beyond two, start from three," the researcher Su PinWen takes the second-person perspective in reinterpreting the artist Su PinWen's feminist tracks, believing that "starting from three" would be a method of breaking the notion of binary opposition in the Western knowledge system. [5] The broken two have been 'yes' and 'no,' while the questioning 'three' would suggest tacit approval, a process of mutual exploration through interactions sited between 'yes' and 'no.' The #MeToo movement originated from the American entertainment industry advocates that in the workplace, at least, preconditions of any physical interactions between indivisuals – especially with women – must include affirmative consent (i.e. only yes means yes). The breaking of 'two' in *Girl's Notes II* arguably is Su PinWen's interrogation of the underlying problematics of binary opposition associated with the #MeToo movement.

However, we must be clearly aware that Su PinWen is not against the #MeToo movement, nor does she believe that 'affirmative consent' is not important. If we thought that way, then we would have easily succumbed to the pitfall of binary opposition that the artist wants to dismantle. To put it more clearly, Su PinWen's act of challenging the right of 'affirmative consent' in the context of #MeToo with tacit approval does not represent whether they stand for the #MeToo practice. Arguably, the significance would have become that 'affirmative consent' or 'tacit approval' are both cultural products in specific social contexts. Thus, the #MeToo movement and 'affirmative consent' could be a kind of resistance against heteronormative patriarchal capitalism, but they would not be absolutely applicable in all contexts. Perhaps Su PinWen's exploration of tacit approval during this dating work was also a form of tacit approval in theater culture and its protocols, and the more profound intention was to guide audiences to rethink the potential of breaking the notion of binary opposition.

Possibility and understanding of transcending the binary

In the performance *Girl's Notes III* at Thinker's Theatre with its high walls, giant bookshelves, and vast collection of tomes, the afternoon sunlight shone through large French windows, scattering onto the wooden floor and falling on the body of the sunglasses-wearing Su PinWen lying thereon. When I walked into the space, I immediately noticed Su PinWen – with her hair let down and dressed in a black boilersuit – not only because they must be present as the solo performer, but also because they were present in non-performative ways – simply just lying there on the floor without any intention. The sun shone in real-time, and 'her' skin was feeling what was right there and then. They/'she' noticed us coming in, as expected. Through their/'her' sunglasses, I saw them/'her' glancing over and quickly scanning the entering audience members, including me. This glance confirmed the fact that we co-existed in a shared present.

'She' tied up her hair, stood up, and picked out a volume of *Girl's Notes* from the bookshelves. Turning to the marked page, Su PinWen put on over-ear headphones and black latex gloves, and began 'her' cooking process. Sitting with the audience, or more precisely, sitting on a foldable chair in Thinker's Theatre, I vaguely heard the powerful beats spilling out from the headphones match the rhythm of the sounds and movements produced from 'her' cutting, chopping, folding, and pounding of the ingredients. I tried to imagine the

music 'she' was listening to, as well as the energy this music provided. I could not be sure of what 'she' was experiencing, but I did my best to imagine, just as I – as a biological male – could not be acquainted with the unique corporeal experiences of a biological female or other genders. Nonetheless, there would always be something – the beats, the power, or the contraction of inner core muscles – that reminded me of things and events I had once experienced.

According to Su PinWen, [6] the use of the headset and music are perhaps related to their experience in Berlin. When they stayed at a shared residence and it was time for them to do the dishes, they would put on headphones and listen to electronic music to complete this task that they disliked. I could not 100% relate to their experience as I enjoy cooking and do not mind washing dishes, but I could more or less understand the suppression they felt through certain things I disliked. As long as I was willing to understand, it did not matter that I was a biological man who liked cooking and they were a biological woman who detested doing the dishes.

Compared to some feminist concepts that emphasize unique experiences of women as a kind of exclusive resistance, Su PinWen reminds me that the concept of 'the female' as the second sex is also the result of heteronormative patriarchal exclusion. The roots of violence may not originate from the binary division of male and female, but fundamentally, identity is shaped through 'recognition' and, paradoxically, 'exclusion.' Thus, only when I willingly read and attempt to understand Su PinWen's (performative) female body could I imagine the life experiences of another body, through my own metaphoric associations. This connection, ignited through their/'her' body performance and my will, transcended barriers which had been considered disparate and uncrossable.

The trilogy as a discursive trajectory

Mapping out the trilogy, I have observed how Su PinWen toppled the mechanism of heteronormative patriarchy through various bodies displaying female nudity in both the biological and social sense. In *Girl's Notes*, Su PinWen challenges heteronormative patriarchy's gaze at the female body; in *Girl's Notes II*, they explore the third (or more) alternative to 'yes' and 'no' through a blind date replete with tacit approval; in *Girl's Notes III*, Su PinWen leaves behind the binary construction of gender, highlighting the possibilities of mutual understanding between diverse identities.

Such subversion does challenge the patriarchy through the heterogeneous approaches of twisting, tilting, and folding actions in plural axes. Today, defying the apparatuses of heteronormative patriarchy is no longer just about the one-way weakening of patriarchy while strengthening women's rights, but to probe into deeper dimensions and stir up the unyielding and stubborn bedrocks through 'she/her' — their feminist entity in social contexts — so as to shatter those foundations that we have deemed normative and universal, in order to emancipate the possibility of transformation.

Su PinWen's expressions in the works reminded me of the sculpture *Fearless Girl* on Wall Street — a Latino girl standing with her hands on her hips fearlessly and candidly in front of the *Wall Street Bull*. Although this artwork was commissioned by State Street Global Advisors to advertise an index fund that operates under capitalist logic, sculptor Kristen Visbal's presentation of a girl fighting the giant bull all by herself is nevertheless striking and moving.

Compared to this, I would say, the girl enacted by Su PinWen actually has placed herself in front of such social hegemonies of Taiwan, regardless of heteronormative patriarchy or the system under which the field of performing arts functions. With their naked body and determined eyes, Su PinWen has made me helplessly ashamed to look directly at or write about their works. However, it was also this shameful feeling that stimulated me to start searching for new ways of thinking and writing: a function beyond illustrating action with the written word, an alternative connection and presentation of symbols that heteronormatively used to be inapplicable... I now understand that this is the power attained by the feminist manner, as expressed through Su PinWen's body of work in the *Girl's Notes* series.

1. Here I refer to Su PinWen with the third-person pronoun, 'they,' which Su prefers. However, to highlight my interpretation of the female body in the context of sociality in the performance, I use 'she' in quotation marks to refer to the portrayed character.

2. In the trilogy, I have only seen *Girl's Notes III*. Discussion of *Girl's Notes* in this article is based on the records of the performance at 2020 Nuit Blanche Taipei; due to the unique presentation of *Girl's Notes II*, I could not obtain acceptable video records, and could only rely on my interview with Su PinWen, information from the Taipei Fringe Festival, and critiques and records by Hsieh Chweng-Ching, and try to imagine the performance. Hsieh, Chweng-Ching, "Caress of Glance, Mysterious Smile: Girl's Notes II", PA Reviews: https://pareviews.ncafroc.org.tw/?p=36714, last accessed on November 20, 2021.

3. Interview with Su PinWen, Taipei, October 15, 2021.

4. Girl's Notes II – A Blind Date without Marriage in Mind. Website of the 12th Taipei Fringe Festival 2019: http://61.64.60.109/196taipeifringe.Web/Program.aspx?PlayID=186. Last accessed on November 24, 2021.

5. Su, PinWen, "Postmodern Feminist Practice of a Taiwanese Artist – Su PinWen's *Girl's Notes*" (2018), published in *Transdisciplinary Dialogue 16 – Performing Arts Conference*, National Taiwan University of Arts, New Taipei City, October 1, 2021.

6. See 3.

Su PinWen

Su PinWen (He/him/They) is an artist and the Artistic Director of KuaBo Dance Theatre. They hold an MFA in Choreography from Taipei National University of the Arts and a Bachelor of Philosophy from Nanhua University. Their works challenge heteronormativity revolving around the notions of gender, feminism and nudity. Since 2013, Su has been researching and practicing tactile culture. They take dance into conceptual art beyond the esthetic genre.

Seven Drifts on the Possibilities of Shared Spaces [1]

Convivial awning in Phnom Penh. Image courtesy of Xin Cheng.

Xin CHENG

Car park in Tainan.
Image courtesy of Xin Cheng.

Taipei Liangting.
Image courtesy of Xin Cheng.

Walking is slow compared to riding a bike, sitting in a car or catching the train. The slowness allows me to notice things and be free to stop and see more whenever I like. While I do walk to get somewhere, I often leave extra time so the journey could be more of a drift: the pleasures of being lost in unexpected places!

Walking is in-between. The space where one could wander through, between home, school, work, the streets, alleyways, semi-hidden paths, markets, foyers, libraries, grassy edges, riverbanks, bushes; playgrounds, parks, empty fields; public, private, shared spaces....

Walking is a way of getting to know a place and its dwellers. "The earth is a form of writing, a geography of which we had forgotten that we ourselves are the co-authors." [2] Walking, seeing, touching, reading traces left from activities of other beings. The awareness and attentiveness of ecological fieldwork can be equally applied in urban environments. Here are some of my own, from over twelve years of walking around.

1. Berms, sidewalks and other dimensions

As a child growing up in China, most of my waking hours revolved around school 'education' where it was all about doing well in exams. One of my escapes was to feed the spiders dwelling in the five sets of stairs on the way home. I would catch an ant, drop it onto the web woven in the corner of the stairs, and watch: the spider, first startled, would hurry to the struggling ant, wrap it up in its silky cocoon, then suck the juice out of it. What would it be like to be an ant, dying? Or how would it feel to be the spider, where most of the day seems to be about waiting, stillness, and sudden bursts of action? These are reminders of other realities, existing in parallel to my daily life of solving arithmetic riddles of counting rabbit heads and chicken legs. I did not know that Jakob von Uexküll, the Baltic-German biologist who introduced the concept of 'environment' in 1926, had asked the same questions regarding ticks and hermit crabs, and worked out that, in any given environment, there are infinite possible perceptual worlds, depending on whose perspective you see through. [3]

Kyohei Sakaguchi, in *Build Your Own Independent Nation* (2016), recounted playing marbles in his childhood as an instrumental experience in seeing other dimensions parallel to the reality of school that he was forced to take part

in as a youngster in Japan. He took that train of thought one step further as an adult in Tokyo: from the despair of being an architecture student and realising how many houses remain empty in the city, yet many people work themselves sick just for a place to dwell; then later discovering utopia by the riverside, where the so-called 'homeless' had built their own dwellings and economies of sharing. He realised that there are many layers coexisting in the world, and one's task is to choose which layer to be part of, and perhaps, jump in-between them.

The berm is a strip of land between the footpath and the road. Usually in Auckland, these are planted with lawn and mowed regularly, for no reason other than that being the 'norm'. In one particular berm in the suburb of Mt Roskill, someone had planted a small corner into a succulent garden. Then sheep and dinosaurs were introduced. Suddenly there is a Jurassic jungle on the sidewalk!

This delight of such scale is not restricted to children. In a street corner in Taipei, I discovered a miniature world on the edge of a parking lot, bringing unexpected pleasures for anyone who notices. Even better, its miniature landscape is rustic, a sort of architectural ruin, yet constantly regenerating with plants sprouting up – a simulacrum of the bigger landscape around it. Robert Smithson [4] would have smiled. The *liangting* (Chinese pavilion) had been mortared down, so no typhoon could take away the resting spot for the tiny wayfarers. There are the remains of what looked like a ceramic hippopotamus, now on the way to becoming an amphitheater.

Who are the caretakers? Do regular passersby enjoy its change, and perhaps talk with the person when s/he is tending this garden of the miniature world? What stories do they make up in their minds?

2. Trees as...

A tree is not only a tree. [5]

The squirrels outside my kitchen window in Hamburg, they jump in-between the branches, from one tree to another; or climb up and down, twirling around in a game of hide-and-seek with one another. They experience the trees in vastly different ways to me, a human being with a not-so-agile body. For them, trees are networks of passageways, corridors, highways. What humans

need civil engineering for, nature provides for them already.

...playgrounds

Perhaps trees are the original playgrounds, before the profession of 'playground designer' came into being. The kids in Phnom Penh and Auckland showed me just how versatile trees can be: climbing, swinging, taking shelter from the blaring sun. The big leaves also make good sunhats. Of course, trees follow no health and safety standards, so one learns how to take care through doing.

...supportive structures

There are lots of big, tropical trees in Phnom Penh, and plenty of enterprises on the street. In a motor workshop, which has grown around the tree, the trunk becomes part of the workshop storage. On the side of another street, a tree turns into a kiosk: a piece of string tied up high around the trunk, and bags of merchandise hanging from it.

Ratchet straps are useful, not only for tying up tarpaulin on trucks. A letterbox is fixed onto a tree in Stockholm, without damaging the tree itself. Following a similar idea, beside the picturesque Lake Geneva, a circular table is perched around a tree, perfect as a beer stand on summery days. A tree is a readymade upright pole.

...sprouting up from ruins, a rooftop paradise

Ever since my first visit to the White Building (Phnom Penh) [6] in 2013, I have noticed a papaya tree growing on its roof and wondered how it got there. A year and a half later, after living in the building for a few weeks, I found the stairwell that led up to the rooftop. It turned out the tree was growing out of rubble comprising compost and broken bricks. Under its generous shade, a master embroiderer was working a frame of delicate silk fabric, destined to become the gilded costumes of the royal court dancers. A very kind man showed me the rest of his garden and handed me bits of it: fragrant herbs and medicinal aloes. A convivial encounter despite the lack of a shared language. On that concrete rooftop, I glimpsed a paradise: how human beings support the livelihood of other beings, and in turn, derives pleasure and nourishment from it. All it needed was a pile of rubble and a daily bit of care.

3. Urban epiphytes

In forests, an epiphyte is a plant that perches on the branching point of another tree. It seeks nourishment from the humus that accumulates in the branching joint, without harming the host. It takes advantage of the height, much like someone standing on the shoulders of a giant. In the urban environment, epiphytes grow out of existing infrastructures, extending their possible range of activities. Usually there is an anchor to the host: a hole, a hook, something tied around a pole, or two boards sandwiching a lattice grill; string, fabric, a light pole like a bamboo stick, a ground weight for stability, soft, reversible joinery; more advanced/permanent are the use of hinges, which enables folding, easily put out of the way when not in use. As a technique, these are used by non-specialists and professionals alike. Most of the time they are collapsible, and temporary, though some are semi-permanent, such as in the case of hanging gardens.

Some of the most spectacular extensions I have come across are food places.

In Taipei, 2016, I found one of the oldest family-run establishments for breakfast and lunch in a rapidly gentrifying neighbourhood. Tarpaulin shelters grew out of the five-storey building, held up with poles set in concrete-filled buckets, protecting a whole kitchen and seating area. The construction may look temporary, but it has been there for 30 years. It is also typhoon-proof, the owners told me: "Everything can be dismantled and stored safely inside when it is too windy." This echoes Hong Kong urban researcher, Tse Pak-chai's words: "Temporary construction is a permanent phenomenon." The owner also told me of how the whole neighbourhood used to look like their place – the streets used to have daily markets, but that changed rapidly in recently years. Hence, their place now stood out.

Taking shelter from the rain under the shade, I looked out to the opposite corner: the convenience store made of steel and glass, which felt like it was made to be there forever.

On a sidewalk in Kobe, 2016, I was puzzled by a broom standing on a concrete base beside a nondescript building. One night, when walking back to my accommodation, I was surprised to encounter a tent with a bar-counter where people were laughing and having a good time with the TV blasting in the background. How come I had not noticed such a lively dwelling-place

before? After passing by several times, I came to realise that all the hand-made furniture and equipment were 'in storage' behind some plastic sheets during the day.

A similar example of extending conviviality was discovered in Phnom Penh, 2014. This time, the orange and yellow awning sheltered coffee and drinks, printed publications, playful kits hanging on poles, a waist-height table for perching around – a space for gatherings and chance encounters, without an intimidating door to walk through. It all seemed like a perfect platform for an artist-run space to me. (See p.98)

The holes on the ground for the bamboo poles were made by digging out the existing pavement, inserting a small section of blue plastic plumbing pipe, then refilling the space around it with concrete.

4. Non-standard modular joinery

Modularity, as in Lego or Meccano, is based on precise joinery or exactly matching holes. However, there are other kinds of modularity that are fuzzier, grown rather than prefabricated: connections that are repeated and gradually strengthened over time. The result is not smooth, but of variations, a building up of textures and layers, gradually weathering and changing over time. My appreciation for variation came from looking at roof tiles in vernacular building traditions: Norwegian slate tiles, the earthenware roof tiles in rural Slovenia, the roofs of huts in northern Thailand fashioned from leaves. They mirror variations through repetition, as found in nature.

The terra-cotta bricks in Cambodia come with four holes. On a wall hastily constructed to separate a former slum from the famous White Building in Phnom Penh, the exposed holes came in handy as a system for protruding horizontal sticks. The length of the bricks (around 20cm) means that they can hold the sticks in place, without them tipping over or falling out. Any stick roughly smaller than the hole could be used and it, in turn, became an anchor for other things: shelves, hooks adapted from plastic plumbing pipes, hanging plants (with a self-watering system), bags of sprouts, rubbish bags, metal pipes forming a C-shaped frame, awning, rainwater collectors, among others.

Why are there not more walls with holes in them?

5. Car connections

"The process of arriving in a house, and leaving it, is fundamental to our daily lives; and very often it involves a car. But the place where cars connect to houses, far from being important and beautiful, is often off to one side and neglected" (p. 554).

In *A Pattern Language*, first published in 1977, C Alexander et al. suggested the following on car connections for private houses: "Make the parking place for the car into an actual room which makes a positive and graceful place where the car stands, not just a gap in the terrain... make it a positive space – a space which supports the experience of coming and going.... It may be achieved with columns, low walls, the edge of the house, plants, a trellised walk, a place to sit... A proper car connection is a place where people can walk together, lean, say goodbye."

Twenty-seven years later, parking places have grown. Rebecca Solnit realised, in a farcical comparison of the L.A. Getty Museum's carpark to the hell and heaven in Dante's Divine Comedy: "The world seems to be made more and more of stuff that we are not supposed to look at, a banal infrastructure that supports the illusion of automotive independence..." At least, where she was: "Los Angeles consists mostly of these drably utilitarian spaces, in part because cars demand them, and it is a city built to accommodate cars." [7]

I have not been to L.A., but in my wanderings around Asia, I have found small touches showing the human(e) in the caretakers of these "banal infrastructures".

In Seoul, 2015, I was initially intrigued by the road cone extensions with colourful striped poles rising from the apex (similar cone modifications were found in Kyoto, and recently at Billstrasse, Hamburg, in a driveway frequented by large trucks). Looking closer, I discovered the extensions were made from printed plastic posters taped together with insulation tape, thus the banding stripes made total sense. Further down the road were other improvements on the standard road cone, such as one that sits atop the base of a former wheelie chair, thereby adding extra stability and mobility.

Venturing into the parking lot, I discovered more things made from used posters: rolls of them woven together with string, tied to the wall and window

security grills, acting as a holder for cleaning tools. One corner of the parking lot was used for the storage of these off-cut materials. Looking up at the shelter for these materials, I was awed by a string that ran across the entire parking lot, linking one corner of the rain shelter to the building on the other side. The fact that it seemed to have endured at least a good few months is a testimony to Buckminster Fuller's tensegrity principle. On the way out, one arrived at the caretaker's cubicle, and all of this made sense: here is someone with a knack for making stuff for the needs of the situation, be it a lampshade created out of an old plastic bottle, a chunk of Himalayan salt serving as a welcoming statue, or a clock for the drivers running to their appointments. I sensed plenty of personality, without even meeting the caretaker in person. I felt welcomed already.

6. Parking lots to parks

A place in Tainan not only fulfilled the recommendations from Alexander et al., but grew upon it, bringing the potentials of parking lots to a whole new level, and not only for humans.

In a carpark for the surrounding residents, there is a shed-ecosystem made of old bamboo ladders, treasured scraps, as well as living plants and creatures (see p.98). During my repeated visits, I was fortunate to have met its human companion/caretaker, who told me that the ladders were discards from his workplace (for climbing telephone poles). He liked to collect different kinds of wood for their fragrance, and even gave me a small bottle of a particularly aromatic kind, carefully made into shavings.

Another morning, when I walked by, the whole family was engaged in a careful excavation, due to complaints from the neighbour that it was causing a mosquito infestation. Under rotting wooden boards, we uncovered the eggs of geckoes, a species which hunts mosquitoes – I was gifted some.

The whole structure was assembled without nails or screws, only through a twisting of wire (of various thicknesses, including telephone wire) which joined short pieces of wooden sticks together, in a piecemeal construction, like the growth of plants.

Here, string, wire, roots, branches, plants alive and regenerating were entangled together in a porous co-existence.

In Europe, I have seen 'insect hotels' in front of houses, designed as a response to the alarming decline of insect populations. I have heard that such structures become hotspots of insect-hunting birds, or wasps, which are already over-abundant. Here is an approach closer to permaculture, where the needs of human beings and related creatures are catered for simultaneously, in multiple ways. So many parking lots, so many possibilities...

7. Co-caring

Open shelters are welcoming places in a tropical place like Taipei, as sudden rain is frequent and the temperature is pleasant for being outdoors all-year round. In a *liangting* in a neighbourly park, a concrete pillar became an open living room, starting with a repaired metal shelf and a stack of disposable teacups piggybacking with coiling plastic string. From walking by over a couple of weeks in 2015, I noticed many retired residents lounging there, reading newspapers while the younger ones played in the outdoor gym. Often a huge metal teapot sat on the shelf, without anyone in sight. Given the setup, it seemed like anyone is free to take a drink. Four years later, I was pleasantly surprised to find not only the well-loved pot of tea on offer, but that the coiling rope had been strengthened, and was now supporting cleaning rags, salvaged plastic bags, even some found keys (see. p.98).

1. Modified from a piece originally published by Hainamana in 2019, which was supported by Amy Weng and Creative New Zealand.

2. Georges Perec, "co" added by the author.

3. Von Uexküll, J. (1934), "A Stroll through the Worlds of Animals and Men", in *Instinctive Behavior*, C. Schiller (ed.), New York, International Universities Press, 1957.

4. See *Hotel Palenque* and *Monuments of Passaic*.

5. Referencing Christopher Alexander, "A City is Not a Tree", 1965.

6. The White Building was the base for Phnom Penh art group Sa Sa Art Projects from 2010 to 2017.

7. Rebecca Solnit, *London Review of Books*, Vol. 26 No. 13, 2004, https://www.lrb.co.uk/the-paper/v26/n13/rebecca-solnit/check-out-the-parking-lot.

Joining the Current of Love: On the Practice of Latai Taumoepeau

The Last Resort, Latai Taumoepeau, 2020. Image courtesy of the artist. Photo by Zan Wimberley.

Jessica OLIVIERI

Dark Continent, Latai
Taumoepeau, 2018.
Image courtesy of the artist.
Photo by Zan Wimberley.

Why I do not leave the house

Like many people, over the last three years (2019-2022), I have seen very little live performance. In the return to live, as the world 're-opens', I have ventured out cautiously, living with someone who is immunocompromised and a small child has meant that we live by a different risk matrix to the 'healthy majority'. This has given me a new relationship to the documentation that makes up part of the digital offerings that have flooded our screens.

To add to this, as I write, there is a 'rain-bomb' above the east coast of Australia, so far causing the worst flooding this country has ever recorded – and more is forecast. Underground tunnels have turned into rivers, people are waiting on roofs to be saved, bodies are being found in stormwater drains.

In the old days, when I used to leave the house, I saw two of Latai Taumoepeau's pre-pandemic performances in person – one at Campbelltown Arts Centre (CAC) on Dharawal land, the other, a collaboration led by Luke George at Carriageworks on Gadigal land (Sydney, Australia). The performance at CAC was a few years ago, my memory is a little hazy on the details: I cannot remember any of the other works in the exhibition, but I remember with clarity the orange short-sleeved wetsuit that Latai wore whilst suspended by large white ropes under a giant platform of ice. As the ice gowned and melted, Latai jerked uncomfortably towards the gallery floor. She looked cold as the water dripped onto her goose-pimpled brown skin. But mostly she was composed, her body and spirit absorbing the current and future threats of harm dished out by 'the elements'.

The piece described above is *Island Exile (i-Land X-isle)*, Latai's first significant solo work. I found the performance difficult to watch: the simplicity of the action left space for a deep discomfort to arise, my complicity in the melting of the polar ice caps, my relative safety on an island that sits (at the moment) at a comfortable level above sea level, my understanding that Tonga – Latai's ancestral land – does not share this comfort and is currently experiencing devastating flooding every day with the movement of the tides, not to mention the implications of being a white woman watching a brown woman endure an action utilised in torture, in an attempt to wake 'us' up. Here, 'us' refers to the rich, able country of Australia with our current disregard for the climate emergency already unfolding.

This tension is, of course, intentional and lies at the heart of the work. In an artist statement for NIRIN, Latai asks:

Who is doing the heavy lifting around climate change? We know in Australia that we should be moving towards renewable energy sources, but I think we are moving way too slow, so this work (The Last Resort) is a meditation around fragility, around resilience and adaptation, in a hope that the wider community will take more action towards the change that's needed for valuable communities. [1]

I was so moved by *Island Exile* that the nagging voice in my head is amplified, the voice that occasionally tells me to leave the house. The thing I wonder is, if we skip the 'sitting with' live performance, is it still possible to stir the empathy that can elicit change? Is there a danger that we have become so comfortable with viewing works from our screens (thanks COVID) that if we do not all get back into the live space, and commune with each other, that we might become apathetic keyboard junkies unable to be moved to make the changes so necessary for our survival on this planet? The nagging voice sounds something like that of American art historian Peggy Phelan:

Performance cannot be saved, recorded, documented, or otherwise participate in the circulation of representations: once it does so it becomes something other than performance. To the degree that when performance attempts to enter the economy of reproduction it betrays and lessens the promise of its own ontology... performance becomes itself through disappearance. [2]

Phelan was adamant that we be there 'in person', something that has been ripped to shreds by Amelia Jones, Shannon Jackson, Claire Bishop, and others, so much so that Phelan has distanced herself from this statement. Photography, video, and interview now sits comfortably within an assemblage shared by live performance that circulate within the art machine. There is so much we could talk about in relation to the power dynamics of these elements and the ways in which they circulate. But let us do that another time, and instead focus on Phelan's emphasis on the ephemeral, uncapturable nature of performance – that we must let performance go.

But I am getting ahead of myself. Let us hold that thought lightly and come back to it later. Before I go on, I have asked Latai to introduce a few central ideas that inform her practice.

Definitions

In order to make accessible the conversations that Latai and I have on these pages, here are a few terms as defined by Latai that draw from her Tongan heritage:

Vā: space;
Tā: time (to strike/beat);
Fonua: land, also burial site, placenta, and is used metaphorically for the body;
Faivā: *Faivā* is what I do; *Faivā* is how I continue to produce the historical documentation of my heritage about the most pressing issue on the planet.

At the centre of everything is my indigenous Tongan practice of *Faivā* and the Tongan doctrine of *Fonua* - The word itself has multiple meanings: land, burial site, and placenta. The metaphor of the body, a belonging to place, a cyclical relationship of the body and place (lol compost). Cyclical time, a continuum of culture in the corporeal, metaphysical, and transcendental space.

I centre my indigeneity as an act of sovereignty of cultural practice and expression. [3]

A constellation

In order to make clear the elements of Latai's practice, for those who, like me, enjoy a good diagram, the next page is a map of the interconnected elements of her practice:

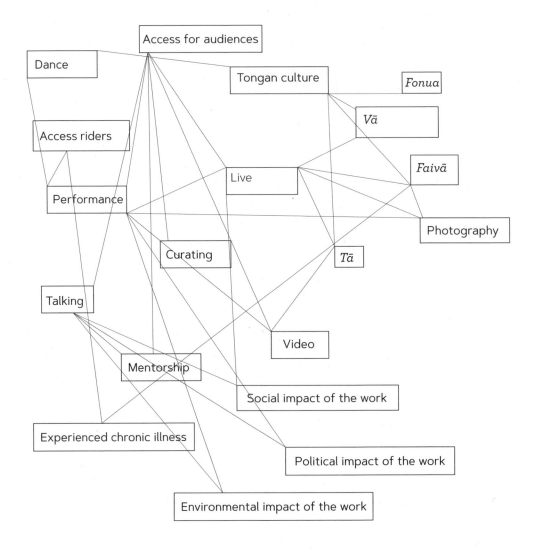

Dance

Access for audiences

Tongan culture

Fonua

Vā

Access riders

Faivā

Live

Performance

Photography

Curating

Tā

Talking

Video

Mentorship

Social impact of the work

Experienced chronic illness

Political impact of the work

Environmental impact of the work

What can art do?

Theatre historian Shannon Jackson advocates for an art practice that "helps us to imagine sustainable situations (in order to build) a more complex sense of how art practice contributes to inter-dependent social imagining." [4] I am personally very drawn to a practice that attempts to harness the potential of art to 'do something'.

Latai's practice does many things. It is a call to action on climate change and a recentring of indigenous contemporary practice within a 'white' arts discourse.

It is a sharing of cultural knowledge in the hope of eliciting empathy and, as a result, change. It is also a cross-cultural, collective re-imagining of climate futures, solutions, and adaptations.

I find Latai's generosity astounding considering the blatant disregard our political leaders and general population have for the climate emergency, even as we feel the impacts on this continent with disturbing regularity. There is a quote from Latai that I often return to when dreaming of her work, there is a sense of futility built into it that feels devastating:

It (my work) is how I mourn the eventual submergence of my ancestral home, which my children's children may never feel the same belonging to and cultural deference to, that I do. [5]

I have had many conversations that follow this trajectory, but what strikes me about the conversations I have with Latai is the buoyant hopefulness about the potential of her work to be useful for the circulation of ideas in the Pacific region. She has a particular focus on the ecology between the artist, activist, academic and scientist, and how the artist can act as a Translated of sorts in order to make information more accessible to the general public. I ask Latai to expand on this:

How does your everyday person find a way into this very complex thing (climate change), and that's where the vehicle of making work that is image based and durational... becomes a very accessible form of building empathy, because we know we can do that through performance, we can't always do that through a scientific report.

(Island Exile) was my very first work about climate change, and where I found my solo practice and where I found the necessity to have a solo practice... this frustration about what my work is doing, what's the point of making work... understanding how I could take my contemporary dance training and align it so that it sits inside with the world of (change-making) campaigns... (addressing) our inability to access climate change and find ourselves inside the big 'what do we do about climate change'.

The function of performance, from a cultural perspective, is always about Vā, always about space, it's always about relational space. Those are the same tools as choreography and composition. When you learn about choreography and composition, you learn about space, but you don't think about it as endless connection to the past and future... time becomes the way to mark the space, mark the Vā, Vā is endless, and it's not just the physical space, it's all-encompassing space, spiritual space, the environment, our place in the environment. So, then the body becomes the

material to undo some of the Western (dance) training (and thinking) and centre the Tongan philosophy of what the body is – the body is a moment in time.

The innovation of that work, which rarely gets talked about, is the centring of another performance structure, from outside the Western canon of performance, and yet it sits so perfectly inside white art. It's so indigenous, and yet there is no sign of that indigeneity except for my body.

Island Exile is about space. In the Tongan language, Fonua means land, also burial site, placenta, and is used metaphorically for the body. The function of my body is representation of space and place. [6]

The image and the mouthpiece

Like much of Latai's practice, the striking image of her body suspended below the ice in *Island Exile* has been immortalised in documentation, photographic, video, and accompanied interviews. Latai is eloquent. Cynically, I wonder if part of the desire to ask Latai to talk about the issues that preoccupy her work is in the hope that we might not have to do the work. We might not be complicit. I wonder if it is easier to hear her talk, and watch the excerpts of documentation, than it is to sit with the performances, often durational, slow.

I asked Latai about her thoughts on documentation and if there was a frustration that her work was often viewed through the secondary document. I was interested, in particular, to hear her thoughts on *Vā* and its place in the document.

It is very difficult to find the Vā in the documentation... but I would also argue that very few people have seen the original work, that work (Island Exile) has only been performed twice, but it's one that people talk about, so in my mind, it (documentation) works... Is that frustrating? It is. But what's more frustrating is that this work is ten years old and we are still having the same conversation about climate change. That work is still relevant, that's a problem.

Oratory cultures use performance to document time. That's how I see my performance. This is when climate change was important. Or this is when the world changes in a way. The artworks say something about these times...

My view with some of the documentation, especially in terms of collections, is that the work is trying to speak to other generations. Of course, it's not going to have the same impact. But it doesn't matter. If you're a person in 40 years-time, dealing with extreme weather events and

you even get to see an exhibition (or the documentation of an exhibition) then I'll be surprised, but it's like a time capsule, because I'm deeply embarrassed for the future – that we didn't do enough. There is a complicity that I want an audience to feel as a spectator in the live, in the documentation (viewed in the future) I want the work to do something else to that audience, it's not complicity, it's to say, 'We did feel things about the future.'

(I'm interested in) using the intuitions (and their archives or collections) to hold messaging. In the same way that the old dances from my village are passed on, you learn a dance that's from that time, it's about those plants, it's about those shells or that coastline, or that family. My question is what are the dances of today that get passed on, that hold the information of this time? [7]

The only thing left is to leave

This week, on the east coast of this continent, many contemplate permanently relocating to higher ground after the second 1-in-500-year climate change-induced flood in as many weeks. This makes my decision to leave the house seem petty and insignificant. Nonetheless, I will attend my first in-person live performance event since March 2020: an event curated by Latai and Brian Fuata for the Art Gallery of NSW (AGNSW) entitled *Monumental (working title)*. I am looking forward to joining the flow of the live performances. I am craving the transformative radical joy that I feel in the presence of performance that can change my mind, move me, make me feel something...

I arrive at AGNSW and search out a programme. On the back of it is a Tongan proverb:

Fe'ofa'aki 'a kakau. 'oku 'uhinga ki ha fe' ofa'aki 'a ha 'oku mau nofo kehekehe 'I ha ngaahi motu kehekehe.

The currents of love. When the love between people is thought to travel between their islands of residence. [8]

I see Latai to congratulate her, she speaks of the currents of love that are passed from one performance to the next as the audience travels around the expansive forecourt space, following the curated bursts of activity. There really is nothing like witnessing the energetic current as it passes from performer to audience, and then onto the next performer. This is what I have missed. The ability to complete the circuit of the work – the old theatre

115

adage that the audience completes the work feels very real in this instance, or as Latai beautifully puts it, the experience of live performance is "a collective marking of time and space" [9].

What makes this event extra special is the sense of community: we have not seen each other for so long, I have my one-year-old with me and people remark they had no idea I had a child. I wonder if this community might feel exclusionary to a newcomer, but I realise that there have been very conscious steps taken by Latai and Brian to create an expansive sense of community. I ask Latai what this process looked like:

In co-curating Monumental (working title) we considered access from a variety of positions. Starting with the state gallery as a public space that may frame and hold the ephemeral work of the Sydney local independent contemporary performance community, who were enduring a particular hardship to their livelihoods due to a lack of financial support and loss of work during the pandemic lockdowns. We tried to spread our resources well with care toward the emotional and mental health of the artists.

We tried to make works accessible with the necessary inclusion of Auslan interpretation of text/ vocal based performance. [10] The QR code activated Transcending Bodies dance video by Sela Vai and Fetu Taku also included captioning. One area of failure that I could only reconcile myself to was that I had to personally wear a mask to reduce the risk for immunocompromised and vulnerable patrons to attend our exhibition of performance.

We loved presenting performance in the entrance court or the foyer – this in-between space of the gallery or theatre for connection and conversation between works. This, for us as the curators of Tongan and Samoan heritage, is also our cultural obligatory work to the Vā in creating and nurturing the relational space in between us (lifeforms), between artworks, between performances, between the culture makers and public space between colonial structures and unceded Gadigal land and waters. [11]

I would like to end with a bit of a call to arms to artists, curators, and institutions. If we are to hold the live experience of performance as one that transcends long-held views and creates new community in a collective experience of radical joy, then I would like to suggest that we need to think really carefully about how we can 're-open' in such a way that does not leave people behind. Personally, I do not only want to be curating for the 'healthy majority', I want to make sure that we can create the conditions such that people with intersectional access needs can experience the mind altering that takes place when encountering works like Latai's.

1. Latai Taumoepeau, NIRIN artists interview, https://www.youtube.com/watch?v=USdCAUXbFGE, viewed April 7, 2022.

2. Phelan, Peggy, *Unmarked: The Politics of Performance*, London: Routledge, 1993, p. 146.

3. Latai Taumoepeau and Dr Jessica Olivieri in conversation for this essay on March 11, 2022.

4. Shannon Jackson, *Social Works: Performing Art, Supporting Publics*, London: Routledge, 2011, p. 15.

5. See 1.

6. See 3.

7. See 3.

8. Art Gallery of NSW, *Monumental (working title)* programme, 2022.

9. Latai Taumoepeau and Dr Jessica Olivieri in conversation for this essay on April 20, 2022.

10. Malcolm Whittaker, *Dirty Work*, and the cancelled reading by SJ Norman of *Permafrost* and artist talk.

11. See 9.

Latai Taumoepeau

Latai Taumoepeau makes live-art-work. Her *faivā* (body-centred practice) is from her homelands, the Island Kingdom of Tonga and her birthplace Sydney, land of the Gadigal people. She mimicked, trained and un-learned dance, in multiple institutions of learning, beginning with her village, a suburban church hall, the club and a university. Her *faivā* (performing art) centres Tongan philosophies of relational *vā* (space) and tā (time); cross-pollinating ancient and everyday temporal practice to make visible the impact of climate crisis in the Pacific. She conducts urgent environmental movements and actions to assist transformation in Oceania.

CHAPTER 2

WORKING COLLABORATIVELY IN TRANSCULTURAL PRACTICES

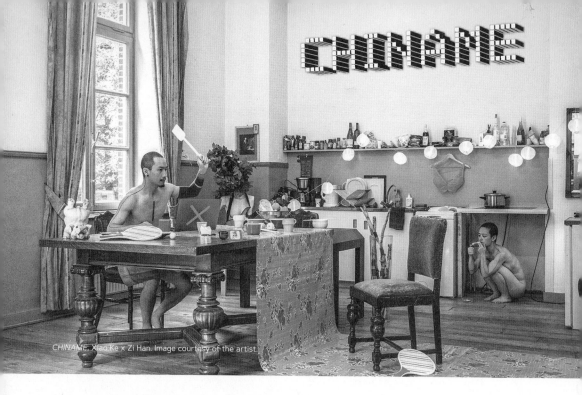

CHINAME, Xiao Ke x Zi Han. Image courtesy of the artist.

A Waffle Named 'What is chinese?'

Cheng-Ting CHEN

Translated by **Stephen MA**

"'What is chinese?' The question is a pseudo-proposition, a great pitfall."

After saying this, Xiao Ke bursts into laughter in our Zoom interview. At the current stage (in 2021), our mobility is still restricted by the pandemic. In Taipei, Shanghai, Berlin, and Dresden, we have relied on intangible and invisible conditions of the Internet to stay in touch while caring about each other's life and work. Xiao Ke, Zi Han, and I look back together at the 'theatrical production' *CHINAME* which connects with 'Chinese' with different identities who live in different parts of the world and have participated in it in various ways. The project has been ongoing for three years, and remains fluid and evolving to this day.

Xiao Ke comes from a background of dancing as well as journalism and communication, while Zi Han's expertise lies in video and visual art. They both live in Shanghai and have traveled to over 20 countries through presenting works, residency programs and various forms of exchange. Living and working under a kaleidoscope of social conditions in different places, one's contours, as well as identity, become defined. "The way people understand, talk about and contextualize our work is often related to the fact that we are artists from China. Some trivial reflections on our lives have also been accumulated over time. We thought maybe this was the time to address this Chinese subject.

Why is it titled *CHINAME*? This compound word invented by Xiao Ke can be interpreted as 'China + Me' or 'Chi + Name,' and is pronounced differently in English, German, and Dutch. In the Chinese context, it has been translated as '*Zhong Wen Ming*' (Chinese Name), as the name itself is fluid for viewers to freely interpret.

By 2021, *CHINAME* has been presented in at least three different formats: lecture-performance, documentary, and in Germany and the Netherlands, performance-exhibition. Recalling the entire process, Zi Han said, "We always adapted this work to local conditions, and nothing was planned in advance." Depending on the places they go and the conditions they are provided, this project, as well as the artistic methods of staging, varies. "I have never worked like this before," said Xiao Ke.

The initial stage

The first stage was devised during their residency program at Roepaen Podium, an art organization in Ottersum near the German-Dutch border. Living far from the city and surrounded by fields, livestock and the graves of WWII veterans for several months, they managed to seek out and interview more than 20 members of the Chinese community based in Berlin, Dusseldorf, Kleve and Riga. The first-stage video documentation was then produced. In the presentation at the end of their residency, Xiao Ke and Zi Han, as performers and guides, walked the audience through the entire venue via the enactment of dialogues and rituals. They welcomed them in the smoke-filled foyer, led them past the sound installation in the long corridor, and proceeded to give a lecture performance in the restaged dining room and chamber. In the performance, they presented an analysis of the section of their genealogical DNA test regarding what makes them Chinese and what makes the Chinese 'Chinese,' while the TV installation played their parody of the CCTV program *Xinwen Lianbo* (lit. 'News Simulcast'), in which they dressed up and acted out news items set in 2045, imagining the relationship 'China' has with the world in the future. Finally, the audience was invited to another room to watch the video documentation of the interviews. This is what *CHINAME* looked like at the very beginning.

To Xiao Ke, the performance process during this first stage presentation was quite intuitive and honest: "It was like a manifesto to launch this project. It was also probably a kind of projection. The things I believe in, my subjective opinions, my personal questions as an individual, my dissatisfactions, my resistance against the West, as well as my resistance against myself and the so-called 'identity' – all of these were assembled into ironic and absurd acts. That's how I sum it up." As for the fictional *Xinwen Lianbo* video used in the performance, Xiao Ke explains, "We borrowed from Lu Xun's way of mocking; we wanted to come across as being ironic and aggressive, but we actually weren't. We acted like big men in that video performance, and that had something to do with a specific context. Because CCTV's *Xinwen Lianbo* has that sense of absurdity about it, that video also marks our life trajectory. This was how we resisted and what we wanted to convey." Xiao Ke adds, "But what is resistance? Resistance, to a certain degree, is something that requires caution and discretion. Sometimes when we move forward, we might end up acting in the same way as the enemies that we criticize. And this is dangerous."

They first of all needed to confront the scrutiny of foreign and heterogeneous cultures in a town on the border, they had to offer up their 'selves' before returning to their 'Asia.'

Documentary films

After the first presentation of *CHINAME* in Europe, Xiao Ke and Zi Han continued collaborating on several projects in different cities and took the opportunity to visit Taipei, Bangkok, Penang, Guangzhou and Tokyo, as well as Melbourne and Canberra, where they eventually filmed a total of 150 interviews with 'local' Chinese. The materials were edited into four documentaries with different themes: *You?, Relationship, Chinese?* and *Portraits.* These have been screened or live-streamed publicly at the 2019 Taipei Arts Festival and 2021 Stadt.Raum.Fluss. fetsival held in Hellerau, Dresden.

How did they go about making the documentary films with such extensive materials in terms of selecting, grafting and shaping?

As the primary editor that deals with the visuals, Zi Han describes, "(The films) finally formed an impression and essence. This was the shared and collaborative understanding between Xiao Ke and me. At first glance, it seems like we didn't edit them, but at the same time, each interview has an interesting connection to one another with a touch of humor, while also basically keeping the interviewees' messages integral in the footages, rather than editing and taking their words out of context as is done in directed storytelling."

"The subjective consciousness of an author was there since the beginning, without a doubt. Even if the subjective consciousness acted in a non-subjective way, that was still the subjective consciousness of the author at work. But if you were to ask whether I edited interviewees' words into montages to form a certain narrative, then I certainly did not."

Therefore, neutrally speaking, they have become 'art-ificial' documentaries.

Traveling around cities with different cultures, communicating through English and/or Chinese, processing the life experiences of 150 individuals, transcribing every single word said during the interviews, and reviewing all

the videos in the editing process, the voice and emotions of every interviewee remain distinct and vivid in the artists' minds. These have been the most powerful artistic materials of the *CHINAME* project. Xiao Ke eventually discovers an overturning aspect: "It's undefinable. The question 'what is chinese?' is a pseudo-proposition. The initial questioning has been dismantled by each individual's manifestation of life. It's clear that we created this project for these community members rather than defining what they are. It's like a waffle: this piece of pastry is called 'what is chinese?' Put it into a bag and squash it, and there will be many fragments and crumbs, but not any one of them can represent the whole. Those fragments, regardless of how you put them together, cannot be joined into a singular waffle again. That is what it feels like."

Site-specific lecture-performance

In summer 2018, the artist duo was invited to participate in the ADAM in Taipei. In addition to screening parts of the documentary films, they also developed a new lecture-performance and premiered it to arts professionals from across the Asia-Pacific region and beyond. Later, they presented the lecture-performance in Hanover and Macau, and of course, each iteration was adapted for local conditions. So, what was featured in the context of Taipei?

Xiao Ke recalls, "In the performance there was an interaction with audience members about 'defining Chinese.' That question immediately aroused tension. The more the questions provoked, the more the audience debated among themselves. This situation would have happened only in Taiwan. My most vivid memory is of the crowd surrounding us after the performance and bombarding us with their questions and opinions – I can still feel and picture it. *CHINAME* is not a project that serves politics exclusively. Once the question of 'what is chinese?' pops up, it becomes a mirror, reflecting what is extremely sensitive and most painful."

ADAM 2018 and the 2019 Taipei Arts Festival mark the most intimate moments this project has shared with Taiwan. The process was highly intense not just because Xiao Ke and Zi Han are Chinese, but also because of their identities and practices as artists whose works deal with social conditions and situations. The sincere exchange 'onsite' is always the most important happening.

Montaged Q&A and flashback

Lastly, I have edited the inconclusive *CHINAME* into rapid fire questions, summarizing the artists' reflections thus far below.

Was there ever any confusion?

Zi Han: *What I have always been confused by is how important this 'identity' is. Is it worthy of discussion? This might be the most fundamental (question) I have for this project. One interviewee in Dusseldorf left a very strong statement. She is a young Chinese girl, and her perception was clear: "I am German. Although my parents came from Guangdong, I grew up in Germany and don't even speak Chinese. I only know a little Cantonese." She has no confusion about her identity. The confusion is imposed on her by society – because of her Asian face and the fact that her parents are Chinese, people tell her, "You are Asian," but she doesn't have this dilemma herself.*

Xiao Ke: *When it comes to collective crises that threaten the existence of communities, this so-called 'identity' that has constantly troubled you seems to disappear suddenly. As an individual from the PRC who is independent and does not represent any institutions, I should have nothing to feel confused about while meeting members of Chinese communities living abroad, should I?*

How can fluidity be a norm?

Xiao Ke: *This project radiated from me, and my surroundings have become a precious and valuable archive. Initially, I wanted to present it in a theater setting, but it has grown into different things in different forms and regions. At first, I thought I was a citizen of the world, and now, I feel like I am a part of the world. Where are you from? Where are you now? I experienced the helplessness of being crushed by overwhelming global trends, and it was because I was too 'me.'*

Zi Han: *The most helpful and influential of this project was that I learned to deal with the diversity and fluidity of life and things in general, as well as to accept them for what they are, whether they change or not.*

Now?

Xiao Ke: *Now, this project has been paused. I cannot continue. The involution is too much. The pandemic has divided the world, and it has become very clear that there is too much*

to process. Of course, I still participated in projects via remote formats, but they didn't make me feel connected. Over the past year and a half, I have gained a brand-new understanding of the different regions within China. I visited many rural villages and observed the daily lives of several local communities. This country is too vast in terms of size, complexity and various other aspects. So, I have discovered that while I have been proudly identifying myself as a global citizen who is connected with the world, in reality, I do not know anything about the place I live in. I began to pay attention to these domestic events (in China), and I really had no choice. What exactly does this root and lineage have to do with you? It is more than just a piece of DNA data and what it represents, and you really have to get out of the house and expose yourself to the land – hold the red, yellow and black soil in your hands, meet the people and see how they live – rather than live in places like Taipei and Shanghai forever. I have been disconnected with the land for too long.

Future?

Zi Han: We hope that we can interview more friends in China. Most of the people we interviewed are living overseas, and the different geographical contexts result in different perceptions. So, I still look forward to this. If we got to do it again, these interviews could be held across China; they would also be young people, with different professions and backgrounds, bringing voices different from those overseas. This is actually very important for investigating the tensions and relations in between.

Xiao Ke: When I paused CHINAME, I also prepared to face the drastic changes that would come once we start again, be they related to my own ideas, the environment, or other aspects. How should I continue? Sometimes you just need that spark – an unexpected event, an emotion, or something that will relight the fuse of CHINAME – and then we will do it. That's the way it'll go until it's reactivated.

Xiao Ke

Born in Kunming, Yunnan, Xiao Ke studied in Shanghai, where she also currently resides. She has been pioneering the way for performance art as physical art and contemporary social theater that alludes to the reality in today's China. Xiao Ke has developed various artistic forms that are no longer limited to the theater. She was the recipient of the ZKB Award at Zurich Theater Spektakel in 2006.

Zi Han

Zi Han is a theater artist, performer and audiovisual artist. The scope of his work includes, but is not limited to, contemporary theater, photography, sound and video. A member of ZuHe Niao, an independent artist collective in Shanghai, he has been collaborating with Xiao Ke since 2011, focusing on the individual body and the possibilities of expression in the public environment.

Down the Garden Path: The Work, Origin and Legacy of *Paeonia Drive*

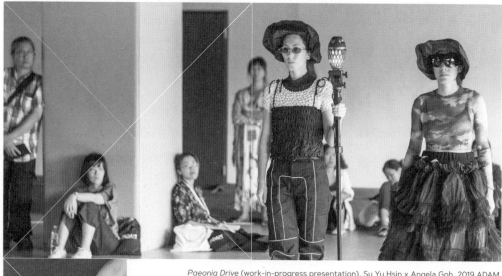

Paeonia Drive (work-in-progress presentation), Su Yu Hsin x Angela Goh, 2019 ADAM. Image courtesy of Taipei Performing Arts Center. Photo by Pi-Cheng Wang.

Anador WALSH

Work

I first encountered Angela Goh and Su Yu Hsin's *Paeonia Drive* in August 2020. Melbourne was responding to the emergent COVID-19 pandemic with its second long-haul lockdown (which lasted 111 days). It was 6:23pm and I closed the nine work-related tabs I had opened, unplugged my laptop from my monitor and threw it gently on my bed beside the notebook that was already lying there. I grabbed a cup of tea, a green apple and a 'healthy' cookie from the kitchen before walking the two or so meters back to my room. I sat down on my duvet, curled my knees to my chest and punched 'BLEED', 'Paeonia' and 'navigation' into Google. While the page I had selected loaded, I opened Gmail, clicked on Google Drive and opened a document I had stored there titled 'PD BLEED notes'. I scanned it and re-entered my original tab as an eerie, game-like soundtrack swelled and the *Paeonia Drive* navigation began.

This iteration of *Paeonia Drive* was presented in 2020 as part of BLEED (Biennial Live Event in the Everyday Digital), a collaboration between Arts House, Melbourne, and Campbelltown Arts Centre, Sydney. BLEED is an ongoing project, conceived prior to the pandemic, for the purpose of exploring the conflation of 'live' art with the digital. Initially planned as a tandem IRL (in real life) and online event, BLEED was forced by COVID-19 to 'pivot' into being purely digital in order to deliver its 2020 programme. *Paeonia Drive* employs the garden as a metaphor for the ways that our behaviour is choreographed in online spaces, and is an experiment in digitally mediated performance. In a BLEED Curatorial Digest held online, Goh and Su spoke of their original intention to use mirrors and screens as interfaces, to mediate their interactions with one another and their interactions with an audience during an IRL performance. When COVID-19 made this unfeasible, they reframed the presentation of this work, creating a 360-degree view, scrolling website, composed of 3D scans of plants, objects and the performers' bodies; text and internet sourced videos, to house and communicate the research underpinning this project. The digital landscape of *Paeonia Drive* could be explored two ways: by navigating the space yourself, or tuning in for a guided navigation, described by BLEED as a "live-streamed desktop performance". I did both.

Set against a background reminiscent of the colours of a tequila sunrise, *Paeonia Drive* is a carefully cultivated and manicured digital garden with clear aesthetic ties to *Grand Theft Auto*. The 40-minute guided navigation unfolded

like a duet between Goh and Su. The artists lead me down the garden path of their online world, "forcing your view towards the horizon where perspective crashes". Throughout the performance, what I encountered were shifts between the *Paeonia Drive* website, the artists' own internet browsers and footage of them performing. This performance footage, shot from multiple angles, depicts Goh and Su interacting through the intermediaries of screens and mirrors: Su, using a smartphone, films Goh wrapping her arms around a screen mounted on wheels; later, Su touches Goh's face as she caresses an avatar of herself, displayed on a screen, lying on the floor. Self-navigating *Paeonia Drive*, I was able to reorientate my perspective between a god's eye, bird's eye and groundless view and orbit the space. A drone hovered amongst a series of digital objects which, when clicked, opened up windows into Goh and Su's research. I selected the climbing vine and found myself exploring the Gardens of Versailles. I hovered over the road and was shown an aerial view of a large traffic intersection and I touched a hand and watched a drone dog run across a field. In the centre of this landscape, a karaoke screen displayed the text: "gardening is an activity of growing and maintaining the garden."

Goh and Su's *Paeonia Drive* emphasises the pervasive control of surveillance capitalism and the way in which it organises power relations. By engaging, either through the guided navigation or independently, with the three key aspects of this work: point/perspective, screen and the garden, I was made increasingly aware of the power structures inherent in this work and contemporary existence. The artists' situating of *Paeonia Drive* within the familiar frame of a website and allowing the audience/participant to orientate themselves, as well as to choose their own adventure, holds a mirror up to the ways that our computers and smartphones codify our behaviour. *Paeonia Drive* mediates experience through the technological interface and the choices made when moving through the space: the perspectives you employ, the directions you move in and the objects you select. This mediation creates a moment of encounter between the work and its audience, in which the audience becomes both an observer and a producer of the work. This experience mirrors the way we labour every day under neoliberalism, creating and disseminating images, endlessly scrolling, always watching and being watched.

Origin

In an interview held via Google Meet on the last day of Melbourne's sixth

COVID-19 lockdown (which lasted 82 days), Goh and Su unpack for me how *Paeonia Drive* came into being. They tell me that *Paeonia Drive* has its origin in a premonition of sorts: "I can see you and Su working together in the future," Justin Shoulder uttered to Angela Goh late one night during the 2018 edition of ADAM Project. Shoulder and Goh, both Australian artists, were in Taipei for the ADAM Artist Lab and it was there that they met Berlin-based Taiwanese artist Su Yu Hsin. The ADAM Artist Lab of that particular year brought together a group of 16 participating artists for a period of three weeks, during which they lived together (some in rooms accommodating as many as five people) and attended three to four daily workshops presented by other participants and outside practitioners. The curatorial framework underpinning this iteration of the ADAM Artist Lab stipulated that rather than sharing their previously performed work or collaborative experiences, the artists instead shared their practice with the group by facilitating a workshop. Rather than charting connections and overlaps in interest by conventional means, this approach meant that they had to actually show one another how they work. Su facilitated a cognitive mapping exercise for the group and Goh had them form an imaginary dance company.

Though still structurally a work in progress in 2018 (this was only ADAM's second year of running), it was understood by Goh and Su that, over the course of this residency, they were expected to find someone to collaborate with and work towards producing something to share. Originally, they were working through the ideas that would come to form *Paeonia Drive* with Justin Shoulder. When I ask how this collaboration began, Goh tells me that rather than the workshops facilitating this, it was "more the interstitial spaces where we could actually have conversations about art," like walking between venues, eating lunch or over WhatsApp, that this working relationship was cemented. Towards the end of the residency, a psychic presented a workshop to the whole cohort, and they decided to let him choose who should work with whom. However, due to the strength of the bond formed in these in-between moments, Goh, Su and Shoulder peeled off from their assigned groups to explore the common threads of inquiry they had found between their practices and to try to make something from these overlaps. These overlaps were charted in another cognitive mapping exercise, this time just between these three artists. Instrumental to this early stage of *Paeonia Drive* was a floral arrangement workshop the three had participated in, computer accessories they had found in a nearby market and conversations they were having on the ways that nature is controlled and regulated through technological means.

This version of *Paeonia Drive* differs substantially from the one I experienced in 2020, both aesthetically and in the ways that it prioritises the core concepts of the work. This is largely due to Shoulder exiting this collaboration shortly after the 2018 ADAM Artist Lab in order to pursue another project with a conflicting timeline. Following this, Su and Goh returned to Taipei in 2019 to participate in ADAM's Kitchen program, which they describe in our interview as following a more conventional residency format. Over the course of three weeks, the two undertook an intense period of independent and collaborative research, pooling their findings. Both drew references from a broad spectrum of sources and disciplines: Goh explored strategies for choreographing interactions between performers and audiences, while Su experimented with ways of installing a video so as to allow an audience to both see and be seen. Central to this period of *Paeonia Drive*'s development is the phrase "a gardener's vision of war", taken from the essay *The Gardener's Vision of Data* by Os Keyes, which uses the violence through which a garden is ordered and maintained as a metaphor for data surveillance. This period of development culminated in a work-in-progress (WIP) shown in Taipei that plays with screens and mirrors as means of mediating the audience and the image. The recording of this performance was presented as part of the BLEED *Paeonia Drive* navigation in 2020.

Su tells me that this WIP performance was only 20 minutes long and that it was her and Goh's intention, as a next step, to expand this work into a longer production. This stage in *Paeonia Drive*'s evolution was to include further work on installation and staging, experimenting with movement practices, front and backstage logistics and incorporating more performance elements. This process was begun in 2018 when Su travelled to Sydney, after ADAM Artist Lab, as part of a Performance Space [1] residency and would continue in early 2020, during the height of the bushfires then plaguing Australia, at a production residency Goh and Su undertook at Campbelltown Arts Centre (CAC). It was through CAC that *Paeonia Drive* would become part of the 2020 BLEED programme. After Su returned home to Berlin, she and Goh continued developing both the IRL performance and digital components of *Paeonia Drive*, which they frame in our conversation as being an ongoing research project that takes on and incorporates new elements specific to the location this work is going to be presented in.

When I probe what they feel had changed or was lost in the 2020 presentation of *Paeonia Drive* for BLEED, as a result of COVID-19 restrictions

inhibiting an in-person performance, Goh tells me that as they were already toying with scanning their heads and shoulders into digital space, "it wasn't a big compromise or pivot per se, but more like another chance to continue this research in another way." In working to present *Paeonia Drive* in a purely digital capacity, Goh and Su were able to delve deeper into the work's conceptual framework and use point/perspective, the screen and the garden to explore the ways in which an audience can be, and by virtue is, choreographed in digital space. This is most evident in the 2020 *Paeonia Drive* navigation, in which Goh carefully controls the way in which the audience scrolls through and experiences digital space and encounters her and Su's research.

Legacy

Since meeting three years ago at ADAM, Goh and Su have continued to collaborate, most recently on *Tidal Variations* (2021), a new work for Sydney Opera House, Sydney, and the Taiwan Contemporary Culture Lab (C-LAB), Taipei. *Tidal Variations* continues these artists' interest in the power structures that underpin and construct digital space and our existence therein. This 14-minute-40-second video work is conceptually grounded in ideas of water, light and wetness. The pandemic experience of encountering the world largely through windows (both digital and physical) was the starting point of *Tidal Variations* and informs the framing of the camera work. Su describes it as looking at the "wet mechanics of seeing, how we perceive an image and how this data has been transferred through undersea cables, across ocean floors to our screens". It explores the way that water mediates our digital experience and the physical infrastructure of the Internet, which Su says, despite the notion of everything being in 'the Cloud', is made up of "things you can kick". This infrastructure, as it relates to digital experience in Australia, is deeply colonial and follows imperialist trade routes. As Goh and Su talk me through *Tidal Variations*, I find myself switching between our video call and a series of new tabs I am opening out onto veins of their research: the weather forecast website windy.com; a Wikipedia article on the All Red Line, the system of electrical telegraphs that at one stage linked the whole British Empire, and the Sternberg press web shop page for *Against the Anthropocene* by T.J. Demos. When our conversation ends, I close out of Google Meet and find myself in much the same position I was in when I first encountered *Paeonia Drive* over a year ago, navigating a digital space that has been choreographed for me by Goh and Su.

1. Performance Space is the long-term partnered institution of ADAM.

Su Yu Hsin

Su Yu Hsin is a Taiwanese artist and filmmaker currently based in Berlin. She approaches ecology from the point of view of its close relationship with technology. In her film and video installations, her artistic research reflects on technology, ecology, and the critical infrastructure in which the human and non-human converge. Her analytical and poetic storytelling focuses on map-making, operational photography, and the technical production of geographical knowledge.

Her work has been exhibited at the Centre Pompidou-Metz, Museum of Contemporary Art Busan, 2020 Taipei Biennial, ZKM Karlsruhe and Haus der Kulturen der Welt, among others.

Angela Goh

Angela Goh is an artist who works with dance and choreography. Her work is presented in contemporary art contexts and traditional performance spaces. Most recently, Goh's work has been performed at the Art Gallery of New South Wales, the National Gallery of Victoria, Sydney Opera House, and a range of venues in Australia, Asia, Europe and North America, including Performance Space New York, Shedhalle Zurich, Baltic Circle, Auto Italia, and Arnolfini UK. She was awarded the Keir Choreographic Award in 2020, the Create NSW Performing Arts Fellowship in 2019-20, and the inaugural Sydney Dance Company Fellowship in 2020-21. Angela Goh lives and works in Sydney, Australia.

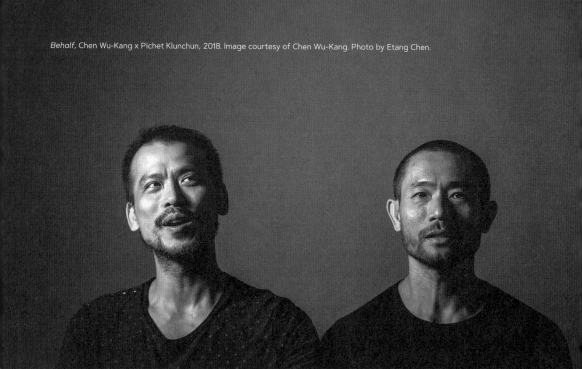

Behalf, Chen Wu-Kang x Pichet Klunchun, 2018. Image courtesy of Chen Wu-Kang. Photo by Etang Chen.

Behalf: Chen Wu-Kang and Pichet Klunchun's 'Non-Western-Centric' Transcultural Performance [1]

I-Wen CHANG

Translated by Elliott Y.N. CHEUNG

Behalf, premiered in 2018, is an experimental dance work born out of the collaboration between choreographers Chen Wu-Kang from Taiwan and Pichet Klunchun from Thailand. The first half saw the artists performing routine motions from daily life, followed by a 'faux' 'post-show talk' for which Chen brought a chair onto the stage and invited the audience to ask questions. Some spectators departed during this 'post-show talk,' unaware that it was part and parcel of the performance itself. In the final part of the presentation, Chen walked into the auditorium and handed an audience member a placard at random. The chosen spectator was asked to hold on to the placard, and the performance officially ended the moment they decided to raise it in the air.

The encounter between Chen and Klunchun

Chen and Klunchun's first encounter dates back to *Men Dance* by Novel Hall in 2007. However, it was only when Klunchun returned to Taiwan by invitation of the Taiwanese Ministry of Culture as part of Taiwan's New Southbound Program that the two truly began to connect. While visiting Chen's Horse Dance Theater, the two got to know each other; at that time, Klunchun's daughter was four years old, and Chen was awaiting the birth of his daughter with his artist wife Yeh Ming-Hwa, who was three months pregnant. The two talked about family and children, but not a word about dance. Chen says, "Klunchun looked very calm. That year, I was going to attend a Chan session with Ming-Hwa, which prompted me to ask him about his religious practice." [2] In the course of their conversation, Chen learned about Klunchun's deep-rooted connection with traditional culture, including the fact that Thai men would all take monastic vows at least once, or that Buddhist culture is a part of daily life. Chen believed that he was not familiar with his own cultural traditions, "so I thought whether I could collaborate [with Klunchun] and find a way to see myself, as well as the possibility of traditions, in a new light through their strong [Thai] cultural tradition." [3] This discussion became the spark for their later collaboration.

Later, with the support of the Ministry of Culture's *Jade Project*, Chen sent a Facebook message to Klunchun, inviting him to visit Taiwan again, but he "wasn't sure what we were going to do". [4] In fact, everything began from getting acquainted, and the specifics would come as they went along. At the time, Chen was reading an article about cultural interaction studies, illustrating how human history consisted of innumerable cultural interactions. [5]

137

Thus, he thought to search for his own history through dance. The two met once again in Taiwan in 2016, and three weeks later presented *The Tradition of the Body* at Treasure Hill Artist Village. After the performance, Chen Pin-Hsiu, then Head of the Archives at Cloud Gate Dance Theater, sent a message to Chen: "Will you continue to develop *The Tradition of the Body*? What are your future imaginings regarding this project?" By then, a camaraderie had gradually developed between Chen and Klunchun, and the duo decided to meet in Thailand to continue developing the work. They also sought out Tang Fu Kuen, the Curator of Taipei Arts Festival (2018-2022), to be their dramaturge. Incidentally, this would sow the seeds for their performance *Behalf* at Cloud Gate Dance Theater.

Chen and Klunchun both expressed that their creative process consists mostly of conversation and dialectical examinations into their own thoughts. As Klunchun puts it, "Because we do too much dancing, why don't we discuss how it is we create dance, or else discuss the underlying meaning behind a produced or created work?" [6] Meanwhile, Chen believes, "We're already this far along in our years, so we couldn't possibly choreograph for each other. Rather, all communication is founded on being considerate of the other person, with the mutual understanding that we're both very busy." [7] It was so that two mature choreographers came to collaborate through the method of deliberation, and the final title of the work evolved from *The Traditions of the Body* to *Behalf*.

From 2017 to 2019, the two studied Thai, Cambodian, Indonesian, and Burmese traditional classical dances through fieldwork visits, the inspiration of which came from the Indian epic poem *Ramayana*. This myth was disseminated far and wide throughout Southeast Asia, influencing the development of classical dance in various places. Chen hoped to examine the connections and contemporaneity of Asian dance through this epic poem. They conducted rehearsals with local masters such as Ajarn Chulachart Aranyanak (Thailand), Sophiline Cheam Shapiro (Cambodia), Sardono Waluyo Kusumo (Indonesia) and Shwe Man Win Maung (Myanmar). During the course of their fieldwork, they visited historical sites, collected archival materials, and studied the masters' movements.

In their collaboration, Chen and Klunchun both coincidentally reconsidered their own cultural traditions and identities, using it to challenge the performance ecologies each of them faced. However, their lines of

questioning differ: Klunchun is concerned with how to transform a classically trained body into a new body under contemporary choreography through a reflection on traditional dance, while Chen is interested in the identity of the Taiwanese people.

Klunchun's dance identity is diverse; in Thailand, he is seen as a contemporary choreographer, but when touring overseas, he is frequently advertised as a dancer of Khon, the Thai classical dance. Khon illustrates the story of the *Ramakien* (the Thai adaptation of the Indian epic *Ramayana*), and has been identified as an intangible cultural heritage by UNESCO. As part of royal rituals and important national ceremonies, Khon has become a Thai classic tradition; through a Khon performance, the shared identity of the Thai people is not only sustained, but also linked with the values of the royal family. It is because of this that Klunchun believes it is necessary to revisit and reflect on tradition.

As for Chen, as a third-generation descendant of Mainlanders who moved to Taiwan after 1949, he intends to search for his own Taiwanese identity through dance. He had previously received ballet and modern dance training; compared to Klunchun, Chen's body does not intend to 'resist tradition' because he himself is not completely sure of the 'Taiwanese tradition' in which he was raised. Because of this, he began to explore different dance traditions as a sort of contemporary choreographic strategy, responding to his 'rootless' bodily situation as a Taiwanese.

A dual rebellion through dance

Chen and Klunchun both made attempts to turn away from their own 'traditions' (dance training), which can be seen clearly in the opening of *Behalf*. Klunchun arranges, plays with, and even kisses his props, such as a helmet used in Khon. However, Klunchun's movements gradually transform from traditional dance vocabulary to daily movements, conveying a message of diverging from tradition. Opposite from Klunchun, Chen begins with his arms outstretched (akin to the extension quality in Western dance aesthetics), his hands extended into a cruciform shape (hinting at symbolism in Western religions). He then uses his limbs, generating movement from his hands, wrists, feet, back, neck, and chest, to connect the extremities of his body through live sounds such as clapping and stomping, displaying a conscious sense of getting to know his own body. At the end of the performance, he

rolls into a small, fetus-like position, seemingly suggesting his self-revelation of having left behind his own ballet training.

Behalf is subversive on many fronts; first, it breaks down the tiered relationship between performer and audience (as when giving the audience the power to end the performance); further, it is non-narrative, a choreography that rather hews to a conceptual structure, as in the 'performed' 'post-show talk' discussion, and an ending decided by the viewers. These all suggest a non-narrative, conceptual choreography, and attempts to establish a new kind of relationship with the audience.

In the creative process, the two artists also sought an egalitarianism in dance through their experimentation. As discussed previously, the content of the performance was defined by the audience. Secondly, through several formal settings, the choreographers stressed the equality between each other, such as how they were to have equal stage time. Klunchun says, "We were focused on how to balance our power relations and tried to be as egalitarian as possible. This includes the equality between two cultures as well as two people on stage dancing a duet. Because of this, we were intentional about using a timer. Three minutes per person." [8] Aside from this, when one was performing, the other would stand in the corresponding spot on the other side of the stage. There was also the spatial exchange between the fluid and the static. Along with the implication of the English title, *Behalf*, of 'who can speak on whose behalf,' these all manifested the desire for proportionality and egalitarianism.

According to Klunchun, contemporary dance places greater emphasis on democracy than traditional dance. He says, "When appreciating traditional dance, the audience applauds at the conclusion, and that's that, because tradition is part of the ruling class. However, in the contemporary concept of democracy, there can be mutual exchange of thoughts and concepts between the dancer and the audience, or even between the government and the society." [9] Therefore, Klunchun particularly brought up that nobody has the one correct answer when it comes to contemporary dance, because each dancer is an individual independent of others.

A non-Western-centric intercultural performance method

What surprised Chen was that, at the start of the project, many in the Taiwan

dance community were skeptical. "They asked me, what exactly do you want out of Southeast Asian dance?" [10] On some level, this seemed to imply that, with cultural exchange between Taiwan and Western countries having become more frequent, the preconceived notion when it comes to transcultural performance is that only working with the West ought to be seen as meaningful 'international collaboration.'

In view of this, the collaboration between Chen and Klunchun could be arguably seen as a critical response to the intercultural piece, *Pichet Klunchun and Myself*. This work was collaboratively choreographed by French artist Jérome Bel and Klunchun in 2004. Under the binary construct of 'East versus West,' it successfully assisted Klunchun in making a splash on the international stage. However, this work extended "the stale stereotypes of East and West," [11] and was criticized for having overlooked the inequality between the political and economic backgrounds of the two artists. [12] In comparison, the investigations into Southeast Asian dance in the collaboration between Chen and Klunchun provides new imaginings for contemporary dance under the concept of decentralization, as well as a new method of practice.

Chen and Klunchun broke down the norms of 1990s 'intercultural performance,' escaping the Eurocentric collaborative mechanisms thereof and entering into the surrounding regions of Asia directly, conducting research and experimentation locally. Understanding one another's inter-Asian cultures and societal conditions has enabled them to accept one another's histories, as well as liberating new identities from their traditions. From the perspective of Asian colonial history as well as the 'similarity' between peripheral identities, these artists with shared experiences, under the pretext of mutual respect and curiosity, challenged the hegemonic canon of intercultural performance. They propose a 'non-Western-centric' intercultural performance method, opening a dialogue in Asia that transcends Eurocentrism, as well as contemporary dance norms. Through their contemporary choreographic strategies, Chen and Klunchun emancipate the body from traditional cultural conventions and colonial apparatuses, thereby illustrating up-to-date corporeality and speculating the 'in-between' state of 'encounters' through diversity.

1. A portion of this article has been adapted from the discourse of the author's conference paper, "Dancing me to the South: On Wu-Kang Chen and Pichet Klunchun's Inter-Asia Choreography," presented at the Inter-Asia in Motion: Dance as Method conference, with additional new interview data. For more academic analysis of the Chen-Klunchun collaboration, please see: Chang, I-Wen, 2022, "Dancing me from South to South— On Wu-Kang Chen and Pichet Klunchun's Intercultural Performance," *Inter-Asia Cultural Studies: Movements* Vol. 23 No. 4 December 2022. Special issue: Inter-Asia in Motion: Dance as Method.

2. From an interview on Oct 29, 2021.

3. Please see "Lecture Notes: Out of America, into Europe? Or else, Southbound? The Choice Faced by Contemporary Dance International Exchange." https://pareviews.ncafroc.org.tw/?p=26500

4. See 2.

5. Chen, Hui-Hung, 2013, "An Introduction to Cultural Interaction Studies," *NTU East Asian Culture Studies Vol. 1.* http://140.112.142.79/teacher/upload/Final.pdf

6. From an interview on Oct 28, 2021.

7. See 2.

8. See 6.

9. See 6.

10. From an interview on Oct 7, 2021.

11. SanSan Kwan, 2014, "Even as We Keep Trying: An Ethics of Interculturalism in Jerome Bel's Pichet Klunchun and Myself," *THEATRE SURVEY* 55(2), pp. 185-201. DOI: https://doi.org/10.1017/ S0040557414000064

12. Susan Foster, 2011, "Jérôme Bel and Myself: Gender and Intercultural Collaboration," in *Emerging Bodies: The Performance of Worldmaking in Dance and Choreography*, Klein Gabriele and Noeth Sandra (eds.), pp. 73-82, Bielefeld: Transcript Verlag.

Chen Wu-Kang

Chen Wu-Kang was born and raised in Taiwan. He began studying dance at the age of 12 and graduated from the Taiwan University of Arts. In 2001, Chen danced with Ballet Tech and Peridance, becoming a soloist and starting his long-term collaboration with choreographer Eliot Feld. In 2016, he began an intercultural/dance dialogue with Thai master Pichet Klunchun. *Behalf* premiered in 2018 and toured in 2019. Meanwhile, the duo also worked on the three-year project *Rama House*. His recent online streaming works include *Thank You So Much for Your Time* (2019), *Thank You For Staying Home* (2020) and *14* (2021 da:ns festival, Esplanade, Singapore).

Pichet Klunchun

Pichet Klunchun bridges traditional Thai Classical Dance language with contemporary sensibility, while keeping the heart and wisdom of convention. He trained in Thai Classical Mask Dance, Khon, from the age of 16 with Chaiyot Khummanee, one of the best Khon masters in Thailand.

Pichet has earned domestic notoriety for his efforts in contemporizing Khon. He has participated in many world-class international performing arts festivals as a solo artist. In 2010, he founded Pichet Klunchun Dance Company in order to create pure art performance and to train professional dancers with strong Thai classical dance backgrounds. Since 2010, the company has continuously presented its works in international dance festivals in North America, Europe and Asia with the productions *Nijinsky Siam, Chui Chai, Black and White, Tam Kai, Dancing with Death* and *Bird*. Recently, the company premiered its newest work, *No.60*, in Japan at TPAM 2020.

143

Bound Together: Luke George and Daniel Kok's Collaborative Artistic Practice

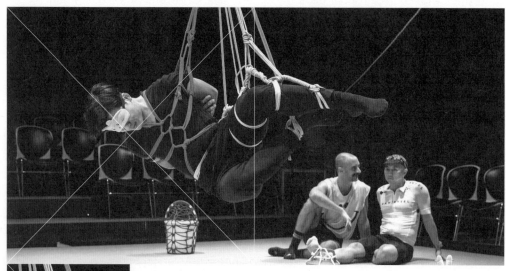

Bunny, Luke George x Daniel Kok, 2019 Taipei Arts Festival.
Image courtesy of Taipei Performing Arts Center. Photo by Hsuan-Lang Lin.

Betty Yi-Chun CHEN

Translated by **Cheryl Robbins**

In 2019, I saw Luke George and Daniel Kok's *Bunny* at the Huashan Umay Theater during Taipei Arts Festival. I remember how the noise from the concert- and cinema-goers outside just vanished as I stepped into the venue. An air of tranquility and attentiveness filled the space which was immersed in a soft bluish white light. George was suspending Kok in the middle of the performance space as the audience sat and watched quietly. Around them, objects (stuffed animals, pillows, an electric fan, a vacuum cleaner, etc.) wrapped in fluorescent ropes appeared to come to life in these psychedelic colors. During the performance, the duo interacted with the audience, tying up several audience members to different extents. The spectators also helped bind or untie them. This was interspersed with high-energy dance moves. Intimacy, temptation, desire, consent, and amicability circulated within the space. There was so much to see that two hours went by without me realizing.

In retrospect, this was what struck me most in the performance: it was as if the many tensions and relations circulating in the air could be seen and savored. Responding to my positive feedback, Kok explained, "I dare to say by the time it reached Taipei, it was ready." That was already the fourth year of their tour. Having collaborated since they met in 2014, George says that *Bunny*,[1] their first project together, marked his creative watershed. I wanted to ask them about their process, how their collaborative partnership developed, how they changed each other's works, and how the performance I saw came into being.

Exploring ways of equal collaboration

George and Kok were introduced to each other by Emma Sonders, curator and choreographer at the Campbelltown Arts Centre in Australia. However, Sonders left in 2012 before an exchange could happen. Although the center continued its administrative support, without a curator, the artists had to find a collaborative path that responded to their respective needs on their own. This was also related to their exploration of an equal relationship. "At that time, I wanted to be quite rigorous about what you mean by collaboration, like equal collaboration is actually quite uncommon," said Kok.

They decided on a double-bill program, in which each presented a solo, creating, in this way, a 'meeting on stage.' After the presentations, they held a discussion with the audience to talk about each other's works. In George's performance, *Not About Face*, participants wore white robes that

covered their entire bodies except for their eyes. Following the performer's instructions, they were moving and uttering sounds collectively, forming various relationships with each other through their bodies. Meanwhile, Kok presented *Cheerleader of Europe*, in which the artist employed the mechanisms of cheerleading in audience interactions to provoke thought on the differences and noises within the European Union against the backdrop of its debt crisis.

"A solo person holding a communal space, making the audience very aware of each other," Kok recalled what he saw in George's work back then, and this aspect quickly resonated with him. For a long time, Kok had been looking for such a figure who could moderate the relationship with the crowd. Before cheerleaders, he had also looked into pole dancers. Within agreements of audience-performer interactions, Kok sought out the protocols for forming temporary communities and explored its correlations with mechanisms that formed social and political groups. This attention to the dynamics in spectatorship brought the two artists together. At the same time, they explored various work distribution possibilities, probing into what it meant to 'team up.' George recalled their point of departure, "If one person can do it, why do we need two? How can we push each other further, to be more open?"

He told me that their initial discussions were often intense, lasting up to 12 hours. They exchanged thoughts on spectatorship, collectivity, and participation; they also talked about experiences of sex, dating, and dancing in nightclubs. They agreed upon rope as their medium very quickly. Rope is often used as a trope to signify relationality (in their *Knot Notes*, several examples are named, such as "keeping one in suspense," "building strong bonds," "unraveling the mystery," etc.). [2] It also connects Kok's pole dance training and George's massage practice, as well as their mutual interest in investigating the flow of desire among performer and audience.

"If it's a tactile sensation, how is that translated to the people who are only gazing? How can we not be attracted to the kind of sensationalist bondage and break it down in relation to what we know as theatrical experience?" Kok commented further on how the choice of rope triggered their work. At the same time, rope provided an equal starting point. The two of them could start learning a technique together that was new to both of them and step out of their comfort zones.

From collaboration to spectatorship

It is hard not to notice that this creative partnership did not start with a comparison of Australia and Singapore or cross-cultural discussions commonly seen in international exchanges. They told me, as neither of them was in their home country back then, the urge to challenge one's own context might have been another important factor that connected them. Coming from Singapore and presenting his works in Europe, Kok was questioning whether it was possible for him to directly engage in the discussion of European issues, rather than being limited to a cultural other who was only expected to talk about where he was from. George, originally from Australia, was frequently touring in the US and Europe at that time, investigating possibilities of connections and transmittance in the audience-performer relationship. Their critical scrutiny on identities and exploration of queer experiences offered them a different path beyond their respective birthplaces.

This also has to do with their similar artistic concerns. The emphasis on relationality in their collaboration has also manifested in their respective experiments on the audience-performer relationship before. George's previous works, such as the aforementioned *Not About Face*, as well as *Now Now Now*, blurred the boundaries between audience members and performers to provoke contemplation on how ideas, emotions, energy, and information were transmitted and given sway among people. In these experiments, the artist quickly became aware of the fact that the connections each audience member had to the performer are heterogeneous. The tension between audience and performer was further complicated, depending on their expectation and existing relations with the performer.

Kok carried out a similar exploration in his earlier work, *The Gay Romeo*. In the first half of that performance, he presented gifts given to him by 40 dates, who were also invited to the performance. In the second half, Kok danced to the strong beats, in his tight underwear, for this audience group which shared different levels of intimacy with him. At the same time, he gave the audience a set of light cues as viewing instructions: when immersed in red, imagine feelings of sexual arousal; yellow, open all senses and enjoy the dance aesthetically; green, appreciate the performance on an intellectual level; and, finally, blue, you're in doubt.

In *Bunny*, we see both elements of George's former interventions to create a

flow, breaking through the dichotomy of viewer and performer, as well as Kok's rigorous procedure, probing into relationality step by step. They wrote in their notes: "Intimacy in bondage is built through the demand for acquiescence, giving of trust, playing with permission, taking up duties of care, testing of boundaries, and the discovery of new desires together." [3] Throughout this process, each participant reacts and perceives the situation differently. This aspect was difficult to grasp in the artists' previous works, yet the setup in *Bunny* has made it tangible in the performance. "If people are upset with the work, we WILL know about it. People would let us know," George laughed. "I haven't had to be in that level of conversation with an audience member before," he added.

During the collaborative process, they each took advantage of residency opportunities to develop the work independently. Since they were focusing on interactions and relationality, they invited people to join in, all the while observing how each person's background, personality, and level of familiarity with them affected their feelings about being bound. Through many such tests, they familiarized themselves with and developed possibilities for a set of operational mechanisms. During Kok's residency in Bangkok, when he had no one to interact with, he started binding objects. From this, he observed that when people are bound, they seem objectified. However, when objects are carefully wrapped in fluorescent ropes, a sense of subjectivity emerges, as if they possess personality.

This was what Kok meant when he said, at the beginning of our interview, that by the time *Bunny* arrived in Taipei, it was "ready." It had been performed in four or five places, with some incidences of friction. They told me that in New York, their show was stopped as some audience members were worried about their friend who had been bound. In Yokohama, an audience member left because she felt that permission had not been granted before an embrace. "It's a minefield," said Kok. It is especially tricky as they were not able to give the same level of care and attention they had for those who were bound to those who were watching. Frictions are almost unavoidable; they can only try to observe and listen more carefully. George told me, "It wasn't until the Melbourne performance in early 2017 that we had enough conversations that we could sensitively, and quite completely, respond to what was happening." It was through these processes that those tensions in the air became perceptible, traceable, and graspable.

Beyond performance

Following *Bunny*, it wasn't until 2019 that Kok and George developed their next collaborative performance, *Hundreds + Thousands*, a plant-oriented project. In between, the two extended their work on bondage, conducting workshops that incorporated massage practices, completing a performance, *Still Lives*, in which people and objects were bound in an outdoor setting, as well as writing and publication. Kok says that, for him, research often involves immersing himself in a community. Some aspects in the process are not visible in a performance, though they are an integral part of it. Their current focus is on exploring more modalities of sharing other than the format of performance.

The choice of plants is related to the friction experienced during their performances of *Bunny*. Those aforementioned encounters made them aware of the blind spots and conflicting perspectives brought about by their own gender identity. This urged them to deal with the question of 'otherness' and how divergent interpretations are produced. Of course, they are ultimately unable to speak on behalf of any other. This led to a change in thinking. Can the performances be an opportunity to practice stepping outside of oneself? What kind of procedure and quality are required to enable a perspective outside of oneself? Plants offered such a path outside of our human selves.

The COVID-19 pandemic also led to their focus on plants, such as how they respond to the environment and their methods of propagation. How can the creative process be made more organic and with more mutual care? Plants became the metaphor in their search for an alternative model. The pandemic disrupted their plans and made them reconsider what their works would look like in this kind of environment. *Hundreds + Thousands* has just completed its first phase of development, in which participants from Australia, Singapore, Taiwan, Hong Kong, and the Philippines were invited to create and share their observations and knowledge of local plants through online and on-site meetings. It is as if they are interacting with an audience and cultivating longer-term and deeper connections one year prior to the performance. In the future, when it is possible to tour again, this content will be woven into their show. This is what they learned from plants.

Looking back on this journey from *Bunny* to *Hundreds + Thousands*, Kok pointed out that in the early days of their collaboration, there were only

the two of them; now it has grown into a network of people working trans-
locally. What feeds their collaboration is their curiosity about and support
for one another. In the beginning, they exchanged their works and gradually
expanded their exploration of audience-performer relations. Now, they are
cultivating deeper networks and connections beyond the presentation of
works. Compared to when they first met nearly 10 years ago, they are now
able to reevaluate their respective contexts in Singapore and Australia
in their cross-regional practice. "It takes a lot of time to understand the
intricacies of context, and I still don't fully understand. But I have a much
deeper appreciation of what Daniel is doing in Singapore, and in the region of
where Singapore sits in the world, and the places it's connected to. That takes
a long time," said George.

To register and identify context is never easy. Perhaps the reason why Kok
and George could reach a different understanding of each other's works and
contexts lies in the fact that through processes of collaboration – through
friction, exchange and recombination – a new self may emerge, or a new 'we.'

1. *Bunny* premiered in Sydney in 2016.

2. See *Knot Notes*, written by George and Kok, entries 2 and 5.

3. *Knots Notes*, entry 9.

Luke George

Luke George (lutruwita-Tasmania, 1978) is a performance and visual artist residing and creating on Wurundjeri and Boon Wurrung Country. Luke's artistic practice is informed by queer politics, whereby people are neither singular nor isolated; bodies of difference can intersect, practice mutual listening, take responsibility for themselves and one another. Luke's works explore risk and intimacy and employ daring and at times, unorthodox methods, to create further possibilities for artist and audience to encounter each other. His work takes him across Australia, Asia, Europe and North America, with notable presentations at the Venice Biennale, Dance Massive (Melbourne), National Gallery of Singapore, Rencontres chorégraphiques de Seine-Saint-Denis (Paris), Time Based Art Festival (Portland) and many more.

Daniel Kok

Daniel Kok studied BA Fine Art & Critical Theory (Goldsmiths College, London, 2001), MA Solo/Dance/Authorship (HZT, Berlin, 2012) and Advanced Performance and Scenography Studies (APASS, Brussels, 2014). Exploring the relational politics in spectatorship and audienceship, Daniel has worked with pole dance, cheerleading, bondage and other 'figures of performance.' His performances have been presented across Asia, Europe, Australia and North America, notably in the Venice Biennale, Maxim Gorki Theater (Berlin), AsiaTOPA (Melbourne) and Festival/Tokyo. His recent performance works include *Bunny* (2016) and *xhe* (2018). Collaborating with Luke George (Melbourne) since 2014, *Hundreds + Thousands* (2021) involves people and plants as audience and participants, while *Still Lives* is a series of performance-installations in which rope bondage is performed not just on bodies but on entire cultural contexts.

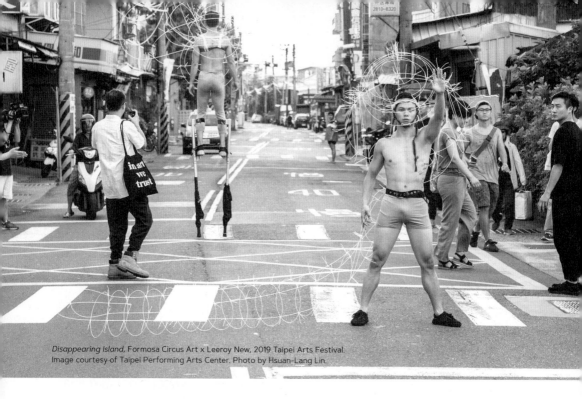

Disappearing Island, Formosa Circus Art x Leeroy New, 2019 Taipei Arts Festival.
Image courtesy of Taipei Performing Arts Center. Photo by Hsuan-Lang Lin.

In Search of Similarities amid Differences: International Collaboration and Local Participation of *Disappearing Island*

Tsung-Hsin LEE

Translated by
Cheryl ROBBINS, Johnny KO

Disappearing Island is a collaborative work between Taiwanese acrobatics troupe Formosa Circus Art (FOCA) and Filipino visual artist Leeroy New. This site-specific theater work leads audiences through the 'disappearing' landscapes of Shezi Island in the city of Taipei. The collaboration was made possible through 2017 ADAM, where FOCA's Director Allen Lin and Leeroy New first met. FOCA's Artistic Director Lee Tsung-Hsuan and Creative Consultant Yu Tai-Jung joined soon after and the collaboration took shape. It took three years for the work to develop into its final iteration shown at the 2020 Taipei Arts Festival. The trajectory of *Disappearing Island*, including the encounter between the artists, the conception of ideas, fieldwork, and the two work-in-progress presentations, has been a protracted one. This article, albeit short, hopes to provide a critical view of the work to stimulate possibilities in terms of transcultural collaborations, and to extend the life and meaning of 'the disappearing.'

Beginning with similarities

Leeroy New from Manila and FOCA, whose studio used to be based on Shezi Island (and has since relocated to Taoyuan City), became partners because of shared experiences of social marginalization. This, together with their similarity to adapt, is what Lee Tsung-Hsuan recalls as the critical factor which made this collaboration possible. [1] In the Philippines, the arts do not have much visibility. Moreover, as New creates atypical visual art, such as installations and costumes in collaboration with performing artists, he is positioned along the margins of Filipino art circles. Similarly, as acrobatics is considered a form of popular entertainment, it is often excluded from 'art.' In recent years in Taiwan, the notion of absolutism that ranks different artforms hierarchically has faded, and with the emergence of new theater institutions, acrobatics has gradually received attention. In addition, New uses easily obtainable materials found in daily life, so that he is able to adapt his works to different settings, while a circus travels from place to place adapting to different spaces and venues. As such, the creative process between New and FOCA began with their shared experiences of being marginalized and forced to adapt.

Apart from their artforms, the respective geographic locations of Shezi Island and Manila are also similarly marginalized. Despite lying within the borders of Taipei City, Shezi Island remains on the margin of the prosperous metropolis as construction has been banned there for a prolonged period

due to hydrological factors. It is lined with traditional factories and old low-rise buildings, and lacks hospitals and educational institutions. Moreover, a high embankment isolates it from the urban area on the opposite shore. The people on this 'disappearing island' can only stand on this embankment and look out at the unreachable prosperity on the other side. Meanwhile, although the coastal city of Manila is the capital of the Philippines, it is plagued by an excess of locally produced garbage, as well as rubbish imported from Western countries. Furthermore, large amounts of ocean waste have washed into Manila Bay, creating mountains of debris that cannot be effectively removed, blocking waterways and estuaries, thereby causing urban flooding. Therefore, Shezi Island and Manila share similar fates, lying along the margins of affluent areas, silently enduring the various problems brought about by prosperity.

Lee, Yu, and New decided to use the similarities between Shezi Island and Manila – the island geography, the waters in their respective surroundings, and the presence of plastic – as connecting points for their international collaboration. They then began conducting fieldwork on Shezi Island, documenting the complex and interdependent ecosystems among people and those among people and the environment. New visited Shezi Island numerous times to learn more about this place and FOCA, and even stayed at FOCA's rehearsal space for two weeks, interacting with the environment and FOCA members, as well as exploring the various aspects of Shezi Island. [2] FOCA and New unveiled the first work-in-progress presentation of *Disappearing Island* during 2018 ADAM's Kitchen program. Images of Shezi Island's environment were combined with FOCA's stunt performances, in which performers donned plastic wearable props designed by New, to explore the island's animistic beliefs and *yin miao* (temples dedicated to wandering and homeless spirits) culture. However, Lee believes that using images to tell a story creates distance. In addition to the visual and auditory aspects of black box theater, the sense of physicality and space outside the venue, as well as the interactions between people, are all important components of the Shezi Island experience. Consequently, the team decided to expand its scope of creation and introduce site-specific concepts to take audiences on a tour of Shezi Island, tapping into the senses so as to incorporate different aspects of perception into the audience experience.

Multiple perceptions arising from the bystander perspective

The second work-in-progress presentation of *Disappearing Island* was showcased at the Think Bar program of the 2019 Taipei Arts Festival. This time, FOCA and New gave audiences a taste of life on Shezi Island, leading them on an exploration that was no longer just limited to images of 'homeless and wandering spirits.' Leaving the theater and making use of spaces such as the shore, embankment, and public square provided different inspirations for the stunt performers' movements. They stacked themselves on top of one another in front of an old residence, jumped onto metal plates, scratched metal siding with fiberglass, shuttled through drainpipes and wandered along the embankment. Audience members were no longer mere spectators of a show or tourists traveling to and from designated spots: at times, they needed to pass through New's designs, such as a square structure composed of fiberglass, to physically perceive the ways in which they had to adjust their height by bending down, lowering their head and dodging – just like how the buildings on Shezi Island have to comply with height restrictions due to the landmass being situated along the flight path to and from Songshan Airport. Lee believes that site-specific works enable interactions to become a part of performance, a notion that also resonates in the context of circus acts, where the interactions between audience members, performers, and the environment form an essential element. [3] Therefore, the change of venue in this site-specific part of *Disappearing Island*, a work about Shezi Island, enabled the performance to truly take place on Shezi Island, while also allowing audiences to appreciate it through a different sensory experience.

Disappearing Island made its formal premiere at the 2020 Taipei Arts Festival. However, due to the COVID-19 pandemic, New was unable to participate as planned, thus temporary adjustments had to be made. For instance, the fiberglass installations created by New were either set up in the performance space or worn and used by the performers. As a result, when audience members passed through the lanes and alleys, they had to lower their head or turn sideways to dodge the flexible installations. Meanwhile, the performers dressed in armor-like suits, constituting of giant geometric shapes, embodied the complex relationship between people and spaces. In the midst of a global pandemic, the landscapes of Shezi Island, the living conditions of its residents, the stunts performed by FOCA, the installations and props designed by New, as well as the physical experiences of the audience, culminated in the forging

of new understandings in multi-sensorialism and cross-culturalism.

The international collaborative experience of the *Disappearing Island* team not only resulted in the cultivation of a tacit understanding between FOCA and New, but also enabled both parties to discover different creative paths. From the fieldwork and cross-cultural communication in the early stage of the creative process to the simulation of bodies in various spaces, and from the interactions with the wearable props to the performers' wandering between multiple points and the building of sensory memories among audience members during the performance, all these were creative methods explored by the *Disappearing Island* team. Their next goal is to replicate, to a certain degree, the Shezi-themed creative process in marginalized areas of other cities with similar experiences. As New emphasizes, in a transnational collaboration, cultural and individual differences can never be eliminated. However, if both sides deal with their differences openly and honestly, take an active interest in them by recognizing their existence, and make observations from different perspectives, these distinctions become a reference point for identifying the similarities between them. Likewise, the team's experience on Shezi Island also serves as a reference point for their next creative steps.

Bidding farewell to Shezi Island

In 2021, FOCA had to move from its rented rehearsal space due to the implementation of a development plan for Shezi Island. In fact, it was *Disappearing Island*, a rare performance art piece themed on this landmass, that set this development plan in motion. Looking back on the historical development of Shezi Island, this plan has been proposed repeatedly, withdrawn, and put forward again due to various considerations and forces at play, even evolving into poison pen letter attacks during the Taipei City council elections. [4] According to the findings of FOCA's fieldwork, Shezi Island residents are divided on the topic of development. As a group renting a rehearsal space there, Lee believes that FOCA cannot represent the residents, nor is it its place to advocate or oppose the plans. He only hopes to preserve some memories of Shezi Island's complicated historical development through art. As such, *Disappearing Island* became "a work that can preserve memories and include this land in discussions on art." [5] This was FOCA's intention from the outset, and the piece is proof that it had spent time on Shezi Island. Lee recalls, "Every time I conducted a 'dry run' there, I would visit the places that we had used before." Many of the locales chosen for the

formal launch of *Disappearing Island* in 2020 differed from those of the work-in-progress presentation in 2019. This decision was made not only in hopes of finding more and different possibilities for Shezi Island, but also to leave behind a record of more locations, as FOCA members felt that the island's 'disappearance' was imminent.

In the context of this work, 'disappearing' refers to the vanishing of landscapes, history, as well as questions. The title *Disappearing Island* was inspired by a description of the Kun Tian Ting Temple: "Back when Shezi Island was still prone to flooding, if you stood on Yangmingshan and looked toward it, the whole island would be submerged, as if it had disappeared." [6] Shezi Island was formed at the confluence of the Keelung and Tamsui rivers. This was the very reason it became a flood-stricken area during a typhoon in 1963, thus resulting in restrictions being imposed on its development. The recent decade has seen the steady accumulation of culture due to these restrictions, as well as their gradual disappearance with the changes brought about by the resumption of development. It is as if the island is in perpetual limbo, toing and froing between emergence and disappearance. To reflect this, during the presentation of *Disappearing Island*, the performers erected a tower with their bodies to mirror the towering metal birdcage behind them, and then dispersed to proceed to the next location. They would also emerge unexpectedly from alleyways and immediately disappear into the darkness, as if they were phantoms of historical memory. Performers adorned with fiberglass props who looked like monsters also appeared at one point. They were followed by other performers in white protective clothing spraying disinfectant, as if to erase everything that the audience had witnessed. If this is a representation of the fate of Shezi Island, or the tension between history and progress, then what can be preserved amid this cycle of emergence and disappearance?

Leaving behind meaning in the wake of artistic action

As a question posed by artistic action, *Disappearing Island* does not attempt to provide any answers. For instance, regarding the choice of development or preservation, the team has no intention, right, or ability to take a side. As a spectator, I traveled to different places on Shezi Island while following the performance. I saw a sign for a funeral director, heard a news broadcast coming from a metal sheeting factory, walked along paths, and interacted with the spaces above and below the embankment. I will remember the island

the way I experienced it on that particular occasion. *Disappearing Island* preserves the image of Shezi Island in the memories of its audiences. As for the meaning of this image, it is left for people to interpret according to their differing viewpoints, just like the meaning of development and preservation.

Due to the ongoing COVID-19 pandemic, what comes next for the *Disappearing Island* team remains unclear. However, it is foreseeable that they will move to the next landscape and raise more questions through art. In this transnational collaboration, the similarities between the two parties enable dialogue, while cross-cultural differences facilitate observations and questioning from a bystander's perspective. Being marginalized has empowered these creators to inspire further interpretations of meanings and impart perceptions to audiences, preserving landscapes in memories and leaving behind meaning in the wake of their artistic action.

1. Online interview with Lee Tsung-Hsuan on November 5, 2021.

2. Online interview with Leeroy New on November 6, 2021.

3. See 1.

4. Shen Chang-Lu. "Poison Pen Letters and Backstabbing: Paper Bullets Can Do Harm, Only Heaven Knows What's Right or Wrong," *United Daily News*, December 21, 1991, p. 14.

5. See 1.

6. Chen Yu-Ru. "A Circus Paints the Textures of the Shezi Community, the Island that Will Never Disappear," *Disappearing Island* by FOCA, 2020 Taipei Arts Festival, September 3, 2020. http://61.64.60.109/205taipeif estival.Web/blogContent.aspx?ID=927, last accessed on January 3, 2022.

Formosa Circus Art

Named after the beautiful island, Taiwan, FOCA (Formosa Circus Art) was established in 2011. Its purpose is to develop the various contemporary circus arts of Taiwan, mixing them with other styles of performance, including traditional forms, acrobatics, as well as street culture and theater arts, in an attempt to create a physical vocabulary that is unique to Taiwan. FOCA's team members come from many different fields of performing arts, including, among others, acrobatics, juggling, dance, and drama, which makes FOCA the only circus company in Taiwan that has over ten full-time members. Additionally, FOCA is the only circus company that has continuously received the Taiwan Government's annual grants since 2017.

Leeroy New

Leeroy New (b. 1986, General Santos City) is a Manila-based multidisciplinary artist whose practice overlaps and intersects with different creative industries: fashion, filmmaking, theatre, public installations, product design, and performance. This practice of moving across different modes of creative production has become the backbone of his work, driven by concepts of world-building, hybrid myth-making, and social change.

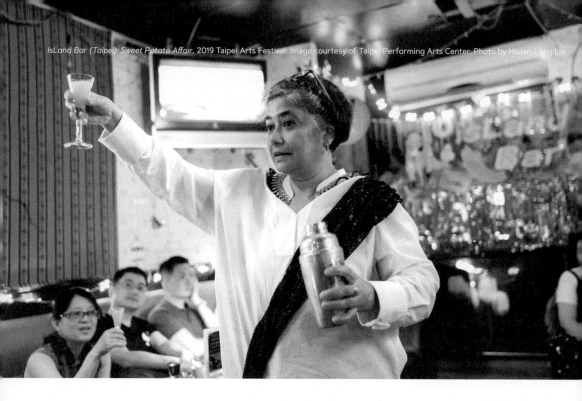

IsLand Bar (Taipei): Sweet Potato Affair, 2019 Taipei Arts Festival. Image courtesy of Taipei Performing Arts Center. Photo by Hsuan-Lang Lin.

Collective and Collaborative Work and Its Pre- and Post-Performance IsLand Bar (2017-2021)

Ding-Yun HUANG

Translated by Elliott Y.N. CHEUNG

Since its inaugural presentation through the ADAM Artist Lab in 2017, *IsLand Bar* has made tremendous progress. [1] The many editions of the work that followed have each exhibited specific strategies and concerns, taking various forms depending on the composition of participating artists, curators and producers. This essay focuses on the contexts of *Island Bar* regarding its development, its spirit of experimentation, and the power and ethical dynamics of collective creation in a bid to open up possible avenues of thought.

Individual islands networked by booze

We held a wine tasting at the Artist Lab that morning on the spur of the moment. Tuan Mami [2] brought wine that he had brewed himself, and Moe Satt [3] was also in the process of making a cocktail-related project... Early in the morning, a bunch of us were all tipsy... – Henry Tan [4]

During the short itinerary of the first edition of ADAM's Artist Lab program, artists from all across Asia [5] gathered in Taipei for two weeks. We spent time messing around, getting to know each other. Around the morning of the third day, artist Tuan Mami brought wine that he had brewed himself and requested basic mixing ingredients and tools. We got to it. Early in the morning, as our buzz-inducing coffee was still kicking in, over half of the artists were already tipsy – despite having just met, we were no longer strangers. During the first week in the Lab, instead of discussing what the final public sharings would look like, we took it slow and got to know each other. Aside from our unfamiliarity with our neighbors in Asia, it was also a gradual process of building camaraderie and friendship as individuals. When overseas artists take up residency programs in Taiwan, they more or less carry specific expectations. Chikara Fujiwara [6] is a notable example: he is concerned with how the customs and culture left over from the Japanese colonial era have impacted Taiwanese society today. At the same time, he has an inherent affective connection with Taiwan due to his family's *wansei* background. [7]

At the time, I visited the red-light district on Linsen North Road. I've always been interested in the culture left behind in Taiwan from the colonial era. I noticed a flyer for a 'Girls Bar.' I thought, 'What if an artist could host their own table like that, mix their own cocktails for visitors, and each table were like an island of its own?' – Chikara Fujiwara

Fujiwara and Scarlet Yu Mei Wah [8] were the first to propose the concept of *IsLand Bar*. On one hand, because details of the work were still in

development, artists had a modicum of flexibility. On the other, because it was getting close to the public sharings/presentations, any participating artists who had yet to develop a clear direction seemed to have found some degree of room to maneuver. That year, about half of the artists joined the work-in-progress presentation of *IsLand Bar*.

Through the expandable and variable potential and conditions of the concept, each participating artist was enabled, within the setting of the bar, to host one table as a designated performance space. Audience members circulated between the tables in the bar, as if traversing between unknown islands, one after another. The artists mixed various ingredients into newfound cocktails as their icebreaker, bringing out their own selves, cultural backgrounds, and knowledge on migration and identity, concocting a new, hybrid sensation for the taste buds amid lively conversation and lovely cocktails. In this context, the artists were at once curators and event organizers, while still able to hew to their own artistic works. For a collective of artists who barely knew each other, this was a rather perfectly modest and collaborative strategy.

I've always been fond of 'islands' as a concept. We come from different cultural backgrounds, like many different islands. When I heard Chikara's idea, I got on board very quickly.

———————————————————————————————— *Scarlet Yu Mei Wah*

Generally, a 'bar' is often perceived as a place of 'de-identification.' In a relaxing and enjoyable atmosphere, we mix with people alongside alcohol. The artists use ingredients signifying historical and social codes to develop and create glass after glass of unique concoctions, infusing personal histories and cultural identities into drinks in the process of 'de-identification.' This reflects the complex situations of 'Asia' – a hybrid and mixed body of plural existence – and conflates all kinds of differences, like an archipelago whose islands are mutually connected yet individually independent. Another feature regarding the concept of *IsLand Bar* is that it was not a group of artists making one single production. Rather, it was co-produced through the collective setting of the Lab and shared process during which each artist was able to invest their own effort: the concept proposed by Fujiwara and Yu, the consultation and mixology techniques provided by Moe Satt, the homemade wine brought by Tuan Mami, or the research experience at Otani, a Japanese bar on Linsen North Road, recommended by Tang Fu Kuen, one of the facilitators of Artist Lab and Curator of Taipei Arts Festival (2018-2022).

When the artistic direction was established, Henry Tan created photoshopped portraits for each artist as romantic hosts of their island-bars, while Leeroy New [9] invented a 'business slogan' for each island to connect with one another. "No man is an island," especially when we have rehearsed the creative recipes of our tentative cocktails and constellated all the ingredients to strengthen the connections between each island/artist. Indeed, it evoked the spirit of transculturalization. During the performance, no one stayed put at their table; the artists interacted with each other, bringing in customers and getting involved at others' tables. The culmination of the entire process of experimentation and presentation refracted an imagination of the collective and the individual through experience. All this was also generated by, and responding to, the concept and initiation of ADAM.

The last few days of Artist Lab coincided with the Public Meeting of ADAM, for which professionals from all over the world were invited to Taipei. This program does not only feature the sharings/presentations of Artist Lab, but also work-in-progress showcases, symposiums, screenings and workshops. In other words, the design of ADAM's Public Meeting is associated with how the art market functions. Such a format is frequently seen at international performing arts fairs in the context of buying and selling works, as well as seeking opportunities and co-producers. Normally, existing and ready-to-tour works are presented at these performing arts fairs. However, ADAM spotlights the presence of artist, thus Lab artists are strongly motivated to make themselves seen and heard through their presentations.

The Lab artists of the 2017 edition also realized that the idea of *IsLand Bar* was akin to a container. There was no need to make compromises and corral one another's creativity within a limited time. Rather, the artist, like the host at a bar, was pushed to the very forefront of the work and initiated a deep exchange and interaction with the professional audience. [10] The concept of the 'bar' also evinced the social nature of the Public Meeting. The artists presented their labor in front of the audience as the provision of a 'service.' What role does the artist truly play in the context of this Public Meeting? During a temporary assembly, rather than the artists pitching their own work, why not package themselves to be marketed instead? Rather than getting to know my work, why don't you get to know me first? This tactic was precisely the clear and direct response that *IsLand Bar*, as a concept, gave to ADAM's Public Meeting and Artist Lab.

Who shaped and owns *IsLand Bar*? It is hard to tell, because not only was it a collective contribution by the artists, but it also involved the cultivation and planning of the ADAM platform. In retrospect, each of the lead artists was individually able to distill their particular discoveries and perspectives during the creative process. The above aspects are an account that came out of conversations with Chikara Fujiwara, Scarlet Yu Mei Wah and Henry Tan, as well as from my own personal recollections. Even so, it is only a part of the entire experience.

Who is allowed to continue running the business?

The composition of artists presenting *IsLand Bar* expanded beyond the original cast soon after its debut. Any artist who has participated in the ADAM Artist Lab of whichever edition is given the opportunity to take part. Meanwhile, the Taipei Performing Arts Center (TPAC) was interested in turning *IsLand Bar* into a part of its Taipei Arts Festival Collection, which would see the work presented for three consecutive years, with each edition performed, directed and curated by different lead artists. [11] In 2019, Chikara Fujiwara, the lead artist behind the Artist Lab version of the work, collaborated with the Rockbund Art Museum in Shanghai on *IsLand Bar: Dream of the Butterflies*. In an instant, all the parties involved – be it TPAC, which facilitated the birth of the work, or the participating artists – seemed to have the right to restage or commission iterations of *IsLand Bar*.

However, with the further and various iterations of the work, the relationships between the first-generation artists who conceived *IsLand Bar* and the work itself have changed. 'Who owns this work? Who is allowed to restage it?' have become the haunting questions. From my up-close observation, in the mid-to-late stage of the development of *IsLand Bar*, the institution and Lab artists had different attitudes towards the work. The former valued its sustainability and potential, and anticipated the post-development of *IsLand Bar* to be a rolling project as a one-concept-multi-editioned artwork. For the latter, the tradition of singular authorship still carries a certain weight. But when the work is situated in collaboratively creative processes, with a leaning towards a shared concept and artists-as-orgranizers strategy, its composition then supports the possibility of another collaborative expansion in its post-performance state.

Since its inception, *IsLand Bar* has been transformed into an 'open source'

project, allowing artists who have been involved to continue working on further editions. It is a typical example of the transformation from singular authorship to collective creatorship, as well as from the singular production of an artwork to artist-curated and collaborative ones. This paradigm shift in conceptual artistic production, which views artwork as a platform and a vessel to invite possibilities, is actually visionary for the future art ecosystem. This concept of 'communality' is also without a doubt an essential value in today's society. However, when it comes to the product of transcultural exchange, it inevitably involves possible criticisms of cultural appropriation and representation, such as the ambiguous issue of 'who holds the power and right to speak, from where and for whom.' At the same time, the notion of 'communality' is not only an artistic concept, but must also be implemented in productional and curatorial negotiations. How artists and institutions trial and practice 'collective creatorship' in actual productions will also project imaginations of the future of transcultural production. What we must do in the next stage is to continuously reconcile the politics of collaboration, production and power structures in between.

As a project that is curatorial, collective and highly collaborative, *IsLand Bar* indeed requestions modes of contemporary art production in terms of cultural reproduction, editioned contexts in different cities and cast expansion. When we explore what 'Asia' and 'Asian contemporary performance' are, such strategies of investigation and mutual integration are exactly what make *IsLand Bar* valuable. In this bar, where the harmony of differences are mixed and remixed endlessly and served up in glasses, we are enticed to explore.

1. *IsLand Bar* was first presented at ADAM as part of the sharings of the Artist Lab program in 2017. It was officially commissioned in the following year at Taipei Arts Festival. Various editions of the work have been presented at Rockbund Art Museum in Shanghai (2019) and Performing Arts Meeting in Yokohama (2020). Since the pandemic, its digital or half-onsite-half-online editions have been presented by Taipei Arts Festival, Melbourne Fringe Festival and Camping of CND (France).

2. Participant of 2017 Artist Lab. Tuan Mami is an artist constantly exploring new mediums and methods of expression. He adapts different methods from different fields, including anthropology and social research, into his practice in increasingly meditative experiments with installation, video, performance and conceptual art. In recent years, he has begun explorations of performative-multi-installations in both private and public places. A graduate of Hanoi Fine Art University in 2006, he later co-founded MAC-Hanoi in 2012, Nha San Collective Art Space in 2013 and Á Space in 2018, where he is creative director. He was a member of the visiting faculty at San Francisco Art Institute in 2013.

3. Participant of 2017 Artist Lab. Moe Satt (b. 1983), lives and works as an artist and curator in Yangon, Myanmar. He has participated in live arts festivals throughout Asia, Europe and the US. Satt addresses provocative social and political issues in military-ruled Myanmar, such as the role of religion and that of the individual in society. His work has been featured in several group exhibitions, including Political Acts: Pioneers of Performance Art in Southeast Asia (Melbourne, 2017), CAFAM Biennale (Beijing, 2013) and Busan Biennale (2012). He was a finalist for the Hugo Boss Asia Art Award for Emerging Asian Artists in 2015.

4. Participant of 2017 Artist Lab. Based in Bangkok, Henry Tan is the co-founder of Tentacles Art Space and a member of Freaklab (Thailand) and metaPhorest (Japan). Tan explores the concept of LIFE and SIMULATION through the investigation of technologies such as synthetic biology, mixed reality, brain stimulation and artificial intelligence, as well as how life adapts and negotiates with the changing environment such as climate, geopolitics and geoeconomics. He worked on the Lunartic Dream project with Fablab Hamamatsu and Kornkarn Rungsawang, which tells stories about how life began on the Moon, how synthetic biology helped terraform the princess's memory, and how life is celebrated with microbial and vagina dance.

5. Twenty artists participated in the first iteration: ten from Taiwan, and the other ten respectively from Japan, Hong Kong, Myanmar, the Philippines, Vietnam, Thailand, Australia, Indonesia, India and Cambodia. There were also five facilitaors respectively from Indonesia, Australia, Singapore, Germany and Taiwan, with many among them coming from hybrid backgrounds Please see the appendix for the participants of each iteration.

6. Participant of 2017 Artist Lab. Based in Yokohama, Japan, Chikara Fujiwara has been acting in various cities as an artist/critic/curator/dramaturg. In order to connect the world divided by 'invisible walls,' he produced the flaneur-style promenade-performance work *Engeki Quest* which has been presented in the Japanese cities of Yokohama, Kinosaki, Myoko and Tokyo, as well as Manila, Bangkok, Ansan, Hong Kong, Macau, Düsseldorf and Lausanne. Since 2017, he has obtained a fellowship from The Saison Foundation and the East Asian Cultural Exchange Envoy of Japan Agency for Cultural Affairs. In 2019, he founded the art collective orangcosong with Minori Sumiyoshiyama.

7. *Wansei* refers to Japanese who were born in Taiwan during the colonial period, including children born to Japanese-Taiwanese couples.

8. Participant of 2017 Artist Lab. Scarlet Yu Mei Wah was born in Hong Kong and currently lives in Berlin. She has been working primarily with the medium of dance in various contexts, as well as researching and devising different projects that challenge notions around knowledge, production, behavior, transmission, questioning the ways we understand biographical/historical material, navigating the in-betweenness of the politics and poetry of listening and telling. She uses Autobiography and Memory as tools to reexamine private/public embodied narration.

9. Participant of 2017 Artist Lab. See his introduction in "In Search of Similarities amid Differences: International Collaboration and Local Participation in *Disappearing Island*" in this book.

10. The 'professional audience' here refers to professionals who work within the art industry such as organization or venue directors, producers, managers, curators, art critics, art creators, etc.

11. The series includes *IsLand Bar* (2018), *IsLand Bar (Taipei): Sweet Potato Affair* (2019) and *Is(o)Land Bar: Single Take (Cloudy)* (2020).

Thinking Borders, Oceanically: On *The Past is a Foreign Country* by Michikazu Matsune and Jun Yang

Freda FIALA

The Past is a Foreign Country, Michikazu Matsune x Jun Yang, 2018.
©Michikazu Matsune Jun Yang. Photo by Elsa Okazaki.

Some 20 years ago, the artists Michikazu Matsune and Jun Yang met through mutual friends in Vienna. "Becoming friends," they told me in a conversation, means "being yourself." This "intimacy of friendship", as Derrida writes, lies in the sensation of recognising oneself in the eyes of another. [1] For Matsune and Yang, their most obvious commonalities are their sense of humour, as well as their transnational and inter-related living and working processes. Born in the port city of Kobe in Japan, Matsune has lived and worked in Vienna since the 1990s as a performance artist and educator. For his stage-performances, he often engages with historical anecdotes in his personal artistic style, as a method to examine cultural ascriptions and patterns of social identification. Yang was born in Qingtian in China, from where his family emigrated to Austria when he was four years old. His artistic practice that encompasses various mediums including film, installation and performance, develops through continuously shifting cultural contexts, as Yang is based in three cities, namely Vienna, Taipei and Yokohama. While there are many artists trying to, fashionably, list multiple geographies to their practice, there are certainly not many who manage a transcontinental engagement with as much endurance as him.

In their respective bodies of work, Matsune and Yang often engage with the conceptual fluidity of identity. Over the years of their friendship, their exchanges have reflected in each other's pieces. In his 2015 performance *Dance, if you want to enter my country!,* Matsune investigated the profiling and surveillance mechanisms that apply to international travellers. For this purpose, he manipulated his biometric passport portrait by shaving off his eyebrows and gluing them onto his skin as a moustache. While Yang contributed to the textual script for this performance, Matsune's photo, in return, featured in Yang's 2019 project *The Artist, the Work and the Exhibition* at the Kunsthaus Graz. *The Past is A Foreign Country* would, still, be the first time for both artists to conceptualise and perform an entire piece together, leading them to thematise the risk of two friends putting themselves through the 'lockdown' of a shared creation process, and having to bear the responsibilities of such endeavour. Premiered at the 2018 Gwangju Biennale and later shown in Vienna and Taipei, it demonstrates a collaboration in which both artists' individual practices converge, as they engage the semantics of mobility to articulate a relational poetics. The adaptation for 2020 Taipei Arts Festival had to especially find ways to respond to the circumstances of the COVID-19 pandemic, as travel restrictions made it impossible for the performers to both be in Taiwan physically. It therefore comprises of two

parts: a 45-minute screening of the live work, followed by a specially created annex, *Dear Friend*.

"The past is a foreign country: they do things differently there," wrote L.P. Hartley in his 1953 novel *The Go-Between*. While the phrase may be well-known and audiences may even "come back loud and strong on their own with the second half," [2] very few people may actually be able to recall the book's narrative, or even know the literary source. Their choice of title thus somewhat presupposes how Yang and Matsune understand the performance setting – as a horizontal assemblage of rhizomatic narratives, which engage historical and intercultural frameworks to elicit new connections. Seemingly comparing their own to other collaborative missions, they recall historic duet constellations, such as Edmund Hillary and Tenzing Norgay climbing Mt. Everest, as well as Neil Armstrong and Buzz Aldrin's arrival on the moon. The latter links to the contemporary pandemic situation in a comical manner, since the crew of the spaceship, upon returning to earth, had to quarantine in a metal tin for three weeks to prevent the spread of any 'alien contamination'.

The performance employs a mode of pictorial storytelling inspired by Kamishibai, a form of street theatre and storytelling from Japan. This oral storytelling form first emerged as street-performance in the 18th century, and would later develop in diverse ways in the country's different regions. [3] For the Japanese context, Kamishibai is said to have been widely enjoyed during the Great Depression of the 1930s and in the post-war period, until the advent of television during the mid-20th century. [4] Kamishibai was performed by a narrator who travelled with sets of illustrated boards, which were then placed in a miniature stage-like device. Stories, sometimes unscripted, were told alongside the changing of images and accompanied by sounds that the artists made. Some outgrowths of the form would, for example, feature a stage to enhance the performer's presence; while other forms would use the stage to have the storytellers 'retreat behind' it. The art of the latter would be considered in creating "an effective oral 'soundtrack' to enhance the pictures without drawing undue attention to the performer". [5] As a performative past of Japan, one of the places that links together Matsune and Yang's biographies, Kamishibai methodically informed the staging. The performance narrative is accompanied, guided, and sometimes also interrupted by photographic image boards. Performing alongside these images, in some moments the artists recall Kamishibai's potential of hiding, gesturally concealing their identity with the photographs. Yet, in most parts,

they present their narratives in a frontal, reportage-like manner, facing the audience. The photo-form then functions both as dramaturgic guidance and itinerant interruption. It holds the space to speak through images, show up through images, and even provides for images to communicate with each other, to approach each other.

Border lands

The staged collaboration radiates from the artists' East Asian backgrounds, and how, consequently, Matsune and Yang's life-dynamics have been shaped by factors of interculturality and mobility. Their inter-Asian essay looks at and challenges the narrative framing of the region and its transnational, global relations. Most of the narrative fragments presented concern the experience of borders, both metaphorically and literally. As an ambiguous concept, the border holds space for positive and negative attributes, inclusion and exclusion, allowing for processes of identification, as much as for processes of distancing. [6] The pair's presentation is involved in this complexity, as it includes reflections on borders as regions, everyday rituals as well as political events performed at borders; stories of individuals testing on their limits and humanity trying to overcome its planetary 'embordedment'. Instead of regarding a border as a dividing line that separates two entities, whether they are state leaders, civilians or territories, their outlook focuses on the performative foundation of borders, what can be called their "mediating moment". [7]

Among the historic junctions mentioned in the performance are the entering of the US Black Fleet into the harbour of Yokohama in 1853, which led to the re-opening of Japan, and its subsequent rise as a regional imperialist power. The narration further approaches the flag ceremony at India and Pakistan's Wagah border, as a daily evening ritual "at the gates, which for a long time were the only way between areas that were once united as one country, and that are *now two*," as Matsune recalls. Attempting to unravel the inherent performativity of state-official 'border practices', another narrative pitstop is made to review the historic April 2018 inter-Korean summit meeting between South Korean president Moon Jae-in and Supreme Leader of North Korea, Kim Jong-un. The occasion of this summit, focused on the denuclearisation of the peninsula, marked the first time since the end of the Korean War in 1953 that a North Korean leader has entered the South's territory. The meeting started with the two politicians shaking hands over the demarcation line.

Moon then accepted an invitation from Kim to briefly step over to the North's side of the line. With many elements expressly designed for symbolism, the event's affective frontiers provide Yang and Matsune's exploratory curiosity with fertile ground.

Revisiting this gestural climax of recent political history, Yang observes that "photographers both from the side of the North and that of the South are running in and out of each other's frames, as to not be included in the photographs of each other." He points to how, while bolstering transnational aspirations, the scenic mediation of international politics reveals political history as a series of constellations performed by (often) two men. Ultimately geared to investigate the arts' role in what are considered 'historical settings', Matsune and Yang's essayism arrives at how, inside the Inter-Korean Peace House, carefully selected paintings and photographs were displayed to impress the Northern visitor. In the banquet hall, a painting by artist Shin Tae-soo depicted Baengnyeongdo, an island that, due to its geographic position has, as a 'contact zone', [8] seen several naval skirmishes between the two countries. Thinking of borders with islands, and of islands with borders ultimately expands the imagined straightness, to involve the element of water, tides, flows, and *foam*. [9] With Baengnyeongdo and also Taiwan serving as examples, islands thus form particular kinds of border areas, such that they "point to flows of people, movements among islands, the relations between water and land and between [other] islands and the mainland[s]". [10]

Oceanic borders

In the very beginning of the performance, Matsune recalls how the ocean has been an important presence in his childhood in Japan. The photo, alongside which he speaks, shows him with his siblings, growing into life together, in close proximity to the sea. He describes their shared sense of the world as shaped by interactions with the water and by learning how to swim. His story, also in a larger sense, prompts an invitation to *think oceanically*, to anchor one's understanding of existence not in an economic, nation- and land-based sense, but rather in a metaphoric sense of shared regional (and global) planetarian identity. As the Fijian-Samoan scholar Epeli Hau'ofa, who was the first to draw a manifesto of *oceanic thinking*, suggests, the ocean "is our most wonderful metaphor for just about anything [...]. Contemplation of its vastness and majesty, its allurement and fickleness, its regularities and unpredictability, its shoals and depths, and its isolating and linking role in our histories, excites

the imagination and kindles a sense of wonder, curiosity, and hope that could set us on journeys to explore new regions of creative enterprise that we have not dreamt of before". [11] As a manner of "making apprehensible modes of historical and geographical consciousness that exist not behind or instead of modernity's, but rather beside them, complexly interwoven with them", [12] *oceanic thinking*, in its full utopian dimension, binds Matsune and Yang's performance narrative. It characterises connections that are in constant motion, impacted by migration and travel.

Understanding events from an oceanic perspective requires one to rethink country-based spatial and temporal logics. Matsune therefore dives into the writings of Dutch jurist and philosopher Hugo Grotius, who in *Mare Liberum* (1609) argued that the sea was free to all, and that nobody had the right to deny others access to it. Historically however, Japan proves as a specifically antithetical case, as the country entered into a self-isolation period of more than two centuries, which only ended with Commodore Perry's arrival in the port of Yokohama in 1853. Yang, later in the performance, describes himself in exactly this city, as he recalls a visit to the Yokohama Immigration Bureau office. "I tried to picture the US Black Fleet, the gunpowder ships entering the harbour." To extend his resident status in Japan, he was asked to fill in a form, point 17 of which, titled 'Reasons/Family', allowed the following options: 'Biological child of a Japanese national' or 'Child adopted by a Japanese national'. The process thus foresees that only a child of a Japanese national would be eligible for residency. The nation-state ideal that manifested in the modern era has entrenched politically constructed borders, defining national identities as key and uniform, which in turn leads to an exclusion of undesirable non-nationals as threats to an imagined national homogeneity. Confronted with the form's binary preselection which eliminates other potential realities simply by excluding them, Yang suggestively muses to "apply the other way around", in his case meaning "not as a child of a Japanese national, but as the biological father to his two Japanese children". He claims his role as a father within the *embodied dimension*, as a regular visitor – who, for this purpose, needs to extend his residency status. His story yet demonstrates how transnational biographies are often haunted by an intimacy of the factual, as the individual becomes attached to the bureaucratic. Introducing to the audience *his* approach, to legally 'become part', as one that favours interdependent connections instead of an ethics of simple and reductive dichotomies, he addresses an ethics of care beyond the subjective, embedding the personal within the political. Such perspective

emphasises that "the cultural construction of citizenship does not take place only within the confines of the policy sphere, but it is also shaped by the continuous re-elaboration of discourse in the public sphere." [13] Lived relationships, rather than static dispositions, then constitute the frameworks of belonging, to a cultural setting and its affective knowledges.

Living and thinking (with) borders

Transborder movement and the subsequent experience of border-selves and their inherent multiplicities have, for both Jun Yang and Michikazu Matsune, been conditional to building and sustaining their lives and artistic careers. The conjuncture of art and migration can potentially be explored in myriad ways, as artists are often viewed to challenge frontiers and create spaces of in-betweenness and encounter that challenge hegemonic fixities. In this context, 21st century postcolonial East Asia may be regarded as a paradigmatic site to problematise the art world's only seemingly inclusive dispositive and the implicit expectations that artists from the region are confronted with on the global stage. Yang's sharing about the realities of the migratory experience, however, forces us to rethink the naive and bleeding-heart opportunism that largely dominates circulating narratives of the visual art as well as performing arts markets. Within the context of his work, unafraid of challenging institutional forces, he keeps returning to the crucial discussion of 'for what and for whom art works'. *The Past is a Foreign Country* essentially presents a narrative that expands the view of the gifted, visionary, internationally working artist; to include personal relations and the multifaceted responsibilities which they entail. Relocating, in this case, is less connected to a quest for becoming *visible*, but expresses a need for becoming *present* and *co-present*. Moreover, as the performance toured during the pandemic, *The Past is a Foreign Country* reflects how circumstances of COVID-19 magnified the challenges faced by anyone who had been used to realise their presence transnationally. People living and working between different geographies, in an interconnected world, were suddenly left with opaque hopes over when and how it would be possible to travel again. With the discourse of borders strongly linking to the exclusion of all that is foreign, hybrid forms of living became seen as threats to the carefully mediated construction of socio-political 'immunity'. This becomes especially evident as the Taipei performance is followed by the additionally created work *Dear Friend*. Yang performs live on stage and is joined online by Matsune from Vienna. They read out letters to one another, addressing their felt sense of loss of not

being able to meet. Matsune, who as a consequence of disease-prevention policies, had been unable to travel to Taiwan, becomes present only through his voice, describing his experience of the pandemic in Central Europe.

Both the lecture and letter forms that the artists chose for their performance make processes of knowledge formation (and transformation) visible and understood. Allowing for such constellations, Matsune and Yang's essayism harnesses concepts of interculturalism, geo-spatiality and separation, in interpersonal and playful scenarios. The performance, in this sense also documents how their biographies and life-itineraries have shaped distinct geographies of knowledge, to which the collaborative working dialogue serves as a sort of hermeneutic tool. While, certainly, the intention in this case, is not to impose a fictive sense of togetherness, as "kinship", [14] the content they decide to share rather turns to an understanding of and, perhaps, even commitment to 'Asianness' as a geopolitical responsibility. As Rossella Ferrari writes, it is "not just Western epistemological and economic privilege that demands scrutiny, but also the political economies and financial mechanisms whereby inter-Asian hierarchies of empire and capitalistic domination can become manifest". [15] In this regard, *The Past is a Foreign Country* and *Dear Friend* engage with the quest of decentralising and dislocating Western as well as Inner-Asian colonialist pasts.

I would like to end this essay on a personal note. Although we have a common connection through living, at least part-time in Vienna, I first met Jun Yang and Michikatsu Matsune in Yokohama. It was at the occasion of TPAM Performing Arts Meeting in February 2020 that we started engaging in conversation. Over many evenings, I have been lucky to continue this exchange with Yang in Taiwan, from where I returned to Austria later that year. I am thus especially grateful for having been asked to write about Yang's and Matsune's collaboration, to keep our conversation going and growing. Thank you for sharing your time and views on this interconnected world, dear friends.

1. See Derrida, Jaques. *The Politics of Friendship*. London: Verso, 2005.

2. Smith, Ali. "Rereading: The Go-Between by LP Hartley". *The Guardian*, 17.06.2011. https://www.theguardian.com/books/2011/jun/17/lp-hartley-go-between-ali-smith.

3. See McGowan, Tata M. *Performing Kamishibai. An Emerging New Literacy for a Global Audience*. New York/London: Routledge, 2015.

4. It is worth noting, however, that similar forms of vagabond-storytelling exist in many cultures. As Victor H. Mair pointed out, Buddhist folk literature from China, known as *pien-wen*, that has its origins in India as an oral form, used paintings as an aid for storytelling. He shows how the form influenced performance and literary traditions in India, Indonesia, Japan, Central Asia, the near East, Italy, France, and Germany. See Mair, Victor H. *Painting and Performance: Chinese Picture Recitation and Its Indian Genesis*. Honolulu: University of Hawaii Press, 1988.

5. McGowan, Tata M. *Performing Kamishibai*, p. 21.

6. See Vaupel, Angela (Ed.). *Borders, Memory and Transculturality: An Annotated Bibliography on the European Discourse*. Zurich: LIT, 2017, p. 85.

7. Dijstelbloem, Huub. *Borders as Infrastructure. The Technopolitics of Border Control*. Cambridge, MA: MIT Press, 2021, p. 62.

8. Weigelin-Schwiedrzik, Susanne; Linhart, Sepp (Eds.). *Ostasien 1600 - 1900: Geschichte und Gesellschaft* [East Asia 1600-1900: History and Society]. Vienna: Promedia, 2004.

9. See Sloterdijk, Peter. *Sphären III: Schäume, Plurale Sphärologie* [Foams: Spheres Volume III: Plural Spherology]. Frankfurt: Suhrkamp, 2004.

10. Dijstelbloem, Huub. *Borders as Infrastructure*, p. 129.

11. Hau'ofa, Epeli: "Our Sea of Islands", in *A New Oceania: Rediscovering Our Sea of Islands*. Waddell, Eric; Naidu, Vijay; Hau'ofa, Epeli (Eds.). Suva: School of Social and Economic Development, University of the South Pacific, 1993. Reprinted in *The Contemporary Pacific, 6*, 1994, pp. 147-261.

12. Werry, Margaret. "Oceanic Imagination, Intercultural Performance, Pacific Historiography", in *The Politics of Interweaving Performance Cultures: Beyond Postcolonialism*. Fischer-Lichte, Erika; Jost,Torsten; Jain, Saskya Iris (Eds.). London: Routledge, 2014, pp. 97-118.

13. Ambrosini, Maurizio; Cinalli, Manlio; Jacobson, David. "Introduction: Migration, Borders and Citizenship", in *Migration, Borders and Citizenship: Between Policy and Public Spheres*. London: Palgrave Macmillan, 2020, pp. 1-26, p.9.

14. See Ferrari, Rossella. *Transnational Chinese Theatres*. London: Palgrave Macmillan, 2020, p.11.

15. Ibid., p.10.

Jun Yang

Jun Yang is an artist based in Vienna, Taipei, and Yokohama. His works encompass various mediums – including, film, installation, performance and projects in the public spaces while addressing institutions, societies and audiences. Having grown up and lived in various cultural contexts, he examines the influence of clichés and media images on identity politics in his artistic work. Previous exhibitions in which he has participated include the Biennial of Sydney, the Gwangju Biennale, the Taipei Biennial, the Liverpool Biennial, the 51st Biennale di Venezia, and the Manifesta 4. Yang's most recent project was a series of solo exhibitions/retrospectives that started at the Art Sonje Center, Seoul (2018), continued at Kunsthaus Graz (2019), and then shown in Taipei at Kuandu Museum (2020), TKG+ Projects (2020/2021), and MoCA Taipei (2021). Yang decided thereafter to take 'off' from making exhibitions. With his interest in institutions, Yang joined the board of the Vienna Secession in 2021.

Michikazu Matsune

Michikazu Matsune is a performance-maker who develops works in his signature style that incorporates documentarist and conceptualist practices. He utilizes diverse approaches which range from stage-performances, interventions in public spaces, to creating text-paintings. His method, characterized by both playfulness and criticism at the same time, examines the tension around our cultural ascriptions and social identifications. Matsune is originally from the seaside town of Kobe and has been based in Vienna since the 1990s. He also teaches performance-practice and is currently a guest tutor at Art University of Linz and Iceland University of the Arts. Matsune has previously taught at University of Agdar in Norway, Hochschulübergreifendes Zentrum Tanz (HZT)/Universität der Künste in Berlin, and Salzburg Experimental Academy of Dance, among other institutions.

CHAPTER 3

MAPPING THE ART ECOSYSTEM

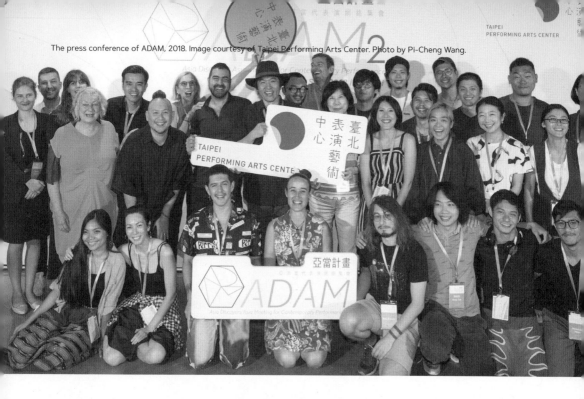

The press conference of ADAM, 2018. Image courtesy of Taipei Performing Arts Center. Photo by Pi-Cheng Wang.

Curating/Rethinking Arts Ecosystems in Asia with Networks and Gatherings

Rosemary HINDE

Networks and meetings have been a key driver of the development of the intra-Asian arts scene in recent decades. This article uses the concept of an ecology to chart the nature of their growth and change, and to consider current and future directions. It looks at the ways the ecosystem of arts practitioners, institutions, organisations and events, particularly in the performing arts sector, has interacted in Asia over this time, in the wider economic, social and political context of the region.

Ecosystems were originally defined in the mid-19th century by scientist/artist Ernst Haeckel, as the study of the relationship of organisms with their environment. Environmentalist writers from the 1960's applied the theory to species in a wider context. In his book *The Web of Life* (1997),[1] the great systems thinker Fritjof Capra focuses on the systemic information generated by the relationships among all the parts of the web-like structure of all systems and thus the interconnectedness of all parts. Ecology came to mean looking at changes in both internal relationships as well as external changes and shocks.

The concept of ecology has been applied to many areas of study including the arts, recognising that culture exists within a wider environment, and those internal relationships between the parts, and external shocks, influence each other. As John Holden wrote:

...culture exists within a wider political, social and economic environment with both proximate and remote connections. No account of the ecology of culture can be complete without recognising the broader contexts in which culture sits. [2]

Legacy of the 20th century

Coordinated performing arts networks have operated in Asia at least since the 1970's. However, two particular decades, the 1990's and the decade commencing 2010, saw the number of networks expand significantly. In both cases, this expansion was driven by the impact of major external events, or shocks, in the wider political, social and economic context in Asia.

The first such external shock came in the shape of an economic crash in the early 1990's in Japan where rapid economic growth had previously given the country a leading position in Asia. This was followed by a prolonged economic recession (1992-2000) which had a significant impact on the networks that

existed in the performing arts in Asia. Japan had been dominant in networks due to its economic power. Two immediate impacts were: closure of the first Asia Centre of the Japan Foundation and destabilisation of the only major presenter's network in the region at that time, the Federation for Asian Cultural Promotion (FACP), a network (largely focused on touring Western classical music) led by private promoters and headquartered in Japan.

Also at this time, the limitations of relying on the private sector to manage the arts became apparent and Asian governments began significant investment in arts infrastructure, mainly in venues. Unsurprisingly, the network to replace FACP as the predominant meeting in the 1990's was a network of public sector venues, the Association of Asia Pacific Performing Arts Centres (AAPPAC) established in 1996.

A mixed economy public/private model evolved, and this was the decade when many of the performing arts markets commenced operation. These included the Australian Performing Arts Market (APAM; 1994), Tokyo Performing Arts Market (TPAM; 1995), China Shanghai International Performing Arts Fair (ChinaSPAF; 1999) and continuing onto the early part of the 21st century, the Asian Arts Market in Singapore (2004-2009) and the Performing Arts Market in Seoul (PAMS; 2005).

Most of these meetings continued to be primarily transactional in nature at this time as they were initially influenced by markets in France (Marché international des arts de la scène, MARS) and Montreal (Conférence internationale des arts de la scène, CINARS). An exception was Little Asia Dance and Theatre Exchange Network which was a consortium-based network from 1997 to 2005 that started in Hong Kong and extended to Taiwan, mainland China, Japan, South Korea, Australia.

The second major shock was in 1997-1998 when the Asian financial crisis pushed the Asian economy into a deep recession, putting millions of people in Asia out of work. By September of 1997, contagion from Southeast Asia extended its reach to South Korea, Hong Kong and China.

Transition and reflection

Unsurprisingly, there was less confidence and growth in the early part of the first decade of the 21st century. This was a period of transition and reflection.

Many networks had arisen within a context of rapid economic, social and political development in Asia in the last decade of the 20th century. Taiwan and South Korea had shed military rule, Japan had fallen from economic power and mainland China had opened up and was beginning to rise.

Asia looked to have survived a major economic crisis. The formal networks that had been established in Asia until this point had been strongly influenced by European and North American models where the ecologies operated very differently. The first meetings had been established by Asian presenters who largely staged Western classical music. The networks served primarily to facilitate the buying and selling of this performance genre, whether via the private sector or public subsidised venues. The arts ecology of Asia did not fit easily with this model.

From 2005 to 2010, the European membership-based organisation, Informal European Theatre Meeting (IETM), held a series of satellite meetings in Asia as part of their international programme. These were undertaken in partnership with many organisations in Asia. IETM had made the transition from being a closed presenter-driven transactional network to being essentially a peer-driven network open to all in the performing arts.

The IETM satellite meetings were of interest to many meeting organisers in Asia due to the failure of the transactional model in these markets. While some players did consider starting an Asian version of IETM, this was never a realistic option. Asia does not have the shared political, economic and cultural infrastructure that underpins the European Union and strong touring markets.

Growth of infrastructure

From 2010 onward, many new and very diverse Asian regional networks, meetings and platforms began to emerge in the performing arts in Asia. Unlike the markets and meetings of the 1990's, the focus of these was less transactional and placed a greater emphasis on networking and general discourse about the performing arts. And importantly, the focus and content were Asian.

The growth in these meetings was driven by several factors. Once again, a rapid growth in performing arts spaces meant that venues became a significant part of the ecology.

In mainland China, approximately 2,000 performing arts venues have been built since the beginning of this century. But it was not only in mainland China where this growth occurred.

In Hong Kong, several new venues were built. The Tai Kwun-Centre for Heritage and Arts, at the time Hong Kong's largest ever historic building revitalisation project, transformed the city's former Central Police Barracks into a commercial and cultural space by restoring 16 buildings on the site and creating two new buildings.

The West Kowloon Cultural District Authority (WKCDA) was established in 2008 following extensive consultation with the community. Unlike Tai Kwun, this was a greenfield investment. Stretching across 40 hectares of reclaimed land, the West Kowloon Cultural District is one of the largest cultural projects in the world. It is planned to ultimately comprise 17 cultural venues. In 2019, the first of the venues opened – Xiqu Centre in January and Freespace in June. WKCDA organised Hong Kong Producers' Network Meeting and Forum (PNMF) from 2015 to 2018. The meeting aimed to have a particular focus on China, Hong Kong, Taiwan and Macau.

In Taiwan, several new and existing venues were opened or extended post 2010. The October 2018 opening of the National Kaohsiung Center for the Arts (Weiwuying) completed Taiwan's national umbrella organisation, National Performing Arts Center, incorporating Taipei's National Theater and Concert Hall and the National Taichung Theater.

The Taipei Performing Arts Center (TPAC) is a cultural and theatrical complex located in Shilin District, Taipei, Taiwan. The project is being undertaken by the Department of Cultural Affairs, Taipei City Government, to promote the development of local performing arts groups and to strengthen Taipei's image as an international cultural hub.

As the Center is an administrative legal entity supervised by the city government, it also manages several large cultural projects including Taipei Arts Festival, Taipei Fringe Festival and Taipei Children's Arts Festival. The team was already networked with many artists and institutions in Taiwan and abroad.

Programmers for these new venues were interested in alternative ways of

programming and organising performing arts institutions and saw their roles as being part of the performing arts ecology in the Asian region.

Changes in the ecology post 2010

There were four major changes to the performing arts meeting ecology post 2010. These were: the instigation of new meetings, change in purpose and format of older generation meetings, the addition of sidebar meetings alongside performance platforms (HOTPOT, Liveworks, City Contemporary Dance Festival Hong Kong, Yokohama Dance), and the growth of professional development networks.

1. New meetings

In 2017, TPAC launched an annual programme, Asia Discovers Asia Meeting for Contemporary Performance (ADAM), dedicated to fostering cross-cultural and trans-disciplinary exchanges between artists from across the Asia-Pacific region and beyond.

Where most other meeting programmes focused on presenters, producers and curators, ADAM focused on artists and artistic processes. It hosted an annual one-month residential Artist Lab. Participants were selected by an open call for artists to meet, exchange ideas and invent new collaborative possibilities. Following the residency, artists were invited to publicly share their research with both local and international arts professionals and audiences at the Annual Meeting programme.

The very specific focus of ADAM gave it a unique position within the performing arts ecology of Asia.

Bangkok International Performing Arts Meeting (BIPAM) was another new meeting. It emerged in 2017.

BIPAM, like Singapore before it, with its central location in Southeast Asia, is a convenient destination for artists, practitioners, and academics in the region to gather and exchange. BIPAM aspires to become a gateway for the world to explore Southeast Asia as well as for the local community to expand, learn and grow. The organisers of this meeting work closely with their artistic community to jointly present an annual meeting and platform. There is

considerable interest in this meeting from Europe and Asia, but it has been organised with very few financial resources.

2. Transformation of older generation meetings

Post 2010, several meetings that had been established in the 1990's or early 2000's underwent significant change. This change was reflected in 2010 with TPAM changing its purpose, name and location. 'Market' became 'Meeting', and it relocated to Yokohama, becoming arguably the largest and most influential performing arts meeting in the Asian region during this period. In this decade, the Japan Foundation re-established the Asia Center in 2014. Its focus was on ASEAN countries, and TPAM was funded to programme works from these countries and as a site for delegates from these countries to attend up until 2020. For the previous five years, TPAM had been strongly influenced by Europe and, to a lesser extent, North America and North Asia. TPAM became a site for multiple purpose meetings by presenters, artists, producers, academics and other arts organisers from around the world.

Ten years later (2020), APAM would also change its structure and format from a biennial market style event to a year-round series of meetings that moved location to different Australian cities. PAMS, which had for the previous ten years been focused on Korean artists and new markets, incorporated a PAMS 'Salon' for discussion of contemporary issues.

3. Sidebar meetings alongside performance platforms

In addition to the occasions labelled as 'Markets' or 'Meetings', it became more common in the past decade for performance programmes, often niche festivals, to develop an adjoining exchange platform. These events targeted and invited presenters from around Asia and the world with a specific interest in the genres of works presented at the performance programme.

For example, from 2015, Performance Space in Australia has been presenting Liveworks Festival – a festival of experimental arts from the Asia Pacific region. To the performance programme, it added both an artist's Lab and an exchange meeting of invited international delegates. Liveworks linked into the loose network that was forming around TPAM and ADAM.

Inspired by the concept of Ice HOT in the Nordic countries, HOTPOT was a

consortium of dance presenters from Japan, South Korea and Hong Kong. These were: Yokohama Dance Collection, Seoul International Dance Festival and City Contemporary Dance Festival. The platform rotated between the three different locations and invited presenters from around the world. These meetings of presenters became a networking base for many contemporary dance presenters.

Kyoto Experiment, a highly regarded festival in Kyoto, has intermittently organised sidebars for international delegates since 2015, always attracting an international following due to the calibre of the artists presented and the lure of Kyoto as a destination for international guests.

4. Professional development meetings and networks

Post 2010, many single artform and/or professional development networks were established that also became part of the arts ecology in Asia. These organisations were largely invitation-only, but most had a public facing meeting once a year. They responded to new areas of interest in the performing arts in Asia such as dramaturgy, producing, circus and contemporary dance.

These networks include Asian Dramaturgs' Network (ADN), Asia Network for Dance (AND+), Asian Producers Platform (APP) and Circus Asia Network (CAN).

Impact on the performing arts ecology of Asia

Due to the growth in the number of meeting points in the decade, 2010-2020 witnessed an unprecedented number of opportunities for Asian artists and arts workers to meet each other.

Many people attended multiple meetings as interests intersected between the various gatherings and network groups. The exchange of people and ideas was fluid. In Asia at least, it appeared that Holden's culture of the future had already arrived:

Culture in the future is more likely to be described in terms of fluid movements and startling shifts: someone who creates followers through one activity might follow it up not with a similar activity, but a different activity with the same followership. 'Likes' and 'Followers' will come

together and fall apart, creating temporary cultural moments in new ways, and a new language is already emerging to describe them: pop-ups, mash-ups, Instagram. [3]

The meetings of this decade disrupted the power dynamics of previous eras. In turn, this changed the relationship between small players and large institutions, and artists and presenters. Many artists found it easier to meet both other artists and presenters at these meetings as the power hierarchy of the market was disrupted. It was largely personality-based rather than predicated on position in a hierarchy. Were these meetings more democratic? Some were, and some were not. The removal of hierarchy may change the power relationships, but it does not eliminate them. In some ways, all networks have an inside and outside layer, and those that formed post 2010 were similar in this way.

However, access by smaller players and interaction between players of different sizes was more possible. From these networks, new relationships were formed that would not have been as likely in the more hierarchical era that preceded them. Many of these meetings were led by presenters with backgrounds as artists, and many artists are also self-presenters and producers in Asia. The borders between roles were blurred. The focus was on shared values and aesthetics.

Many of the participants in these networks had considerable international experience and actively wanted to develop networks in the region that suited their particular circumstances and promoted and developed opportunities for artists in Asia, which they knew were very different to Europe or the U.S.

Climate change, pandemic and the future

Just as external shocks changed the previous eras of meetings in the 1990's, the post-2010 era was to experience an even bigger shock in the form of the COVID-19 pandemic.

In the 21st century, networks and meetings operated on the basis of unprecedented physical mobility within Asia resulting from cheap air travel, growth in open-minded and well-resourced institutions and use of new technology. But for all in the arts, and particularly those whose primary rationale was international, the years 2020-2022 would prove to be challenging.

While climate change hovered in the background in the decade 2010-2020, it did not stop that quick weekend visit to Shanghai or Taipei. The idea of using technology via platforms such as Zoom to reduce the amount of travel was less of a priority than finding the resources to keep travelling.

The impact of the pandemic world-wide has also had the effect of pushing to the foreground the implications of climate change. The elephant in the room has been named.

It may be that travel will be less frequent due to the consequences for climate change, added level of complexity and cost due to post-COVID restrictions. The last-minute spontaneity of travel may be reduced, and travel will be more strategic at least in the early post-pandemic stages.

Meetings and platforms have historically had a significant impact on the performing arts ecology in Asia. They will continue to play an important role, and their formats will continue to adapt to the wider context in which they operate, just as they did in the previous century.

The model of not only meetings, but international touring, production and exchange, will operate very differently with technology continuing to play a key role. TPAM has become YPAM, and ADAM has completed a five-year cycle. The networks continue to evolve.

Live (IRL) connection will remain important, but the pandemic has shown us that it is not the only way to remain connected. All the meetings that were initiated in 2010-2020 have continued post 2020. Meetings and platforms that offer both live and online options will enable more people (i.e., those who cannot travel) to connect. They will also facilitate more frequent connection in either format and, arguably, greater access by people who cannot travel, such as carers of children, disabled artists and artists who lack the financial means to travel. The networks and the ecology may become more diverse as a result.

The combination of more strategic travel to IRL events, coupled with more online components to meetings, can facilitate more borderless networking for the exchange of ideas and for a wider range of people. This will be true for artists as well as presenters and producers. Online will not replace IRL, but it will complement it and the two elements will strengthen networks and

knowledge of Asia amongst participants. Networks in Asia have never been stronger or deeper.

1. Fritjof Capra. *The Web of Life*. New York: Anchor Books, 1997.

2. John Holden. *The Ecology of Culture: A Report commissioned by the Arts and Humanities Research Council's Cultural Value Project*. Arts and Humanities Research Council: Swindon, 2015, p. 22.

3. *The Ecology of Culture*. Ibid, p. 5.

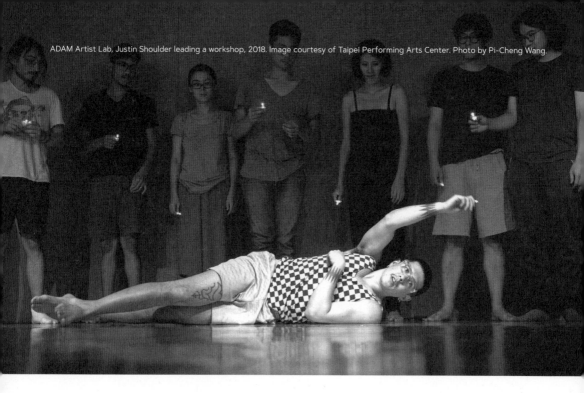

ADAM Artist Lab, Justin Shoulder leading a workshop, 2018. Image courtesy of Taipei Performing Arts Center. Photo by Pi-Cheng Wang.

The Lab-ing Must Go On...

Ding-Yun HUANG

Translated by **Cheryl ROBBINS**

The term 'Asia' is often polysemic and ambiguous. If we go a step further to portray 'Asian performing arts,' what often comes to mind generally are traditional music, dances, theater and operas. Consequently, 'Asian contemporary performance' is even more complex to describe. For a long time, in Taiwan, whether in terms of cultural policy, institutional practices, or the work of artists, it has been difficult for 'Asian contemporary performance' to break away from the Eurocentric point of view. Even creators who were born and have mostly worked here evoke a sense of the exotic when presenting 'Asia.' This latent post-colonialism is manifested in concrete and subtle ways in how artists describe the context of their works and the intensity of collaborations among Asian performing arts organizations. [1]

The ambiguity of Asia between individuals

It is clear that the first edition of ADAM Artist Lab had put the role of artists in the spotlight of artistic production and the arts market by looking at the research process and potential collaboration between invited artists from across the Asia-Pacific region. [2] The composition of participating artists was half Taiwanese and half international, and during the Lab, it became evident that the Taiwanese artists were unfamiliar with the context and scene of Asian performing arts/performance. In contrast, many of the non-Taiwanese artists held broader knowledge of and wider networking experiences with the Asian arts ecosystem. Therefore, the Taiwanese artists were somehow less confident or engaged in getting to know each other and thought exchange. It actually reflected the urgency for Taiwanese artists in general to deepen our understanding of 'Asia' through this Lab.

The international artists allocated their time especially to attend the Lab. In contrast, most of the Taiwanese artists were juggling projects and productions simultaneously, causing a bubble to form around them. I then realized embedded engagement would matter significantly in terms of what we would take away from the Lab, and so proposed to stay with Thai artist Henry Tan as his roommate in order to spending more time together, whereas my other Taiwanese peers usually stayed at their own place during the residency program when they were off from work. I made the right decision. After working through a packed daily agenda, chit-chat between Henry and me continued late into night. Our conversations were not only about work, but also whatever was happening in our lives, as well as culture, society and politics. Those relaxing and perhaps aimless exchanges actually nourished

193

our friendship and collaboration.³ I also learned much and gained a better understanding of my local city through the foreign lens of my international fellows. Arguably, when it comes to (re)visiting Taipei, the perspectives between our respective extended cultures have been, in fact, intertextual instead of individual.

A multi-perspective, nudging environment

What has characterized the Artist Lab throughout various editions is that participating artists (not limited to Taiwanese nationality) would have the opportunity to become guest curators and facilitators for its next iteration. Different from normative working patterns which divide the roles of curators and artists, Artist Lab intentionally blurs the boundaries, enabling artists to curate Artist Lab and lead its direction. In addition, the notion and practice of 'co-curating and co-facilitating' has also featured in the form of an artist-led curatorial team since the second edition. As such, artists are empowered to build long-term and evolving relations with this residency program and their old and new fellows, collectively and continuously.

When Tan and I co-curated the 2018 Artist Lab, for which we attempted to accommodate our shared interests and to think about the scenarios and conditions that benefit artists, our roles and perspectives shifted from that of artists to curators. For example, Tan proposed "leaving Taipei" during the Lab, as foreign visitors usually prioritize the capital as their destination. He then grew curious about exploring what Taiwan would look like from a non-Taipei-centric perspective. This proposition reminded me that while I interpret and label myself as a Taiwanese artist, all my personal experiences are in fact rooted in Taipei, and even unconsciously embedded with Taipei-centric notions. We eventually organized a trip to the city of Yilan to enable Lab members to learn from other kinds of local cultural contexts and ethnic migration histories. For the participating artists, this resulted in eliciting questions of belonging and ownership between places and cultural groups that are perpetually ambiguous and context-dependent.

Viewpoints shift not only because of cultural differences, but also through the process of co-facilitating enacted by co-curators. As Natsuki Ishigami, the guest curator of the 2019 Artist Lab, ⁴ recalls, "Among the three of us, Szu-Ni was like a father, always energetic and taking everyone here and there. JK was like a mother, gently providing suggestions and methods. I was like a

bystander, calmly watching everyone's organic process of research and collaboration." Carefully curated company, dialogues and exchanges serve as the foundation that supports the Lab's agenda. It is clear that neither 'mentorship' nor a packed itinerary is critical to the creative process in artistic production. Instead, creating a framework enabling multi-layered discourses in flux is what matters.

The creative process is often complicated and spontaneous. Most of the time, it does not follow the tentative itinerary. Artists have their individual rhythms, as well as specific aesthetics. The hybrid composition of artist-curators and facilitators circumvents the closed-door circulation of thoughts, and takes care of the artists' human needs, as well as their physical and emotional conditions, via a peer-to-peer approach rather than a top-down curator-artist model.

When artists return to curate the Artist Lab for new fellows, their production becomes about creating an ideal environment for artmaking and housing collectivity. Wen Szu-Ni, the facilitator of the 2019 Artist Lab, recalls, "It was challenging to form a group of artists into a collective in terms of further acquaintance and shared understandings. Meanwhile, our task was to connect this group with community members from various social groups." This statement confirms that the creative process cannot be formed without immersive settings for artists to take time to explore. In Artist Lab, exploring together what constitutes the immersive has become crucial.

In general, curator-facilitator meetings are held daily during Artist Lab to discuss how to "nudge" [5] artists into further engagement with research processes and practices. It includes, for instance, observing how artists interact with one another and respond to the theme of the Lab through the daily agenda; giving time and space to allow artists with similar interests to connect with one another; hosting check-in and check-out moments every day for artists to share their feelings, observations and findings.[6] The task of curator-facilitators revolves around paving the way for artists to navigate freely, catalyzing new ideas and, at the same, mediating agendas between the artistic process and institutional expectations. In other words, facilitating 'hangouts' between artists to be productive in a relaxed and open-ended way is their duty of care.

Developing a joint outlook

The direction or theme of each iteration of Artist Lab has been conceived through the invited curators' reflections on their previous participation. This flow shows how artists continue and transform their shared artistic concerns into curatorial practices for further development.

In 2018, the theme *Performativity of the In-between* questioned what performativity in everyday settings is, as well as how performance and performativity are signified individually and in relation to each other, suggesting how the notion of performance wanders in the grey zone between real life and its representation. In 2019, *Performing (with/in) communities: Relations, Dynamics and Politics* emphasized the aspects of facilitation and ethics when artists enter a collaborative community or venue. In 2020, the theme was *An Internet of Things*, [7] with which came the expansion of observations and reflections on artist networks and an emphasis on the possibilities of working together. Throughout the trajectory, the theme of each iteration has been connected sequentially to extend an avenue of thought for circulation.

With this in mind, I have found that the thoughts and practices of the artists have also cultivated a shared vision which imagines a decentralized Asian network, and connections to that sustains the future of the arts.

For me, the intention of ADAM was to address geopolitical problematiques and, arguably, to piece together a constellation of Asian contemporary performance from its fragmented and ambiguous parts in various places and regions. However, this constellation is not informed by perspectives of linear history, but through continuous communication and negotiation between the artists, as well as gradual accumulation and formulation during Artist Lab.

How long is enough?

In addition to the curatorial connections between each iteration of Artist Lab, artists who present ideas or works in progress also have the opportunity to enroll in the next edition of ADAM to further develop their work and connect with this growing network. [8] This design is instrumental because artists would realize their involvement in ADAM is not a one-off touristic affair. There is an invitation for building relationships with this platform. Therefore, with each

encounter comes new imaginings and findings, and artists are encouraged to play a part in building this networked body of 'our Asia.'

If Artist Lab only focuses on 'production' resulted from a two- or four-week residency, it will frustrate artists as expectations will not match the given conditions. Today, cultural and artistic production goes beyond an artwork itself – the building of cultural infrastructure also concerns networks, gatherings, communication and co-working. Once the Artist Lab residency comes to an end, what is more important is how artists would continue networking and forge longstanding friendships. When a creative seed has been planted between artists for potential collaboration, it needs cultivation to grow. Institutions play a key role here: they need to follow up by organizing informal gatherings, take care of the artists' post-Lab creative process and provide next-stage support for the individual phases of their works in progress.

Artist Lab is where the relationship between artists, and that between artists and institutions, begin. In order to create an Asian landscape of our own, let us keep lab-ing: take it slow and steady, and always be open to understanding and learning from each other.

1. For decades, cross-cultural, Asian, and local discourse has been part of mainstream practice across various fields, with a clear shift in direction within Taiwan's performing arts field. However, performing arts venues and organizations still invest much of their resources in 'representing and introducing' mostly European (Western) works, while paying relatively little attention to Asian performing arts.

2. Most of the invited artists work and live in the Asia-Pacific region. However, they may originally be from another region or have a different cultural background.

3. Henry Tan and I served as guest curators and facilitators during the second (2018) Artist Lab. In 2019, we collaborated on *IsLand Bar (Taipei): Sweet Potato Affair* for the Taipei Arts Festival and presented *The Song of Naga Cave* during ADAM's Kitchen and at the Wonderfruit Festival in Pattaya, Thailand. We continue to collaborate and to develop new projects.

4. The guest curators and facilitators of the third Artist Lab were Natsuki Ishigami of Japan, Wen Szu-Ni of Taiwan, and JK Anicoche of the Philippines.

5. Nudge theory is widely used in psychology, economics, politics, and design. Through positive reinforcement and indirect suggestions, the behavior and decision-making of groups and individuals can be influenced. This differs from other ways to achieve compliance such as enforcement and legislation.

6. Artists gather at a fixed time every day to talk about their progress, observations, and thought processes in addition to the workings of the group and program arrangements. On the one hand, this strengthens the sense of participation and enables artists to understand one another's progress and thinking. On the other, a question that is brought up by one artist may strike a chord with their peers. In this way, diverse feedback and solutions are proposed.

7. In 2020, due to the COVID-19 pandemic, Artist Lab was combined with the Meeting to be an online program titled *An Internet of Things*; and in 2021, Artist Lab was adjusted to a new facility for Taiwanese artists to study local culture named *Shihlin Study*.

8. For example, the development of *IsLand Bar* during the first Artist Lab and *Paeonia Drive* during its second iteration.

Call and Response: A Practice in Dialogue, an Exercise in Imagination, a Rehearsal for a Different Future—A Look Back on Drama Box's IgnorLAND of its Loss

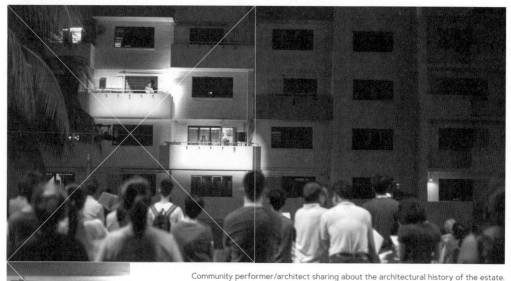

Community performer/architect sharing about the architectural history of the estate.
©The Pond Photography/Drama Box

Xuemei HAN

When people ask, 'What do you have in Singapore?', what do you tell them? In my opinion, a lot of Singaporeans cannot tell these stories... it's very unfortunate for us... so we have to learn to keep heritage, to have a kind of belonging, [but] we tear down all the old buildings, we don't reimagine them. [We need to] reimagine, then we can do something to keep this place alive.

—————*Bilyy Koh, former resident of Dakota Crescent and community performer for IgnorLAND of its Loss (2016)*

Singaporean society is generally disconnected from the land and environment we reside in. This disconnect can be associated with a history of erasure brought about by our colonial past and nation-building policies since the post-independence period from 1965. These policies [1] enabled state control and regulation, and often prioritised 'national interests' such as economic progress and security at the expense of nature, heritage, people and freedom of expression. On one hand, this emphasis on economic development alongside the rapid modernisation of the island has contributed to a sense of indifference towards our land and an unhealthy reliance on the government to make decisions; on the other, ground-up attempts to create meaning and connection with our environment in public spaces that are deemed 'threatening' and/or 'offensive' by the government have either been censored or disallowed.

Against this backdrop, Drama Box has continuously created works that address and respond to this environmental and cultural disconnect and displacement. "Founded in 1990, Drama Box is a socially-engaged theatre company based in Singapore known for creating works that inspire dialogue, reflection and change" (Drama Box). Over the years, Drama Box has evolved from creating socially conscious Chinese language theatre plays to developing a socially engaged practice that tends towards processes and projects that are more participatory and cut across language, discipline, sector, as well as culture.

Drama Box's approach towards community and social engagement is shaped by an ethos and aesthetics of "call and response, [which] translated to engaged performance, foregrounds the many opportunities for interactivity between a theatre artist and the people involved in the situation in question. These exchanges happen at various points along the performance process: the early phases, especially research and devising, or perhaps a workshop not intended to lead to anything else; the duration of the play itself; and the

period following, whether a talkback conversation, story circles, or more long-term actions that the production supports or inspires. The process is iterative: the call may be initiated from a community, and the response may come from an artist, who then sets forth a new call directed to an audience" (Cohen-Cruz, 2010).

In this article, I reflect on how this "call and response" is practised using *IgnorLAND of its Loss* (2016) as a case study.

Phase 0: Deciphering the call

The *IgnorLAND* series is a site-specific promenade theatre programme designed to excavate shared memories and unknown or forgotten stories of a place. The name 'IgnorLAND' is a combination of the words 'ignorant' and 'land'. First conceived in 2007 by Kok Heng Leun, then Artistic Director of Drama Box, the first two projects – *IgnorLAND of its Name* (2007) and *IgnorLAND of its Desires* (2009) – brought audiences to selected locations in Singapore, where they uncovered memories and stories of these places through plays performed by theatre actors.

From the third project, *IgnorLAND of its Time* (2014), then Associate Artistic Director of Drama Box Koh Hui Ling took a different approach towards the process of research and creation with the intention to explore ways of involving and engaging the communities in the selected locations on a deeper level.

In 2013, Hui Ling and I had the idea of creating a new *IgnorLAND* project in Dakota Crescent, a public rental housing estate located in South-Eastern Singapore, because we were drawn to its unique architecture and spatial environment. Before we could start, the government announced at the end of 2014 that Dakota Crescent would be redeveloped and the residents were to relocate by the end of 2016.

The first instinct at that moment was to kickstart the project in response to the announcement. However, the announcement had also attracted the attention of various parties ranging from heritage advocates to social media influencers who used the estate as a backdrop for their photoshoots. At one point in time, one could find multiple activities happening concurrently in the estate – guided trails by ground-up community groups, education tours

organised by schools, filming and photoshoots by various groups of people, and even a concert held at one of the blocks. Everyone had something to say or wanted to do something about Dakota Crescent, so the question for us in that situation was whether a call existed – was there even a call that required our response? We decided that we could not know without first getting to know the community better.

At the start of 2015, we carried out on-site visits to Dakota Crescent to understand the community, the concerns and issues, as well as perspectives that are under-represented – in other words, to find out what was happening on the ground and what was hidden beneath it.

On-site observations and conversations with the people we met during our visits, along with secondary research about the history of the estate, helped us identify several dimensions to the situation:

(i) **Place (history and heritage):** As the estate was the last remaining housing estate built by the British prior to Singapore's independence, it was unique both for its history and architectural significance, leading to calls for its conservation.

(ii) **People (displacement and resettlement):** At the time of the announcement, the estate was approximately 60% occupied, and home to mostly lower-income, elderly Chinese residents. What were the relocation and resettlement plans? How would the residents' lifestyles and existing relationships be affected?

(iii) **Process (decision-making and communications):** There was a lack of engagement and transparency from the authorities prior to the decision as well as after the public announcement. Why was there a need to redevelop Dakota Crescent at that time? What research and engagement had been conducted before and after the decision was made? Who was included and excluded from this process? What were the redevelopment plans for the estate?

We also observed that the existing attention and activities surrounding Dakota Crescent had been largely focused on its heritage and history, while media reports profiled selected residents with interesting stories to share. There was a general sense of acceptance and efforts were inclined towards

documentation and reminiscence. Perhaps then, there was a call for a narrative that could present a more layered perspective of the situation in a visceral way that also invited imagination, and *IgnorLAND of its Loss* could become our response to this call.

Phase 1: Building relationships & uncovering perspectives

The first phase of our response focused on building relationships with the local community as well as other stakeholders outside the estate. This relational aspect of our work lays the foundation for the call and response approach to be iterative. Without this relationship-building process, it is easy for artists to initiate irrelevant calls that the community does not respond to.

Usually, there are two aspects of this relationship-building work: (i) building spaces and opportunities to strengthen community relationships; and (ii) connecting with the community in order to understand them better. In the case of Dakota Crescent, our focus was more on the latter for two reasons – the community was potentially going to be broken up due to the relocation and, thus, it would be more meaningful and sustainable to leave community-building work to after the relocation; given the short amount of time we actually had for the project, the more responsible thing to do would be to focus on gathering perspectives that would present a layered account of the situation, and to do it in a way that would involve the community as deeply as possible.

1.1 Hello Party
To start off, we organised a 'Hello Party' that served to introduce the project team to the residents. This official introduction was important as it provided an opportunity for us to explain our 'outsider's presence' in their space. This was our way of showing respect towards them, and was especially crucial at a time when they were receiving so much attention and the presence of strangers was a regular occurrence.

1.2 Community Workshops
We also organised workshops to gather the residents' perspectives and stories. These workshops were developed in response to the earlier groundwork we had done. For example, one of the earliest community gatekeepers we discovered was the Centre Manager of Tung Ling Community Services, a voluntary welfare organisation that had been serving the residents

for almost 15 years. Through him, we found out the residents' concern that they could not start packing for the relocation as they did not know how much smaller their new apartments would be. In response, we conducted a workshop where the residents could use a life-size floorplan of a studio apartment, as well as photography, to help them visualise and start thinking about things that they wanted to bring along.

Our earlier work on the ground not only helped us respond to existing needs, but also encouraged us to identify and excavate under-represented perspectives. Although it was well known that the estate housed mostly elderly residents, our encounters with the children around the area prompted a series of workshops that focused on engaging with them. Led by Lin Shiyun, these sessions invited the children from and outside of the estate to freely play and imagine alternative forms of existence for Dakota Crescent. Their creations eventually became a part of the performance.

1.3 Community Performers

This process of building relationships and engaging with various stakeholders also facilitated our work in identifying people who desired and were able to share their stories and perspectives with a public audience. We conducted in-depth interviews with them so as to shape their 'scripts' together.

Phase 2: Inviting public conversation & imagination

The engagement with the community in the previous phases of the project culminated in a site-specific promenade theatre experience in July 2016.

It was framed by a fictional narrative about two characters dealing with the emotional implications of the relocation and redevelopment of the estate where they grew up. Integrated within this frame were stories told by the community performers, as well as interactive activities and video projection.

The content was drawn from the interactions with the community. For example, different residents mentioned on separate occasions that the balcony was something they will miss after the relocation. This led to an activity during the performance that invited the audience to design their own mini 'balconies' to be attached to 3D models of the iconic blocks in the estate.

The audience, who were mostly 'outsiders' to the estate, navigated the

performance themselves using a programme guide and following the cues given by the performers.

The theatre performance was significant to the project in a few ways:

(i) **Community Self-Representation:** The performance created a space for the community performers to share their stories, perspectives and questions directly with a public audience, and through that, participate in cultural democracy whereby they were able to present dimensions to the issue that were not prominently featured on mainstream platforms. For example, resident/community performer Bilyy Koh shared his thoughts on the importance of preserving "layman's heritage" – history that belonged to the ordinary people – while another resident/community performer Low Shui Lin highlighted the trees and their unique presence in the estate.

(ii) **Collective (Re)Imagination:** Besides allowing space for expression of stories, the performance also invited the (re)imagination of possibilities for the estate. Architect and founder of the Save Dakota Crescent group Jonathan Poh intended to use his segment to gather public input that could contribute to the Conservation Report to be submitted to Parliament. He asked the audience for suggestions, stating that "housing is always about people", to which the audience responded by discussing about the river beside the estate and the open courtyard spaces that are rare in newer housing estates.

Phase 3: Leaving & expanding dialogue

3.1 Goodbye Party
Finally, upon the conclusion of the performance, we organised a 'Goodbye Party' as a way to thank the community for their generosity in welcoming us and participating in the process.

While the fight for the conservation of the site continued with the team working on the Conservation Report, and the welfare of the residents were being taken care of by the volunteer-led resettlement team, we as theatre practitioners also had to contemplate the question of 'what happens next?'. How do we build on this project to extend the public conversation on land and displacement?

3.2 *The Lesson* (2015-2020)

At the beginning of the planning for *IgnorLAND of its Loss*, there had been a curatorial decision to restage *The Lesson* – a participatory performance that consisted entirely of discussions amongst members of the public involving decisions about land use – in the following year to continue public dialogue.

First conceived of and presented as part of *It Won't Be Too Long*[2] at the 2015 Singapore International Festival of the Arts by Li Xie and Kok Heng Leun, *The Lesson* is a participatory performance that sets up a public conversation about land and development.

Participants are made up of two groups of people: (i) those who sign up to be 'The Residents' prior to the performance; and (ii) those who register to attend the performance as 'The Public' on the day itself. At the performance, they are introduced to The Town and a situation where the government has decided to build a new MRT station there. In order to make space for it, The Residents and The Public have to discuss and vote for one out of seven sites to be evicted and demolished. The seven locations, namely the marsh, cinema, columbarium, flea market, halfway house, rental flat and wet market, were curated and designed based on actual sites in Singapore. During this process, there are panelists made up of actual social, community, heritage and nature workers who contribute to the discussion, and facilitators who manage the flow and decision-making process.

In 2017, following the situation surrounding Dakota Crescent, *The Lesson* toured to three locations in Singapore – the shopping and night life district of Bugis, as well as the residential neighbourhoods of Toa Payoh and Hougang.

The Lesson is both a critical thinking exercise about land contestation and a physical practice in public dialogue and a democratic decision-making process. As Akanksha Raja summed up in her review of *The Lesson*, "Drama Box situates a microcosm of actual society in *The Lesson*. It therefore realises the intermingling and contesting needs of diverse communities that coexist in a town or in a country – the lower-income, migrants, ex-convicts, even the biodiversity of marshland critters that have no agency of their own. Each performance of this show is unpredictable in process and outcome because audiences are varied… In any case, every attendee is given an opportunity to speak, make their case, persuade others, or change their opinion before casting their final vote, in an exercise in transparent democracy."

A practice in dialogue, an exercise in imagination, a rehearsal for a different future

The environmental and cultural disconnect is an ongoing issue to this very day. Since the entire journey of *IgnorLAND of its Loss* concluded in 2016/17, the former residents of Dakota Crescent have relocated – some have passed on, while some still struggle to resettle; several other residential estates and iconic buildings have either been demolished or vacated for redevelopment; precious plots of forested land have even been cleared by mistake...

While socially engaged theatre cannot reverse these actions and may not directly prevent future decisions, it is important as a practice in dialogue, an exercise in imagination, and a rehearsal for a different future – one where people are not disempowered from caring and telling their stories; where economic growth is not the primary motivation and consideration that overrides everything else; and where the paradigm shifts away from the polarising narrative of 'trade-offs' towards symbiosis. This rehearsal is not without the challenges and questions that come with any socially engaged work that deals with relations and aspires towards change. Whose voices are included/excluded in the process? How much time is truly enough for the artistic intervention to be meaningful to the people involved? What if the artistic intervention does not seem to bring about any concrete change to the situation?

In the case of *IgnorLAND of its Loss*, while it ultimately cannot claim to be influential in altering the fate of Dakota Crescent and its former residents, its significance probably resides in the spaces and time it made for community, intersectoral and public dialogue on the immediate situation of relocation and long-term issue of development and displacement. It also created spaces and time for the (re)imagination of possibilities – what if we took time to listen to the sentiments on the ground? What if we could conserve parts of Dakota Crescent? What if we could collectively come together to discuss what matters to us, how we want to use our resources, and how we can co-exist with our environment? In Singapore's context, where such spaces and time are increasingly being stifled by various factors including state control and economic pressures, perhaps theatre remains one of the few domains in society that can still afford to dream.

In this sense, *IgnorLAND of its Loss* has achieved an important goal of socially

engaged theatre outlined by Cohen-Cruz, where "the process brings a community together for both political and spiritual reasons – political because it provides a way for a group of any status to participate in a public discourse about issues that affect their lives; spiritual because a purpose is embedded in the process and goal of such work that goes beyond material results and day-to-day existence. Both the political and spiritual provide models of how we live together, suggesting something bigger than our individual selves".

Girl: Do you know how the pathway on the grass patch between Blk 2 and the MRT station was made?

Boy: I know, it's because we take the same route every day, day by day, the same people walked the same way until the path was made.

Girl: So every day we chose to walk that path instead of the lane that was made for us.

Boy: Because that's the fastest and shortest way.

Girl: So we defied the rules, and we made the shortest path all by ourselves.

Boy: Because that's the practical thing to do.

Girl: But also because we knew what the best path was. We didn't need anyone to tell us.

———————————————— Excerpt from IgnorLAND of its Loss (2016)

1. Examples of policies and legislation include the Land Acquisition Act, the Public Order Act and the Public Entertainments Act.

 The Land Acquisition Act was "introduced on 17 June 1967 to provide the government with the legal framework to acquire private land compulsorily at market prices". By 1985, the government became the biggest landowner, owning 76.2 percent of land in Singapore (Oon & Lim, 2014).

 The Public Order Act was enacted in 2009 "to regulate assemblies and processions in public places, to provide powers necessary for preserving public order and the safety of individuals at special event areas, to supplement other laws relating to the preservation and maintenance of public order in public places" (Singapore Statutes).

 The Public Entertainments Act was enacted in 1958 "to provide for the regulation of public entertainments" and stipulates that all public performances and events require the application and approval of the Public Entertainment License (Singapore Statutes).

2. *It Won't Be Too Long* is a project that explores the dynamics of space in Singapore. It blends performance and participation in two arts projects, *The Lesson* and *The Cemetery*, whereby the latter is made up of a movement performance and a verbatim theatre play responding to the proposed exhumation and redevelopment of a part of Bukit Brown Cemetery.

References

Shaun Oon & Lim Tin Seng (2014). Land Acquisition Act. Singapore Infopedia. https://eresources.nlb.gov.sg/infopedia/articles/SIP_2014-04-09_112938.html

Public Order Act (Chapter 257A). Singapore Statues. https://sso.agc.gov.sg/Act/POA2009

Public Entertainments Act (Chapter 257). Singapore Statutes. https://sso.agc.gov.sg/Act/PEA1958

Drama Box – About Us. http://www.dramabox.org/eng/about_db.html

Jan Cohen-Cruz (2010). *Engaging Performance: Theatre as Call and Response.*

Akanksha Raja (2017). *Drama Box's "The Lesson": Rehearsal for Life.* Arts Equator. https://artsequator.com/dramabox-the-lesson-2017/

Drama Box

Founded in 1990, Drama Box is a socially-engaged theatre company known for creating works that inspire dialogue, reflection and change. By shining a spotlight on marginalised narratives and making space for the communal contemplation of complex issues, it seeks to tell stories that provoke a deeper understanding of Singapore's culture, history and identity.

Drama Box is a charity and Institution of Public Character (IPC) registered in Singapore, supported by the National Arts Council under the Major Company Scheme for the period of April 2020 to March 2023.

KOREOGRAFI, An Indonesian (Missing) Biography

Choreo-Lab: Process in Progress #2, 2015 incarnation of the previous 1970s-1980s platforms organised by JAC.
Image courtesy of Helly Minarti.

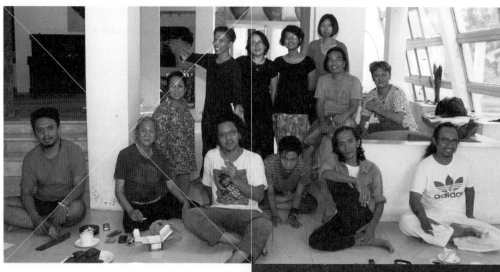

Helly MINARTI

Rrdrah, Wahyu Santosa Prabhawa, 1979. Photo reproduced from the
programme book of 1979 Festival of the Young Dance Arranger.

Creating and designing platforms for choreographers has been a part of my curating/scholarly practice over the past eight years, firstly and mostly for facilitating the creative and artistic process of young dancemakers in Indonesia and, to some extent, the region. Over time, for me, it became a conscious practice for creating a *choreographic* platform by embodying a space imbued with collaborative energies that enable the creative processes to flow.

Creating such a platform came from a sense of urgency as well as awareness of continuing a history – after all, such platforms are nothing but new ideas. Over decades, they have taken many shapes and guises with varied names the likes of 'artistic exchange', 'choreo-lab', or 'artist lab' (in the case of being interdisciplinary), just to name a few; and the little, peculiar things I do are simply minuscule on this larger canvas.

My first involvement in such a platform – mostly by accident – was when I agreed to co-curate the 2nd Asia-Europe Dance Platform with curator Bettina Masuch in Berlin (2004). It was quite a learning curve for me, and what greatly guided me towards my next direction in dance. In the past eight years, I have been involved in co-designing such projects in Indonesia, [1] most recently within the region through co-facilitating the Southeast Asian Choreographers' Network (SEACN), a platform initiated by Kelola Foundation for choreographers who are alumni of the American Dance Festival (ADF) residency. [2]

In the following, I simply wish to retrace a particular Indonesian experience of encountering 'choreography' first as a borrowed foreign word, and later as it was unfolding to be a practice that is yet to be critically discoursed. Now that Indonesian contemporary dance seems to have broken its cocoon by opening up, refashioning towards embracing interdisciplinarity, I wonder if the (historical) routes are recognised, and whether the experiential roots are strong enough to prepare us to be self-reflexive and self-critical about our own doings. I hope to rethink the notion of 'choreography' both as a specific experience of certain localities as much as a shared global practice, and how the two, at times, dis/connect.

Down the historical lane: Of the entangled words and embedded practice

Within Indonesia's context – or more specifically, Jakarta's – the word 'choreography' (*koreografi*), as pertaining to dance, emerged in the public consciousness no later than the early 1970s – a fact to which many articles from the national daily *Kompas* would attest. Back then, artists – not just journalists – reviewed each other's performance, and often their writings reflected on the larger issues or even sparked debate among themselves that took place in cafes or corners around the TIM Jakarta Arts Centre. [3] However, it shall be noted that the word 'choreography' was often eclipsed by the words 'modern' and 'contemporary' (*kontemporer*) dance which were not seldom conflated and used interchangeably.

Indeed, the naming of *a thing* tends to come later, not before its embedded practice has been instilled and acknowledged. Within the dancemaking realm, apart from *koreografi*, we Indonesians also use another term, *menata tari*, which literally means 'arranging dance'. Meanwhile, the *koreografer* is sometimes referred to as *penata tari* (someone who arranges dance). *Penata tari* somehow connotes an image of someone *composing* movements in space. It took, probably, some time for the presence of the *penata tari* or even *koreografer* to really be registered, as the figure of the dancer was possibly more pronounced. This is understandable since dance used to belong to the community, bearing the consequence of its creators appearing nameless or unknown. There were exceptions, of course, such as in certain cultural contexts of Indonesia's locality where court culture exists, in which case there would be dance masters who created special dances for all kinds of rituals commissioned and/or directed by the kings or sultans themselves. Occasionally, these dance masters would be credited as the author of the dance (but more often, it was the kings or sultans themselves).

As in many cultural contexts, dance in Indonesia has been subject to many transformational changes in society, cultural politics included. It took quite some time to discover Indonesian 'dances' in its glorious- yet complex cultural differences; and the process is still very much ongoing. The pre-Independence period (mostly the 1930s) saw some attempts from the orientalists – Westerners residing or visiting mainly in Java and Bali – to document local dances (such as research by Claire Holt and Beryl de Zoete) or even co-create a new dance (Walter Spies came to mind, with the famous Balinese

Kecak dance – although Spies avoided to claim so – with great help from dancer I Wayan Limbak). [4]

After, the early nationalism of the 1950s to mid-1960s saw Indonesian dancers from all over the archipelago being mobilised by President Sukarno himself. The first President, who happened to be an arts lover, had them train in the capital of Jakarta before they were sent around the world as part of a national cultural mission (Lindsey, 2012). They mostly performed revised versions of their respective local dances as directed by the President in order for the dances to fit the cultural diplomacy framework. This meant the dances were drastically shortened, not seldom with the musical accompaniment quickened to sound more 'dynamic'.

Traveling abroad to perform exposed these national dancers to other forms as well, and in turn, this too influenced the way they performed their dances, oftentimes to a point when they started freely altering the forms. As research by Lindsey and Liem (2012) revealed, many expressed being fascinated by the speed and virtuosic nature of some foreign dances – such as African bird dances and Russian classical ballets – that they watched during their travels. Not seldom this kinetic sensation would find a way to the changes of pace or certain embodiment specific to a certain local culture. Inevitably, the dances became more energetic and, at times, the grounding of the body was lifted and straighter. I would imagine that the energy was transmuted into something else – moving away from the original form.

All these changes were also enhanced by travels in the reverse direction, those undertaken by foreign artists to the newly found Indonesia. One of the most remembered was the visit of Martha Graham and her troupe to Jakarta in 1955, and the sending of two Javanese dancers, Wisnu Wardhana and Bagong Kussudiardjo, to the US for a six-month residency in 1958. The first was a major national project funded by Eisenhower's Emergency Fund to project an idea of American high culture by touring a curated programme of the main American dance companies throughout the world, while the second was an exchange funded by the Rockefeller Foundation. In hindsight, it is clear that such a cultural campaign was the effect of Cold War politics between two polarised global ideologies. Up to that point, Sukarno indeed sent the dancers mostly to socialist-communist countries. The tension on the greater political side culminated in 1965's genocide which wiped the left (including artists) off the Indonesian mainstream scene, a void that was soon animated by the dawn of Americanisation in almost every aspect of national politics.

215

In Jakarta, the new TIM Jakarta Arts Centre (henceforth TIM) opened in November 1968. To my limited knowledge, the Philippines is the only other country in the region that built a similar establishment not long after (1969), namely the Cultural Centre of the Philippines (CCP) in Manila. Under the supervision of the then-governor, Ali Sadikin, a modern flâneur whose ambition was to transform Jakarta from a big village into an international metropolis, a quirky (almost ideal) alliance was forged between city government and artists as, surprisingly, Sadikin consulted artists and the literati on how to curate TIM. This resulted in the unique platform of Jakarta Arts Council (JAC/DKJ) which was in charge of programming for the Centre, and whose members consisted of these artists and literati.

TIM soon became the magnet that drew in artists to gather and showcase their work. In the 1970s to 1980s, or even 1990s, Indonesian artists would feel the urge to perform or exhibit their work at TIM as part of earning national recognition. In those early years, partly thanks to the JAC/DKJ framework whose Dance Committee recruited the 23-year-old dancer Sardono as the youngest Council member, dancers from all over the region were attracted to the Centre. New rehearsal and theatre spaces, as well as some production funding, facilitated these dancers to exchange and collaborate in each other's work.

The 1950s to 1960s could be seen as the period when Indonesian dancers from different localities (and islands) learnt for the first time the wide spectrum of embodiment from each other. A Javanese dancer with a classical background had to learn a certain Sumatran dance (Melayu, for instance), which has a contrasting style, if not a totally different embodiment and cultural sensibility. The sense of national community was forged. In contrast, the early years of TIM – especially from 1968 to 1971 – seem like a reviving moment of the former, but tinged with a deep soul-searching for the modern self. This is partly triggered by each respective individual journey across geography and/or within the dance form itself. The key dancers of this period happened to just either return from performing/studying abroad, or reached a high stature in their community as dancemakers but felt greatly limited by the artistic environment of their hometown.

Only four years earlier, at the age of 19, Sardono (b. 1945) spent six months performing at the Indonesian Pavilion at the 1964 New York World Fair. He decided to extend his stay for another six months to explore the city and its

dance scene. Dutch-Indonesian ballerina Farida Oetoyo (1939–2014) just resettled in Jakarta after lifelong travels following her diplomat father, the final days of which were spent studying at the Bolshoi Academy in Moscow. Meanwhile, Balinese I Wayan Diya (1937–2007) had resided in India in the previous decade, partly at the Santiniketan and Kalasethra (founded by Rukmini Devi as a place to experiment with new forms of Indian modern/national performing arts). Huriah Adam (1936–1971) from Minangkabau (West Sumatra) moved her family (her husband and five children) to Jakarta despite having been highly successful in her hometown where she got endless commissions from local government and the army. Other notables include Julianti Parani (b. 1939), who trained in classical ballet under Dutch teachers before they all returned to the Netherlands in the 1960s, and Setiarti Kailola (1919–after 2014), [5] known for her stint on the Martha Graham technique, as well as being Graham's first and longest-mentored Indonesian student. Alongside were an animated group of dancers from Surakarta (Central Java) who, like Sardono, earlier performed at another national project of Ballet Ramayana in 1961 which gave birth to a new form, sendratari. [6] One of them was Sal Murgiyanto, who later became among the first Indonesian dance scholars/curators to study at an American university, where he obtained his postgraduate degree.

From dancemaking to choreography

TIM during the 1968-1971 era was such a brief and yet eclectic, auspicious creative moment, I would say. A burst of collective, artistic energy in the form of a line-up of experimental works, albeit created under the lurking shadow of fresh national trauma resulting from what happened in 1965. Or, maybe, it was more a relieved feeling that transmuted into some kind of political amnesia? What became the story was those key dancers collaborating in each other's works by taking turns being a dancer for their peers, and then later recruiting them as dancers in the role of the choreographer. Organically, each of them had to dive into the dance forms they trained in through teaching and learning from each other.

In navigating the foreignness in their dance tradition of Western classical ballet, for instance, the aforementioned Oetoyo and Parani created repertoires which would later be defined as 'ballet Indonesia' – a ballet with Indonesian stories, performed to original music by modern Indonesian composers. First though, they had to train those dancers from a variety of

non-ballet backgrounds for their works. Oetoyo once told me that it was indeed impossible to command a Bolshoi body onto those dancers in such a short time, so the ballet body had to seep in as more an air of sensibility rather than a technique. In turn, these ballerinas, too, had to train themselves in the dance forms of others when, for instance, Sardono or Adam, cast them as dancers. It was about how to put aside their balletic body so that the groundedness required in classical Javanese dance could be asserted in place, or how to master the silat-based (martial arts) Minangkabau dance with its contrasting sharp/graceful quality, again, with one's feet deeply rooted to the earth.

I collected anecdotes, memories and stories from this generation of dancers and dancemakers, in the face of not having one single video archive left to see except for Sardono's *Samgita Pancasona* and his later years. I collated newspaper clippings and fading black and white pictures, piecing together the oral memories of what I would coin as the first gestures of choreographic experimentation within Indonesian dance history. These images and their ephemerality are what have been haunting me throughout my practice of creating/designing choreographic platforms. Because, if one is to talk about Indonesian experiences of choreography, where should one start?

The choreographic platform as a form in Itself

Moving on further from 1971, the JAC/DKJ (the Council) later initiated a platform for young choreographers to gather at TIM, performing their latest works and discussing them. The Dance Committee, of which Sal Murgiyanto was a member, created the first so-called Festival Penata Tari Muda (Festival of the Young Dance Arranger) I to V in 1978, 1979, 1981, 1982, and 1983; Pekan Penata Tari Muda (Young Dance Arranger's Week) VI in 1984; Festival Karya Tari Baru (New Dance Works Festival) in 1986; and – this is interesting – Pekan *Koreografi* Indonesia (Indonesia's Choreography Week; my emphasis) in 1987.

In the early editions of Festival Penata Tari Muda, if I am not mistaken, Murgiyanto had just returned from completing his master's degree at a university in the US. In my archive, I only have the programme books of the 1979, 1981, 1982, 1983 and 1984 editions, all of which were edited by Murgiyanto. Alas, I do not have those from the first (1978) or 1986 iterations, and, most importantly, the 1987 edition when the word *koreografi* was used

as the programme's title, which to me, might indicate a fundamental shift.

Up to the 1984 iteration (since I do not have the 1986 and 1987 editions), most selected dancemakers were graduates or lecturers at the national arts academies and at the LPKJ[7] (Jakarta Institute for the Arts), the latter of which was located just behind the TIM Centre whose founding lecturers were the artists from TIM 1968-1971 mentioned above. They mostly came from the main cities in Java, Bali, and West and North Sumatra – predictably, cities where those national arts academies or institutes are based.

The early editions seem to follow a format whereby five to six dancemakers perform a new commissioned work before proceeding to a discussion, in which they had to read their 'working paper' detailing their respective creative processes in front of a forum. Some senior dancemakers or literati were then specially tasked to comment on their presentation, and the audience was given the opportunity to ask questions or to comment at the very end. In the latter editions, probably from 1983 onwards, workshops held by the invited dancemakers and a smallish screening of dance films were added to the programme. Invariably, JAC/DKJ also arranged for young dancemakers from several cities to visit as audience members – and that is what makes such a platform important, as it demonstrates an early gesture to distribute knowledge beyond the usual centres.

In the first four editions, the core discussion was still around the notion of 'dance' framed within a forum somehow imbued by an academic vibe. Most works were based on a local tradition and dance form, with the exception of two works by S. Trisapto (1982, 1983) which tried to explore experimental music and modern, urban life through new ways of moving, leaving no traces of his background in Javanese classical dance. The association to 'choreography' was mentioned first only in passing when Farida Oetoyo responded to the collaborative work titled *Awan Bailau* by Deddy Luthan (1951–2014) and Tom Ibnur (b. 1957). She was recorded as uttering, "...choreographically, *Awan Bailau* (Minangkabau language for The Cloud of Sadness) presented new things."[8] The 1982 edition was also important because it was organised in tandem with Young Composer Week, so designed for connecting the two practices.

In the 1983 iteration, the notion of 'choreography' seems to be more centre stage. This, it seems, was triggered by the three commissioned works (instead of five or six in the previous editions) which were contrastingly different in terms of artistic approach. Much heated discussion surrounded a particular work by Tom Ibnur, titled *Ambau Jo Imbau* (a Minang proverb which means "to go down the stream and to call"). Ibnur originated from Minangkabau (West Sumatra) and migrated to Jakarta, ditching corporate life as a chemical analyst to study at the dance department of LPKJ. He ignited debate for basing his piece on three traditional forms from Minangkabau and (re?) presenting them on a proscenium stage, complete with what sounds like a re-enactment of a funeral ritual. He brought local Minang dancers – including elderly ones – who shared the stage with the students of LPKJ as performers.

The opinions of the invited observers were polarised. Oetoyo commented that Ibnur actually only worked on the last 10 minutes of the whole piece, of which the rest, as others agreed, was too slow and boring. [9] She said that Ibnur should have considered the fact that the work was staged in a proscenium, "a place that owns a certain power" (or aura?), hence a 'performance' that typically takes place outside this modern theatre context should be first adjusted. Murgiyanto could not agree more, but pointed out that a dance work based on a certain local tradition cannot only be viewed from a "choreographic perspective", i.e., how it could be applied consequently. He asked people to listen to Ibnur's working paper presentation, to what he wanted to do – only then might one appreciate things beyond the studio work [here identified as "choreographic work" or "choreographic aspects"]. [10] Further down the discussion about all three of the works, dancemaker Endo Suanda (b. 1947), later better known as a dance ethnographer, suggested that perhaps within the Indonesian context, the figure of the 'choreographer' or 'composer' should be reconsidered – for example, not so much individualised as in the West. [11]

All these early debates inform me of how the choreographic gestures of the 1968-1971 TIM era, which exhibited a more cosmopolitan self (embodied by those dancers returning from their respective journeys), were becoming subdued as the practice trickled down and spread out, somehow rendered blunt in the process of attempted academisation, as reflected in the latter forums in the 1980s. I had imagined that such debates would soon be included in the curriculum of those national arts academies, but this did not seem to happen. As I accompanied some young choreographers in

their artistic process much later in the noughties – either through casual friendship or the formality of a choreo-lab framework – it is clear that we have inherited the notion of *koreografi* that remains elusive, even hollow for its ahistoricity. Platforms such as the choreo-lab probably exist as respite for today's young Indonesian choreographers – most of them graduates of such academies, with the few wishing to break free from the academic rigidity of choreographing as a still heavily craft-based practice – to simply unlearn and think afresh. Hopefully making such platforms a safe, creative space will provide the tools and support for them to formulate and articulate their own unique choreographic voice.

However, the more I follow this through, the clearer it has become that however slowly and late, it is important to first root in the biography of *koreografi* itself, of Indonesia's particular and peculiar experiences as part of self-knowing – nonetheless, this remains a missing concept. Here, I simply start by unpacking its multiple rendered meanings across different times and contexts, by revisiting certain momentums such as those early debates of the 1980s which seem to keep echoing hauntingly in today's practices: what constitutes *koreografi*? Is it a form or a process? A language for movement or an embodied knowledge? An evolving and unfolding practice?

The act of questioning is only a beginning.

1. Choreo-Lab: Process in Progress in Jakarta, as part of the programme of the Dance Committee of Jakarta Arts Council (2013–14). Please consult the respective programme books. I also re-designed the showcase of Indonesian Dance Festival for emerging choreographers with the curatorial team (2014, 2016 and 2018). In 2018, the platform was renamed Kampana (Sanskrit for 'vibration').

2. I facilitated the platform for two consecutive years (2019 and 2020), each with totally different formats (2019 live in Yogyakarta with co-facilitator Daniel Kok and 2020 going online with Kok and Arco Renz). This year, Kelola Foundation teamed up with the Dance Committee of Jakarta Arts Council to hold this platform which became much more interdisciplinary (for the Indonesian chapter), with other regional chapters organized independently in Thailand, Cambodia and Vietnam.

3. TIM stands for Taman Ismail Marzuki or the Ismail Marzuki Park, named after the Indonesian composer, of Betawi origin (native Jakartan).

4. Claire Holt (1901–1970) was a Latvian-American dance journalist/critic who lived in the Dutch East Indies (today's Indonesia) from 1930 to 1938 with intermittent travels in between. She did some research on dances in the archipelago in the 1930s and later in the late 1950s. In one of her lectures/demonstrations in 1936, she identified herself as a 'choreologist', someone who analyses choreography. She also proposed the idea of 'choreology' being the next subject in the family of other '-ologies' such as sociology, anthropology, etc. Her seminal book, *Art in Indonesia: Changes and Continuities* (1967), is considered a classic on the subject. Beryl de Zoete (1879–1962) was a British dance critic who co-wrote *Dance and Drama in Bali* (1937), the first book on the subject in English, with Walter Spies (1895–1942), a German artist who lived in the Dutch East Indies from 1923 until his demise in 1942. Spies's muddling in creating Kecak is, undeniably, based on a ritual trance dance, Sanghyang Dedari. Transforming this speculation into an attempt of reading choreography deserves a space in itself.

5. I cannot remember the exact year of her death. And alas, at the moment, I do not know whom to ask since the two people I personally know who have knowledge of this passed away this year. What I do remember is it was probably in 2014 or not long after.

6. Sendratari is a new dance form created out of adapting the epic of Ramayana into a large-scale performance for a specific site, Prambanan, a Hindu temple in Central Java. It was carefully designed by the government and supported by extensive research carried out by the then-Minister himself. The result is a new form of dance-drama informed by Javanese classical dance, but deliberately mimicking Western classical ballet by stripping off the dialogue originally spoken by the dancers. It was done so for catering to non-Indonesian tourists.

7. The embryos of various national arts academies date back to 1950, when Sukarno founded a Western-styled conservatory in Java. Others then followed suit in other major cities, creating institutes for traditional music (karawitan), dance, theatre, and fine art.

8. Festival Penata Tari Muda 1982 programme book, p. 8.

9. Festival Penata Tari Muda 1983 programme book, p. 24.

10. Ibid. p. 25.

11. Ibid. p. 61.

References

Lindsay, J. (2012). "Performing Indonesia Abroad", in Lindsay, J., and Liem, M.H.T. (eds), *Heirs to World Culture: Being Indonesian 1950–1965*. Leiden: KITLV Press, pp. 191-222 and its accompanying DVD.

Lindsay, J., and Liem, M.H.T. (2012). "Heirs to World Culture 1950–1965: An Introduction", in Lindsay, J., and Liem, M.H.T. (eds), *Heirs to World Culture: Being Indonesian 1950–1965*. Leiden: KITLV Press.

Vuth Lyno, Moeng Meta, Prumsodun Ok and Community Arts Education in Cambodia

Artist Sao Sreymao doing a performance during her solo exhibition at Sa Sa Art Projects, 2018. ©Sa Sa Art Projects

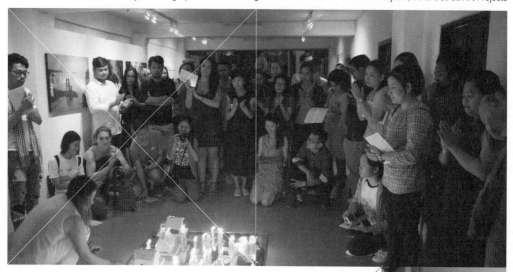

Danielle KHLEANG

Moeng Meta
Image courtesy of the artist.

Vuth Lyno
Image courtesy of the artist.

Prumsodun Ok
Photo by Nobuyuki Arai.

Vuth Lyno, Moeng Meta, and Prumsodun Ok are three seminal figures in the contemporary arts ecosystem of Cambodia. Meta is well known as a curator, Lyno as a visual artist, and Prumsodun as a Khmer classical dancer. However, their impacts on the arts ecosystem extend beyond the borders of their individual practices. During the last 10 years or so, each of them has emerged as architects of community rooted in arts education and care. Despite surfacing within a different system of knowledge, their pedagogical work calls to my mind the ethos of mutual aid. Stemming from Peter Kropotkin's theory that cooperation is as much a basis for evolution as competition, I first learned about mutual aid at the beginning of the COVID-19 pandemic as a type of "by the community for the community" care in the face of lagging government services as shutdowns ensued (Petrossiants, 2021; Whitely, 2021). Matthew Whitley highlights that mutual aid is:

About building 'bottom-up' structures of cooperation, rather than relying on the state or wealthy philanthropists to address our needs. It emphasizes horizontal networks of solidarity rather than 'top-down' solutions, networks that flow in both directions and sustain the life of a community. (2021)

Though Lyno, Meta, and Prumsodun's work type does not entirely fit with mutual aid, it is a useful starting point for conceptualizing how their pedagogical work supports the arts, artists and, at times, broader communities in Cambodia.

In the paragraphs that follow, I begin with a brief literature review on the situation of art production and education in Cambodia from national independence in 1953 to the 2000s. Then, I highlight how Lyno, Meta, and Prumsodun's educational and residency formations constitute 'bottom-up' networks of multidirectional flow that support the vibrancy of the Cambodian arts ecosystem.

Arts production & education in cambodia: A literature review

Following national independence, visual art production during the 1950s and 1960s was influenced by Cold War-era soft power in the form of visual culture. Ingrid Muan describes the moment as one where French colonial cultural policy that had a rigid unchanging expectation for Cambodian art fell away (2005). In its place, with the support of Head of State, Norodom Sihanouk, Muan states,

a young elite embraced creative thinking, modernization, and an expansion of the definitions of what Cambodian culture could be... drawing some of their ideas, models, and images from Cold War-generated aid and information programs. (44, 2005)

A significant event for the development of new Khmer classical dances during this time was the formation of the Royal University of Fine Arts – which continues today as a central node of institutionalized arts education – in 1965 by Norodom Sihanouk (Turnbell, 2002). Today, many look back at the 1950s and 1960s as a 'golden age' of modern Cambodian culture which included the rise of the film industry and the famous visual artist Nhek Dim (Muan 2005; Nelson, 2018).

However, the peace and prosperity of that time ended as the country was entangled with the American War in Vietnam in the late 1960s, followed by civil war, and the rise of Khmer Rouge control of Cambodia from 1975 to 1979 (Chandler, no date). During the Khmer Rouge regime, former Deputy Director-General of Education in the Ministry of Education, Youth and Sport of Cambodia, Leang Ngonly, reports that "all educated people – including teachers, students and civil servants – were persecuted..." and that an estimated "75% to 80% of Cambodia's teachers and higher education students fled or died [sic]" (82, 2005).

Politically, the 1980s were characterized by the sensitive situation of Cambodia being liberated from the Khmer Rouge by the Vietnamese and subsequently occupied by them. At the same time, reconciling with the immense loss of human resources, Nelson attests to the instrumentalization of, and support for, the arts during that rebuilding period and highlights the emergence of the White Building in Phnom Penh (2017). Designed by Lu Ban Hap as social housing two decades earlier, the White Building came under the governance of the Ministry of Propaganda and Culture and was reserved for artists (Nelson, 2017). He posits that one of the first areas of focus for national reconstruction was support for traditional arts (2017).

Moving into the 1990s, Nelson notes a decline in governmental support for contemporary arts following the removal of Vietnamese authority that was replaced by the "United Nations Transitional Authority in Cambodia (UNTAC) occupation in 1992-93, under Prime Minister Hun Sen... [with] most artistic activity since the 1990s... organized without official involvement of the government, ministries, or palace" (11, 2017). Pamela N. Corey highlights

that the UNTAC elections were a turning point following decades of turmoil because it marked Cambodia's reintegration into global politico-economics (2021). As Cambodia was rebuilding "legitimacy in the eyes of the international community... NGOs were allowed significant flexibility to operate within the new state" (Corey, 102, 2021). This influenced arts production because aid workers constituted much of the local art market from then into the 2000s. Like aid institutions, many exhibition briefs centered on themes of memory, reconciliation, and healing (Corey, 2021). Despite these thematics influencing art production, foreign cultural institutions "granted possibilities for training, art-making, and more open interface with local-publics" that served as "alternative sites of artistic formation... opposed to the curricula regimen of the Royal University of Fine Arts" (Corey, 103, 2021).

It is with this backdrop of development and accessibility to some open spaces for arts production and education that Lyno, Meta, and Prumsodun began their careers in the arts during the 2010s.

Vuth Lyno and Sa Sa Art Projects

Vuth Lyno is an artist, curator, educator, and founding member of the Stiev Selapak collective. [1] Many members of Stiev Selapak, including Lyno, met in a photography workshop hosted by Stephane Janin, held between September 2006 and June 2007 at his Popil Photo Gallery in Phnom Penh (Corey, 2021). In 2010, Stiev Selapak opened Sa Sa Art Projects, [2] a Cambodian artist-run "experimental and critical contemporary art practices space" that provides contemporary art education through critical discussion amidst a lack of arts education infrastructure (Sa Sa Art Projects, no date-a).

Sa Sa Art Projects' first home was in the White Building. From 2010 to when the White Building was demolished in 2017, Sa Sa Art Projects engaged multidirectional flows of exchange between local and international artists, as well as the community members living there. These flows made a lasting impression on the philosophy that underpins Lyno's work and Sa Sa Art Projects today.

Lyno shared with me that Stiev Selapak was inspired by the historical context of the site and the breadth of the community (2022). There, Sa Sa Art Projects developed practices premised on accessibility and participation. Lyno described this process as "an open conversation of co-thinking and

challenging each other" that facilitated the exercising of agency by artists and non-artists alike (2022). One example that opened Lyno and the Sa Sa Art Projects team up to greater sensitivity regarding how to engage their neighbors was *The Sounding Room* (2011).

A collaboration between Sa Sa Art Projects and the UK-based arts organization, Incidental, *The Sounding Room* was an immersive sound and music environment that existed for two months. It included improvised performances and special events where visitors were encouraged to participate in spontaneous, collaborative pieces among workshops and talks as well (Sa Sa Art Projects, no date-b). Recalling this project, Lyno said, "It was quite challenging for the community because it was different and strange. People didn't know how to respond and engage" (2022). This meeting of worlds between Sa Sa Art Projects and the residents attuned Sa Sa Art Projects to the mentality of their neighbors and better developed their ability to facilitate opportunities for connection. Through their *Pisaot* residency [3] and art classes, they continue to impart observation as a methodology for art production at their new location on street 350.

Some critical questions they asked when transitioning out of the White Building were, 'who do we serve?' and 'who do we engage?' Since many of their former partners and audiences were dispersed throughout the city following the demolition, they decided to lean into their strengths and hone in on art classes and the *Pisaot* residency. Through these efforts, they primarily sought to engage emerging artists and students.

While at the White Building, art classes were structured around ad hoc thematics. At street 350, they implemented a clear curriculum and over time, expanded to three courses: Contemporary Arts Class taught by Khvay Samnang, Documentary and Contemporary Photography Class taught by Lim Sokchanlina, and English for Artists workshops which are co-taught by Lyno and Prumsodun Ok. Contemporary Arts Class is a 12-week mixed media course that covers the steps of artmaking, including conceptual vantages. For this reason, the course features guest speakers from other disciplines such as art history, anthropology, and politics which enables multidisciplinary exposure that builds critical perspectives. Documentary and Contemporary Photography Class shares a similar structure and multidisciplinary approach that supports students' abilities to find their voice and develop new bodies of work. While English for Artists, in addition to teaching English to artists,

combines Lyno's knowledge of visual arts with Prumsodun's knowledge of performing arts to support students' understanding of the art world with English as the means. Among other topics, they cover how to write and talk about art generally, their own practices, and the art that influences them. Each session is guided by a group discussion around an artwork to both practice speaking and broaden their worldview on art. Now at street 350, the *Pisaot* residency, instead of being anchored in artistic research and production concerning the White Building, has developed into a more expansive engagement with Phnom Penh as the field of research for new work. During the COVID-19 pandemic, due to global travel restrictions, the residency became another avenue for mentoring emerging and young Cambodian artists.

A common current through all of Sa Sa Art Projects' education programs and the *Pisaot* residency is an investment in observation and careful consideration of power relations between artists and communities that enter the field of artistic representation. On this point, Lyno said:

We try to raise the consciousness of the students about how to engage communities so they are not just creating their work, putting it in the exhibition, and that's it. We ask them to think beyond that and acknowledge that we are artists, not social workers or community workers. We need to acknowledge, as artists, what can we do within our limits, and beyond just making art. At the same time, we must challenge ourselves; consider the process, our role, and agency.

At the end, when the work is out there, how does it relate back to the community? Does the community see the work? What do they think? Did you have a conversation, do you go back again to show them the work and get their perspective? How can this be kept in a cycle of learning and development with new input for further research besides the gallery context? There are ways you can do it. (2022)

Through these initiatives, Lyno and the whole Sa Sa Art Projects team are fostering a new generation of artists to implement multidisciplinary art practices founded on critical observation and empathetic flows of exchange between themselves, their environment, and surrounding communities.

Moeng Meta and independent community spaces

Beginning her career in the arts at SA SA BASSAC, [4] the sister organization to Sa Sa Art Projects that was co-founded by Stiev Selapak and the curator

Erin Gleeson, Moeng Meta acted as the Community Project Manager from 2013 to 2017. There, she connected SA SA BASSAC's work with non-arts audiences.

This interest in building pathways of connection flows through her work as she became an independent arts manager and curator. Since 2017, Meta has developed three independent initiatives: Contemporary Arts Space Tours, the community space Kon Len Khnhom, and the arts resource home Dambaul. Through these projects, Meta built bridges between the contemporary arts community and other creative sectors.

Contemporary Arts Space Tours originated under the umbrella of SA SA BASSAC and became Meta's independent project when she left. The model of the tours switched from serving international visitors to focusing on local students. With Meta, students could participate in free tours and only pay transportation while charging others a fee. The updated tour visited five institutions, SA SA BASSAC, Java Creative Cafe, Meta House, Bophana Audiovisual Center, and the French Institute of Cambodia. More than a fun way to spend an afternoon, Meta looked at the tours as a tactic to expand the arts ecosystem:

Everything I did was about quality, not quantity. I believed that just 10 people could spread the word about arts spaces. The tour was [a form of] mapping. Once you knew the space, you could come back. My background is in business management, so I'm always thinking from that perspective about expanding the arts. (2022)

After a year of introducing students to some of the staple arts institutions in Phnom Penh, she began looking for a space to train students to take it over. This led to the formation of Kon Len Khnhom. Meaning 'my place' in Khmer, Kon Len Khnhom was a significant step in Meta's career and for the arts community because it was her first time managing her own space. It also gave students, artists, and researchers a place to develop.

While at SA SA BASSAC, she forged relationships with architecture students from the The Vann Molyvann Project when they installed an evolving exhibition of models and drawings of the architect's designs in the gallery space. Meta approached two students from The Vann Molyvann Project to lead the tours and learned from them that architecture students often had difficulties completing their projects due to factors such as lack of space

and social barriers. Hearing this, Meta decided to make Kon Len Khnhom freely accessible to students. In exchange, they would give a public talk on their projects and help support the events. Kon Len Khnhom also hosted workshops and developed long- and short-term residency programs. As Meta explained:

I didn't want to do only artist residencies because they already exist here. I wanted to do something different, fill the gaps. So, we hosted curator, researcher, and [creative sector] residencies. The founders of Wapatoa [5] are among the residents Kon Len Khnhom hosted. At the end, each would have to give a talk on what they developed.

By creating a community space for people from across the arts and creative communities to call their own, Meta opened the door for the free flow of ideas.

After six years of enabling audience development and sharing knowledge, she decided to become a curator. At the same time, Erin, her former mentor, decided to permanently close SA SA BASSAC. Without any institutionalized paths to curating, Meta approached Erin about adopting the books from SA SA BASSAC's resource center to expand her knowledge, "You have to make a choice. You can go overseas to learn but, for me, [contemporary Cambodian art] was in front of me, right here" (2022). Erin happily left the books to Meta.

Dambaul is unique because its collection of books focuses specifically on contemporary arts and houses many books on Cambodian art difficult to find elsewhere in the country. Though the arts resource home was created to advance Meta's curatorial career, it retains the same ethos of 'community' as the Contemporary Arts Space Tours and Kon Len Khnhom. When Lyno and Prumsodun were looking for a space to host English for Artists, she offered Dambaul. This gave the workshops a home and the participants an opportunity to engage with art books. In 2022, Dambaul moved to a new location in the same building as the film production company, Anti-Archive, and other creative offices. In doing so, the arts resource home joined a central meeting point in the creative sector which increases the possibility for exchange between the contemporary arts and film communities.

Prumsodun Ok & NATYARASA

Prumsodun Ok is an artist, teacher, writer, and creative producer known as

"the new face of Khmer dance" for introducing the "avant-garde in antiquity" while founding Cambodia's first gay Khmer classical dance company, Prumsodun Ok & NATYARASA (Prumsodun Ok, no date). Raised in Long Beach, California, by Cambodian parents, Prumsodun began studying Khmer classical dance with Sophiline Cheam Shapiro as a teenager (Escoyne, 2019). Later, he taught at Khmer Arts Academy in Long Beach. In 2015, he came to terms with the realization it was unlikely he would encounter one student that would commit themselves to the art and, shortly after, resigned from his teaching post (Escoyne, 2019). However, through the experience of receiving a MAP Grant to produce *Beloved*, a contemporary take on a 13th century Cambodian history of ritual lovemaking portrayed through the dancing bodies of gay men, Prumsodun found his way to residing in Cambodia and founding Prumsodun Ok & NATYARASA (Escoyne, 2019). As the founder and director of the company, he accepts the responsibility of stewarding the traditions of Khmer classical dance into the contemporary era through the master-apprenticeship model. In doing so, he creates networks of relations that enable the personal, professional and creative development of his students so that they may affect societal change and community formations.

The company consists of two levels of dancers: the junior level and the professional level. At the junior level, dancers are developing their technique and stage presence, and receive a stipend for performances. Meanwhile, the dancers at the professional level are full members of the company and receive full-time wages among fees for performances. Training takes place in Prumsodun's living room throughout the week and consists of both level-specific and mixed-level classes. While professional dancers train their juniors, Prumsodun works with those at the professional level to impart to them advanced knowledge concerning the history, theory and conceptualism behind the artform. His curriculum integrates both the traditional works of the canon as well as his original pieces that draw from seemingly disparate influences such as pop music and foreign folktales.

Though all members of the company are gay men, they come from socio-economically diverse backgrounds and mixed education levels. This poses unique dimensions to the master-apprentice relationship that extends Prumsodun's role beyond dance education. On this point, Prumsodun said:

Sometimes, I have to give my students an education that they couldn't receive here in Cambodia, because... the quality of our institutions is very low. There's a lot that's missing. I'm teaching

history, professional work ethic, leadership, and developing their character in addition to teaching dance. (2022)

A component of this character development manifests as the need to be brave. As an openly gay dance company, Prumsodun knew there would be a variety of opinions about them wherever they went. For this reason, he needed dancers who could follow this journey without running away from the first piece of ridicule. As Prumsodun shared with me:

It takes a lot of bravery to be who you are, to be seen in a very vulnerable place. When people attack you... They're attacking your very essence... So, I asked my dancers to really be brave, honest and share who they are... with the stage and the media. Me, as a gay man, an American, I feel like I'm fighting two histories of erasure. On the one hand, we have the Khmer Rouge genocide, which nearly destroyed this tradition. And on the other, there is the HIV/AIDS epidemic in the United States that nearly wiped out a whole generation of leaders, thinkers, and doers within the LGBTQ community.

Bravery means honesty. It means sharing, offering, love, and it means resilience of my people. The resilience of LGBTQ people here. I need my dancers to have that courage, to go against the wind, to understand who they are, and share that with the world. (2022)

By facilitating personal development through artistic development among gay men in Cambodia of mixed socioeconomic and educational backgrounds, Prumsodun organizes a bottom-up social structure that exercises agency to affect societal perceptions and form community.

Conclusion

Through the facets of visual arts, arts management, and dance, Lyno, Meta, and Prumsodun chart new pathways of connection, stability and growth within the Cambodian arts ecosystem. By focusing on education, students, and communities, they resist the rigidity of institutions and enable flexible bottom-up networks founded in care.

1. When founded, Stiev Selapak collective included Vandy Rattana, Heng Ravuth, Khvay Samnang, Kong Vollak, Lim Sokchanlina, and Vuth Lyno.

2. Current co-founding members involved with Sa Sa Art Projects are Khvay Samnang, Lim Sokchanlina, and Vuth Lyno.

3. *Pisaot* is an experimental arts residency for Cambodian and visiting artists lasting up to six to eight weeks.

4. The sister organization to Sa Sa Art Projects, SA SA BASSAC was co-founded by Stiev Selapak and the curator Erin Gleeson. It was active from 2011 to 2018.

5. Wapatoa, meaning 'culture' in Khmer, is a dual language English and Khmer website creating content for young Cambodians covering arts, health, career, and money among other topics.

Bibliography

1. Corey, P. N. (2021). *The City in Time: Contemporary Art and Urban Form in Vietnam and Cambodia*. Seattle: University of Washington Press.

2. Chandler, D. "Cambodia: A Historical Overview". *Asia Society*. Available from https://asiasociety.org/education/cambodia-historical-overview [Accessed July 3, 2022].

3. Cravath, P. (1986). "The Ritual Origins of the Classical Dance Drama of Cambodia". *Asian Theatre Journal*, 3 (2), 179–203. Available from https://doi.org/10.2307/1124400 [Accessed July 3, 2022].

4. Edwards, P. (2007). *Cambodge: The Cultivation of a Nation, 1860–1945*. Honolulu: University of Hawai'i Press. Available from https://www.academia.edu/3394254/Cambodge_The_Cultivation_of_a_Nation_1860_1945 [Accessed July 3, 2022].

5. Escoyne, C. (2019). "Why Prumsodun Ok Founded Cambodia's First Gay Dance Company in His Living Room". *Dance Magazine*. Available from https://www.dancemagazine.com/prumsodun-ok-natyarasa/ [Accessed June 26, 2022].

6. Khleang, D. (2022). *Interview with Moeng Meta*. Phnom Penh. May 30.

7. Khleang, D. (2022). *Interview with Vuth Lyno*. Phone Conversation. June 27.

8. Khleang, D. (2022). *Interview with Prumsodun Ok*. Phone Conversation. June 29.

9. Muan, I. (2001). *Citing Angkor: The "Cambodian Arts" in the Age of Restoration 1918-2000*. Ph.D. Thesis: Columbia University. Available from https://www.studykhmer.com/videos/muan_citingangkor.pdf [Accessed July 3, 2022]

10. Muan, I. (2005). "Playing With Powers: The Politics of Art in Newly Independent Cambodia". *Udaya: Journal of Khmer Studies*. 6, 41–56. Available from https://angkordatabase.asia/libs/docs/03_Ingrid-Muan_UDAYA06.pdf [Accessed July 3, 2022]

11. Nelson, R. (2017). *Modernity and Contemporaneity in "Cambodian Arts" After Independence*. Ph.D. Thesis: University of Melbourne. Available from https://findanexpert.unimelb.edu.au/scholarlywork/1474709-modernity-and-contemporaneity-in-%22cambodian-arts%22-after-independence [Accessed July 3, 2022].

12. Nelson, R. (2018). "'The Work the Nation Depends On': Landscapes and Women in the Paintings of Nhek Dim". In Whiteman, S. et al. (2018). *Ambitious Alignments: New Histories of Southeast Asian Art, 1945–1990*. Sydney: Power Publications. 19-45.

13. Nguonly, L. (2005). "Needs Assessment for Art Education in Cambodia". In Meleisea, E. (2005). *Educating for creativity: Bringing the arts and culture into Asian education*. Bangkok: UNESCO. 82-83. Available from https://unesdoc.unesco.org/ark:/48223/pf0000142086?posInSet=7&queryId=99d4153c-565b-4a01-b0ac-9dcc26d05730 [Accessed July 3, 2022].

14. Ok, P. (2018). *The Serpent's Tail: A Brief History of Khmer Classical Dance*. Available from https://www.academia.edu/36957739/THE_SERPENTS_TAIL_A_BRIEF_HISTORY_OF_KHMER_CLASSICAL_DANCE [Accessed July 3, 2022].

15. Opertti, R., Kang, H., and Magni, G. (2018). *Comparative Analysis of the National Curriculum Frameworks of Five Countries: Brazil, Cambodia, Finland, Kenya and Peru*. UNESCO IBE. Available from https://unesdoc.unesco.org/ark:/48223/pf0000263831?posInSet=5&queryId=99d4153c-565b-4a01-b0ac-9dcc26d05730 [Accessed July 3, 2022].

16. Petrossiants, A. (2021). *The Art of Mutual Aid*. e-flux. Available from: https://www.e-flux.com/architecture/workplace/430303/the-art-of-mutual-aid/ [Accessed July 3, 2022].

17. Ok, P. (No date). Available from https://www.prumsodun.com/copy-of-home [Accessed July 4, 2022].

18. Sasagawa, H. (2005). "Post/colonial Discourses on the Cambodian Court Dance". *Southeast Asian Studies*, 42 (4). 418-441. Available from https://kyoto-seas.org/pdf/42/4/420403.pdf [Accessed July 3, 2022].

19. Sa Sa Art Projects. (No date-a). Available from https://www.sasaart.info/about.htm [Accessed July 3, 2022].

20. Sa Sa Art Projects. (No date-b). "The Sounding Room". Available from https://www.sasaart.info/projects_thesoundingroom.htm [Accessed July 4, 2022].

21. Turnbull, R. (2002). *Rehabilitation and preservation of Cambodian performing arts: final project report*. Phnom Penh: UNESCO Office Phnom Penh. Available from https://unesdoc.unesco.org/ark:/48223/pf0000149285 [Accessed July 3, 2022].

22. Whitely, M. (2021). "Why 'Mutual Aid'? – social solidarity, not charity". Open Democracy. Available from https://www.opendemocracy.net/en/can-europe-make-it/why-mutual-aid-social-solidarity-not-charity/ [Accessed July 3, 2022].

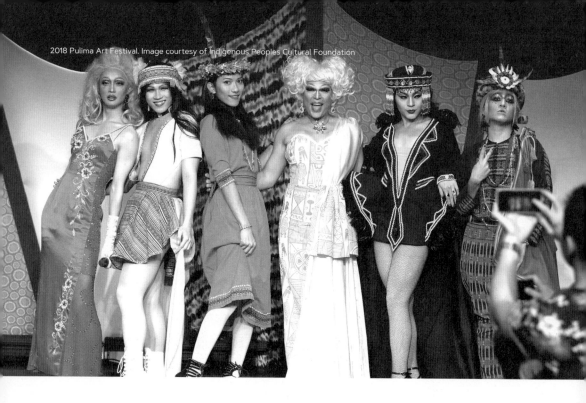

Ten Years of Transformation: The Positioning and Evolution of the Pulima Art Festival

Cheng-Hua CHIANG

Translated by **Cheryl ROBBINS**

In Taiwan, the Indigenous Peoples' Movement and localization trends of the 1980s have placed the notion of 'sovereignty' at the heart of Indigenous creative and curatorial practices while artists' bodies of work emerged in multiple fields including the arts, crafts, and design. In addition, some public and private cultural institutions that serve this demographic have become important drivers of the development of Indigenous art. [1]

However, apart from overlapping anthropological research, Indigenous art has not received much attention from academics or art critics, and its positioning often drifts between Primitive Art, Ethnic Art, Traditional Art, Modern Art, and Contemporary Art. Over the past 30 years, through the emergence of Indigenous artists across various generations, and their constantly changing artistic concerns and techniques, Taiwan's Indigenous visual and performing arts have evolved and transformed. The notion of 'Indigenous art led by Indigenous peoples' has also been recognized thanks to the avocation of global Indigenous artist communities. Today, Indigenous contemporary art and performance are perpetually strengthening solidarity, challenging the art market and narrating their own positioning.

The Pulima Art Award and the Pulima Art Festival were established in such context by the Indigenous Peoples Cultural Foundation in 2012. The ethos is to honor the originality of the contemporary art of the Austronesian peoples, embody the spirit of sovereignty through art made by Indigenous peoples in Taiwan, and foster dialogues and collaboration between Indigenous peoples in Taiwan and around the world. Biennially, the festival presents works through a contest, as well as curated exhibitions and live events, to bring together fresh and current artistic practices. [2]

In its inaugural edition, the Pulima Art Festival was initially an extension of the Pulima Art Award. In 2014, the two became separate entities, with the festival committee being founded and working independently. The committee conceives themes and programs by looking at contemporary phenomena and presenting mature works of music and performance. In 2016, the award and festival committees were merged again, and the role of artistic director/ curator was created to lead the festival towards a professional positioning. [3]

The Pulima Art Festival has become curatorial since 2014, [4] presenting work through open calls, exhibitions, performances, and forums. Through a branding strategy, an attempt has been made to connect with the mainstream

market. As Taiwan shares cultural, linguistic and historical similarities with the Austronesian peoples as well as the global Indigenous community, the festival has also worked with various international sectors and artists to deliver collaborative projects.

Pulima x YIRRAMBOI: Encountering and opening up new worlds

The opportunity to collaborate with the Melbourne-based YIRRAMBOI Festival came after a visit by Jacob Boehme, then YIRRAMBOI Festival's Creative Director, and Ben Graetz, former producer of ILBIJERRI Theatre Company, to Taiwan in 2016. In 2017, due to perceived differences and a lack of understanding between the two sides, 'a festival within a festival' concept was proposed as a two-year exchange project. The plan looked at inviting eight groups of artists from both cities to show works in both festivals. With Nakaw Putun's appointment as the 2018 Pulima Art Festival Curator, and the support of Pan Sheau-Shei (Yuki), former Director of the Museum of Contemporary Art, Taipei (MOCA), the exchange project came into being.

In 2018, YIRRAMBOI at Pulima spotlighted issues with which contemporary Indigenous artists from Australia are concerned, including identity, gender politics, and colonial history. The Australian delegation to Taiwan was led by Elder Uncle Larry Walsh, who performed the Smoking Ceremony at the opening of YIRRAMBOI at Pulima. Other participating artists included visual artists Glenda Nicholls and Peter Waples-Crowe, drag queen Miss Ellaneous (Ben Graetz), and singer-songwriter Alice Skye. In 2019, artists from Taiwan for Pulima at YIRRAMBOI included Dondon Hounwn, Labay Eyong, and Ilid Kaolo, who had carried out exchanges with Australian artists the year before, as well as RoseMary, the winner of a drag queen competition at Pulima at YIRRAMBOI in Taipei. Additionally, *Red Earth*, co-created by TAI Body Theatre of Taiwan and Carly Sheppard, Australian artist-in-residence at YIRRAMBOI at Pulima in 2018, was again presented in YIRRAMBOI in 2019.

The curatorial methods of YIRRAMBOI and Pulima differ due to differences in history, resistance, and identity. In 2017, the YIRRAMBOI Festival was curated by Boehme, its title meaning 'tomorrow' in the shared local languages of the Boonwurrung and Wolwurrung peoples. The theme demonstrated the resistance against institutions in a colonial background. [5] In that edition, the works and actions of artists were located across different districts, streets

and marketplaces of the city. The decentralized and guerrilla-type program of the festival shook the normative cultural configuration of the city. In contrast, the curatorial concept of Pulima is comparatively docile, praising the exquisite craftsmanship and thinking of the Indigenous peoples and reflecting local contemporary Indigenous issues.

An alliance between the two festivals was formed with the intention of breaking the stereotype of how their respective societies have contextualized Indigenous peoples. Its goal is not only to promote Indigenous art, but also to reduce cultural misuse, while reflecting on the core concerns of Indigenous works: ecology and the environment, identity, and historical justice. In the context of the aftermath of colonialism and the Indigenous policies of the two countries, Dondon Hounwn's work, *SMAPUX – The Turning Power of Medicine*, presented in Melbourne, was especially distinguished. With the notion of healing, this work provides sharp criticism related to the reality in which Indigenous peoples live. [6]

Joint initiatives on the body and gender equality

True exteriority is that which lies within the gaze that forbids my conformity.
——————————— *Emmaneul Lévinas*

From 2016 to 2019, the relationship between Pulima and YIRRAMBOI was continuously tweaked and negotiated due to cultural, production, and political differences. In Australia, an artist not of a particular ethnic group is not allowed to use their music, images, stories, or express a position on behalf of them. Moreover, based on the Protocols for Using First Nations Cultural and Intellectual Property in the Arts, local Indigenous elders or representatives, as masters of their traditional territories, must be invited to open public events and offer greetings or remarks. [7] In Taiwan, the construction and deconstruction of 'pan-Indigenous consciousness' have led to a completely different route of resistance. Looking at this in another way, due to the distances between Taiwanese and Australian artists and the cultures with which they identify, as well as differences in curatorial spaces, it was difficult for exchanges to be completely equal. When we opened up to one another and recognized these differences, we discovered aspects on which we could collaborate. Among them was the Miss First Nation Taiwan competition, which focused on gender issues in Indigenous societies, transcending ethnicity and gender (taboos). This has continued to be a fond memory for many. [8]

In Taiwan, in the past, contemporary works featuring gender or queerness did not play a major role in Indigenous art practices or discourse, but they now catch people's attention. In her video performance entitled *The Mask (The Tattoo on Faces)* (2014), Ciwas Tahos covers her mouth with transparent tape and, with a marker, draws traditional tattoos seen on the faces of Atayal women. Her actions and methods are reminiscent of body politics. [9] Tjimur Dance Theatre's choreographer Baru Madiljin's video work, *Uqaljai Moth*, featuring two same-sex dancers leaning on and pulling away from one another, highlights the dialectics of gender cognition and ethnic identity. [10] With an emphasis on *écriture féminine*, Dondon Hounwn goes *Beyond Binary Gender, Blurring of Body Image Boundaries* [11] TAI Body Theatre's *Weaving: Man x Woman* (2016) reflects on the traditional division of labor between men (hunting) and women (weaving). The Adju Music Festival also paves the way for a broader discussion related to gender and gender identity in the Indigenous arts. Overall, Taiwan's journey from not talking about such issues to the legalization of same-sex marriage has been priceless. For this reason, during YIRRAMBOI at Pulima in 2018, the Miss First Nation Taiwan drag queen competition was held, with the intention of bringing gender issues to the forefront. Over a week of workshops and rehearsals culminating in a final performance, Miss Ellaneous coached four Indigenous Taiwanese drag queens. Taking to the stage, they represented a collective celebration of gender freedom. While cheering on the inclusion of marginalized groups in contemporary art, we come to understand that social oppression still exists and the challenges are not yet over. [12]

Polycentric formation, imbalance, and reconfiguration

In recent years, art festivals in various countries have publicly acknowledged and paid respect to Indigenous traditional territories and discourses, gradually handing over Indigenous art curatorship to Indigenous curators. In doing so, the 2020 Pulima Art Festival, which marked the event's 10th anniversary, subverted the curatorial and organization methods. It examined the estrangement from Indigenous communities. Breaking away from the previous curatorial focus on specific cities, venues, and time spans, the festival sought to return to Indigenous tribes as artistic sites and formed community-based projects. Six curators invited artists and programs, and facilitated the presentation of exhibitions and performances. They also formed a group that, together with festival consultants, set the theme of

mapalak tnbarah – meaning 'damaged' or 'broken.' Through visiting each other's projects in cities outside Taipei, namely Hsinchu, Pingtung, Taitung and Hualien, the curatorial method and connections between their respective curated programs became more liberal and interrelated. [13]

As critic Hsi Chen says, "Confronting the environmental, contextual, and generational changes in contemporary Indigenous art, the 2020 Pulima Art Festival has shifted the normative ways of festival making and responded to the entangled ecosystem of contemporary art. It empowers discourses through curatorial projects that are formed by allied, collective and collaborative curatorial processes rather than being under the dictatorship of a singular 'celebrity curator.' Bringing together the curatorial projects conducted in various tribes to a post-production exhibition format in the mainstream art space as a new-generation advocacy, it has catalyzed an experimental and alternative method amid the white-hot and institutionalized ecosystem of the contemporary art world." This decentralized reconfiguration might have challenged the festival's 'one-banner branding' and the work of emerging curators, but it has led the body of artistic production to a more down-to-earth reality of Indigenous art.

The last 10 years saw attempts at loosening the power structure by presenting the Pulima Art Festival outside Taipei and in arts museums, cultural venues, as well as Indigenous communities. In the general arts and culture ecosystem, the Pulima Art Festival occupies a niche and lies along the fringe, which actually gives it greater speaking power. The trajectory of Pulima has been, as reflected by previous curators of the festival, a platform that gives a voice to artists of different generations and ethnic experiences, as well as providing them with collective healing. [14]

To respond to internal expectations and those of curators, artists, and audiences, the positioning of the Pulima Art Festival has been deconstructed for speculating the notion of 'What makes an Indigenous arts festival?', including the collaboration with YIRRAMBOI as well as the community-based curatorial shift. The global art market has experienced shock and contraction during the COVID-19 pandemic, while art initiatives that address climate change and ecological issues have matured in recent years. For the sake of our future, reflecting on the role and necessity of Indigenous arts festivals is more urgent than ever.

1. Examples of public agency and organization involvement include the Austronesian Contemporary Art Project of the Kaohsiung Museum of Fine Arts (2007-2009), a three-year project to promote Indigenous community employment through Indigenous artist residencies by the Council of Indigenous Peoples (2009-2011), and Indigenous cultural and art grants by the Indigenous Peoples Cultural Foundation (2011-present). These residencies and grants have led to the promotion of Indigenous art. Private efforts, such as the establishment of the Formosa Indigenous Dance Foundation of Culture and Arts in 1991 and *Indigenous Consciousness* project in the Jinzun area of Taitung County in 2002, are also of great significance.

2. 2020 Pulima Art Award guidelines: http://www.pulima.com.tw/Pulima/artaward202001.aspx (in Chinese).

3. The Pulima Art Festival is overseen by the Indigenous Peoples Cultural Foundation (IPCF), with no professional division of labor in aspects such as curation, production, marketing, and ticketing. Instead, a staff member is assigned to prepare tender documents and handle the outsourcing process. In 2013, this author took over the planning of the Pulima Art Festival upon entering the IPCF and assembled the 2014 Pulima Art Festival committee, which was responsible for researching the theme, preparing proposals and venue applications, commissioning performances, and carrying out marketing and procurement. An international tour was organized, and international collaborations were negotiated. After 2016, it became necessary to hire an external artistic director or curator and to form a group to develop the theme, carry out curation, and oversee program selection and production. This gradually highlighted the personality and positioning of this festival.

4. The 2014 Pulima Art Festival was consciously oriented towards the performing arts. A theme was developed, programs were produced, and collaborations were initiated. Within a small but exquisite structure, opening activities, three theater productions, two to three music or outdoor programs, and closing activities were held. In the non-festival year, domestic and foreign tours were planned. The Pulima Link website was updated to include an artist database, articles, and reviews. In 2016, works from New Zealand and Australia, as well as co-productions, were introduced in addition to the Indigenous New Talents Selection Project for those in the performing arts. In 2018, the Performing Arts Competition for New Talents was included as a category of the Pulima Art Award. However, due to budget constraints, this festival was relegated to the opening and peripheral activities of the Pulima Art Award exhibition. Two international performing arts creators were invited to Taiwan to complete residencies and to co-create and experiment, initiating a two-year collaborative project with the YIRRAMBOI Festival. In 2020, the curatorial direction responded to the return of Indigenous artists to their communities and the maturing of local creative energy, and a project was launched to support curators. These efforts were greatly assisted by the New Zealand Commerce and Industry and Australian Offices in Taipei. In addition, invitations for collaboration were received from various international organizations, providing the foundation and resources for the development of this art festival.

5. From the content shared by Jacob Boehme during the Taiwan Season at Edinburgh Festival Fringe online forum organized by the Ministry of Culture in 2019.

6. Dondon Hounwn and Elug Art Corner performed *SMAPUX – The Turning Power of Medicine* at the Koorie Heritage Trust in Melbourne, which describes the aggression and oppression suffered by Taiwan's Indigenous peoples at the hands of the Japanese colonial government and Han Chinese immigrants. (This history is complex and includes the Hakka and Hoklo peoples.) Dondon Hounwn, a traditional shaman (Smapux), and Australian visual artist Peter Waples-Crow collaborated on this work. A ritual was performed in which healing spiritual power was used to relieve Waples-Crow's pain and trauma induced by the separation from his traditional culture and roots. Fred Chuang, YIRRAMBOI's producer at that time, believed that this work highlighted the historical trauma and pain experienced by many Indigenous peoples. As a result, it resonated with artists and audiences and generated memorable dialogue.

7. White settlers entered Australia on January 26, 1788. Then, in 1910, began the 60-year White Australia policy, which led to the loss of Indigenous languages and traditional roots as well as cultural discontinuity, giving rise to a complex history of colonization and change. There are as many as 250 Indigenous languages in Australia. Among them, only 13 are not critically endangered. Since 1970, Australia's Indigenous peoples have been active in the areas of cultural revitalization and land rights. The National Native Title Tribunal, Aboriginal Land Fund, and Protocols for Using First Nations Cultural and Intellectual Property in the Arts were established to restore the human rights, land management rights, and supervision rights of the Indigenous peoples. Representatives of Indigenous peoples at the locations of public events featuring Indigenous elements are to be invited to such events, and the content produced by one ethnic group, such as stories, songs, symbols, and cultural products, may not be used by another ethnic group, so as to protect the intellectual property rights of all ethnic groups.

8. The theme of 'gender equality' arose from the emphasis on LGBTQ+ issues by Jacob Boehme and the continuation of the co-production direction for the two festivals set by Soda Voyu (2016 festival Creative Director) and myself in 2017. In 2018, I went with Curator Nakaw Putun to Australia to discuss the framework for four programs with YIRRABOI. We also visited Ben Graetz to talk about holding a drag queen competition. Subsequently, Boehme came to Taiwan to view the event space at MOCA and a consensus was reached on the development of the Miss First Nation Taiwan competition.

9. 2014 Pulima Art Festival publication.

10. 2016 Pulima Art Festival publication. In the Paiwan language, *uqaljai* means 'male.' The *Uqaljai Moth* video work earned a Pulima Honorable Award.

11. Lu Wei-Lun. *Feminine Imaging – Possibilities for Contemporary Indigenous Art*. Pulima Link. Article link: http://www.pulima.com.tw/Pulima/0308_19121311453861763.aspx (in Chinese).

12. The early stages of candidate selection and communication with YIRRABOI on curatorial concepts and format went smoothly. Before the start of the event, pressure from the management of IPCF and MOCA led to friction between the two festivals. Although this event was held successfully, it did not trigger discussions on the relevant issues as publicity was purposely limited.

13. In 2019, Rosemary Hinde, former International Development Manager for the Australia Council for the Arts, and I discussed further opportunities for international collaboration. We chose the Biennale of Sydney to promote the 2020 Pulima Art Festival. We also talked about the shortage of Indigenous curatorial talent and realized the urgency of cultivating Indigenous curators in Taiwan. As such, I designed a curator support project and invited Nakaw Putun, Curator of the 2018 Pulima Art Festival, and Gong Jow-Jiun, Director of the Doctoral Program in Art Creation and Theory at Tainan National University of the Arts, to serve as consultants. Due to the COVID-19 pandemic, a scheduled trip to the Biennale of Sydney was cancelled, which gave us more time to focus on the promotion of art at the local and community levels. Over a one-year period, surveying work and exhibitions were completed at six locations in Hsinchu, Pingtung, Taitung and Hualien. We then returned to the Taiwan Contemporary Culture Lab (C-LAB) in Taipei, where Dondon Hounwn, the Curatorial Group Coordinator, and IPCF Curator Lovenose presented an exhibition of the festival highlights. 2020 Pulima Art Festival curatorial background: http://www.pulima.com.tw/PulimaENG/Pulima.aspx.

14. Soda Voyu (2016 Creative Director) says that the Pulima Art Festival is not only a stage for creators in Indigenous communities, but also for Indigenous peoples living in urban areas to connect with their culture through artistic practice. Nakaw Putun (2018 Curatorial Group Coordinator) believes that the Pulima Art Festival functions to create connections, internationally and between old and new, to provide a space for dialogue. Dondon Hounwn (2020 Curatorial Group Coordinator) defines this art festival as a collective healing space for all peoples to face the trauma, conflicts, and contradictions of the past and present.

Dancing in Museums: Choreographing Live Art in Taiwan [1]

Oral Movement: Musée de la Danse in Taipei, 2016. Image courtesy of
Taipei Performing Arts Center. Photo by Pi-Cheng Wang.

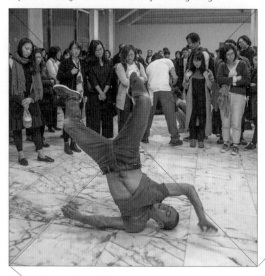

I-Wen CHANG

Translated by Elliott Y.N. CHEUNG

André Lepecki, a writer and curator working on performance studies, has stated that dance's corporeality and presentness suggest "forces of imagination" for visual artists. With choreographers working and experimenting in gallery settings, the fields of dance and visual arts have seamlessly merged in the context of the performative-choreographic turn in contemporary art. Dance and live art performance have become all the craze in the art world. [2] This article revisits a very brief history of dancing in museums in Taiwan against the backdrop of the Crown Theater's experimentation in the '80s and '90s, as well as case studies on the Taipei Fine Arts Museum, to speculate the contemporary performance scene in Taiwan.

Taiwan's Judson Dance Theater - Crown Theater's transdisciplinary experimentation

The trajectory of Crown Theater's experimentation charts the emergence of dancing in museums in Taiwan. In 1984, Ping Heng had just completed her master's degree program in dance at New York University and returned to Taiwan. With the anticipation to simulate the model of Judson Dance Theater, [3] where the transdisciplinary experimentations of dance's postmodern era happened in New York, she founded the Crown Theater, a black box theater with portable seating. At that point, it invited many artists from various fields to work together and the National Theater and Concert Hall of Taiwan had not yet been established. [4] In an era when art was under censorship, the Crown Theater provided opportunities for artists to freely unveil their works.

In 1989, Crown Theater launched the dance company Dance Forum Taipei, with Sunny Pang from Hong Kong serving as Artistic Director from 1990 to 1997. He introduced many postmodern choreographic concepts which were new to Taiwan. Thanks to Cloud Gate Dance Theater, dance training in Taiwan prior to 1984 was primarily based on the Martha Graham Technique. However, Ping Heng employed dancers from overseas to teach the postmodern techniques of Cunningham and Limon, as well as courses such as contact improvisation, and organized choreography workshops. All these paved the way for interdisciplinary practices in dance.

In 1993, Pang conceived the project *Take a Stroll,* inviting dancers to step out of the black box setting and make 'unorthodox' performances outdoors. For example, Chan Tien-Chen presented *Much Obliged,* in one train car at a time,

at Taipei's Songshan Train Station: each of the six cars were likened to a segment of a journey in this work exploring the notions of faith, hope, love, courage, death, and truth. It was an immersive experience comprising smell, sight, hearing, and touch – for instance, the petite dancers were allowed to crawl along the suitcases stowed above the passenger seats, and the audience could literally pass through 'technology' and 'information' in a train car stuffed full of obstacles like newspapers, computers, and recording devices. Certain spectators went so far as to climb into the train car through the window to watch the performance. [5]

The performances of *Take a Stroll* also received solid support from the Taipei Fine Arts Museum (TFAM). Chiang Chiu-Mei's *Flowers for Soups*, held in the foyer of TFAM, saw the use of 100 boiled eggs arranged neatly in lines on the ground, with the dancer standing on a tall ladder, moving elegantly in what looked like a dangerous setting. [6] Chan also performed *Roar to the Skies* in the TFAM's courtyard surrounded by glass partitions, as if "[because] during that era, we were still trapped within the legacy of the martial law; many things still carried a feeling of repression."[7] The dancer howled as she climbed the shelves, suggesting the animalistic energy within humans that cannot be tamed. The howling was contained within the glass partitions that separated the performance space and audiences. Spectators could see what was happening but could not hear the howling. The artist employed this performance to allude to the situation of Taiwanese society where martial law had just been lifted in 1987.

Chan was active in many important events and protests, such as the movement to preserve Tsai Jui-Yueh's Dance Studio in 1994. [8] Meanwhile, Hsiao Wo-Ting, the choreographer of Tsai Jui-Yueh Dance Studio, had also once collaborated with the Garden of Hope Foundation in 1995, performing *The Escapades of an Urban Girl* at TFAM. Three-story-high scaffolding was installed in the plaza in front of the museum; the dancer was like a teen prostitute mired in an industrial concrete jungle. The 55-hour durational performance and action suggested that the emergence of performance outside black box settings was a vehicle of resistance against society. Although the performance-related aspect of '80s and '90s Taiwanese art history is mainly characterized by avant-garde theater, performance art, and noise art, dance was not absent in social discourse or transdisciplinary experimentation. The works outlined above were a foretaste of dance's foray into other realms of art.

Dance and the art museum – TFAM as the prime institution for Taiwanese interdisciplinary performances

The early practice of performance in the context of visual art could already be seen as early as Huang Hua-Cheng's project *Manifesto of the École de Great Taipei* and its associated *École de Great Taipei Autumn Exhibition* in 1966. However, when it comes to institutions, it was not until 1987, with the exhibition *Avant-Garde Installation Space* which consisted of works of installation, action painting and performance art (including the work of Circular Ruins Theater), that the institution held its first exhibition featuring performance. It broke boundaries between the mediums of fine arts, performing the body, space, audiences and art works as living organisms. This also marked a starting point where emerging and experimental artforms were exhibited in the mainstream platform of public institutions. [9]

Since the beginning of the '90s, a new wave in contemporary art in Europe has explored the intersection of human relations and social engagement. In his seminal *Relational Aesthetics* (1998), art historian Nicolas Bourriaud proposes that "art has always been relational in varying degrees... logos, icons, signs, all produce empathy and sharing, and all generate bond... Relationship art is a set of artistic practices which take as their theoretical and practical point of departure the whole of human relations and their social context." [10] The concept swiftly made its way to Taiwan through the globalized system of the art biennial.

Inaugurated in 1998, the Taipei Biennial has presented critical works with the notion of performativity. The 2000 Taipei Biennial, titled "The Sky is the Limit," curated by Jérôme Sans and Manray Hsu, looked at the global remixed cultures and presented live works performed by audience members and artists. Among many participatory works, the notion of 'relational aesthetics' was staged, such as Shu Lea Cheang's *Fluid* (2000), in which performers auditioned to be in the piece through the casting process of a Danish erotic sci-fi film; Michael Lin transformed a public space into a private living room using the pattern printed on a peach-colored bedsheet; Surasi Kusolwong allowed audience members to deposit NTD 20 into a coin box in the hallway of the museum to take any given product home; Lee Ming-Wei's *The Shrine Project* invited participants to be part of the installation; Erwin Wurm's *One Minute Sculptures* had audiences themselves become the sculptures, while Chang Hsia-Fei mixed video, dance performance, and installation into one body of work.

After his debut with the solo exhibition *Way Stations* at the Whitney Museum of American Art, New York, Lee has been well-known for the inclusion of 'audience participation' in his works. Co-presented by Tokyo's Mori Art Museum and TFAM, *Lee Ming-Wei and His Relations: The Art of Participation* (2014-2015) marks a crucial moment in TFAM's trajectory of performance curation. This show at TFAM presented the curation by Mami Kataoka at the Mori in 2014 and a new commission *Our Labyrinth* (2015) for TFAM, accompanied by works of other artists regarding 'relations,' including John Cage, Allan Kaprow, and Taiwanese artists Mali Wu and Michael Lin among others. With the add-on, the exhibition provided a genealogy of contemporary art encompassing Taiwanese and global perspectives about participation and performativity. As it was presented after the 2014 Taipei Biennial curated by Bourriaud, the trend of participatory art and performance enthused the arts community of Taipei.

Oral Movement: Musée de la Danse in Taipei, presented by Taipei Performing Arts Center in collaboration with TFAM and curated by artist River Lin, invited choreographer Boris Charmatz, then Director of Musée de la Danse in France, to Taipei in 2016. [11] This event marks the dance turn of curating in Taiwanese contemporary art. In the same year, the Taipei Biennial, titled "Gestures and Archives of the Present, Genealogies of the Future: New Words for the Biennial" and curated by Corinne Diserens, further extended TFAM's curatorial approaches to performance. Diserens employed the notions of the archaeology of knowledge and presented a series of works staged through the artist's body [12] It challenged the perspectives of participants in gallery settings through performing living bodies. With the notion of 'performing the archive' or 'performing the retrospective', it also broadened performative possibilities for the constitution of the art biennial mechanism. [13]

At the 2016 Taipei Biennial, Diserens viewed the body of an art museum as a knowledge platform traversing historical, societal, and cultural texts through proposing the notion of performing the archive. The curated archives have become approaches to the knowledge genealogy of the future. While performance is embraced by the Biennial, the body of artists and dancers has also become their personal histories as well as living archives. As performance scholar Diana Taylor states in *The Archive and the Repertoire,* "the repertoire of embodied memory – conveyed in gestures, the spoken word, movement, dance, song, and other performances – offers alternative perspectives to those derived from the written archive and is particularly useful to a

reconsideration of historical processes of transnational contact." [14] Performance itself is a 'living history' and aligns with the art museum's tendency to 'collect art history.'

Amid these currents, TFAM's in-house curator Jo Hsiao has curated a series of 'live exhibitions' involving various forms of performance, including *Alice's Rabbit Hole* (2015), *Arena* (2017), *Beneath the Blue Sky* (2020), and *Modern Exorcist* (2021). Hsiao states that although the live works were presented under the 'exhibition' framework, the expression of 'corporeality' is not a 21st-century product. [15] Movements or practices such as Dada, action painting, Futurism and body art were all anti-establishment and not collectable due to their immaterial nature. Hsiao believes that contemporary live art, because of its performative relations to contemporary social-media culture, has become rather more presentable in the institutional sphere as it speaks to the current society of the spectacle.

In the conversation with Xavier Le Roy during his presentation at the 2016 Taipei Biennial, Hsiao realized that Le Roy has his own specific frame of reference. In addition to organizing workshops as part of the audition, he had one-on-one chats with each candidate to 'review' their personal memories and histories, mirroring contemporary art's method of 'reinterpretation' by reviewing art history. Hsiao recalls Xavier arguing that his work is not dance, that "dance is the material of the artwork and it exists in the framework of an exhibition." [16] He added, "The work begins (to perform) when the museum opens and ends when it closes. It is not necessary to make a reservation to access the work. And audiences can come and leave at any point. This is why the work *Retrospeticve* works exactly in the same way as other artworks do. The piece makes sense with the presence of viewers." [17] This reflection by Le Roy got Hsiao thinking about how the artist thinks with precision. Even a motion on pause could be an object. Thus, the concept of what makes an exhibition is redefined.

Hsiao believes that the 'live exhibition' has the power to move people because audience members are able to experience live actions happening right here, right now, and potentially become participants rather than viewers. What Le Roy is concerned with is the conceptualization of performance in exhibition settings – it has gone beyond being categorized as 'dance' and become a work of art in the visual art context. The Taipei iteration of *Retrospective*, seemingly, has responded to how the notion of 'non-dance' in the European-

American context and the experimentation of live art has influenced the practice of transdisciplinary performance in Taiwan over the past decade. Moreover, through working on *Retrospective*, many Taiwanese dance and performance makers (including River Lin, Yu-Ju Lin, Su PinWen, Fangas Nayaw, and Hao Cheng among others) have had deepened exchanges with Le Roy.

From the experimentation of Crown Theater in the '80s and '90s, the historical context of TFAM's encounters with performance, to today's manifold performative practices of local artists in the backdrop of the global art ecosystem, the diverse contemporary interdisciplinary art and performance scene in Taiwan has revealed a new chapter in curating and choreographing performativity.

1. This article is part of the research project entitled, "The Choreographic Turn? From Crown Art Festival to Contemporary Interdisciplinary Dance in Taiwan (I)" (Project No. MOST 110-2410-H-119 -001 -), funded by the Ministry of Science and Technology, Taiwan.

2. André Lepecki, "Dance Choreography and the Visual: Elements for a Contemporary Imagination", in *Is the Living Body the Last Thing Left Alive? The New Performance Turn, Its Histories and Its Institutions*, Cosmas Costinaş & Ana Janevski (eds). Berlin: Sternberg Press, 2017, pp. 12-19: pp. 18-19.

3. In the early 1970s, the dancers of New York City began the most important movement in postmodern dance — the Judson Dance Theater. This group of postmodern choreographers included individuals such as Yvonne Rainer, Steve Paxton, Lucinda Childs, Trisha Brown, and Meredith Monk. Stimulated by Cunningham's methods of random structural choreography, as well as the influence of West Coast choreographers Anna Halprin and Simone Forti, their performances emphasized the process rather than the product. In a single day, they would have countless performances rich with experimental flavor, redefining the meaning of dance.

4. The National Theater and Concert Hall was founded in 1987.

5. From a telephone interview with Chan Tien-Chen on July 11, 2021.

6. Ping Heng, "On Dance Troupes: They Must Be Omnipotent!", *Crown Magazine* 796, June 2020.

7. From a telephone interview with Chan Tien-Chen on July 11, 2021.

8. In the "1994 Taipei Arts Movement" to protect the Tsai Jui-Yueh Dance Theater, Chan and choreographer Hsiao Wo-Ting suspended themselves 15 stories above the ground, participating in the movement piece *My Home is in the Sky*.

9. *Annals. Thirty. TFAM*. Taipei: Taipei Fine Arts Museum, 2013, p. 32.

10. Nicolas Bourriaud. *Relational Aesthetics [English edition]*. Paris: les presses du réel, 2002. pp15, 113.

11. Charmatz was the director of Centre chorégraphique national de Rennes et de Bretagne from 2009 to 2018. During his tenure, he changed the institution's name to Musée de la danse (Museum of Dance).

12. Such as Xavier Le Roy's *Retrospective*, River Lin's *20 Dances for the 20th Century, But Asian*, and Yvonne Rainer's related research works.

13. For discussion related to this exhibition, please see: Chang, I-Wen, 2020. "Choreographing Exhibitions: Curating Performativity in Taiwan." *Curatography, Issue 3: Curating Performativity*. Full text at: https://curatography.org/choreographing-exhibitions-curating-performativity-in-taiwan/.

14. Diana Taylor. *The Archive and the Repertoire: Performing Cultural Memory in the Americas*. Duke University, 2003.

15. From an interview with Jo Hsiao on December 1, 2021.

16. From an interview with Jo Hsiao on December 1, 2021. These contents have been confirmed with Le Roy via email by the author.

17. Based on Le Roy's supplementary explanation to the author via email on December 29, 2021.

When Shows Must Go Online: The Framing of the Visual Interface and Its Extension

FW: *Wall-Floor-Window Positions* (screenshots), 2020 ADAM. Image courtesy of Taipei Performing Arts Center.

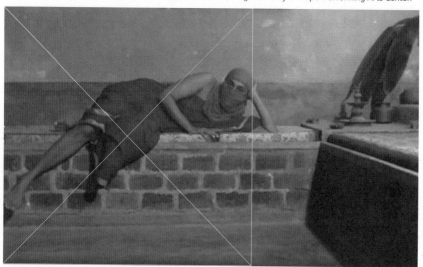

An interview with Po-Wei WANG by Hsuan TANG

Translated by **Elizabeth LEE**

In 2020 and 2021, because of the restrictions of international and interregional mobility, ADAM's program, like many other cultural events, had to shift from in-person and on-site settings to online ones and, at the same time, figure out ways to keep the networking alive. In its online iteration, ADAM, however, reflected how art can respond to the production models and meanings shaped by contemporary networks and digital culture.

This article discusses two performance series, namely *FW: Wall-Floor-Window Positions* and *My Browsing History*, in the 2021 ADAM online art project "An Internet of Things." The former frames performers' movements within the computer screen through Google Meet, merging online and on-site spaces to depict situations of life in quarantine. The latter takes the form of lecture performance, and deals with the relationship between content and experiences in the post-digital age by showcasing how artists present and stream information via various digital interfaces, platforms and software.

On the whole, under the circumstances of lockdown and quarantine, curator River Lin's attempt to frame artists' movements using software and hardware, in effect, highlights the fact that various technological conditions have long become part of the infrastructure and basic needs of contemporary life in the digital and internet age. People have long lived in the 'post-digital' existence, and cyberspace is no longer a metaphor, but a physical reality. The borderline between reality and virtuality has shifted significantly, and their respective realms expanded.

My Browsing History: Different experiences and knowledge generated by algorithms

The slang 'surfing the internet' pictorializes web browsing behavior. The act of browsing between different web pages through an infinite number of hyperlinks is likened to constantly riding on ocean waves. *My Browsing History* considers, from the perspective of internet topology, how the acts of logging-in, indexing and searching on the internet have directed people's understandings towards things. Through presenting 'browsing performances,' the various artists reveal the online journey of their 'browsing history' via search engines that eventually constitutes internet maps informed by stacks of visual and audio content.

However, if one tries to follow the artists' browsing journey by inputting the

same keywords, they would be led to perhaps quite different search results, as the digital information world is constructed by algorithms that compute differently depending on specific conditions and behaviors of each individual. Everybody has a personal algorithmic world. The sequencing and nature of each person's search results vary, thus the generated information is not homogenous. In the WWW, people do not really share one world as imagined. Instead, a host of customized worlds exist, each represented as a personal entity shaped and surrounded by visible and invisible data, overseen by a back-end system operated by algorithms.

More precisely, the digital world that only exists with the individual and not the collective is called the 'echo chamber effect.'

Here, I would like to distinguish the differences between knowledge-to-experience and experience-to-knowledge production. The ubiquity of the Web, since 2000, has transmuted ways of learning knowledge. The notions of 'he that travels far knows much' or 'The Lonely Planet,' whereby one takes physical actions and labor to gain knowledge, no longer exist. Instead, it has become 'information processing' through the internet. In particular, when browsing, all 'keywords' lead to Rome. In order to query and look for knowledge, 'curating' keywords/information has become a precondition in the exploration of more information via search engines. This is to say, the realms of reality and virtuality have integrated, and 'experience' and 'knowledge' have been transposed to diverge from normative epistemology. To date, various tools of digital technology at our disposal are not only devices that serve our work, but also ones that expand our connections with an internet of things through ubiquitous computing. They facilitate instant and automatic interactions whenever we need them and shape our identities and social relations.

FW: Wall-Floor-Window Positions:
The complementarity of virtuality and reality

FW: Wall-Floor-Window Positions also touches on relevant problematique. This series takes American artist Bruce Nauman's single-channel video Wall-Floor Positions (1968) as the point of departure to see, in the context of 'performing for the webcam,' how artists would measure the directions of their choreographed movements and bodily relations between the actual and screen space. In his work, Nauman seemed to constantly shift his gestures

and positions to disrupt the preconceived conditions of how human gestures exist within horizontal and vertical dimensions. *FW: Wall-Floor-Window Positions*, therefore, invites 15 artists to respond to Nauman's approach with a curatorial framework that sees the 'window' as another add-on dimension of the performance space for physical and virtual communication. It questions, "Through what channel or interface do we get to know the world? Is the world constructed via the webcam and screen shared by audiences and artists?"

For example, during a videoconference or an online event, if someone moves and their face goes out of the laptop camera frame, leaving only their belly or a part of their body on the screen, we generally do not assume that 'their belly is trying to perform' or believe that 'their shoulders are trying to express something.' We merely understand that the person is simply altering their body position. In the context of a videoconference, we do not assume that the person vanishes from the world when they leave the screen, nor do we equate the screen itself 'completely' with reality. There exists a complementary relationship between the interface of the screen (virtuality) and the on-site space (reality); the world of images and the world of everyday reality are both part of the gestalt.

However, for the artists who express themselves via videoconference settings at home due to the pandemic, the 'window' has become everything and forms the foundation of their communication with reality. In the performance, the image captured by an artist's webcam and seen by remote audiences has become a projection of the artist's real life. Online viewers hypothesize that whatever is recorded by the webcam becomes the object of viewing and bears meaning. The real-time spectatorship through webcam settings dismantles the complementarity between screen and real-life spaces. This program assembles the external world into one single-channel visual interface, presenting a series of 'framed' positions by the artists to reveal 'actual' human conditions under lockdowns and mobility restrictions, moving beyond metaphors.

Let me take two instances to illustrate my point. If a social media account does not have a profile picture, people immediately suspect the account's credibility because a 'profile picture' has become certification for one's 'social' identification and representation – a face means all in this reading. The other example concerns meme images, which are sometimes created by combining irrelevant text and pictures. Readers usually accept whatever

meanings they suggest as, for some reason, they believe that text and images always coexist. Such an understanding corresponds to the user's accustomed way of interacting with the internet interface, because in the concept of UI (user interface) and UX (user experience), there is no difference between foregrounds and backgrounds. Everything is integrated and brought to the surface without depth of field.

Haptic visuality: The visual co-presence

Overall, the two online performance programs of ADAM have emphasized the interface of visuality, while reflecting on modes of visual-oriented remote communication. In *FW: Wall-Floor-Window Positions*, Sri Lanka-based artist Venuri Perera [1] has further explored the notion of 'haptic visuality.' Generally, tactility is based on the premise of 'on-site interaction' and through physical contact; visuality, on the contrary, can happen through remote contact. In this context, haptic visuality indicates a sense of physical and emotional co-presence generated by remote visual contact. In her work, Venuri Perera, wearing traditional dress, positions the webcam in a semi-public space, and quietly ex/poses herself using various gestures – subtly with 'seductive' intension, staring into the webcam to provoke the protocol of how a female body is seen and projected by heteronormative gazes. This action is performed and directed by visual communication, presenting how certain cultural codes are embodied and visualized through viewing. The artist's body and action even transcend the screen to 'touch' online spectators through visual 'friction,' redirecting our understanding of South-Asian culture through the feminist lens. [2]

Utilizing the online settings of the videoconference and search engine, and exposing their interface of ICT (Information and Communications Technology) as performance strategy during global lockdowns, ADAM's online performance series enacts a collective action of post-digital culture. While the bodies of the 'window,' 'screen' and 'interface' are everywhere in contemporary life, the performances have not only responded to the new normal of quarantine or lockdowns, but also questioned the liveness of performance: re-defining the notion of liveness located in remote settings and seeking its co-presence of screen-based haptic visuality.

1. Venuri Perera is a performance artist based in Colombo. Her works inhabit the space between dance, behavioral arts and rituals, dealing with nationalism, patriarchy, borders and the violence of class. She completed her Post Graduate Certificate in Dance from LABAN Centre, London, in 2008 and received the Michelle Simone Award for 'Outstanding Achievement in Choreography.' Perera was the curator of Colombo Dance Platform 2016 and a member of the independent arts group The Packet.

2. Wang Po-Wei, "Constructing a Narrative Outside the Screen Frame in the 'Post-Digital' State: An Observation of the 2020 ADAM Project." *Performing Arts Redefined Magazine*, October 2020.

Notes on Enquiries into Asia(s)

Enoch CHENG

I.

During the COVID-19 pandemic, I came to accept the fact that art is not considered a priority in our society. Through this invitation of looking at performance in Asia from the queer perspective, I have been questioning myself in today's context of performance (when we still do not know how the pandemic will end), whether 'queerness' can be an approach to enquire about 'Asia', and how 'Asia' exists.

It is productive to think about utopia as flux, a temporal disorganization, as a moment when here and the now is transcended by a then and a there that could be and indeed should be.
— José Esteban Muñoz

Since the 2000s, the shifts in queer studies and Asian studies have allowed intersectional analysis to go beyond psychoanalysis and gender performativity to the geopolitical critique (Chiang and Wong, 2017). The merging of the two addresses the plurality of Asia, breaking down the old lens of seeing Asia as a faceless singular continent. What is indeed instrumental about queerness is the urge to seek the possibilities outside the normality of how to 'perform' the idea of utopia. While it is by no means my intention to boil down queerness in Asia, performance in Asia, or Asia itself into a definite notion, I do find it inspiring as an artist myself to borrow Muñoz's idea, and see Asia as flux, a temporal disorganisation as a condition, through enquiring where we are now. By acknowledging that we are in a state of 'disorganisation', the task of calling for change is bestowed upon us, artists, the makers of performance.

Allow me to describe the state of this 'disorganisation' as of this moment while writing this piece in early April 2022: we are in a mess.

II.

My home of Hong Kong has been experiencing two months of unprecedented impact due to the Omicron variant of COVID-19. In the first month, hospitals were overloaded, and there was not enough space in the mortuaries for the deceased. Businesses have shut down. Civic, sports, and cultural venues have been closed indefinitely. Once again, like at the beginning of the pandemic in 2020, the cancellation or postponement of cultural events have left many cultural workers and freelancers struggling to survive. In order to plan the next steps forward, we have been waiting for the announcement of the new policy that would eventually and constantly be altered. For my upcoming

project, for example, I have at least five contingency plans. And my case is not unique – it is the new normal.

The pandemic has now entered a new phase. I remember when it first began in China, many Western countries were not aware of the severity of the new virus, with some comparing it to the flu. However, many East Asian countries were more prepared to devise an apt model to handle the situation. This global public health crisis has forced Western leaders to reconcile with the fact that they knew less. They needed to adapt to a new culture different from what they were used to. For instance, learning from Asia, they gradually changed their mind about masks; they also compared examples from places in Asia (such as South Korea) of how to mitigate the virus by introducing new measures including social distancing, or even lockdown.

Since 2021, COVID-19 vaccines have been introduced and gradually distributed in many countries. In 2022, while the virus has mutated from the Delta variant to now Omicron, many European and American countries have decided to live with the virus and resume normal life in order to keep the economic machine running. Meanwhile, Asia, given our crowded living environment, our very different governmental, social and cultural structures, is still planning – in one way or another – to cautiously reopen the borders. It seems that the Asian models are no longer a reference for the West, nor Asia's current affairs their interests beyond their political or economic concerns.

Speaking of politics, Asia's direct neighbour, Russia, has begun a war against Ukraine. Not only is Asia close to Russia geographically, but it is feared that some of the authoritarian countries in Asia may be its allies. We see missile testing in Asian skies and navy patrolling in the region's oceans more frequently on the news every day – it is the new normal.

III.

It is not easy to be optimistic in Asia right now. Cultural exchanges between different countries have also become less frequent. Who has the time to accommodate different time zones and attend more Zoom meetings or events these days, when one is busy trying to return to, or retain some degree of normalcy (or sanity) in life? (I have saved so many links, but they all eventually expired without being visited). Compared to the time before 2019, before COVID-19 and the social unrest that continues to this day, perhaps it is realistic to note that at a certain level, the arts and cultural scenes are

bleak at this very moment. Even when the pandemic is finally over, even if all theatres are opened, we do not know whether all the alternative scenes (such as many self-organised performance festivals in Southeast Asia, or other underground organisations), can return under the new political climate, let alone flourish.

Furthermore, what if there is no going back to normal, and uncertainty becomes the determinant of our plans. For example, audiences may only decide to attend a performance at the last minute, when someday they feel safe or are permitted to go out and enter a venue. Artists who are invited to perform at festivals may often have to shift to formats other than the one originally intended (such as going online), or they may not even get their visa issued.

What if many more ambitious new theatre projects that have just been completed or are still under construction would remain unopened? What if physical performance sites would eventually become ruins, as totems of how we used to live with culture? What then is the story we want to tell our future generations about the cultural landscape of our past? What is the story we are telling each other now, and how?

IV.

If this were a sci-fi film, this could be the opening line: institutions from the normative times have failed. The pandemic denoted a global collapse of the universal healthcare system, while the war symbolised a collapse of the global peace-making system. In many countries, measures on national security have tightened. Borders are virtually or practically closed. Many people's livelihoods have been altered. Artists certainly are not a high priority in society. Artistic directors of institutions have a hard time keeping their jobs stable with all the agenda on their hot plates (such as keeping their theatre or festival financially viable, ensuring the safety of artists and audiences, or simply complying to the state's ideology – the list goes on).

It is a dystopia. This is a critique of the 'now', as flux, as disorganisation. But to practise utopia, Muñoz calls for a "perpetual becoming" through a "performative doing". He speaks about the power of "aesthetics that fuels the political imagination" by refusing the dominant normative terms, to emphasise "antinormativity" (Muñoz: p. 171).

In the practices of performance and theatre, here, I think of ADAM in Taiwan. Since 2017, I have actively participated in at least four editions as an artist, performer, and observer. This annual occasion for Asian colleagues to gather had a different vibe to many mainstream performance markets, producer meetings, or trade shows led by major cultural institutions. The ADAM organisers seemed to be hosting the event in response to other market-driven models that were trendy at the time. It was not about strategic collaborations, cultural mind-mapping, co-production, resource gathering, or career experience sharing. ADAM was more of a platform for seeing artists as people; of seeing how old friends have been and meeting new ones. There was a sense of a laboratory setting where things were not meant to be finished, but to be tried out. The experience was meant to be shared by different artists and practitioners, while they themselves might be the ones who were continuously presenting their works in progress or talks on their thoughts and creations. It was a potluck party. There was not a common set of goals to reach, not an outcome driven by the cultural industry that always craves for a successful mode of production.

However, sometimes, artists would find it difficult to place their expectations. Many audiences were also indeed professional directors, producers, and managers who might eventually decide to commission their work. Meanwhile, I have also observed that there was indeed a level of separation between artists and other 'higher' professionals in a social gathering setting. The way I see this is that there was not a common language among the participants, as humans. And fundamentally, it was an occasion to 'discover'. Hence, the hierarchy of discovery would seem to always exist when no one decided to break it.

V.

In any case, the ADAM I am describing happened in the heyday, when there was a sense of optimism of Asia coming together and of discovery. It was also the time when there was a host of new ambitious theatre/cultural projects being built all over the continent. The prospect of new (forms of) performances was hoped to fuel the future of the Asian arts scene, one that might be different from the European or American model. And ADAM was indeed born under the umbrella of the enormous Taipei Performing Arts Center (TPAC).

In retrospect, I ask: what was the notion of 'discovering Asia' behind ADAM?

Did it mean to suggest that Asia had never known much about itself, so discovery was needed? Or was there indeed a different kind of Asia that was expected to emerge? To me, ADAM was there to demonstrate that Asia has never been one. The inclusion of Indigenous and various community programmes, as well as artists being invited from countries without strong institutional structures, addressed that there was a mix of backgrounds being played out in our reality. Historically, Asia, with its multifaceted stories, has always been pluralistic, be it geographically, culturally, or ideologically. Thus, perhaps it is a perpetual task for Asia-s to discover, to 'get to know' each other.

But since 2020, under various security regimes and the COVID-19 pandemic, border control within Asia has become tougher than ever, making it difficult even for Asians to enter another Asian country. The act of leaving our home to get to somewhere else to 'discover' other Asia-s is now a luxury.

I wonder what the point of an Asia gathering in the name of performance such as ADAM is now. Under what conditions can we 'discover'? Is it meant to be for TPAC? Or the Taipei Arts Festival affiliated to it? In the past two years (2020-2021), what paradigm have these 'authorities' of arts and performance been producing? This last question also applies to all the major ambitious institutions or cultural projects in Asia. Are these giants the place for Asia to get to know Asia?

Or maybe, all along, we have simply been projecting a never-ending desire of producing the discourse that we know each other? Or have we simply been trying to adopt the ideology of becoming a successful model in the cultural industry, or even becoming international? Is this model still functioning?

Who does the ecology of performance ultimately serve when we come to 'discover' Asia-s today?

VI.

During 2020 to 2021, many cultural events, including ADAM, have gone online. Over the first year of the pandemic in 2020, online programmes proliferated when many people across the globe stayed home during lockdowns. There was an illusion of the possibility to 'see' and 'discover' faraway places beyond one's national borders. Many programmes were even free, offering the possibilities (another illusion?) to eliminate the barrier of costs related to

traveling, production, and ticketing. This pioneering model suddenly opened up new avenues for engagement and discovery.

However, such a model depends on whether: (a) everyone can afford hi-speed internet; and (b) everyone will be staying home (in the case of 2020, as conditioned by COVID-19) at the same time. In 2021 and 2022, as COVID-19 measures began to vary in different places, the requirement to stay home changed. Consequently, the interest to organise and watch performances online declined drastically. Physical live events are still the norm, with many organisers and audiences claiming that they embrace the time of being together physically.

Yet, what has been made clear is that the old practice (in the old normal) might not always serve us. Hence, a new (temporary) model has arisen to (temporarily) dismantle the former modes of resource distribution to break (physical) limitations, thus offering an alternative to the norms of the past. This shift has allowed me to naively ask if physical live events are the only answer for our performance ecology? And more imperatively, can the resources for performance/art truly be free and borderless, so as to always offer different kinds of possibilities of 'discovering' others, like how we have somehow experienced in 2020?

Here, we could go further and ask, "Who has been in charge of such resources of 'discovery' in the first place?" Are these resources part of a larger social fabric? How can the distribution of such resources for 'discovery' shape the lens of a society, especially at a time that is grim for artists?

In the past two years, in the context of ADAM, we have witnessed the dire situation of our Asian colleagues: some former ADAM artists have been arrested in their home countries due to their involvement in political activities, while many artists from all over the region have not received an income, nor any state support, during the pandemic when physical performances were not possible. Does the precarious nature of artists suggest that it is a norm for them to live on the margins of society?

VII.

The pandemic has reminded us that artists are living in the dark. Despite the fact that, in the past, we might have created – in one way or another – according to market desire, curatorial interest, funding mechanisms, box-

office results, audience expectations, or contractual terms, we have kept up to stay fresh and new. However, there is no guarantee that reality, as we are experiencing it now, can promise our livelihoods or safety. In this particular moment, how would we justify our existence in our own terms as citizens in the COVID era and the post-COVID time to come (or which has come)? How much can we do?

I know, there are many things that are beyond our humble power, but if we look at our very own reality (one can define its proximity), perhaps it is timely to learn how to survive from the queer lens. Scholars Alyson Campbell and Stephen Farrier propose through queer dramaturgies that one must be attentive to the "geographical, temporal, spatial, political and social" [here, I would also add: natural] environment and culture with a "critical eye on its attendant problems, hierarchies and assumptions" (Campbell & Farrier: p. 4).

In other words, we need to evaluate every aspect of the performance process as a potentiality of actualising a reality. It is also to enquire 'queerly' about the very framework that enables performance: what kind of values are being performed, produced, and actualised in the context of today's world? Ultimately, performance makers can step up to reclaim and reappropriate the theatre apparatus — the conditions under which performance operates – and refuse the mode of unexamined production.

With regard to the scarcity of public resources, we could ask if and how we can be the stakeholders in our society. And when we are so lucky to actually obtain any resources, it is indeed an opportunity to define our role by asking how they can be better re-allocated, and what we are spotlighting it onto. This process of shaping our role should not merely be considered based on the show we are presenting on the stage. It needs to be extended to every single aspect through interlocution with the various parties involved over the entire process, including, and especially, during the stage of drafting the contract with our organisers or funders. This helps us 'perform' our role in building the eloquence to envision a society through law and order. We must know that each contract we sign will likely be a reference in the future, that may, in turn, inadvertently become a power to oppress or free others.

In our reality, hierarchy exists in all aspects of our society. Nonetheless, one should not take such power dynamics as a given. In the sphere of the theatre, which is a site for rehearsing a new reality, it is only right and righteous to

see those in power as the custodian of shared resources. We can gently and dutifully enquire, as human beings, about their views on our society, and further, our shared Asian futurity in the post-COVID paradigm.

As for performance and its ecology in the current state of our world, simply focusing on what is being presented on stage will direct us back to old times and old values. When the theatre stalls or stales in the time that is now, we must all repurpose it as a new site to perform the dialogue from behind. Our job needs to challenge how this very stage ought to be reconstructed as a way to reconstruct our society. As we 'rediscover' and re-articulate the specific context of Asia in today's world, we should take the opportunity to 'rediscover' the world through a new queer lens, a lens that yearns for the utopia which does not exist unless one demands it. As pluralistic as Asia, we can realise as many futures as possible potentials for our world.

VIII.

I remember seeing a work in progress entitled *IsLand Bar*, conceived by Scarlet Yu Mei Wah and Chikara Fujiwara among others, on the very last day of the first edition of ADAM. Seven artists turned the performance site into a bar, each serving an audience a cocktail like a bartender. While making the drink, they narrated their diasporic stories through each ingredient they had chosen. By carefully selecting and deconstructing the material with which they performed, and taking ownership of, and redefining the conditions under which they performed, they 'turned the tables'. They created a queer ecology that served both them and the audience intimately.

To my fellow artists and arts colleagues, let's hold on to our stories now. Let's assume that all traumatic scenarios will be our perpetual conditions now. I know many of you have grown accustomed to adversity even before the pandemic, and I salute you for your honourable struggle thus far. I wish we could imagine the theatres as ruins, as past burdens. Meanwhile, let's project the future to critically look at how we must change the present. And let's not go back to the old normal, nor be complacent with the new normal. The next time we meet – and we should make that happen soon (be it virtually or physically) – please start by asking, "How have you been doing all this time? Have you been well?"

In the process, we might perpetually fail. But if we fail in a queer way, there could very well be a chance to push for something outside the conventions

that give rise to norms. By so doing, we are performing our ecology, queerly and optimistically.

Bibliography

1. Campbell, Alyson & Farrier, Stephen. (Eds.). *Queer Dramaturgies: International Perspectives on Where Performance Leads Queer*. Basingstoke: Palgrave, 2016.

2. "Asia is burning: Queer Asia as critique". Chiang, Howard & Wong, Alvin K. (Eds.). *Culture, Theory and Critique*. New York: Routledge, 2017.

3. Muñoz, José Esteban. *Cruising Utopia: The Then and There of Queer Futurity*. New York: NYU Press, 2009.

Responding to the Shifting Worlds: Chiaki Soma's Curatorial Practice

Betty Yi-Chun CHEN

Translated by **Elizabeth LEE**

Chiaki Soma began her career at the Tokyo International Arts Festival in 2002. In 2009, the festival was renamed as Festival/Tokyo (F/T) and appointed Soma to be Program Director. During her tenure (2002-2013), Soma proposed festival themes responding to the society and its zeitgeist, providing a brand new link between festival productions and the Tokyo life. At the same time, she actively promoted exchange platforms for young artists in Asia. Apart from presenting their works in Tokyo, she created the Residence East Asia Dialogue (r:ead) project in Japan, Taiwan, South Korea and Hong Kong, fostering exchanges themed on historical contexts and current social realities among artists in East Asia through brief stays in the various cities.

In 2014, Soma left F/T and founded Arts Commons Tokyo which continues to promote modes of artmaking that respond to the society through production, media, as well as talent- and audience-cultivation. Her practice goes beyond the dichotomy between large-scale institutions and small arts communities, emphasizing independent perspectives and constantly proposing models that break away from preconceived frameworks and limitations. In 2021, together with Kyoko Iwaki, Soma was appointed one of the curators of the 2023 Theater der Welt in Germany, becoming the first non-European curators to take up the position. This interview aims to understand her curatorial practice shaped by and revolving around the notion of Asia, through reviewing her key projects and issues of concern over the past decade.

Proposing new artistic methodologies

Since her time at F/T, Soma has been expanding the possibilities of 'theater' and 'festival' in her curation. Her strategy includes introducing many works that take place outside of theaters or the city. Rimini Protokoll's *Cargo X*, for instance, takes the audience on a ride to the periphery of the city. The converted truck with one transparent side on the container frames the cityscape seen along the journey into a stage for viewing. Another example is Akira Takayama's *The Complete Manual of Evacuation*. The artist utilizes the Yamanote Line of the metro in Tokyo as an axis to annex and map out the 'evacuation sites' surrounding each station while the network takes the audience to investigate the heterogeneous communities and spaces that fall through the cracks of the sophisticated systems of urban surveillance. In these practices, the meaning of theater resides no longer merely in stage performances, but in the ways that the audience can look at the city afresh through theatrical perspectives and compositions. This approach

defamiliarizes the landscape of everyday life while the artists probe into society's unseen people and latent memories. Because of these interventions, the audience's perceptions of what is fictional and what is real are shaken.

"The term 'theater' can refer to the performance as well as the performance space and architecture of a theater. Therefore, it is necessary for theater to evolve with the times and be up to date, and we do see the transformation," Soma unpacked the ongoing focus of her work with this statement. And 'festivals' can "bring the non-everyday into the everyday and manifest what is imperceptible in the social community's quotidian experience." She added that traditional artforms like Noh and Kabuki also impress people by being 'unusual' as they can only be seen at festivals. At the same time, festivals are occasions for creating encounters between the different classes and/or between 'insiders' and 'outsiders' (such as the encounter between citizens and visitors), or between entities that are internal to and external from the arts field.

To contemplate art from the 'outside' and to produce works that can generate dialogues with society thus serve as coordinates in her curatorial practice. For instance, after the Tohoku earthquake and tsunami in 2011, exploration on ways to narrate the unspeakable became a continuous theme. "From all those phrases of support and encouragement that sprang up in the streets, I sensed that the language we use in our daily life is insufficient. We should look for new discourse," Soma once commented in a talk in Taiwan. [1] As a result, for two consecutive years, F/T commissioned different artists to create a site-specific work, an exhibition and a musical performance based on *Kein Licht* – a work themed on the earthquake by Austrian playwright Elfriede Jelinek – in order to reflect on this juncture in society.

Developing a new methodology of art that responds to the society is central to Soma's work. The independent non-profit organization that she later founded – Arts Commons Tokyo – endeavors to 'propose various kinds of ideas and models towards the future' and produces art-related projects. These include productions, publication, think tank research that integrates cultural policies and urban planning, as well as building educational infrastructures that aim to foster talents and audiences. For instance, since 2017, the small-scale annual art festival Theater Commons Tokyo (TCT) has been promoting reflection and exchange on specific issues through lecture-performances and forums. Theater Commons Lab, which experiments with

contemporary expressions and socially-engaged practices in art on the basis of theater studies, also produces local knowledge and opens up creative paths that confront the world through an assembly of individuals engaging in creative processes, including artists, producers, editors, Translateds, journalists, performers and researchers. Soma wishes to strengthen the connection between art and the society, thereby creating 'commons' – practices and exchanges that belong to the public. [2]

Plural 'worlds'

These curatorial motivations originate from Soma's awareness of the Asian context. During the interview, she mentioned that it was not until the past decade or so that more exchange platforms have emerged in the Asian region. Before that, many countries placed numerous restrictions on traveling and the exchange of ideas. Some state-funded institutional platforms, such as Performing Arts Meeting in Yokohama (TPAM) in Japan, and Asia Cultural Center in Gwangju, South Korea, came later. However, the functions of these bodies would be severely impacted if the state were to cut back on its support. As an independent curator, she has been working on opening up more viable avenues in the light of resource distribution and the cultural context in Asia.

What concerns her is the distance between cultural production and the producers' own environment. "I grew up and worked in the arts field in Asia. However, I am not familiar with Asia or Japan. Some of that knowledge seems to be deliberately left in oblivion," she commented. Lecturing at a university, she has found that Japanese students know very little about their neighboring countries. They did not even know about Japan's history of invasion and colonialization. "As opposed to Taiwan and Korea's familiarity with conscription, Japanese students do not understand the idea that one has to protect their own country. Having been long accustomed to social stability and safety, they do not think about the significance of their own country's historical position or actions in East Asia." She also reflects on her own limited understanding of such matters in the past, recalling that most of her knowledge [about Asia] had come from books. "I don't consider that to be real knowledge," she said. "The Japanese arts world still pursues the masters and values established by the Western system. I've been thinking about whether it is possible to propose some new scales, different from the Western ones, that are based on the realities of Asia. That is what I have endeavored to do in the

past 10 years."

Soma's encounter with Prof. Gong Jow-Jiun of Tainan National University of the Arts through the r:ead project in 2012 became the turning point of her curatorial practice. In the following year, through the duo's collaborative efforts, the project moved to Taiwan, which allowed her to personally experience various parts of this neighboring but unfamiliar country. Although brief, the trip meant a lot to her. She added, "It is beneficial for young artists, curators, or any individual to have the opportunity to learn from the local communities where projects take place and gain an understanding of what the community members experience and think. It does not mean that we must create something themed on Asia, but we should learn more about the society and the environment where we live before creating artworks." That is the reason why she dedicates herself to providing such residency programs, be it domestically or abroad. Apart from the r:ead project, she also curated a month-long residency in Mutsu city in northeastern Japan. The residency asked young creators to conduct on-site fieldwork, and invited folklorists, sociologists and artists to discuss its central subject of "The Question from the Northeast", so as to "connect the cracks and upheaval brought about by the 2011 earthquake with expressions we have never seen before."

Initial steps in the post-disaster investigation had already been taken during the F/T period, and a further push was given at the independent stage after the establishment of Arts Commons Tokyo. This developmental difference has to do with her understanding of the meaning of publicness: "Most people think that publicness means meeting the needs of the majority in society, but I think publicness should be about taking care of the needs of every individual." She pointed out that, in Asia, publicness is often interpreted as the pursuit of an absolute majority. "But if it concerns an absolute majority, it can survive market competition and does not need the government's assistance. I believe that publicness lies in offering citizens avant-garde perspectives that look to the future, or things that exist now but tend to be forgotten. That is to say, publicness is about individual needs. It is only when we are able to pay attention to the differences among individuals that we can achieve real publicness." She believes that it will still take another 20 or 30 years for this conceptual paradigm to shift in Asia.

I am curious about how she manages to produce these carefully curated and transdisciplinary fostering projects without institutional support. She

told me that when she left F/T in 2013, each of the 13 founding members of Arts Commons Tokyo chipped in 30,000 yen, pooling together 390,000 yen to launch the initiative. "I take it as a trial to see how far I can go with the project." She pointed out that Arts Commons Tokyo and the later TCT arts festival rarely take commissions from outside; they are mostly driven by the ideas they want to realize: "You asked me how I managed to realize so many ideas. I can only say that there are still many unrealized ones. All you see is the parts that I have realized, and these are things achieved under heavily restrictive circumstances." For example, the flexible arrangements of TCT might appear innovative in the eyes of an outsider, but for Soma, they are ventures that break the shackles of circumstance. For instance, there are no venues within TCT's tight budget available in Tokyo. And so, she overcomes the obstacle by networking with the civic centers in Minato city, Goethe Institute and Taiwan Cultural Center in Tokyo, and contemplates on how to experiment with the ideals she pursues within a limited space and under unfavorable rehearsal conditions through applying the lecture and workshop models. That is the original intention of her independent practice as well as her strategy. This approach is grounded in the reality of how cultural systems operate in Asia.

Under such a framework of thought formed in Asia, how does she tackle the challenge of curating a gigantic institution like the upcoming Theater der Welt in Germany? Soma said that, as a 'festival,' she would not focus solely on Asia, but pay attention to the diversity of the participating artists and audience. At the same time, she believes that she needs to put up resistance against the concept of 'the world.' She does not think that the concept of 'one world' existed in Asia to begin with. The phrase must have entered the Sino language system relatively recently through translation. "The [concept of] 'the world' is hard to grasp. Asians might think that there are many parallel worlds, not a unified one. The West might feel that such an idea seems to promote division or increase the gap between people. But I do not think so. The world consists of diverse faces. I am trying to convey the concept of plural worlds." She thus formulated her current endeavors.

The concept of plural worlds has always been embodied in her understanding of art being connected to the society. "Performing arts need to be built on the social foundations of a nation or region. Different social foundations give rise to different forms of arts and performance events," she said. The fact that some highly artistic and critical Asian works are not meant to be

performed in large venues serves as a case in point. Such a theater culture grew from its specific conditions and historical context. "I think that we should provide a performance space that is appropriate for these cultures and works, instead of demanding them to fit into our scale and match our methodology." Of course, some performance models (such as the VR technologies which Soma has been working with in recent years) are not constrained by such limitations. But the majority of performing arts depends on the social foundations of its own locality. The aforementioned fieldwork and exchange of ideas regarding our living realities are intended as a means to observe the coexistence of different communities and 'worlds,' and to look for the possibility of dialogues and responses therein.

In the face of turmoil

At the same time, this socially oriented curatorial strategy also highlights the fact that reality is never in stasis. In TCT's closing forum in February 2022, when talking about how the arts can still respond to reality in the face of turmoil and vicissitudes, Soma pointed out that everything happens so fast, but the paradigm shift takes place very slowly – slowly, but surely. Art must capture these kinds of change so as to broaden our understanding of the present. "I understand that there is not much that I can change. But we still have the responsibility to recount the crises or tragedies taking place before our eyes. It is not about making accusations. Rather, many things are being forgotten or becoming invisible as they are happening. People who are experiencing them like us have the responsibility to let the next generation know what has happened." She also believes that although the slow nature of art means that it cannot offer immediate aid, it might be able to build a model that "strengthens people's minds and helps them find the meaning of existence and face the future. That is what I think perhaps art can achieve," Soma remarked.

Two crises that jolted humanity's existence within the space of a decade deeply affect Soma's practice: the first being the 2011 Great East Japan Earthquake; and the second, the COVID-19 pandemic. "These events, which were unthinkable in the past, suddenly happened right before our eyes," she said. It is the same with the Russia-Ukraine war, and the repercussions of these crises remain uncertain. However, she added, "In the long history of humanity, both artists and civilians have gone through numerous absurd disasters and crises. Traditional theater such as ancient Greek tragedies or

Noh were created to comfort the souls who could not attain Buddhahood and offer them a sense of belonging. There are also many unacceptable things happening right now. We can collect these stories, transform them into art, and pass them on." This is one of her key considerations when conceiving curatorial and artistic works.

After the interview, I looked up the etymological origins of the term 'world' (世界 , 'shi jie') in Mandarin. It was introduced into the Chinese language through the translation of Buddhist scriptures: "Temporality (shi) refers to a constant flow; space (jie) signifies direction or position".[3] 'Shi' and 'jie' describe the transitional flow of change from the temporal and spatial perspectives respectively. Perhaps the so-called world was born from the interweaving of time and space; it is plural and always in transition. Meanwhile, artistic creation provides a way for us to process them: through acts of describing, constructing, connecting and expressing.

1. Cited from Chiaki Soma's speech at Taipei National University of the Arts in February, 2015.

2. The concept and projects of Arts Commons Tokyo are cited from their website: http://artscommons.asia.

3. From the *Surangama Sutra*, Volume 4.

Appendix

Programs of ADAM 2017-2021

2017	
Artist Lab *by invitation	**Artists:** Chang Yung-Ta, Tora (Che-Pin) Hsu, Ding-Yun Huang, Blaire (Chih-Hao) Ko, Lee Ming-Chen, Allen (Chih-Wei) Lin, Lin I-Fang, Lin I-Chin, Liu Chun-Liang, Liu Kuan-Hsiang, Tith Kanitha, Chikara Fujiwara, Ikbal Lubys, Leeroy New, Moe Satt, Carly Sheppard, Deepak Kurki Shivaswamy, Scarlet Yu Mei Wah, Henry Tan, Tuan Mami **Facilitators:** Tang Fu Kuen, Yao Lee-Chun, Helly Minarti, Arco Renz, Leisa Shelton
ADAM Public Meeting Program	**Opening Performances:** 1. *Qaciljay* by Bulareyaung Dance Company 2. *Terrace on the Hill* by TAI Body Theatre 3. *As Four Step* by Tjimur Dance Theatre
	Exhibition: 1. *SoftMachine: Expedition* by Choy Ka Fai 2. *Dance Clinic Mobile* by Choy Ka Fai and Tung I-Fen
	Feature Screening: 1. *TPE-Tics* by Jessica (Wan-Yu) Lin 2. *Emergent Voices from Southeast Asian Regimes* by Asia Film Archive - *The Robe* by Wera Aung - *Fat Boy Never Slim* by Sorayos Prapapan - *Three Wheels* by Kavich Neang - *The Fox Exploits the Tiger's Might* by Lucky Kuswandi
	Work-in-progress Presentation: 1. *Huldur* by Tseng Yen-Ting & Chiang Tao 2. *The Bamboo Spaceship* by Ming Wong 3. *Body Tradition** by Chen Wu-Kang in collaboration with Pichet Klunchun * The work has been renamed as *Behalf*. 4. *Self Love* by Sujata Goel 5. *Made in China* by Chou Shu-Yi

Time Out Asia:
Organization | Presenter
1. Cambodia Living Arts (Cambodia) | Seng Song
2. Cemeti - Institute for Art and Society (Indonesia) | Linda Mayasari
3. Sandbox Collective (India) | Shiva Pathak
4. Khoj International Artists' Association (India) | Mario D'Souza
5. Fang Mae Khong International Dance Festival (Laos) | Olé Khamchanla
6. Damansara Performing Arts Centre (Malaysia) | Jane Lew, Tan Eng Heng
7. Sodsai Pantoomkomol Theatre (Thailand) | Pawit Mahasarinand
8. Performing Arts Meeting in Yokohama (Japan) | Hiromi Maruoka
9. Asia Culture Center (Korea) | Sungho Park
10. Yirramboi Festival (Australia) | Jacob Boehme
11. YINZI Theater (China) | Hu Yin

Artist Roundtable:
1. **Bodies and Cultural Identity**
 Moderator: Arco Renz
 Panel: Sujata Goel, Carly Sheppard, Watan Tusi, Chen Wu-Kang
2. **Social Acts: Performance and Everyday Experience**
 Moderator: Kei Saito
 Panel: Tora (Che-Pin) Hsu, Lin I-Chin, Deepak Kurki Shivaswamy, Moe Satt
3. **How to Perform Across Visual and Performing Arts**
 Moderator: I-Wen Chang
 Panel: Ding-Yun Huang, Tseng Yen-Ting, Leeroy New, Tuan Mami
4. **Cultivating Artists: What Do Artists Need Institutionally**
 Moderator: Helly Minarti
 Panel: Chikara Fujiwara, Liu Chun-Liang, Henry Tan, Scarlet Yu Mei Wah

2018

Artist Lab
* via open call

Theme: Performativity of the In-between
Guest Curators: Ding-Yun Huang, Henry Tan
Artists: Chang Kang-Hua, Lee Shih-Yang, Su PinWen, Su Yu Hsin, Wen Szu-Ni, Mike Orange, Norhaizad Adam, Kelvin Atmadibrata, Batu Bozoglu, Angela Goh, Natsuki Ishigami, Jeong Se-Young, Russ Ligtas, Cathy Livermore, Justin Shoulder, Zoncy

Kitchen	1. *Deities of Disappearing Island* by Formosa Circus Art x Leeroy New
	2. *Conversation in the Quest of the New Myths of Ocean and Earth: A Co-op Workshop* by Ong Keng Sen x Wei Ying-Chuan
	3. *An`- Body Returning the Origin* by Lin I-Chin
	4. *CHINAME* by Xiao Ke x Zi Han
	5. *Yellow or Grandma is Tired* by Ana Rita Teodoro x Hung Wei-Yao x Lin Wen-Chung x Lin Yen-Ching x Li Li-Chin
	6. *GUI SHU ("belong")* by Sally Richardson x Tien Hsiao-Tzu x Liao Yi-Ching x Hsu Yen-Ting x Kong Yi-Lin x Laura Boynes x Tristan Parr x Ashley de Prazer
	7. *The Man with the Compound Eyes* by Lukas Hemleb
	8. *W.O.W. / For Want of a Better Word** by Daniel Kok x Luke George
	*The work has been renamed as *Hundreds + Thousands*.

Assembly

Time Out Asia:

Organization | Presenter

1. Taipei Performing Arts Center (Taiwan) | Austin Wang
2. Taipei Arts Festival (Taiwan) | Tang Fu Kuen
3. Arts Commons Tokyo (Japan) | Chiaki Soma
4. Asia Network for Dance (AND+) | Chen Pin-Hsiu (Cloud Gate Theater), Ophelia Huang (International Projects, Shanghai Dramatic Arts Centre (SDAC), China)
5. Bangkok International Performing Arts Meeting (Thailand) | Chavatvit Muangkeo
6. Chang Theatre (Thailand) | Pichet Klunchun
7. Dance Nucleus (Singapore) | Daniel Kok
8. Darwin Festival (Australia) | Felix Preval
9. iPANDA (China) | Xiao Ke & Zi Han
10. Kyoto Art Center (Japan) | Mayumi Yamamoto
11. National Kaohsiung Center for the Arts (Weiwuying) (Taiwan) | Keng Yi-Wei, Kathy Hong
12. Serendipity Arts Festival (India) | Manu Chandra
13. Seoul Street Arts Creation Center (South Korea) | Cho Dong-Hee
14. 2019 Tainan Arts Festival (Taiwan) | Chow Ling-Chih, Kuo Liang-Ting

Artist Roundtable:

1. **Between Art and Politics: A Call for Urgency**
 Curator/Moderator: Low Kee Hong
 Speakers: Xiao Ke, Zi Han, Zoncy

2. **Feminist and Queer Conversations in Contemporary Asia-Pacific Performance**
 Curator/Moderator: Jeff Khan
 Speakers: Danial Kok, Justin Shoulder, Kim Chen, Betsy Lan

3. **Performativity of the In-between**
 Curator/Moderator: Ding-Yun Huang, Henry Tan
 Speakers: Batu Bozoglu, Natsuki Ishigami, Jeong Se-Young, Su Yu Hsin, Wen Szu-Ni

4. What is Contemporary in Contemporary Art
 Curator: Claire Hicks
 Moderator: Angela Goh
 Speakers: Kelvin Atmadibrata, Russ Ligtas, Su PinWen

Lecture and Workshop:
1. The CND, an Art Center for Everybody
 Speaker: Centre National de la Danse

2. Re-living Room(s)
 Speaker: Farid Rakun

3. Transcending Caste and Religious Boundaries through Cuisine - The Kayasthas
 Speaker: Manu Chandra

Curators in Dialogue:
1. For the Generation Next: From Camping to Camping Asia
 Moderator: River Lin
 Speakers:
 Taipei Performing Arts Center (Taiwan) | Austin Wang
 Centre National de la Danse | Mathilde Monnier, Aymar Crosnier

2. Art as Social Action
 Moderator: Museum of Contemporary Art (Taiwan) | Yuki Pan
 Speakers:
 Yirramboi First Nations Arts Festival (Australia) | Jacob Boehme
 Pulima Art Festival (Taiwan) | Nakaw Putun

3. Curating Live Art: From the Context to the Practice of Contemporary Art
 Moderator: River Lin
 Speakers:
 Taipei Fine Arts Museum (Taiwan) | Jo Hsiao
 21st Century Museum of Contemporary Art (Japan) | Yuko Kuroda
 Ming Contemporary Art Museum (Shanghai) | Zhang Yuan

Lecture Performance:
1. *Your Teacher, Please* by Ana Rita Teodoro
2. *Rock the Boat* by Enoch Cheng

Feature Screening:
1. *Tell Me What You Want* by Yu Cheng-Ta
2. *Queer Bodies* by Centre National de la Danse

2019

Artist Lab
** via open call*

Theme: Performing (with/in) communities: Relations, Dynamics and Politics
Guest Curator: Natsuki Ishigami
Facilitators: JK Anicoche, Wen Szu-Ni
Artists: Cheng Xin, Sheryl Cheung, Han Xuemei, Ip Wai Lung, Niu Jun-Qiang, Bunny Cadag, Madeleine Flynn, Elia Nurvista, Chiharu Shinoda, Song Yi-Won, Yasen Vasilev, Vuth Lyno

Kitchen	1. *Future Tao: Songs from the Naga Cave* by Ding-Yun Huang x Henry Tan x Xia Lin x Sheryl Cheung
	2. *Delay* by Norhaizad Adam
	3. *Shampoo Is Telling A Story* by Chang Kang-Hua
	4. *Rama's House* by Chen Wu-Kang x Pichet Klunchun
	5. *Paeonia Drive* by Su Yu Hsin x Angela Goh
	6. *I Am the Beauty Queen* by Kao Yi-Kai, Bunny Cadag

Assembly	**Time out Asia:**	
	Organization	Presenter
	1. Tua-Tiu-Tiann International Festival of Arts / Thinkers' Theatre (Taiwan)	Kao Yi-Kai
	2. C-LAB Taiwan Contemporary Cultural Lab: Taiwan Sound Lab (Taiwan)	Lin Jin-Yao
	3. SPAC-Shizuoka Performing Arts Center, Tokyo Festival (Japan)	Yoshiji Yokoyama
	4. Visible (Italy)	Matteo Lucchetti, Judith Wielander
	5. Guangdong Times Museum (China)	Pan Si-Ming
	6. Jejak-旅 Tabi Exchange: Wandering Asian Contemporary Performance (Indonesia)	Helly Minarti

Artists in Dialogue

1. **Let's Go to the Street: Performing Community and Public Space**
 Artists:
 Les Petites Choses Production (Taiwan) | Sunny (Nai-Hsuan) Yang, Lucky Chen
 Drama Box (Singapore) | Han Xuemei
 Commentator: Betty Yi-Chun Chen

2. **Sharing Together: What We Do with/in Local Communities**
 Artists:
 Sa Sa Art Projects (Cambodia) | Vuth Lyno
 A Centre for Everything (Australia) | Gabrielle de Vietri, Will Foster
 Commentator: Lo Shih-Tung

3. **Performing Together: Transforming the Quotidian through Arts in Participatory Settings**
 Artists:
 Prototype Paradise (Taiwan) | Yoyo Kung
 Madeleine Flynn
 Commentator: Chou Yun-Ju

4. **Kongkow with ruangrupa**
 Artists:
 ruangrupa (Indonesia) | Reza Afisina, Indra Kusuma Atmadja

Due to the COVID-19 pandemic, Artist Lab was cancelled, and the physical annual Public Meeting was transformed into an online art project with three sessions of creation, lecture and dialogue to reflect on the present and future of the art ecology.

An Internet of Things

FW: Wall-Floor-Window Positions	Performance 1: Norhaizad Adam, Joel Bray, Bunny Cadag, Michikazu Matsune, Scarlet Yu Mei Wah
	Performance 2: Lin Yen-Ching, Lin Yu-Ju, Liu Yi-Chun, Venuri Perera, Chiharu Shinoda
	Performance 3: Takao Kawaguchi, Daniel Kok, Lee Tsung-Hsuan, Tien Hsiao-Tzu, Xiao Ke x Zi Han

My Browsing History	Russ Ligtas, ila, Enoch Cheng, Mish Grigor, Riar Rizaldi, Yves (Chun-Ta) Chiu, Su Wen-Chi, Tada Hengsapkul, Au Sow Yee

TBC: Workshopping the Future

Curated by Transient Collective (Madelein Flynn, Han Xuemei, Elia Nurvista, Vuth Lyno)

1. Digital Communities
Hosts: Madeleine Flynn (Australia), Han Xuemei (Singapore)
Guests:
pvi collective (Australia) | Steve Bull, Kelli McCluskey
JK Anicoche (the Philippines), Ip Wai Lung (Hong Kong)

2. Artistic Practice
Hosts: Elia Nurvista (Indonesia), Vuth Lyno (Cambodia)
Guests:
Martinka Bobrikova (Slovakia/Norway) & Oscar De Carmen (Spain/Norway), Enzo Camacho (the Philippines/Germany)
Hyphenated Projects (Australia) | Phuong Ngo, Nikki Lam

3. Labour
Hosts: Han Xuemei (Singapore), Elia Nurvista (Indonesia)
Guests:
Melinda M. Babaran (the Philippines/Taiwan), Brigitta Isabella (Indonesia), Sima (Ting-Kuan) Wu (Taiwan)

4. Ecology
Hosts: Madeleine Flynn (Australia), Vuth Lyno (Cambodia)
Guests:
Green Citizens' Action Alliance (Taiwan) | Chen Shi-Ting
Cassie Lynch (Australia), Natasha Tontey (Indonesia)

2021

Still Reconciling. This is the statement and discursive progress that ADAM's 2021 edition proposed. Through virtual and physical gatherings and working sessions, ADAM invited participating artists to challenge and reflect on our precarious times.

The new program, "Rehearsing (for) the Future", was a research project calling for artists from around the world to deliver their ideas of knowledge production and image ways of making performances responding to burning issues of the now and the near future.

The annual Public Meeting program that initially served as a public assembly in physical settings was deconstructed and transformed into long-running online events throughout the year. The online programs were presented via three seasons and conceived and curated by artists to respond to our contemporary lives and situations based on their various research and practices.

Artist Lab "Shihlin Study" brought together Taiwanese artists to examine the local ecology and connect with communities sited in the Shihlin district of Taipei. Moreover, through the new open call "Rehearsing (for) the Future", Asian artists were encouraged to conceive and invent research-based ideas for performance-based projects that can go beyond travel restrictions in digital or physical

Artist Lab * via open call	**Theme: Shihlin Study** **Facilitator**: Yang Shu-Wen **Artists**: Mao Yo-Wen, Ciwas Tahos, Baï Lee, Yu Yen-Fang, Yu Cheng-Ta, Lee Yung-Chih, Betty Apple, Chang Wen-Hsuan, Yang Zhi-Xiang, Liu Yen-Cheng
Online Programs	**Online Programs in April** *Back to Rituals: Duration, Bodies and Performativity* **Concept and curation: Melati Suryodarmo (Indonesia)** 1. Religious Ritual in Bali as Way of Living Arts Artist: Diane Butler 2. Body and Ritual in Digital Settings Artist: Natasha Tontey 3. Ghost and Spirits in Our Contemporary Lives Artist: Korakrit Arunanondchai 4. Visibility of Time: Body as a Time Tool Artist: Meg Stuart 5. The Body's Speed and Lapse Artist: Melati Suryodarmo

Online Programs in August
Level 3 Alert: Art Variants
Concept and curation: Su Wen-Chi (Taiwan)

1. Reflections on "The Other Shore": Dancing with VR and Beyond
 Artists: Ashley Ferro-Murray & Zoe Scofield
2. Alkisah _ Decentralization is The Future
 Artist: Senyawa
3. Brain, Body, World
 Artist: Daito Manabe
4. U & I: An Online Performative Exercise
 Artist: Dick Wong
5. By the Way of Images
 Artist: Maria Hassabi
6. Speculation on the Semi-Lockdown
 Artist: Baï Lee

Online Programs in December
Time Dresses Up as a Ghost and Arrives to the Party Dripping
Concept and curation: Angela Goh (Australia)

1. Betraying Utopia | Slime Utopia
 Artist: Jassem Hindi
2. Wet Mechanics of Seeing
 Artist: Su Yu Hsin
3. A Free Speaking on Improvisation, Ghosts and Opacity
 Artist: Brian Fuata
4. Dressing Party
 Artist: Verity Mackey
5. New Year's Re/Solution
 Artists: River Lin and the artists from previous editions of ADAM
 - Batu Bozoglu, Ding-Yun Huang, Natsuki Ishigami, Henry Tan,
 Yasen Vasilev, Wen Szu-Ni

Rehearsing (for) the Future

1. **The Currency: Proof of Ambiguity**
 Artists/Presenters: Musquiqui Chihying & Elom 20ce & Gregor Kasper
 Special Guest: John Tain

2. **The Malay World Project: Roots & Routes**
 Artists/Presenters: Mohamad Shaifulbahri & Nazry Bahrawi & Fasyali Fadzly & Amin Farid & Biung Ismahasan
 Special Guest: Lovenose

3. **Body Crysis**
 Artists: Harrison Hall & Sam Mcgilp & NAXS Corp. (Yi Kuo and Feng Han-Yu)
 Special Guest: Yoko Kawasaki

4. per / re form
 Artist: TAKUMICHAN
 Special Guest: Maron Shibusawa

5. WITH motherhood(s) project*
 Artists: Scarlet Yu Mei Wah & Tung I-Fen
 Collaborators: Ziko Yu Le Roy & Nikar Fangas
 Special Guest: Madeleine Planeix-Crocker
 *The project has been renamed as M(Other)hood: Camping

Writers' Biographies

*Listed in alphabetical order of surname.

I-Wen CHANG

Assistant Professor at Taipei National University of the Arts, I-Wen CHANG received her Ph.D. in Culture and Performance at the University of California, Los Angeles (UCLA). Her areas of specialization include Taiwanese theatrical dance, digital performance, and interdisciplinary and intercultural performance. She is the author of *Beyond Dancing: Dance in Contemporary Art* (2022). CHANG's articles have been published in *Journal for the History of the Body, Arts Review, Inter-Asia Cultural Studies,* and *Taiwan Dance Research Journal,* among others. She is the curator of the exhibition *Digital Corporeality* at C-LAB, Taiwan (2021), and the co-curator of the *Taiwan Art Biennial 2022: Love and Death of Sentient Beings* at National Taiwan Museum of Fine Arts.

Cheng-Ting CHEN

Born in 1985 in Taiwan, Cheng-Ting CHEN is a Berlin-based theater designer. She has exhibited her work across Europe and Asia. Her primary focus is on multidisciplinary spatial experiments, visual arts and performance art in an interdisciplinary and cross-cultural context. She works with various artists and is currently collaborating with Polymer DMT in Germany and Taiwan. CHEN has been a contributor to *Performing Arts Review* in Taiwan since 2018.

Betty Yi-Chun CHEN

Betty Yi-Chun CHEN is a dramaturg and a Translated based in Taipei and Munich. Since 2012, she has worked intensively with the Taipei Arts Festival on international co-productions and in 2019 as a dramaturg for the festival's new commissions. Currently, she is working on research projects for Theater der Welt 2023. As a dramaturg, CHEN has worked with artists and curators from Taiwan, Hong Kong, Singapore and Germany. A constant focus of her work is the friction between individual and collective narratives. She writes on contemporary practices of political theater and has translated over a dozen books and plays from German/English into Chinese.

Enoch CHENG

Enoch CHENG is an artist whose practice spans moving image, installation, curating, dance, events, theater, writing, fashion, performance, and pedagogy. His works explore recurrent themes of place, travel, care, cross-cultural history, fiction, memory, time, migration, and extinction. He was a grantee of the Asian Cultural Council Fellowship (2020); artist-in-residence at the American Museum of Natural History, New York (2020); Laureate, Institut Français, Paris (2018); and artist-fellow at Akademie Schloss Solitude, Stuttgart (2017–2018).

Xin CHENG

Born in China and raised in New Zealand, Xin CHENG works across art, social design and local ecologies. Since 2006, she has been researching and hosting workshops around creative making by non-specialists across the Asia-Pacific and Europe. This culminated in *A Seedbag for Resourcefulness,* published by Materialverlag (DE) in 2019. Recently, she set up 'A Place for Local Making' with Adam Ben-Dror, for convivial transforming and thinking with local materials in Wellington (NZ). Xin holds a Master of Fine Arts from Hamburg University of Fine Arts.

Cheng-Hua CHIANG

Cheng-Hua CHIANG received her MFA in Arts Administration and Management from Taipei National University of the Arts and has been dedicating herself to theater, art documentaries management and festival programming for nearly 18 years. She was the Head of Programming & Production for Pulima Art Festival, and also contributed to Indigenous performing arts research, development and cross-cultural communication at the Indigenous Peoples Cultural Foundation, Taiwan, between 2013-2022. CHIANG is the curation manager at Hsinchu Indigenous Cultural Center, guest editor for the Taiwan-Maori art exchange program curated by Govett-Brewster Art Gallery in New Zealand, and International Selection Committee member for Bibu and ASSITEJ Artistic Gathering 2022.

Chih-Yung Aaron CHIU

Professor Chih-Yung Aaron CHIU is the Director of the Interdisciplinary Program of Technology and Art at the College of Arts, the Director of the Graduate Institute of Art and Technology at National Tsing Hua University in Taiwan, as well as a curator, art critic and the Trustee of Digital Art Foundation. He received his Ph.D. from the School of Interdisciplinary Arts at Ohio University in the United States, with a double major in visual arts and film studies, as well as a minor in aesthetics.

Ling-Chih CHOW

An art critic, curator, dramaturg, writer and educator on creative theatrical aesthetics, Ling-Chih CHOW takes on diverse roles in many art festivals, exhibitions, performing arts creations and research projects of artists and institutions.

Freda FIALA

Freda FIALA works across the contexts of performance art, digital and new media dramaturgy and interculturalism, through writing, researching and curating. She is currently a fellow of the Austrian Academy of Sciences and studied Theater, Film and Media Studies, as well as Sinology in Vienna, Berlin, Hong Kong and Taipei. Her research focuses on theater and performance cultures in East Asia and on the performing arts as a means and method of negotiating international cultural relations. She is the co-curator of the performance festival *The Non-fungible Body?* in Linz/Austria which took place for the first time in 2022.

Nicole HAITZINGER

Nicole HAITZINGER is Professor of Dance/Performing Arts and scientific director of the transdisciplinary and inter-university doctoral program Science and Art in Salzburg. Her recent publications include *Staging Europe* (2018, co-edited with Stella Lange) and *Dancing Europe: Identities. Languages and Institutions* (2022, co-edited with Alexandra Kolb). She has published numerous articles and books, and is currently writing a monograph on *Border Dancing Across Time*.

Xuemei HAN

Xuemei HAN is a theatre practitioner based in Singapore. She believes in socially engaged practice and imagines the arts as an integral ingredient for beauty and hope in society. Her artistic practice involves designing experiences, spaces and conditions for people to exercise their right to be creative, disrupt routines and deconstruct paradigms. She explores participatory practices and works with communities and youths. She was most

recently awarded the 2021 Young Artist Award, Singapore's most prestigious award for young arts practitioners, by the National Arts Council.

Rosemary HINDE

Rosemary HINDE has worked in the arts in Asia across multiple artforms and for many institutions including the Australia Council for the Arts, Marrugeku, University of Melbourne, Arts Centre Melbourne, Melbourne Festival and Hirano Productions. Over the past 30 years, she has occupied a variety of roles including Artistic Director, Managing Director, CEO, Manager, Producer, Consultant and University Lecturer. She has been based in Tokyo, Melbourne, Sydney and Hong Kong at different points during this time. HINDE is currently an independent International Arts Development Consultant with an interest in many facets of arts development, production and distribution in North Asia in particular.

Ding-Yun HUANG

Ding-Yun HUANG is one of the co-founders of Taipei-based artist collective Co-coism, which aims at work-in-collective, site-responding, and interdisciplinary practices. They focus on creating a flexible relationship between the audience and the performers. In 2020, HUANG initiated a series of projects on 'Mind and Consciousness,' such as *God in Residence* and *Performing Insanity*.

His works are mainly premiered in the Asia-Pacific region. He has also been invited as a residency artist, facilitator or guest curator by Kunstenfestivaldesarts (Belgium), Gorki Theater Herbstsalon (Berlin), ADAM—Asia Discover Asia Meetings (Taipei), Dance Nucleus (Singapore), Royal Melbourne Institute of Technology (Melbourne).

Danielle KHLEANG

Danielle KHLEANG is an early career art writer. She has studied art history and social change communications. Her research interests include Cambodian contemporary art, lived experiences, and the continuity between past, present and future.

Tsung-Hsin LEE

Postdoctoral Researcher at the Research Institute for the Humanities and Social Science, Ministry of Science and Technology, and Adjunct Assistant Professor at the College of Dance, Taipei National University of the Arts, Tsung-Hsin LEE received his Ph.D. in Dance Studies from the Ohio State University, and Master of Arts from Taipei National University of the Arts. He is interested in the global circulation of dance, dance diplomacy, dance history in the 20th century, dance dramaturgy and artistic Practice-as-Research.

Helly MINARTI

Helly MINARTI works as an independent curator/scholar, aligning her practice to rethink radical strategies that connect practice and theory in the dance/performance realm. Her primary interest is in the historiographies of choreography as discursive practice vis-à-vis the eclectic knowledge that infuses the understanding of the complexities of the human body and nature. She has co-curated a number of events/platforms, among the most recent are *Jejak- 旅 Tabi Exchange: Wandering Asian Contemporary Performance* (jejak-tabi.org) and the Regional Forum of Southeast Asia Choreographers Network (2022). She is also the editor for the post-event publication of both platforms. MINARTI is Jakarta-born and now lives in Yogyakarta, Central Java.

Nanako NAKAJIMA

Dr. Nanako Nakajima is a scholar and dance dramaturg. Her recent research and dramaturgy projects include *Yvonne Rainer Performative Exhibition* at Kyoto Art Theater Shunju-za in 2017, *Dance Archive Box Berlin* at Akademie der Künste Berlin in 2020, and the lecture-performance *Noh to Trio A* at Nagoya Noh Theater in 2021. She was a Valeska Gert Visiting Professor (2019/20) at Freie Universität Berlin. NAKAJIMA received the Special Commendation of the Elliott Hayes Award in 2017 for Outstanding Achievement in Dramaturgy from the Literary Manager and Dramaturgs of the Americas. Her publications include *The Aging Body in Dance: A Cross-Cultural Perspective*, and she recently launched a bilingual website on dance dramaturgy (www.dancedramaturgy.org).

Jessica OLIVIERI

Working from the lands of the Darug people, Dr. Jessica OLIVIERI is the Artistic Director of Utp, an arts organization working at the intersection of community and contemporary art – based in Western Sydney, Australia, working globally. Her experience of growing up in Western Sydney and neurodivergence have informed her commitment to intersectional access to the arts.

Hsuan TANG

Born in 1995 in Taichung, Taiwan, Hsuan TANG lives and works in Taipei. She received her Bachelor of Fine Arts from Taipei National University of the Arts in 2018. TANG was Editorial Assistant at DIANCAN ART & COLLECTION LTD. (2017-2018), Marketing Manager at M.O.V.E. Theatre Company (2018-2020), and has been Executive Planner at Digital Art Foundation since 2021.

Cristina SANCHEZ-KOZYREVA

Cristina SANCHEZ-KOZYREVA is an art writer, editor, curator, and creative projects manager with a Master's degree in International Prospective (Paris V University, International Relations, 2001). She co-founded and was the editor-in-chief of *Pipeline* (2011-2016), an independent contemporary art magazine based in Hong Kong. SANCHEZ-KOZYREVA is a regular contributor to *Contemporânea*, *Artforum International Magazine*, *Frieze Magazine*, among others, and contributes original writing for artists' catalogues and journals, as well as copy-editing and editing work for independent projects and institutions. She is currently the editor-in-chief of *Curtain*, an online magazine focused on curators.

Anador WALSH

Anador WALSH is a curator and writer and the director of Performance Review. In 2020, she took part in the Gertrude Emerging Writers Program and was the 2019 recipient of the BLINDSIDE Emerging Curator Mentorship. Her recent writing includes: *Beyond human* for The Saturday Paper, *Performing Protest* for PICA and *Making Content from the Wreck* for *Contact High* at Gertrude Glasshouse. Until 2018, WALSH was the Marketing and Development Manager of Gertrude.

Po-Wei WANG

Po-Wei WANG is Artistic Director of Digital Art Foundation, Taiwan. His research interests include Media Theory, History of Contemporary Art, Sociology of Culture and Art, and Art/Science/Technology (AST). He translated Niklas Luhmann's *Liebe als Passion: Zur Codierung von Intimität* into Chinese together with Chin-Hui Chang.

NETWORKED BODIES
THE CULTURE AND ECOSYSTEM OF CONTEMPORARY PERFORMANCE
Asia Discovers Asia Meeting for Contemporary Performance
2017-2021

Publisher

TAIPEI PERFORMING ARTS CENTER

No. 1, Jiantan Road, Shilin District, Taipei City 111081, Taiwan
+886 2 7756 3800
service@tpac-taipei.org
https://www.tpac-taipei.org/

Chairwoman : Ruo-Yu LIU
Executive Director: Austin WANG
Head, Programme & Production: Charlene LIN
Producer, Programme & Production: Mei-Yin CHEN

Editor-in-Chief: River LIN
Managing Editor: Claire SUN

Authors: I-Wen CHANG, Cheng-Ting CHEN, Betty Yi-Chun CHEN, Enoch CHENG,
Xin CHENG, Cheng-Hua CHIANG, Chih-Yung Aaron CHIU, Ling-Chih CHOW,
Freda FIALA, Nicole HAITZINGER, Xuemei HAN, Rosemary HINDE,
Ding-Yun HUANG, Danielle KHLEANG, Tsung-Hsin LEE, Helly MINARTI,
Nanako NAKAJIMA, Jessica OLIVIERI, Hsuan TANG, Cristina SANCHEZ-KOZYREVA,
Anador WALSH, Po-Wei WANG

*Listed in alphabetical order of surname.

Translators: (Mandarin Chinese to English) Elliott Y.N. CHEUNG, Johnny KO, Elizabeth LEE,
River LIN, Stephen MA, Cheryl ROBBINS; (English to Mandarin Chinese) Tai-
Jung YU, Yen-Ing CHEN

English Editors: Johnny KO, Betty Yi-Chun CHEN, Wah Guan LIM
Proofreading: River LIN, Charlene LIN, Mei-Yin CHEN, Claire SUN, Johnny KO
Assistant Editors: Ping-Jung CHEN, Maya LEE
Circulation: Lawa LU
Interview Interpreter: Mu-Ju TSAN
Graphic Design: Ming-Wei LIU
Cover Image: *Disappearing Island*, Formosa Circus Art, 2019 Taipei Arts Festival.
Image courtesy of Taipei Performing Arts Center.
Photo by Hsuan-Lang LIN

Printed in Taiwan
1st Printing Edition in October 2022

Print ISBN: 978-626-7144-60-2
ebook ISBN: 978-626-7144-61-9